Psychobroe.
 problems - 6
Painting Truer
 than truth 144-5
Transitional Object
 If imposed = madness 135
 Free = shared
Choose the dog's life 149
No God, but something greater
 150

Ramshakel Christianity →
 temple of art 157
Starry Night 160-161
 Agony Jesus → Starry Night 161
 Bullring and ear 188-189
 Dilemma of narcissism 216-217

Vincent's Religion

The Reshaping of Psychoanalysis
From Sigmund Freud to Ernest Becker

Barry R. Arnold
General Editor

Vol. 8

PETER LANG
New York • Washington, D.C./Baltimore
Bern • Frankfurt am Main • Berlin • Vienna • Paris

W. W. Meissner, S.J., M.D.

Vincent's Religion

The Search for Meaning

PETER LANG
New York • Washington, D.C./Baltimore
Bern • Frankfurt am Main • Berlin • Vienna • Paris

Library of Congress Cataloging-in-Publication Data

Meissner, W. W. (William W.).
Vincent's religion: the search for meaning / W. W. Meissner.
p. cm. — (The Reshaping of psychoanalysis; vol. 8)
Includes bibliographical references.
1. Gogh, Vincent van, 1853–1890—Religion. 2. Psychoanalysis
and art. I. Title. II. Series.
ND653.G7M523 759.9492—dc20 96-23183
ISBN 0-8204-3390-X
ISSN 1059-3551

Die Deutsche Bibliothek-CIP-Einheitsaufnahme

Meissner, William Walter:
Vincent's religion: the search for meaning / W. W. Meissner.
–New York; Washington, D.C./Baltimore; Bern; Frankfurt am Main;
Berlin; Vienna; Paris: Lang.
(The reshaping of psychoanalysis; Vol. 8)
ISBN 0-8204-3390-X
NE: GT

Cover design by James F. Brisson.

The paper in this book meets the guidelines for permanence and durability
of the Committee on Production Guidelines for Book Longevity
of the Council of Library Resources.

Printed in the United States of America.

Table of Contents

Section I
The Early Religious Path

Section II
Toward the Abyss

Section III
The Artist's Vocation

Section V
Vincent and God

List of Illustrations

Preface

The life of Vincent van Gogh is as much a part of the cultural heritage of western civilization as is his art. The events and circumstances of Vincent's tragic life are well documented in careful biographical studies and have even found their way to the silver screen. For the psychoanalyst, Vincent's life and his psychic troubles provide a symphony of symptoms, polyphonic pathology, medical and psychiatric, a turbulent crescendo of disturbed emotions and peculiar behaviors that would challenge the diagnostic acumen and interpretive capacity of any clinician.

The student of Vincent's life and work finds himself confronted with a melange of themes and influences which can be grasped only in relation to one another and to the whole. These include his birth as a replacement child, the patterns of estrangement that pervaded his relations with others, the alienation from his family and bitter conflicts with his pastor-father, maternal depression and failures of empathy, the pattern of idealization of his father that turned to rejection, the desperately symbiotic attachment to his brother Theo, the fanatic efforts to achieve the heights of spiritual self-denial, which ended in painful disappointment and failure and led to the rejection of all conventional religious practice and belief—all this mirroring the conflict-ridden relationship with his father—the resolution of these issues in his artistic vocation, and finally the terrible tragedy of his psychotic process and its termination in suicide. As I develop these themes, I will argue that they are all of a piece—they form an integrated tapestry no part of which can be ignored without detriment to the rest. In a unique and profoundly meaningful sense, Vincent's art cannot be understood without seeing it in the context of his life, his intrapsychic conflicts, his struggles to find some sense of self and identity, and his deeply personal vision of the meaning of life and man's relation to the divine.

His art and his relation to God are so interwoven that they are hardly distinguishable. Vincent's artistic efforts came close to a form of religious expression that at times reached the level of mystical implication. Consequently, although this study is at first glance a study of Vincent's personality and its relation to his work—a subject of considerable interest in itself, especially in view of the intensely personal character of his art—closely related are all the challenging questions regarding the intersection of personality and art, even the somewhat obscure connections between psychological disturbance and artistic genius—the so-called psychopathology of creativity.

But the discussion reaches beyond the immediacy of Vincent and his work to another perspective that has broader and deeper implications. Vincent provides material for a fascinating case study not only of the interpenetration of art and religion but of the complex mutuality between psychoanalytic perspectives and religious experience. My primary intention is to offer this book as a case study of the interrelation of psychoanalysis and religion—a unique case in which the specific qualities of Vincent's religious inspiration are displayed in multifaceted ways on his canvases.

From another perspective, there is a fascination in Vincent's account of himself. The more I have come to know him, the more convinced I am that he struggled desperately to tell his fellow men—those around him whom he knew and touched, those whom he never knew and never touched, and those who were to come after him and were to know him only through his work—something about himself. He wanted desperately to be known, accepted, loved, to feel that he too could belong to the fellowship of human beings. This was something he sought after in clumsy and self-defeating ways throughout his life and never achieved, certainly not to his satisfaction. The only glimmering of such connection came in his relationship with his brother Theo.

The vehicles of this profound self-exploration and self-revelation were twofold: his letters, predominantly to Theo but also to others, and his paintings. In his excellent history of art, Hamilton (1967) writes of Vincent:

> His autobiography in the form of some 755 letters to his devoted brother Theo and a few friends is one of the most relentless documentations of the search for the self in literary history. In his paintings and drawings Van Gogh also illustrated that life, literally and figuratively. Each of his pictures was a stage in his search, each 'a cry of anguish', as he said, so that to understand his art it is not enough to judge it in purely artistic terms. From 1881, when he decided to be entirely an artist, his art was indistinguishable for him from that reality which he hoped his life would become. (p. 94)

In his letters, Vincent poured out a pathetic torrent of deeply emotional and profoundly meaningful introspective thought. They provide a window on the inner turmoil of his heart and mind, as well as a reflection of his ongoing struggle to find that sense of himself that might provide the peace and acceptance he yearned for. They were self-portraits painted in pen and ink rather than brush and pigment. It is in his painting, however, that his desperate effort of self-discovery, clarification and consolidation comes to a brilliant focus, particularly and poignantly in his own self-portraits. My intention is to

let Vincent speak for himself through his letters and paintings. In this perspective, then, the biographical focus moves to the background, serving only to provide the context, the frame, within which Vincent presents himself and within which we can begin to grasp the meaning of what he has to say. It is his self-searching and self-revelation that are the primary focus.

The most central, telling, and poignant aspect of Vincent's search for meaning and identity was his religious experience. The early phase of his religious odyssey was marked by a fanatic immersion in religious preoccupations that became an obsessive and prepossessing theme. His severe asceticism, self-denial, and religious dedication and devotion in his saintly mission among the poor miners of the Borinage match the ascetic adventures of the great saints. His rebellion against the church and God of his father left him with an emptiness, an alienation, a hungered quest for God that he struggled to fulfill through his tortured love of nature and his efforts to find religious meaning and purpose in his art. The religious dimension is not merely an aspect of Vincent's search for identity and meaning in his otherwise fractured and fragmented life; it is the core of his existence, in terms of which all the rest take on perspective and relevance. His worship of nature and seeking after God reached mystical if not ecstatic proportions in the context of his final illness and the ravages it wrought in his heart and mind. To attempt to enter this inner world is to come face to face with a complex, tormented, and all-too-human genius who changed the course of art history but who also probed the depths of the human spirit in his search for a spiritual home.

I am grateful to those who have encouraged me and offered help from time to time. Prof. Jeffery Howe, chairman of the Fine Arts Department at Boston College, has been particularly generous with his time and assistance. A special word of gratitude goes to my research assistant, Miss Elfriede Banzhaf, who has been unfailingly helpful and instrumental at every phase of this effort.

W. W. Meissner, S.J., M.D.
St. Mary's Hall,
Boston College,
Chestnut Hill, Massachusetts

PRELUDE
In Search of Vincent

When we pose the study of Vincent's religious experience, we take on the challenge of entering his heart and mind to discover there the inner forces and conflicts that motivated his religious quest and gave it the shape and form it possessed. The challenge involves more than biography—it seeks to find the inner meaning, the sources and dimensions of his inner life; it searches for the man within or behind the biography. The task is analogous to that the psychoanalyst sets himself in his exploration of the inner psychic life of his patients. Behind or within the details of a life narrative, there is the hidden reality of the patient himself, his desires, wishes, hopes, conflicts, values, ideals, ambitions and disappointments—all the components of his or her sense of self and personal meaning. The task is complex and difficult enough when we are dealing with a living, reacting, talking, and immediately present person. When the subject is dead and can be reached only through the inanimate residues of his life, there are further complexities involved in the process of discovery.

Psychobiography

When the psychoanalyst enters the world of biography, he enters an alien territory, lacking the familiar landmarks he habitually uses to guide his explorations. While he is used to dealing with living subjects, he now finds himself confronted with all the obscurities and opacities of the historical process. The immediacy of the psychoanalytic situation is replaced by the concealing veil of time. Instead of the vitality and spontaneity of a patient's associations, he is met with the residues of history—faceless facts, dates, names, and the infinite impenetrability of documents.

The alliance of psychoanalysis and psychobiography has never been an easy or comfortable one. Certainly the application of psychoanalysis to any context outside the clinical is problematic. Freud (1930) himself was quick to sound a cautionary note: "I would not say that an attempt . . . to carry psychoanalysis over to the cultural community was absurd or doomed to be fruitless. But we should have to be very cautious and not forget that, after all, we are only dealing with analogies and that it is dangerous, not only with men but also with concepts, to tear them from the sphere in which they have originated and been evolved" (p. 144). Psychoanalytic understanding and ideas do their best service in the context of concrete clinical experience; when they leave those fertile fields they begin to falter and grow weak.

There are methodological incompatibilities separating psychoanalytic understanding from biographical interest. Insofar as it represents a subdivision of history, biography tends to be literal-minded, concentrating on facts that are verifiable by accepted methods. Psychoanalysis lives in the realm of metaphor, fantasy, and analogy. Its focus falls on meanings and motives rather than facts—and meanings and motives are not always readily validated, especially when they are found only at an unconscious level. The psychobiographer is not immune to the demands of evidence and proof, but because of the nature of what he deals with—hidden agendas, unconscious fantasy systems, motives, meanings—the causal links are nowhere immediate or evident. The proof rests on a gestalt of facts, opinions, reactions, behaviors in various contexts, comments in letters and other writings—a whole congeries of data that begins to take on meaning and consistency in the light of the given hypothesis. No single fact or connection will validate the hypothesis, but it begins to have relevance in the light of the total complex of data and their integrating interpretations.

Freud (1923) faced a similar problem in trying to account for the validity of dream interpretations: "What makes him [the analyst] certain in the end is precisely the complication of the problem before him, which is like the solution of a jig-saw puzzle. A coloured picture, pasted upon a thin sheet of wood and fitting exactly into a wooden frame, is cut into a large number of pieces of the most irregular and crooked shapes. If one succeeds in arranging the confused heap of fragments, each of which bears upon it an unintelligible piece of drawing, so that the picture acquires a meaning, so that there is no gap anywhere in the design and so that the whole fits into the frame—if all these conditions are fulfilled, then one knows that one has solved the puzzle and that there is no alternative solution" (p. 116).

In the realm of psychobiography, this process may not provide solid ground for the validation of biohistorical fact, but it can provide meaningful ground for psychological understanding based on coherence rather than correspondence. Disproof of this gestalt is more complex than the simple disconfirmation of historical facts. It requires a piece by piece dismantling of the gestalt. When enough of the pieces have been removed, the hypothesis lacks the necessary support and so collapses. The degree to which this process is open to scrutiny depends on the specificity of the hypothesis, the validity of the relevant data, and the construction of the psychological argument in terms of which they are integrated. The process, so conceived, is not unlike the method of the psychoanalyst in his work with the history and meaning of his patient's life.

Methodological Difficulties

If there is legitimacy in the enterprise, there are also significant difficulties. None of the materials that the biographical process offers can serve the psychobiographer without being shaped by his interpretation. His work consists in bringing to bear an interpretive schema, based on his clinical knowledge and experience and drawn from his psychological theory—in this case psychoanalysis—to yield hypotheses that will add a significant dimension to the understanding of the subject's personality and behavior. It is in the interface between biographical fact and psychological interpretation that the risks and the pitfalls of this approach come to roost.

These pitfalls are apparent to any thoughtful observer. Problems arise in the selection of data, in the combination of events into recognizable patterns, in the omission or underemphasis of aspects that do not fit the putative hypothesis, in proposing false connections, in mistaking conjectural hypothesis for historical fact, in allowing one's attitudes or feelings about the subject to influence the process of interpretation. The risk of fitting the data to the hypothesis by inappropriate selection or omission is not inconsiderable. Keeping in mind that the psychobiographical approach carries little explanatory power that would allow it to reach beyond the conjectural, there is an understandable impulse on the part of the investigator to find certainty and factuality where none exists. Distorting factors can easily enter into the process, pushing him in the direction of trimming the subject and his life to fit the procrustean bed of psychoanalytically generated hypotheses rather than designing the model to fit the subject and the rich complexity of his biography (Mack 1971).

These difficulties are not unfamiliar to the psychoanalyst, who is confronted daily in his consulting room with a similar task—to fit the flow of data coming from the patient into some recognizable pattern that will allow them both to better understand its meaning and with enough theoretical perspective to allow useful clinical work to be done. In that context, the patient never quite fits any pre-existing mold and by his very reality and vitality constantly reminds the analyst that there is always more to the picture. The good psychobiographer must learn to live with ambiguity and uncertainty—and to settle for what he can get, even if that is no more than a loosely conjectural understanding of his subject.

In addition to these data-based interpretive difficulties, the psychobiographer is burdened by certain attitudes and feelings about his subject that come from his own psychic makeup and inner life. This phenomenon is familiar to the psychoanalyst in the form of countertransference; it is an aspect of his ongoing clinical experience that he struggles with on intimate terms day in and day out. But it can play a significant role in psychobiography as well. It is

involved in whatever factors determine the decision to study and write about a particular subject. These countertransferential factors determine in large measure the evaluative measure the biographer takes of his man as he enters more deeply into the subject, learns more about him, and begins to shape his understanding of the complex human phenomenon before him. Unrecognized and unmodulated countertransference is a source of distortion and deficits in objectivity and judgment throughout the process. Freud was well aware of this danger and took the trouble to warn future psychobiographers in his essay on Leonardo (1910) that their views of their subjects were in all likelihood contaminated by their own infantile needs and wishes.

Pathological Pitfalls
Analytic interpreters have often strayed from the confines imposed by uncertain data and tentative hypotheses. The investigator can easily lose sight of the limitations in his formulations. The step from the recognition and definition of clinically identifiable patterns of behavior and motivation to interpretation of the behavior of any historical figure is often uncertain. When the investigator identifies such a pattern, he too often leaps to the conclusion that his historical subject is another such case and selects the data to fit the case. The certainty of the conclusion may reflect the biographer's need to gain closure or his sheer intellectual arrogance. But the data are never hard, concrete, and unequivocal—they are frequently merely guesses and speculations, based on less than reliable sources (Coles 1975).

The historical subject may or may not match the clinical pattern in any significant degree. If he does, and that can be thoroughly demonstrated by reliable documentation, what does the discovery contribute to our understanding of historical events? If we could argue to the pathological dimensions of Vincent's life and work, of what significance is that conclusion for the evaluation of that life and work? One should not make the mistake of weighting the psychic hypothesis too heavily. Nor should one lose focus on what a given hypothesis purports to explain.

A major biographical pitfall is the so-called genetic fallacy—explaining current behavior by appealing to its origins in the past, or what Erikson (1975) dubbed the "originological fallacy." In a psychoanalytic perspective, symptomatic behaviors accrue some part of their motive power from psychologically meaningful events and experiences in the course of development. Such originative connections achieve their most convincing validation in the course of psychoanalytic work. In the biographical context they remain no more than conjectural hypotheses that add a kind of texture to the historical picture. This consideration highlights the differences in method and concep-

tualization between the psychoanalytic and the historical, even art historical, approaches.[1]

There is always the question of what can be explained and how. There is always danger in an attempt to determine states of mind that are not evident in the historical material. Genetic reconstructions are also risky, even when their plausibility is confirmed by clinical knowledge. The biographer is on safer ground when he works from what is known about the background or development of his subject to its determinable consequences in later and historically relevant contexts. I would add that when we speak of "causality" in this context it must be understood in the qualified sense of psychic causality, as one determinant among many others, both psychic and nonpsychic.

The application of psychopathological models also carries its own difficulties. Lifton (1974) has noted the tension between the historical paradigm and the pathological paradigm. He cautions: "When this second paradigm dominates, psychopathology becomes a substitute for the psychohistorical interface. The psychopathological idiom for individual development (so prominent in the literature of psychoanalysis) becomes extended to the point where it serves as the idiom for history, or psychohistory. When this happens there is, once more, no history" (p. 26). The risk here seems to be primarily reductive—the need in the psychological observer to see his subject in terms of the pathological models that are his stock in trade. The view through the psychopathological lens is distortive and reductive—it filters out aspects of the subject's character and personality that are less than congruent with the model, even when it allows a clearer insight into the pathological aspects. Such an approach runs the risk of being forced to fit the subject to the pathological model—whether that is cast in specifically diagnostic terms or in terms of the conceptual formulations of a particular theory, such as psychoanalysis. The risks here are as great as the tendency among biographers to ignore or minimize apparent psychopathology.

The Psychoanalytic Approach

But the psychoanalyst is not interested merely in establishing and validating the facts of his subject's life. He seeks to see beyond, into the heart and mind of the man. How is he to do that when his subject is dead and can be reached only through lifeless and opaque residues? Needless to say, he cannot even begin his attempt if the work of biography—that is, the historical work of validating and reconstructing the details of the life—has not been effectively and well done. The psychobiographer depends on the work of the biographer; without it he can do nothing.

Even this much, however, provides only guideposts for the psychobiographical account. Psychobiography is necessarily more interpretive than his-

torical, more concerned with hidden motives and meanings than with facts and historical details. Establishing and validating facts require a methodology of their own—therein lies the claim of biography; substantiating the claims of psychological interpretation requires a distinctly different method.

The analyst's contribution takes the rather limited form of looking at the biographical data through the lens of his analytic theories. The interest of the biographer is in unearthing and verifying the historical record and weaving these data into a more or less factual account. I say "more or less" because even the biographer has to deal with the problem of gaps and omissions. The gaps must be filled even in the objective historical record. In this enterprise correspondence and coherence play complementary roles in the search for historical truth.

The analyst's approach is less avowedly *a posteriori* than the biographer's and more self-consciously *a priori* in that he views the given historical data through the lens of his theory, seeking to gain some congruence between the emergent patterns of the data and the dictates of his theoretical perspective. His clinical concepts are but empty vessels that he seeks to fill with reliable data and content. The risks here are plentiful and obvious—in the need to select those data that fit the hypothesis and ignore those that do not, in the possibility of reinterpreting data arbitrarily to fit the theory, thus forcing a degree of distortion on the available data, in hypothesizing factors and facts to fill the gaps in the record in accord with the demands of the theory, and so on.

The problem is complicated by the nature of the data—remote, lifeless, faceless. None of them conveys any meaning, particularly any psychologically relevant meaning, without interpretation. Personal documents such as letters, even Vincent's self-revelatory letters, can conceal more than they reveal. Often enough, they do little more than skim the surface of consciousness without touching the unconscious layers of meaning hidden from view. They must be read within a specific historical context and set of conditions that qualify their meaning. They are in a sense public documents, and the question of the audience intended by the author, consciously or unconsciously beyond the eyes of the immediate recipient, always lurks in the background. And in all such precipitates of the flow of a human life and experience there remains the issue of what is not said, not included, in a given document. Since the analyst's target in all this is not historical fact but personal meaning and motive, the concealment factor looms very large indeed, since motives are by their very nature largely concealed even from the subject himself. If we could resurrect Vincent, he might tell us what he thinks his real motives were—much as analytic patients do in their analytic hours—but the account would be misleading and faulty—much as it is in a typical analytic exploration. The unconscious does not yield its secrets so easily.

Vincent's Material—Interpretive Difficulties

All these issues arise in a psychoanalytic study that attempts to embrace both Vincent's inner psychic life and its psychodynamics and his religion. There are perils to be met in both departments. Vincent's voluminous letters, devotedly collected and edited by his sister-in-law Johanna van Gogh-Bonger, are intensely personal documents, written presumably for the eyes of the recipient only. Many pages are taken up with mundane matters, with art and artists, affairs of the art world, and with details of everyday life and personal relationships. From time to time, the discourse rises to a level that is poetic, sublime, loaded with intense and conflicted currents of emotion, profoundly moving reflections on the basic human motifs of love, death, faith, hope, and the meaning of human existence. At such points, they become powerful documents expressing the deepest pathos and agony of the human spirit. They offer a unique window into the heart and mind of Vincent as he poured out his thoughts and feelings—almost desperately seeking a refuge from his despair, seeking understanding and acceptance.

But the letters offer particular difficulties of their own. First, not all of Vincent's letters have survived, and of some there are lost portions. It is a wonder that we have as much as we have. Then there is a problem of order and chronology. As time went on, Vincent became increasingly casual about dating his letters and indicating their place of origin. Many of the letters have no such indication, so that fixing them in their proper order and situating them in time and place depend largely on internal evidence. There are many letters in which uncertainties remain, and in some the order decided on by the original editors has been revised by subsequent scholarship. Further, interpretation of the letters is hampered by the paucity of responses from Theo or other correspondents, so that by and large we have only half a dialogue—like listening to someone carrying on a telephone conversation. Consequently, psychoanalytic interpretations and inferences rest on shaky ground and can achieve no more than conjectural status.

The second body of material is Vincent's artistic work—drawings and paintings numbering in the hundreds, the output of ten intense years of artistic productivity. The work of all artists is unique, but in Vincent's case each drawing or painting is a personal statement, an expression of something within the artist that seemed to find its way onto the paper or canvas—a statement about Vincent himself and his highly personalized view of the world, nature, other human beings, his God, and himself. If the letters themselves require a rather extensive degree of interpretation, that element becomes all the more telling in any effort to draw meaning from the visual material. Whatever interpretation one might make is uncertain, tentative, and hardly definitive. The best guide is found in Vincent's own comments, when

he offers them, but there too he may not have been aware of the connotations and significance of what he portrayed—especially when unconscious motifs were involved.

Biographies of Vincent

The gulf that separates biographers from psychobiographers is well demonstrated in the extant accounts of Vincent's life, covering a spectrum of views from the strictly biographical to the opposite extreme of psychobiographical speculation. At the biographical pole among recent biographies, I would put Hulsker (1980, 1990) and Sweetman (1990). At the more psychodynamic or psychoanalytic pole, I would put the older and somewhat dated interpretations by Nagera (1967) and Lubin (1972). The account by Tralbaut (1969) falls somewhere in the middle, since it strains for historical accuracy but also is open to the use of psychological interpretations, particular those advanced by Nagera.

The position taken by Hulsker and Sweetman is an almost literal minded acceptance of the views, accounts and interpretations of particular events by Vincent or other important figures. This archly biographic perspective would maintain that if it is not found as such in the documents, it must have no validity and is therefore to be expunged. A case in point is the replacement child problem.[2] Vincent nowhere makes explicit reference to the death of his predecessor. Therefore, conclude the nonanalytic biographers, there is no valid evidence for the phenomenon or the problem it might have created. Sweetman's attitude to psychoanalytic interpretation is not merely negative, it is outright hostile. The hostility is paradoxical since he also accumulates the data pointing to severe psychopathology in Vincent, not only in his adult years but in his childhood as well. Hulsker, whose work stands as the most definitive biographical account, is less hostile but seems urged to reject analytic commentary whenever the possibility looms. On the psychoanalytic side, both Nagera and Lubin deal with the data somewhat uncritically, even cavalierly, and tend to offer extensive interpretations on the basis of slender or questionable evidence—a circumstance that goads more literal-minded critics into action.

For example, a number of interpreters—not only psychoanalytic but also among art historians (Schapiro 1952, 1980, 1983)—have seen the "Crows over the Wheatfield" (F779, JH2117)[3] as expressing a dark foreboding and ominous portent of Vincent's suicide (the painting was done a few weeks before his death). Hulsker observes that there is nothing in Vincent's letters to substantiate such feelings: if his late wheatfields appear to express any sadness or loneliness, the letters also express an optimistic attitude about the restorative power of nature. Any possibility that Vincent's positive utter-

ances may have resulted from defenses against his underlying feelings of hopelessness and suicidal inclination or might suggest the positive attitude typical expressed by suicidal patients when they have finally decided on a suicidal resolution, or that his optimism may have served the useful purpose of shielding Theo and Jo from his desperate situation and his suicidal preoccupations when they too were in difficult straits—none of this is given a hearing.

Again Hulsker takes issue with the thesis advanced by Mauron in 1976 to the effect that Vincent's decompensations, both in the ear-cutting episode and later, were related to Theo's marriage and the implicit threat of severing the symbiosis between the brothers and the possible loss of Theo's support and love. Hulsker objects that the facts do not fit the hypothesis. At the time of the ear episode, Theo had not told Vincent about his engagement, and Vincent would not have known about Theo's plans to marry for a long time. Similarly, the news of Jo's pregnancy could not have had anything to do with his later decompensation because he wrote of his joyful response without any note of negative feelings and he should have anticipated a pregnancy anyway. A better place to look, Hulsker argues, is in Vincent's associations in Arles, since he decompensated after his visit there to collect his paintings. This argument rests on a disavowal that any unconscious influences might have played a role, either tipping the balance or contributing in some degree to the episodes in question. In the ear episode, the looming engagement may have been sufficiently in the air to stir up a threat for Vincent—but it was hardly the sole precipitant. The events surrounding his relation to Gauguin loom far more prominently in the story, but it is not implausible that both elements were involved. The unconscious meaning of Jo's pregnancy, especially when the connections with the death of first Vincent are taken into account, cannot be ignored or discounted.

But, of course, Hulsker also discounts the replacement child syndrome. His argument essentially is based on an inaccurate comment made by Jo's son Vincent in a revised edition of the letters. It was this passage, argues Hulsker, that induced subsequent psychoanalysts to develop their theory of the replacement child syndrome. That the syndrome has been independently established on the basis of clinical studies quite exclusive of the van Gogh story seems to carry little weight. Moreover, according to Hulsker, the family would have put this unfortunate event aside and not talked about it—certainly not continually. Besides, infant deaths were common at the time. The fairly reliable data on the facts of the replacement, the accounts suggesting that Anna was significantly depressed and for some time, and the possibility of the operation of unconscious dynamic factors simply are given no place.

Edwards (1989), in his thoughtful book on Vincent's religious attitudes, takes a similar position, rejecting any role for the replacement theme, largely on the basis of Hulsker's authority. According to his view, there are plenty of reasons for Vincent's guilt feelings, particularly his rigorous Calvinistic rearing and heritage—one does not need to appeal to a replacement syndrome. The argument is exclusionary—if Calvinism is the culprit, replacement and survivor guilt cannot be. The psychoanalyst would have to challenge this reasoning. Calvinism, and especially Vincent's relation to his minister-father, played an immense role, but not to the exclusion of a more primitive level of guilt, which may well have derived from the replacement ordeal in combination with the effects of early maternal deprivation and lack of empathy. Obviously, if the dynamics were carried on at an unconscious level, one would not expect them to be stated explicitly in the letters. The question is whether the guilt motifs expressed in the letters are open to a deeper interpretation and whether there is anything in Vincent's artistic expressions to suggest a more infantile level of guilt.

The point of this discussion is that the biographer has his own purposes, methods, interests, and aims—and they do not correspond with the purposes, methods, interests, and aims of the psychobiographer. The psychobiographical effort is directed to gaining access to the unconscious, the level of unconscious fantasies, wishes, desires, and conflicts. The evidence cannot be direct or explicit. It is indirect, equivocal, and often hidden from even the subject himself. Just as in the psychoanalytic process, the analyst must take the data as it comes and attempt to piece it together to make a coherent and meaningful story, so this is the challenge in the attempt to probe the mind and heart of Vincent—and particularly in the effort to gain some sense of the depth and intensity of the religious beliefs and feelings that occupied the inner core of his being.

Section I

THE EARLY RELIGIOUS PATH

Chapter I
RELIGIOUS BACKGROUND AND BEGINNINGS

The Family Background

The roots of Vincent's religiosity lie buried in his family history. Over the course of several generations, Vincent's family was principally involved in two areas of human endeavor—art and religion—divergent currents that were to come into conjunction and intermingle in Vincent. Early ancestors came from The Hague and were goldsmith's wiredrawers by trade. David van Gogh, baptized in 1697, his son Jan, baptized in 1722, and his grandson Johannes, born August 29, 1763, all followed the same trade, but Johannes, Vincent's great grandfather, later became a lay preacher. His son Vincent, born on February 11, 1789, was called to the ministry in Utrecht on October 13, 1816, the first in the family to become a pastor by profession. He was Vincent's paternal grandfather (Tralbaut 1969).

Grandfather Vincent had completed his theological studies at the University of Leiden and subsequently followed a distinguished and influential clerical career. He had undoubtedly exercised a strong influence on Vincent's father, Theodorus, the only one of his six sons to follow his footsteps into the ministry. The rest of the sons were all reasonably successful. Along the art line, three of Vincent's uncles were art dealers. Uncle Hendrick, also called Hein, was at first a bookseller in Rotterdam but later became an artist. Johannes, Uncle Jan, joined the navy and became a vice-admiral in charge of the shipyards in Amsterdam. Willem became a government tax collector. Vincent, Uncle Cent, went into the art business with great success—of all the uncles he had the greatest influence on both Vincent and Theo. At 26 he began a small art business and had frequent transactions with large Paris dealers; he did so well that in 1858, he joined the firm of Goupil and Co., the prominent art firm in Paris, and later became a partner. He and Vincent's father, Theodorus, two years his junior, were close companions and remained in close contact over the years. After Cent retired with a tidy fortune, a continuing interest in the art business, and a remarkable personal collection of works of art, he settled near his minister brother and saw a good deal of the family during Vincent's younger years. He housed his collection of fine paintings in a small private museum, and it was probably there that young Vincent enjoyed his first exposure to good art. The youngest of the brothers, Cornelius, also became an art dealer.

The bond of affection between Theodorus and Cent was further strengthened by their choice of marriage partners—the two van Gogh brothers married two Carbentus sisters. Cent and his wife settled at Prinsenhage, not far

from Zundert, where Theodorus and his family lived. Since Cent and his wife had no offspring of their own, they more or less adopted Theodorus and Anna's children and took a special interest in them. Cent favored the two oldest boys, Vincent and Theo, especially his namesake Vincent, whom he wanted to groom for the art business—perhaps to succeed him at Goupil's, perhaps in time even to be his heir. Vincent was named after his two grandfathers as well as his uncle Cent. It was Uncle Cent who placed the boys—first Vincent and later Theo—in Goupil's house in the Hague.

The Nuclear Family

We know that the rudiments of Vincent's story were laid down in childhood and that any sense we might make of it must take its origins in his earliest years. Crucial determinants were brought into play from the very beginning of his life experience that cast a long shadow over the ensuing years and played their role in determining their course and dismal outcome. I will try to piece together the fragments of that early history, as far as we know them, to see how far we can go in reconstructing the determining influences in the early life of one of our greatest and most creative talents.

At the time of his birth, Vincent's family lived in the village of Groot Zundert in North Brabant, near the Belgian border. Theodorus was pastor of the small Dutch Reform church—a handsome and pleasant man, well liked by his parishioners, but without any great gifts that would have led to ecclesiastical preferment. Unfortunately for Dorus, the revivalist faction was in the ascendancy at the University of Utrecht, where he took his degree, and adherents of the more moderate Groningen faction to which he belonged were held in suspicion. He could not find a placement anywhere after his graduation; it was only through the intervention of his influential pastor-father that he was appointed to the little church at Groot Zundert in 1849. Even without the adversarial context, Dorus' prospects were never bright. His theological gifts were limited and his preaching mundane. The border town of Zundert was the bottom of the ecclesiastical barrel, and Dorus would never move very far from it. His career led him from one obscure and impoverished village church to another. Even so, where he served he was remembered with affection and respect as a good, sincere, kindly, and devoted man of God—even if to some he seemed at times somewhat rigid and severe (Tralbaut 1969).

Vincent's maternal grandfather, Willem Carbentus, had been a bookseller or bookbinder. His mother, Anna, was a mild, pedestrian woman who aspired to little more in life than a happy and comfortable home and family. She was apparently not without talents in drawing, but we can only guess at the influence this may have had on Vincent. She would often draw pictures for the children. Vincent's early interest in drawing may have reflected some

identification with her and an effort at pleasing her and gaining her approval (Nagera 1967). Some of his childhood efforts at sketching may have been attempts to copy her drawings.

They were decent, God-fearing people, bourgeois in their views, middle class in their values, concerned with proprieties, outward appearances, and the opinions of their neighbors (Wallace 1969). The family included three boys and three girls. After Vincent, there was a girl, named after her mother, Anna Cornelia (1855–1930); then Theo (1857–1891), four years Vincent's junior; and then Elizabeth Huberta (1859–1936) and Wilhelmien Jacoba (1862–1941), and finally Cornelius Vincent (1867–1900).

From the very beginning of Vincent's life, we can hear the tragic overtones that echoed through his entire story to its bitter end and would have its implications for Vincent's religious experience. Vincent's parenting may have left something to be desired. The siblings did not fare well. Vincent was the victim of a severe, possibly psychotic illness that scarred him from the beginning of his life until its tragic and catastrophic conclusion. Questions have been raised about the possibility of a genetic component to his illness (Gedo 1983). Review of the family history can only strengthen this hypothesis. Theo was a victim of severe attacks of depression and anxiety, and in the final months of his life became deranged and violent, requiring institutionalization. Wilhelmien fell ill, possibly with a form of schizophrenia, and spent most of the latter part of her life in mental institutions. The youngest brother, Cornelius, probably committed suicide in South Africa. He had fought in the Boer War and was listed among the Boer forces killed in action, but unconfirmed reports held that he had died by his own hand. Thus it is quite possible that four of the six siblings suffered some form of severe mental disturbance—possibly some form of affective or schizo-affective disorder. Such a record of family pathology raises questions not only about the pathogenic relationships that constituted the family emotional system (Meissner 1978a) but also about the genetic factors that may have contributed to the incidence of mental illness in this family and may have played a role in the genesis of Vincent's own psychological difficulties.[1]

The Replacement Child

Vincent van Gogh, born on March 30, 1853 and destined to become one of the world's greatest artistic geniuses and one of its greatest human tragedies, was the second child of Theodorus and Anna Van Gogh. Tragedy pervaded his life from its beginning to its end. It is even fair to say that his tragedy began before his birth—even before his conception.

The story begins a year before his birth. On March 30, 1852, the van Goghs' first child was born, and was given the Christian name Vincent Wil-

lem Van Gogh. The infant was stillborn.[2] On the very same date one year later, a second child was born and given the very same name. Not only was there an identity in time and name, but in the birth register of the parish church Vincent's name was recorded under the same number as his dead brother from the previous year (Nagera, 1967).

This simple fact of Vincent's birth has given rise to endless speculation and theorizing. The issue has to do with the effect on the child who is fated to replace the dead sibling. The loss of a child through death has profound effects on the parents and can exercise a powerful influence on the child who becomes the substitute. The parents are drawn to find restitution for their loss and feel compelled to prove to themselves and the rest of the world that they are capable of bringing a child into the world and keeping it alive (Agger 1988).

Often the dead child comes to represent the idealized fantasies and hopes of the parents, expectations that are subsequently imposed on the replacement. Agger (1988) has observed: "When the sibling death occurs before the birth of the subject, the conscious expectation of the family that the subject will be a replacement for the lost child preempts the significance of unconscious fantasy as a formative factor. In these instances, the parent has denied the loss of the child and often consciously resurrects it through conceiving another one" (p. 24). In Vincent's case, the unconscious element in the replacement syndrome[1] is reflected in the arrangement of the circumstances of Vincent's birth to correspond exactly to those of the dead Vincent—exactly the same date of birth—and even perhaps the misplacing of the name in the parish birth register. One would expect that the pastor, Vincent's father, would have been the responsible agent. More conscious components may express themselves in providing him with the same name.

But the replacement child never can live up to the idealized image of the dead sibling, and thus becomes an inevitable disappointment to the parents (Kernberg and Richards 1988). The parents, especially the mother, may be tormented by anxious fantasies of the death of the substitute child, so that the child becomes an object of solicitous anxiety and concern that can implant a pervasive sense of vulnerability and inadequacy in him (Cain and Cain 1964; Nagera 1967). As Mahler (Mahler et al. 1975) observed, "It is the specific unconscious need of the mother that activates, out of the infant's infinite potentialities, those in particular that create for each mother 'the child' who reflects her own unique and individual needs" (p. 60).

And the child is compelled by these unconscious demands to develop in such a way as to fulfill these imposed characteristics. The phenomenon of sibling loss and its effects on the remaining children in a family has been explored by Pollock (1961, 1962, 1972), who wrote: "We know that children

who are dead may remain powerfully in the mother's mind and so can become even more important rivals for the surviving sibling, who has no ability or opportunity for reality confrontation and correction of the image of the idealized dead child" (1972, p. 478). The surviving child can become a victim of a survivor syndrome that involves both a sense of special privilege in being the one chosen to survive, and an abiding sense of guilt for the death of the lost sib. There is often an unconscious fantasy that the dead sibling was destroyed by the replacement child's destructive wishes, resulting in an unconscious need for punishment. A variety of fears, pathological superego formations, and an internal sense of worthlessness and evil are well known aspects of this syndrome (Kernberg and Richards 1988).

Dead siblings can be more powerful rivals than live ones. The narcissistic injury from the chronic failure to measure up to parental expectations and match the idealized standard of the image of the dead child makes its inevitable mark. No effort is adequate, no achievement sufficient, no striving enough to dent the parents' sense of loss and depression. The burden is often significant and imprints a permanent stamp on the surviving child's core sense of self (Balsam 1988). There is little doubt that the dead Vincent cast a dark shadow over the life of the living Vincent.[3]

Maternal Depression

In this reconstruction, Vincent must have been conceived only three months after the death of his brother. His mother would still have been deep in mourning for the loss of her first born. We know clinically how devastating the loss of a child can be for mothers (Brice 1991). There seems little doubt that this melancholic theme pervaded Vincent's mother's consciousness as well as the general atmosphere of the parsonage. The little grave of his brother was close at hand, and Vincent would have passed it whenever the family went to church, or whenever he visited home. The inscription in Dutch read:

<div align="center">

VINCENT VAN GOGH
1852
Suffer the little children
to come unto me
and forbid them not for such is
the KINGDOM
of GOD

</div>

We might imagine that this legend was carved into Vincent's mind as indelibly as into the unyielding stone of the grave.

Some years later, Vincent's nephew's wife, suggested that Anna's grief persisted for several years afterwards and may well have been transformed into a chronic melancholic state. Her hopes and wishes had been shattered, and a part of her may have felt that this new child was a usurper and that acceptance of this child was in some sense a betrayal and abandonment of the old. But he was also a replacement, a substitute who would become the repository for all the hopes and expectations that had been generated around the first Vincent, now distilled and magnified by the process of loss and restitution (Rochlin 1965). The frustrated and denied hopes were passed through a prism of pain and disappointment only to be revived and become even more ladened with narcissistic expectations.

Theo's son would later write that Vincent was "conceived and carried by a mother who was in deep mourning, was able to see the tomb of the one he was to replace every day from the time he was old enough to perceive." The disappointment in the death of her firstborn may have been all the more poignant for Anna since she was then 33, older than her husband by three years, and time was running out. According to the custom of the time, his parents would still have been in mourning when the second Vincent was born. The message, however unconscious and denied, was clear enough—to be dead was to be loved and cherished; to be alive meant rejection and hostility. Erikson (1956) might as well have had Vincent in mind when he wrote: "A mother whose firstborn son dies and who (because of complicated guilt feelings) has never been able to attach to her later surviving children the same amount of religious devotion that she bestows on the memory of her dead child, may well arouse in one of her sons that conviction that to be sick or to be dead is a better assurance of being 'recognized' than to be healthy and about" (p. 87).

We can only speculate on the influence these circumstances of Vincent's birth came to exercise on his development and subsequent history. Was his mother still significantly depressed by the time of Vincent's birth? Might this residual depression and the ambivalence connected with Vincent's position as the substitute have played a role in the bond between mother and child? Was she capable of being, and was she in fact, a warm, loving, and responsive maternal object? Or might she have been emotionally unavailable and unresponsive to her infant? Did the fact that this replacement could never salve the pain or satisfy the dreams associated with the first Vincent influence her relationship with him? Or might he rather have become the repository for her pain, her disappointment, her rage at fate and God for depriving and denying her wishes and hopes?

The psychological and religious ramifications of this theme are many. Lubin (1972) summarizes this aspect of Vincent's fateful identity: "He was

the unhappy outsider, ignored and rejected by a grieving mother whose affection lay with the dead brother who was buried in the earth but had ascended into heaven. In defense, the second Vincent developed an envious identification with the first, made almost inevitable by the mysterious coincidence of name and birthdate. In the fantasy of his artistic life, he alternated between depicting the depressed, unloved outsid er, living in darkness, whose salvation lay in death, and the adored child, reborn on the earth or ascended into the light of heaven" (pp. 86-87). The first Vincent, idealized and raised to the heights of heavenly glory and maternal devotion, will cast a long shadow, as we shall see in later chapters, not only over Vincent's tragic life, but over his canvases and his religious experience as well.

The Vicissitudes of Childhood

A circumstance that exercised a powerful determining influence in Vincent's early religious experience, and a point that it serves us well to remember, is that Vincent spent his early years and grew to young manhood in a parsonage as the oldest surviving son of the local Protestant minister. Little went on in Groot Zundert that was not common knowledge and the subject of common gossip. The situation generated certain conventional expectations for the behavior, dress, manners, and etiquette that befit the local pastor and his family. The context of his family life and the religious and social culture of the period imposed burdens that Vincent rebelled against and rejected. In such a closed and transparent world Vincent's eccentricities and solitary behavior must have stood out in sharp contrast to other children around him. He was soon labeled as different, isolated, peculiar, eccentric—the object of suspicion, distrust, and misunderstanding.

Vincent was always a disappointment and torment for his mother (Nagera 1967). He was a difficult child, described as stubborn, hot-tempered, and given to strange behavior. He was often unpleasant, impressed people with his peculiar manners and strange behavior, and was frequently withdrawn and solitary. He was self-willed and subject to temper tantrums. His mother seemed unable to deal with his storms of temper and rebelliousness. On one occasion, his grandmother van Gogh came to visit and was treated to one of Vincent's tantrums. Battle-hardened by her experience raising her own dozen children, she took the renegade by the arm, boxed him on the ears, and put him out of the room. This action apparently offended Anna, who refused to speak to her mother-in-law for the rest of the day (van Gogh-Bonger 1959).

We do not know how far to trust such a piece of family mythology, but it may tell us something about the relationship between mother and son. Was Vincent's mother so unable to provide him with ordinary parental discipline, and if so why? Was it her view of him as special, privileged? Was it her

guilt and remorse for the dead Vincent he was to replace? Was it an effort to deny and counter her rage at him for displacing her firstborn and for being such a difficult and disappointing child? Was it her own conflicts over aggression and her need to play the masochistic victim role with her aggression-torn son who may—if that were the case—have played out his mother's displaced and denied aggression—perhaps against her mother-in-law? Whatever the reason, Vincent was to a remarkable degree denied the training and discipline that would have helped him to take a more adaptive place in the company of his fellow men. From another perspective, for the child of creative genius an average mother may be equivalent to a misattuned, narcissistic, and perhaps even unempathic mother (Miller 1981).

A governess later recalled Vincent's unpleasant and eccentric manners for which he was constantly being punished. She commented: "There was something strange about him. He did not seem like a child and was different from the others. Besides, he had queer manners and was often punished" (Cited in Tralbaut 1969, p. 25). He was regarded as strange by his mother and sisters as well. The family apparently recognized his artistic talent, but did not do much to foster it. His mother's attitude toward Vincent and his work in later years was ambivalent: she had little understanding of his painting and showed little interest in it. There are occasional mildly positive comments in her letters to Theo, but little else. After her husband's death, in the course of breaking up the family home at Nuenen, she had Vincent's canvases packed away and left them with the local carpenter, who later sold them to a junk dealer for a pittance.

Vincent showed early talent at drawing—something that the pastor was evidently proud of and praised to his friends. At 11 he gave his father a drawing of a farm and wagon scene that pleased Dorus, who had it framed and treasured it. He had a knack for imaginative play that endeared him to his siblings, but he was also stubborn, hot-tempered, and unable to compromise. In the face of parental scoldings and reprimands, he became even more resistant and defiant. He was serious and earnest in the extreme and never seemed to smile—or so he was remembered. He was a stranger even to those closest to him.

We can add to this family picture the somewhat stern, disapproving and distant image of his father—the rather remote and moralistic Calvinist minister, preoccupied with his ministry and little involved in family affairs, especially in raising the children. Theodorus was apparently a pleasant and reasonable man, no hellfire and brimstone fanatic, but remote, bookish and disapproving nonetheless (Sweetman 1990). Vincent was left with a frustrated yearning for acceptance and approval from this olympian father—a yearning

that was never satisfied and finally left him with a sense of bitterness, disillusionment, and failure.

The Foreigner

The van Gogh family came from an educated background and put great stock in learning. Despite their limited resources, Theodorus and Anna extended themselves to the limit to adequately educate all their children. The boys were all sent to good schools through the secondary level, and the older girls were sent to Miss Plaat's boarding school to study languages. In later years they would write to Vincent in English and French.

Dissatisfied with the local school, and perhaps feeling that Vincent's associations with the peasant lads of Groot Zundert was having a bad influence on his development, his father tried to educate him at home for two years. But apparently out of sense of frustration and not knowing how to handle him, as well as from awareness of the boy's need for more regular schooling, when Vincent was 11 his father decided to send him to a boarding school in the neighboring town of Zevenbergen. This was his first separation from home, and we can only guess at the effects it had on his sense of himself and his place in the world. And he did experience it as an exile. Years later he recalled to Theo his feelings as his parents drove away: with tears in his eyes he stood and watched the little yellow carriage as it faded into the distance (Letter 82a).[4] All the pain of separation, abandonment and rejection came to rest on his troubled head. He remained at the school from October 1864 until the summer of 1866, a period he experienced as a painful exile.[5]

In 1866, Vincent was deemed ready to advance to the secondary school in Tilburg, the State Secondary School King Willem II. Things seemed to go well for a while. The school was noted for good teaching and progressive ideas—there was even an art class. Vincent was a good student and excelled in languages—he became fluent in French and English and gained some familiarity with German—and might even have had opportunity for a university scholarship. But for reasons not known, this venture came to an end after 15 months. In March 1868, in mid-term, Vincent returned home where he remained for nearly 15 months (Hulsker 1990). Despite his success in his studies, the four-year separation must have had painful effects and can only have reinforced his sense of not being a welcomed part of the family. His leaving school could not have been on academic grounds or financial grounds either, for even if his parents could not afford the tuition Uncle Cent would certainly have supplied it. We are left with conjecture—was Vincent's departure from school due to some incipient mental disorder? depression? schizophrenia?

At home Vincent was hardly the easiest person to live with. His father and sister commented that he lived in the family "as if a foreigner." There is little doubt that he was not understood by his family. He was awkward, sensitive to a fault, gifted, and precocious. In a family and society preoccupied with convention and religious and social conformity, Vincent was a constant embarrassment to the family. His siblings were reluctant to walk with him in public. His conventional father could only regard his independent and peculiar ways with disapproval. His sister Elizabeth described him at about age 15:

> Rather broad-shouldered than tall, his back slightly bent by his bad habit of keeping his head down, the short-cut reddish-blond hair under a straw hat, shading a strange face; certainly not a boy's face! The forehead already wrinkled, the eyebrows pulled together in deep thoughts above a pair of eyes, small and deep-set, now of blue, now of greenish color according to the impression things around him made. Not handsome, ungraceful, he was remarkable at such an early age because of the profoundness that was expressed in his whole being. His brothers and sisters were strangers to him; he was a stranger to himself; he was a stranger to his own youth. (Cited in Hulsker 1990, p. 10).

There was not much common ground between Vincent and his family. They could not understand him, could not accept his behavior, could establish no bonds of deep affection or intimacy, and generally regarded him as an outsider, an intruder on the seamless web of family conventionality. His abrupt manners, his uncompromising candor, and his unexpected mood changes were disconcerting. Clearly there was no one in this early environment who was capable of appreciating, understanding and supporting his talent and rough-hewn virtues—the sole exception being Theo. Between Vincent and Theo there grew up a close bond of brotherhood, friendship, and companionship. Even though Theo was four years Vincent's junior, they developed a kind of twinship that was to join them together for life.

Vincent blamed himself for his alienation from his family, and this internalized humiliation pointed him toward a path of lifelong resentment, bitterness, and estrangement from his fellow men. The lack of appreciation and valuation, even appropriate narcissistic mirroring (Kohut 1971, 1977), can have life-long devastating effects on any child, even a child of genius. Vincent seems to have been doomed to live out the pattern of these childhood humiliations repeatedly throughout his course (Gedo 1983).

The Suffering Son
These elements came to play a vital role in Vincent's artistic life, found their poignant expression in his paintings, and finally drew him down the path to his fateful suicide. One component found expression in his immersion in na-

ture—a fascination that issued in an outpouring of masterful landscapes, bril-
liant visions of the powerful sun, wheatfields and gardens, still lifes and flow-
ers. But I would wish to focus here on another powerful motif that found its
way from the traumata of his childhood onto his canvases—the motif of what
I will call "the suffering son."

Vincent had never gained the sense of loving approval and acceptance
that he had so desperately sought. He could not find it in any of his relation-
ships, even from those who brought him into this world. His father, the Cal-
vinist minister, was distant, unapproving, disappointed and frustrated with his
oldest son, contemptuous of Vincent's stumbling failures, his obstinacy and
eccentricity, withholding any sense of approval and acceptance. But perhaps
even more significantly for this consideration, there was his mother—the ob-
ject of yearning for an affection and comfort that was constantly denied and
withheld.

Any sense of warmth, understanding, or affectionate acceptance was
never forthcoming. The distance and disappointment persisted even into adult
years; during one trying period, he wrote to Theo: "I should like it very much
if you could persuade Father and Mother to be less pessimistic and to more
good courage and humanity. . . . But I would rather they could understand
more of my thoughts and opinions on many things. . . . One word from
Mother this summer would have given me the opportunity of saying many
things to her which could not be said in public. But Mother very decidedly
refused to say that word; on the contrary, she cut off every opportunity for
me" (Letter 155). And in another letter: "There really are no more unbeliev-
ing and hard-hearted and worldly people than clergymen and especially cler-
gymen's wives" (Letter 161). Vincent has left us only one portrait of his
mother (F477, JH1600). He received a photograph of her in Arles and this
prompted him to paint two pictures—one of the parsonage in Etten, and the
other of his mother. The portrait of his mother was painted in "ashen gray," a
deadly and depressive shade.

We also have another less direct representation of Vincent's mental im-
agery regarding his mother. His painting of two women walking through a
garden was not intended to immediately represent his mother and sister, but
there is no doubt that he had them in mind. He wrote about it to his sister
Willy:

I have just finished painting, to put in my bedroom, a memory of the garden at
Etten; here is a scratch [sketch] of it. It is rather a large canvas. . . . The old lady
has a violet shawl, nearly black. But a bunch of dahlias, some of them citron
yellow, the others pink and white mixed, are like an explosion of color on the
somber figure. . . . Here you are. I know this is hardly what one might call a
likeness, but for me it renders the poetic character and the style of the garden as I

feel it. All the same, let us suppose that the two ladies out for a walk are you and our mother; let us even suppose that there is not the least, absolutely not the least vulgar and fatuous resemblance—yet the deliberate choice of the color, the somber violet with the blotch of violent citron yellow of the dahlias, suggests Mother's personality to me. . . . I don't know whether you can understand that one may make a poem only by arranging colors, in the same way that one can say comforting things in music. In a similar manner the bizarre lines, purposely selected and multiplied, meandering all through the picture, may fail to give the garden a vulgar resemblance, but may present it to our minds as seen in a dream, depicting its character, and at the same time stranger than it is in reality. (Letter W9)

The figure of the old woman—his mother—was cast not only in somber colors, flavored with a pinch of violence, but her bent figure and tragic face speak of despair, pain, bereavement and a deep and lasting mourning, if not depression. She is absorbed in her grief, solitary, withdrawn—despite the companion at her side, to whom she does not speak and whose features are not etched in pain and sorrow. The image of this sad, withdrawn and sorrowing woman comes out of the depths of Vincent's unsatisfied yearning and frustrated desire for love from a mother whose love and affect lie elsewhere.

The Art Dealer

To pick up the thread of the story, Vincent left school abruptly and for reasons we do not know. With his schooling behind him, the question arose as to what kind of work he might pursue. His Uncle Cent offered him a position as an apprentice clerk in the branch of Goupil's art firm he managed in The Hague, and in due course Vincent was transferred to the Paris branch. He seems to have hit it off with Tersteeg, the manager, who was only eight years his senior, and was soon on friendly terms with Tersteeg's family. He was at first enthusiastic about his work. After four years of apprenticeship, he was assigned to the London branch in May 1873. The post meant advancement and offered exciting prospects. Tersteeg gave him a strong recommendation and even wrote his parents that Vincent was well liked and would be sorely missed.

He left for London in May and by June had hired rooms and begun to settle into his work. His circumstances were comfortable and fairly pleasant, but there was an underlying tone of loneliness and nostalgia that surfaced repeatedly. His letters to Theo reflect his ambivalence, his efforts to cope with his new circumstances, and to put a good face on things. In August he moved his lodgings to the rooming house of Mrs. Loyer, where he remained for the rest of his stay in London. His prospects during this period seemed bright,

and his parents were pleased by his progress and apparent good spirits—the letters home were filled with good news and good cheer (Hulsker 1990).

A Libidinal Misadventure

But the optimistic picture was soon to be sullied. Vincent became infatuated with his landlady's daughter, Eugenia Loyer. Eugenia, just 19, was a coquette—outwardly prim and proper, thin, sad-eyed, but apparently also frivolous and tantalizing. Vincent became absorbed and obsessed with her. Unable to express his feelings, he locked himself in his room for days at a time, nursing his fantasies and love-sick hopes. When he met Eugenia face-to-face, he was tongue-tied and could only stammer. She more or less toyed with him, no doubt amused by his awkward embarrassment, but he convinced himself that she loved him. Finally he screwed up his courage and proposed. She literally laughed in his face. As it turned out, she was already secretly engaged to someone else. Moreover, Vincent's awkwardness, his impetuosity and lack of polish, must have made him rather unattractive. She had apparently led him on simply to amuse herself.

Vincent had a strong need to see the world as he wished it to be. Time and again, when he exposed his wishes to reality, they were disappointed and trampled. He assumed naively that Eugenia would immediately reciprocate his love as soon as he confessed his. Her rejection was a terrible narcissistic blow to which he reacted with withdrawal from all human contact, and severe depression. When he returned home for a summer visit in June-July 1874, his parents were appalled by his emaciated appearance and his disconsolate and withdrawn mood. In the midst of this depressive episode, he turned to sketching to distract himself. He filled three small sketchbooks with drawings, which he gave to Tersteeg's little daughter, Betsy. He returned to London and the Loyers in July, this time accompanied by his sister Anna, who was looking for a position in England as a French teacher.

The situation in the rooming house must have been awkward, and within a month Vincent moved to a flat in New Kensington Road, where he lived alone. His family worried about his isolation and seclusion. His letters were sparse and his spirits low. More and more he turned to religion and the Bible to find relief from his depression and consolation. He read George Eliot's tale of unrequited love and hopeless fidelity, *Adam Bede,* identifying with the forlorn hero.

His moody and isolated behavior did not escape notice at work. He seemed little interested in selling art and was moe absorbed in the study of the Bible. The situation was delicate since he was the protegé of Uncle Cent and could not be readily dismissed. It was decided to send him back to Paris. He did not take the move well since it meant separation from Eugenia, but even

more he began to resent the manipulation of his family and the burden of following a career they had laid out for him. He left for Paris in October of 1874, but was back in London in December. After another five months he returned again to Paris.

Religious Absorption

Despite her rejection, he still nourished the hope that Eugenia would change her mind and accept him. The whole affair speaks to the power of Vincent's wishes, the strength of his illusions, and the extent to which they overrode any capacity to assess and deal with harsh and unacceptable facts. He saw himself as isolated and alone, like a man in solitary confinement. The way out of the emptiness and loneliness of this prison was human contact and affection. However much he yearned for friendship and companionship, Vincent was not a man to whom it came easily.

During his visit home in the summer of 1874, it is noteworthy that he did some sketching of his parents house and environs. On his return to London at the end of July, he told Theo that his interest in drawing had ceased. Instead he had begun to read in depth—a characteristic that stayed with him most of his life. There was also a detectable turn toward religiosity and religious preoccupations.

It was already becoming clear that the budding art dealer was losing his enthusiasm for the work. When he returned to Paris in October 1874, he was put to work as an art salesman. But his feelings had changed considerably—he became even more isolated and morose. After about eight weeks in Paris, he was sent back to London, and then again back to Paris. His heart was simply not in the work; Vincent was more invested in going to church, praying, and reading—especially the Bible. By May 15, 1875, he was back in Paris, forlorn and desperate. Boussod, Goupil's successor, treated him kindly and even gave him a sort of promotion, hoping to encourage him. But to no avail—he continued to concentrate on the Bible and took no interest in the vitality of Paris. On Sundays he spent his time visiting churches and listening to sermons.

After a few months in Paris, Vincent, then 22, struck up a friendship with a fellow worker, 18-year-old Harry Gladwell, son of a London art dealer. They shared the same rooming house and spent the evenings reading scripture together. Young Gladwell became the repository for Vincent's confidences and ruminations. He confided to Theo: "I am so glad that I met this boy. I have learned from him, and in return I was able to show him a danger which was threatening him. He had never been away from home, and though he did not show it, he had an unhealthy (though noble) longing for his father and his home. It was the kind of longing that belongs only to God and to heaven.

Idolatry is not love. He who loves his parents must follow their footsteps in life" (Letter 45). The externalization is fairly obvious—Vincent describes his own conflicts and yearnings in his young friend; what he sees in the face of Gladwell is really his own. We can also speculate that the four-year younger Gladwell may have served in some degree as a substitute for Theo.

But even Gladwell tired of Vincent's moodiness and religious obsessions; he announced that he was moving out. They continued to meet on Friday evenings to read poetry, but Vincent was disconsolate (Letter 52). The implicit elements of Vincent's homosexual attachment to young Gladwell come through clearly, but in response to his disappointment Vincent turned once again to immerse himself in his religious readings and ruminations.

At work he was sullen, indifferent, and irritable. He discouraged customers from buying any piece of art he did not think worthy. Vincent rebelled against what he regarded as fraud on the part of art dealers. He did not think highly of the prevailing Salon Art and bluntly told customers so. Despite the many complaints and the loss of business, Boussod waited—probably not knowing what to do and not wishing to offend Vincent's influential uncle.

Vincent turned in desperation to religious ideas in a kind of fanatical mysticism. He became increasingly secluded and isolated, living alone and seeing no one. He even stopped writing to his family. He spent most of his time reading the Bible. Letters to Theo were richly salted with Bible passages and spiritual maxims. Not surprisingly, he was dismissed from Goupil's at the end of March 1876. Thus seven years of training as an art dealer came to an end. Vincent took his dismissal stoically—he wrote Theo, "When the apple is ripe, a soft breeze makes it fall from the tree; such was the case here, in the sense that I have done things that have been very wrong, and therefore I have but little to say" (Letter 50).

If he thought his religious enthusiasm would please his father, he was mistaken. Theodorus was concerned and counseled patience and moderation; he compared Vincent's fanaticism to the image of Icarus, who in his impulsiveness flew too near the sun with disastrous results. He saw Vincent's squandering of his opportunities as totally irrational. Theo seemed puzzled and uncomprehending, but stuck by his troubled brother nonetheless. For Vincent his dismissal was, despite his ambivalence toward selling art, a narcissistic blow, a sign of his failure and unworthiness. He felt as though he had been rejected by his family to begin with, and now he was rejected by the world as well. The only consolation he could find was in religion and in the contemplation of his beloved Bible.

The pattern of Vincent's religious trajectory was being formed through all these experiences. In the face of failure, disappointment, disillusionment, opposition, and rejection, he turned away from the sources of his pain and

sought solace and support in religion. His difficulties at school, whatever they may have been, drove him to abandon the effort and retreat in defeat. His disappointment in love would drive him into moody depression and isolation. His failures in his adopted career as an art salesman doomed him to a sense of failure and inadequacy. These brushes with reality and the hurtful rebuffs he met from it resulted in a powerful wish to escape, to find protection from the slings and arrows of outrageous fortune. He found this haven of protection and consolation in religion—and true to his spirit, his immersion in religion became obsessive, fanatic, total, and uncompromising. The narcissistic crisis created by these traumatic confrontations with the world found its resolution in his religious preoccupations.

Chapter II
RELIGIOUS VOCATION

A Conversion of Sorts

Vincent's early life experiences had led him down the path of disappointment and failure, but their devastating effects on him did not come close to those from his rejection by Eugenia Loyer. He could react to that disappointment only with isolation, withdrawal from all human contact, and severe depression. He sought solace in religion and the Bible, but as in everything else he went to extremes of fanaticism. He adopted a quote from Renan as his credo: "Man is not on this earth merely to be happy, nor even to be simply honest. He is there to realize great things for humanity, to attain nobility and to surmount the vulgarity in which the existence of almost all individuals drags on" (Hulsker 1990, p. 24). He sought to fulfill these ideals in service to the church and in self-sacrifice and devotion to the needs of his fellow men.

Idealization of Father

One of the dominant motivational components of this fanatical pursuit of a religious career was Vincent's idealization of his father and his intense need to please him, satisfy his expectations, and gain his approval. The figure of Theodorus thus loomed large on Vincent's psychic horizon. Idealizing and admiring references to his father are frequent in the earlier letters, along with unfavorable comparisons of himself to his father. He wrote to Theo of their father: "I know his heart is yearning that something may happen to enable me to follow his profession; Father always expected it of me—oh, that it may happen and God's blessing rest upon it. . . ." (Letter 89).

Vincent's idealized image of his father became his own ego ideal, setting the stage for further failure and narcissistic defeat. This ego-ideal was constructed in part on the basis of his intense wish to comply with paternal expectations and wishes, in the hope of gaining the love, affection and acceptance he sought so desperately and unavailingly. It would become pathogenic, engendering a fear of not measuring up, of failing to achieve the goals and ambitions Vincent believed his father held out for him. As Nagera (1967) notes: "[His ideal] was accompanied by a fear of the criticism of those on whose admiration and approval his self-esteem and well-being were largely dependent, as well as by the fear of the criticism of his severe and strict conscience, his own super-ego" (p. 39). He clearly saw himself as the family outcast. This seems to be another area in which the shadow of the dead Vincent may have played a part. Had the father's disappointed hopes for his first son been transferred to his replacement? If so, the unruly and peculiar Vin-

cent must have been all the more a disappointment to his father. As we shall see, these factors played a powerful role in Vincent's turning to a religious vocation.

Ambivalence and Alienation

Yet the ambivalence in his relation with his father was clear. If Vincent idolized his father-pastor, he also rebelled against and rejected not only his father but what he stood for. For his part, Theodorus seems to have been well intentioned and concerned for Vincent's welfare, but he simply could not fathom his difficult and troubled son. One day at Goupil's, a friend found Vincent sitting by the fire tearing pages out of a book and throwing them into the flames. It turned out to be a tract on Christianity given him by his father. What layers of resentment and painful and disappointed rage were played out in this symptomatic behavior? Vincent often referred to his father as the "*rayon noir*," the "black ray," and protested to Theo what he regarded as the cruel, crushing, and unsympathetic treatment they had both received from him: "My youth was gloomy and cold and sterile under the influence of the *rayon noir*. And, brother, essentially your youth too. . . . yet the *rayon noir* is unutterably cruel—unutterably—and at this moment I feel within myself as many repressed tears as there are in a figure by Monteyne!" (Letter 347).

The relations with his family continued to be difficult and tense. In his struggles to find a path of his own, he wrote:

> Involuntarily, I have become more or less a kind of impossible and suspect personage in the family, at least somebody whom they do not trust, so how could I in any way be of use to anybody? Therefore, above all, I think the best and most reasonable thing for me to do is to go away and keep at a convenient distance, so that I cease to exist for you all. . . . Now, though it is very difficult, almost impossible, to regain the confidence of a whole family . . . I do not quite despair that by and by, slowly but surely, a cordial understanding may be renewed between some of us. And in the very first place, I should like to see that entente cordiale, not to put it stronger, re-established between Father and me; and I desire no less to see it re-established between us two. An entente cordiale is infinitely better than misunderstandings. . . . (Letter 133)

The First Ministry

The beginnings of what might be termed Vincent's religious vocation emerged after his fateful encounter with Eugenia Loyer. After a period of isolation and retreat, in which he probably suffered a severe, if not psychotic, depression, Vincent returned to England in mid-April of 1876 to try his hand at teaching. The move was prompted in part by his lingering infatuation with Eugenia, but also by his as yet ill-defined and unspecified desires to follow a religious vocation. Nagera (1967) suggests that the pattern was determined

by his reading a story in George Eliot's *Scenes from Clerical Life*, in which a young clergyman devotes his life to the care of the poor, starves himself into illness, and is nursed by a woman who had been an alcoholic but was saved by this servant of God's teachings.[1] Maybe so. Certainly the pattern was close enough.

In any case, Vincent's religious fervor had begun to assert itself, and prompted him to take a position as a teacher in a boys' boarding school at Ramsgate run by Mr. Stokes. The school was not quite the embodiment of Dickens' Dotheboys Hall,[2] but was buried in penury and thrift nonetheless—dirty, infested, and harsh in discipline. Vincent worked for room and board and no salary. The food was meager and unpalatable at best, disgusting and inedible otherwise. Vincent could sympathize with the lonely and dismal plight of his students—so reminiscent of his own student days. Stokes soon moved the school to Isleworth, closer to London. He invited Vincent to stay on and offered a small salary. But as the promised salary failed to materialize and the working conditions were little better, Vincent decided to look elsewhere. As Hulsker (1990) comments:

> The most significant development in these years, especially during the second half of his stay in England, was his preoccupation with religion. Sometimes it was so exalted as to become a real obsession, and it led to a change in his career plans. In his letters of this period he already spoke of his wish to find "a position in connection with the Church," and it is clear that the veneration he felt for his father would sooner or later lead him to try to follow in his footsteps by becoming a parson himself, an ideal that so far had always seemed unattainable. (p. 43)

Vincent's new position was as assistant to the Reverend Thomas Slade-Jones, the local Congregationalist minister. He began as school teacher with a small salary. The fare was no better than at Stokes' school, but at least he could teach the Bible. Vincent gradually took on some duties in Jones' church, helping at prayer meetings and preparing to do some preaching. He immersed himself in *Pilgrim's Progress* (Letter 82) and *The Imitation of Christ*.

The Sermon

That November he was finally able to ascend the pulpit and preach his first sermons in the little Methodist chapels at Petersham and Turnham Green. His first efforts were marked by enthusiasm and devotion. His first attempts at preaching had been heady experiences that fanned the flames of his religious fanaticism. This part of the job he relished. But when he was asked to go to London and collect the back tuition from poor families in the East End of London, he was appalled by the poverty and misery he saw there (Letter 66).

He has left us a sample of his preaching. The sermon[3] was delivered one Sunday at a small Methodist church in Richmond, near London. The preacher, all of 23 years of age, chose for his text Psalm 119: 19, "I am a stranger on the earth, hide not Thy commandments from me." The sermon is a statement of Vincent's view of himself and of his faith. "It is an old faith and it is a good faith, that our life is a pilgrim's progress—that we are strangers on the earth, but that though this be so yet we are not alone for our Father is with us."

The essence of human life, he goes on to say, is sorrow. For Vincent, grief, sorrow, disappointment, and pain held center stage. Lubin (1972) sums up this aspect of his life:

> His tormenting loneliness and sense of being an outcast were reflections of an omnipresent, though sometimes hidden, depression; they erected a barrier that isolated him from human companionship. . . . He longed for intimacy with others, yet sought out solitude: it was the lesser of two evils. When he felt rejected or unsuccessful in a task, the self-doubt and self-depreciation of depression were intensified. Feeling guilty and doubting his own worth, he often thought that others regarded him as bad and worthless; human intimacy therefore threatened him with punishment and shame. (p. 2)

Vincent saw himself on a lonely pilgrimage in life—a passage marked by alienation, estrangement, and impermanence.

His mind was filled with the glories of the clerical vocation—the calling of his grandfather and father. He confessed to Theo:

> Lately it has seemed to me that there are no professions in the world other than those of schoolmaster and clergyman, with all that lies between these two—such as missionary, especially a London missionary, etc. I think it must be a peculiar profession to be a London missionary; one has to go around among the laborers and the poor to preach the Bible, and as soon as one has some experience, talk with them. . . .(Letter 70)

The Slough of Despair

Just as things seemed to be going well he stumbled. His moods and thinking became unpredictable and erratic. He plunged from the heights of consolation and enthusiasm to the depths of desolation and despair. His letters to Theo reflect the turmoil of emotions and confused religious obsessions that crowded his mind. There is hardly a letter without religious references, pious exhortations, or biblical citations with little or no coherence or logical sequence. His worried father wrote Theo:

> Just now a letter from Vincent. We have not yet been able to read it completely due to the wriggly writing. But in any case it is not a letter that gives us pleas-

ure, alas! If only he learned to remain simple as a child, and would not always go on filling his letter with Bible texts in such an exaggerated and overwrought manner. It makes us worry more and more, and I fear that he becomes altogether unfit for practical life; it is bitterly disappointing. How are his letters to you? If he wants to become an Evangelist, he should be ready to start the *preparation* and necessary *studies*; I would then have more confidence. (Cited in Hulsker 1990, p. 40)

An Interlude

In December 1876, after months of semistarvation and emotional turmoil, Vincent visited his family in Etten, where they had recently moved. His emaciated and forlorn appearance distressed them. His Uncle Cent again used his contacts to get him a job, this time as a clerk and salesman with the booksellers Blussé and Van Braam in Dordrecht. Braat, the manager, agreed to give Vincent a trial even though he had no current vacancy. But again, as at Goupil's, Vincent spent his time surreptitiously translating passages of the Bible and sketching.

Vincent yearned deeply for a change in his life. For him, the religious pilgrimage had the deeper meaning of personal transformation and ultimate salvation in the arms of his heavenly Father. He wrote: "I hope and believe that my life will be changed somehow, and that this longing for Him will be satisfied. I too am sometimes lonely and sad, especially when I am near a church or parsonage" (Letter 88). The last sentence gives the lie to his unconscious motivation: the yearning for closeness to God and Christ was rooted at least in part in Vincent's frustrated yearning for closeness to and acceptance by his idealized father-god. From a psychoanalytic perspective, the yearning for approval and acceptance from the father reflects the homosexual current in the negative oedipal configuration, in which the yearning and love for the father outweighs the negative influence of the father in the positive configuration. This distillation of his passive homosexual yearnings into his religious preoccupations is a noteworthy aspect of Vincent's religious struggles. The love and approval of such a father-god would change his life—or so he devoutly wished.

The bookstore job lasted four months—from January 21, 1877, until April 30. Years later the owner's son recalled his impressions of Vincent (Letter 94a). He described Vincent as unattractive and unsociable, a queer, lonely chap who had little to do with or say to anyone. His landlord thought he was out of his head—always alone, avoiding other lodgers, eating little if at all, never eating meat except for a tiny morsel on Sundays, and up at all hours of the night. He lived frugally, even ascetically, with no luxuries except his pipe. His roommate and fellow worker, Görlitz, described him in the following terms:

Van Gogh's attitudes and behavior often provoked amusement because he acted, thought, felt and lived so differently from others his age: he prayed for a long time at the table, ate like a hermit—consuming, for example, no meat, no gravy, etc.—and he invariably had a withdrawn, pensive, deeply serious, melancholy look on his face. But when he laughed he did so with such gusto and geniality that his whole face brightened.... At night when he came home ... he likewise went to work. That work was not, as one might have expected, art, but religion. Van Gogh sat night after night reading the Bible, making extracts from it, and writing sermons; at that time ... strict piety was the core of his being.... His religious feeling was vast and noble, the opposite of narrow-minded; although he was an orthodox Protestant in those days, on Sundays he went not only to the Dutch Reformed Church but also, on the same day, to the Jansenist, the Roman Catholic, and the Lutheran churches. And when I expressed my surprise and astonishment to him, he answered with a good-natured smile: "Do you think, G., that God cannot be found in the other churches?".... To become a minister of a religious parish: that was his dream, and that obsessed him, although he condemned, or, better, disapproved of the fact that knowledge of Latin and Greek should be required for the ministry. (Cited in Stein (1986), pp. 41-42. See also Letter 94a.)

His family, even Theo, had no inkling that things were deteriorating. Braat was fed up. He discovered Vincent at his desk, translating the Bible into French, German, and English, each in a separate column. When Vincent wrote to seek help in pursuing his wish to study for the church, Uncle Cent washed his hands. Finally Vincent announced that he was quitting, much to Braat's relief.

The fear of failure haunted Vincent's every step, along with a dread of criticism or disapproval from those from whom he desperately sought acknowledgement and approval. Perhaps this self-defeating pattern was Vincent's way of expressing the sense of guilt and inferiority that became his heritage by reason of his replacing the dead Vincent—a stain that he could never blot out. Certainly, it seems clear that he had set himself on a path of abysmal failure—his every enterprise resulted in dismal failure and disgrace. We can only wonder what powerful determinants, playing themselves out on the inner and hidden stage of his unconscious, were driving him unerringly in this pitiful direction.

Theological Training

After other avenues of endeavor had been closed to him, Vincent finally decided, somewhat in desperation, that his true vocation was to be a minister. His desire to follow in his father's footsteps and gain his approval played a dominant role in Vincent's efforts to pursue a religious vocation. He confided to Theo:

In writing to you of my intentions, my thoughts become clear and definite. . . .
As far as one can remember, in our family, which is a Christian family in every
sense, there has always been, from generation to generation, one who preached
the Gospel. Why shouldn't a member of that family feel himself called to that
service now, and why shouldn't he have reason to believe that he may and must
declare his intentions and look for the means to reach that goal? It is my fervent
prayer and desire that the spirit of my father and grandfather may rest upon me,
that it may be given me to become a Christian and a Christian laborer, and that
my life may resemble more and more the lives of those named above; for behold,
the old wine is good, and I do not desire a new one. (Letter 89)

And again: "Oh! Theo, Theo boy, if I might only succeed in this! If that
heavy depression because everything I have undertaken has failed and that
torrent of reproaches which I have heard and felt might be taken from me; and
if there might be given to me both the necessary opportunity and the strength
to develop fully and to persevere in that course for which my father and I
would thank the Lord so fervently" (Letter 92).

The family could accept this ambition, and arrangements were made for
Vincent to study for the ministry in Amsterdam. In May 1877, he began
preparation for the entrance examination to the theological college. The fam-
ily engaged a tutor in Latin and Greek, despite the obvious strain on their re-
sources. Vincent worked hard, but it was little use. Faced with the torments
of Greek vocabulary and grammar, he suffered only more frustration.[4]

Vincent had little more than contempt for the theology faculty at the Uni-
versity of Amsterdam. He regarded them as Pharisees, while he saw himself
as the Christ-figure who could stand in opposition to them. Vincent was im-
patient to be about his religious work. At the same time he carried out severe
penances and self-flagellations that sapped his strength and made study and
concentration difficult.[5]

Vincent's letters to Theo during these months are replete with religious
reflections. He reports on sermons heard, comments on biblical passages and
on religious and spiritual writings, and offers his own religious reflections.
But his father sensed that all was not well. He wrote to Theo on March 2:
"The concern about Vincent oppresses us heavily. I foresee that again a
bomb is going to burst. It is apparent that the beginning of his studies are
disappointing to him, and his heart seems to be torn by conflicting forces. . . .
I am afraid he has no idea what studying means, and now I fear the remedy he
will choose will be again a proposal for a change, for instance to become a
catechist! but that doesn't bring in any bread! We sit and wait, and it is like
the calm before the storm" (Cited in Hulsker 1990, p. 60). And again about a
month later: "I am afraid he is very unhappy, but what can we do about it?
We encourage him and give him the opportunity of continuing his studies, al-

though we hardly know how to manage. It is a sickly existence he has chosen, I'm afraid, and how much he will have to endure, and we together with him" (Cited in Hulsker 1990, p. 61).

After 14 months of effort, he failed the exam. Theodorus could hardly understand why Vincent, apparently so gifted in languages, should have such difficulties with Latin and Greek. His one desire had been to follow a religious vocation—how could he have failed at the crucial point? For Vincent, the disappointment was more bitter than any he had previously experienced. He returned to Etten in humiliation and despair. Some years later, he wrote in bitter disdain: "You understand that I, who have learned other languages, might have managed to master that miserable little bit of Latin—which I declared, however, to be too much for me. This was a fake, because I then preferred not to explain to my protectors that the whole university, the theological faculty at least, is, in my eyes, an inexpressible mess, a breeding place of Pharisaism" (Letter 326). He felt only scorn for those mincing Pharisees who were more interested in theological distinctions than in helping poor souls, more concerned about courting well-fed Dutch merchants than about following Christ and ministering to unfortunate and impoverished peasants.

Despite the rebuffs, Vincent continued to pursue his ideal. He wrote:

> As for me, I must become a good clergyman who has something to say that is right and may be of use in the world; perhaps it is better that I have a relatively long time of preparation and am strongly confirmed in a staunch conviction before I am called to speak to others about it. . . . If only we try to live sincerely, it will go well with us, even though we are certain to experience real sorrow and great disappointments, and shall also probably commit great errors and do wrong things It is good to love many things, for therein lies true strength; whosoever loves much, performs and can accomplish much, and what is done in love is well done. . . . If one keeps on loving faithfully what is really worth loving, and does not waste one's love on insignificant and unworthy and meaningless things, one will gradually get more light and grow stronger. . . . Sometimes it is well to go into the world and converse with people often; at times one is obliged to do so, but whoever would rather be quietly alone with his work and wants but very few friends will go safest through the world and among people. . . . And whoever chooses poverty for himself and loves it, possesses a great treasure and will always hear the voice of his conscience clearly; he who hears and obeys that voice, which is the best gift of God, finds at last a friend in it, and is never alone. (Letter 121)

To Preach the Word

After his failure in the entrance examinations for theology, Vincent had to lower his sights, but he still wanted to follow a religious mission. He wanted to be a preacher and serve Christ, but he found it difficult to submit to any discipline or religious convention. His frustrated father did not know where

to turn. The Reverend Jones came from Isleworth to see if he could help. They finally decided that the best available option for Vincent was the three year course at the Brussels school for evangelists, recently opened in Laeken. With the help of the two ministers, Vincent enrolled in August 1878. After completing the course, the graduates were sent to assist in the ministry in the Borinage, a coal district on the French border and one of worst industrial areas in Europe. For all practical purposes, the poverty stricken miners led lives of slavery and severe squalor (Sweetman 1990). But the story was much the same as in Amsterdam: Vincent had little tolerance for study and discipline. Asked about a point of grammar, he is reported to have replied, "Oh sir, I really don't care" (Letter 126a). In addition his physical condition had deteriorated to such an extent that Plugge, with whose family Vincent lived, felt obliged to write Vincent's family about his weakened condition and his nervous difficulties.

The Suffering Servant
As Vincent was growing up, the people among whom he lived were poor, rustic, and relatively primitive folk, whose virtues and strengths he grew to respect and love. The deep empathy he felt for the unfortunate and down-trodden—even dogs—was rooted in his own identification with them.[6] He even felt like a snarling dog with his own family. This empathy with suffering was a leitmotif that determined and guided Vincent's religious thinking and set him on the course of his religious vocation.

Within three months after his enrollment in the school for evangelists, the authorities decided that he should not continue. The apparent reason was his inability as a preacher. He had little capacity for extemporaneous preaching and could only read laboriously from a prepared text. Without completing the course, he set out for the Borinage to reveal the light of the gospel to the poor miners. The mission committee did not wish to reject someone who was so deeply motivated, nor did they wish to offend his father, a minister in good standing. They therefore authorized a probationary period of service in the coalfields as an assistant, with the meager stipend of 50 Belgian francs a month. Vincent left for the Borinage in December 1878.

He set about his work with a vengeance, visiting the poor, tending the sick, teaching catechism, and trying to preach. He lived in circumstances as poor as, if not poorer than, those of the miners themselves. He spent himself without reserve in compassion and devotion to the miners. If ever he lived out his vision of the imitation of Christ it was there—he became the embodiment of the "suffering servant." He was suffering with Christ suffering, poor with Christ poor. He gave away all he possessed—clothes, money, even his bed. He wanted to be even more destitute than the poor miners he served.

He wore an old soldier's tunic and a tattered cap. Soap became a luxury, and washing went with it. His filth and shabby appearance did not bother him, so absorbed in self-denial was he. No sacrifice was too great to help his flock. Sweetman (1990) comments on this period:

> As we read his thoughts and follow his actions it is like witnessing someone bat-
> tling with God, someone saying: 'I will go to the absolute limits to follow your
> commands so that I can know if this is what You want of me.' In the Borinage
> Vincent set out to test himself, but in a way it was also a challenge to God, a
> subconscious way of breaking free from Him by going to the uttermost limits of
> religious self-mortification. (p. 100)

His divesting himself of all he owned, and his filthy and emaciated ap-
pearance worried the Denis family, with whom he lodged. To them his be-
havior exceeded all bounds of charity or eccentricity. When he moved into
one of the mine shacks—a crude hovel without warmth or protection from the
elements—they wrote to Theodorus out of concern for Vincent's life. Theo-
dorus made the long trip from Brabant with considerable apprehension. He
must have been appalled at what he saw. He was able to influence the mis-
sionary authorities to defer the evaluation, but not long after his father's de-
parture the familiar pattern of excessive mortification and Vincent's over-
whelming devotion to the service of the miners became even more extreme.
He was indifferent to any creature comforts and lived more poorly, in more
filth and deprivation than any of his flock.

The pastor of the neighboring church, who knew Vincent during that pe-
riod, has left some observations:

> Confronted with the miseries he encountered in his visits, his pity had moved him
> to give away nearly all his clothing; his money, too, had gone to the poor; he had
> kept virtually nothing for himself. His religious beliefs were very ardent, and he
> desired to obey the teachings of Jesus Christ to the letter. He felt bound to imi-
> tate the early Christians, to sacrifice everything he could do without, and he
> sought to be even more destitute than most of the miners to whom he preached
> the Gospel. . . . he was absorbed in his ideal of renunciation. He made it clear
> that his attitude was not one of carelessness, but rather of the faithful practice of
> the beliefs that ruled his conscience. (Cited in Stein (1986), p. 46. See also Let-
> ter 143a.)

A more indirect account comes from Paul Gauguin reflecting on his expe-
rience a few years after Vincent's death. Gauguin wrote of Vincent in the
Borinage:

> In my yellow room [At Arles] there was a small still life: this one in violet. Two
> enormous shoes, worn, misshapen. The shoes of Vincent (F255, JH1124).

Those that, when new, he put on one nice morning to embark on a journey by foot from Holland to Belgium. The young preacher (he had just finished his theological studies to become, like his father, a pastor) was on his way to see those in the mines whom he called his brothers, like the simple workers, such as he had read of in the Bible, oppressed for the luxury of the great.

Contrary to the teachings of his instructors, the wise Dutchmen, Vincent believed in Jesus who loved the poor; his soul, entirely suffused with charity, desired by means of consoling words and self-sacrifice to help the weak, to combat the great. Decidedly, decidedly, Vincent was already mad.

His teaching of the Bible in the mines was, I believe, profitable to the miners below, but disagreeable to the authorities on high, above ground. He was quickly recalled, dismissed, and a family council convened that judged him mad, and advised rest at a sanatorium. He was not, however, confined, thanks to his brother Theo.

One day the somber black mine was flooded by chrome yellow, the fierce flash of firedamp fire, a mighty dynamite that never misfires. The beings who were crawling and teeming about in filthy carbon when this occurred bid, on that day, farewell to life, farewell to men, without blasphemy.

One of them, terribly mutilated, his face burnt, was taken in by Vincent. "And yet," the company doctor had said, "he is a finished man, barring a miracle or very costly nursing. No, it would be folly to attend to him."

Vincent believed in miracles, in maternity. The mad man (decidedly he was mad) kept watch for forty days at the bedside of the dying man; he prevented the air from ruthlessly penetrating into his wounds and paid for the medications. He spoke as a consoling priest (decidedly he was mad). The work of a madman had revived a Christian from the dead.

When the wounded man, finally saved, descended into the mine again to resume his work, you could have seen, said Vincent, the head of Jesus the martyr, carrying on his forehead the halo and the jagged crown of thorns, red scabs on the dirty yellow forehead of a miner. (Cited in Stein (1986), pp. 121-122)[7]

From the Borinage, Vincent wrote Theo:

I am a man of passions, capable of and subject to doing more or less foolish things, which I happen to repent, more or less, afterward. Now and then I speak and act too hastily, when it would have been better to wait patiently. I think other people sometimes make the same mistakes. Well, this being the case, what's to be done? Must I consider myself a dangerous man, incapable of anything? I don't think so. But the problem is to try every means to put those self-same passions to good use. . . . So you must not think that I disavow things—I am rather faithful in my unfaithfulness and, though changed, I am the same; my only anxiety is, How can I be of use in the world? Can't I serve some purpose and be of any good? How can I learn more and study certain subjects profoundly? You see, that is what preoccupies me constantly; and then I feel imprisoned by poverty, excluded from participating in certain work, and certain necessities are beyond my reach. That is one reason for being somewhat melancholy. And then one feels an emptiness where there might be friendship and

strong and serious affections, and one feels a terrible discouragement gnawing at one's very moral energy, and fate seems to put a barrier to the instincts of affection, and a choking flood of disgust envelops one. And one exclaims, "How long, my God!" (Letter 133)

But for all his devotion and self-sacrifice, his preaching was not well received by the miners; for whatever reason, his indifferent skills as a preacher or the peculiarity of his behavior or the fanatic intensity of his message, his preaching bore little fruit. He was no better understood by these poor unfortunate people than by his own family. The extremes of devoted service, the excessive zeal, the severe life of self-deprivation and penances, and the failure of his apostolic efforts precipitated a severe mental and emotional crisis. Whereas the miners at first overlooked his eccentricities out of appreciation for his desire to help, their attitude gradually changed, and they came to see him more as a fool or madman than as a saint. Children taunted him in the street. He succeeded only in antagonizing his religious superiors and probably frightening and confusing his miner flock.

More telling, however, was his relationship with his religious superiors. The picture of this filthy, haggard, starving derelict living in utter poverty and squalor was not their image of a pastor. But in his impassioned and single-minded dedication to his ideals, Vincent could find no room for compromise. Despite frequent admonitions and warnings, even pleading from his father, he insisted on his impoverished way. Provoked by his stubborn obstinacy and his need to rebel against authority, a kind of authoritarian and even paranoid stance (Meissner 1978b), the missionary society finally withdrew their approbation and his apostolic career was at an end.

For Vincent this was a desperate and tragic blow that shattered his narcissism and plunged him into a severe depression. He had given his all to God, and God had turned him down. The tragedy was that he had a deep love for humanity but could not find a way to communicate with the men of his world. Despite frequent warnings and urgings by the evangelical authorities, he would not compromise his extreme if deeply charitable efforts and refused to surrender his filthy clothes and impoverished living conditions. They were the badge of his mission and his deepest religious convictions.

In October 1880, he shook the dust of the Borinage—with its gloom, hardship, bitterness and disappointment—from his feet. Madame Bonte, wife of the local pastor, described the scene:

On the evening when he left Vincent came to say good-bye to us. He was terribly pale, and he said to us with profound sadness: *"Nobody has understood me. They think I'm a madman because I wanted to be a true Christian. They turned me out like a dog, saying that I was causing a scandal, because I tried to relieve*

the misery of the wretched. I don't know what I'm going to do. Perhaps you are right, and I am idle and useless on this earth!" Then he went away, all alone, his feet bare, and with his bundle on his shoulder. The children ran after him shouting: "He's mad! He's mad!" My husband made them stop, and he said to me: "We have taken him for a madman, and perhaps he's a saint!" (Cited in Tralbaut 1969, p. 66)

Depression

When they met briefly at Cuesmes, Theo could not escape the impression that Vincent had changed. His emaciated, scaphoid, and degraded appearance disturbed Theo, who found himself scolding Vincent and trying to persuade him to give up this madness. They parted on good terms, but Vincent could barely conceal his bitterness and irritation at Theo's lack of understanding. There were no letters to Theo for about ten months—from August 1879 until July 1880. He again withdrew and kept to himself for several months, communicating with no one; somehow he managed to survive. Finally he wrote to Theo: "As molting time—when they change their feathers—is for birds, so adversity or misfortune is the difficult time for us human beings. One can stay in it—in that time of molting—one can also emerge renewed; but anyhow it must not be done in public and it is not at all amusing, therefore the only thing to do is to hide oneself. Well, so be it" (Letter 133).

Later in the fall of 1880, when he had settled in Brussels, he confessed to Theo:

> If I had stayed in Cuesmes a month longer, I should have fallen ill with misery. You must not imagine that I live richly here, for my chief food is dry bread and some potatoes or chestnuts which people sell here on the street corners, but by having a somewhat better room and by occasionally taking a somewhat better meal in a restaurant whenever I can afford it, I shall get on very well. But for almost two years I have had a hard time in the Borinage—it was no pleasure trip, I assure you. (Letter 138)

SECTION II

TOWARD THE ABYSS

Chapter III
THE PATH TO DESPAIR

Transition

After the defeat of his efforts to follow a religious vocation, Vincent found himself cast into a pit of disappointment and despair. Amid the ruins of his ambitions and hopes, he could find little solace in his religious preoccupations. The temple of hope and self-sacrifice he had tried to construct had come crashing down on his head, and with it any semblance of acceptance of the traditional Calvinistic faith of his father. His depression and hopelessness lasted for months.

He finally decided to become an artist, but the transition from religion to art was not an easy one. It involved a tearing apart of the fabric of his life and a radical reshaping of his beliefs. During the period of this transition—from the fall of 1880 when he left the Borinage until February of 1888 when he left Paris for the Midi—the tragic current of his life diverged into two equally significant and equally troubled channels. The first channel involved the transition from religion to art and his tormented and conflictual struggle to learn and master the techniques of his art. His struggle to become an artist was intermingled with his struggle to resolve the conflicts that had been embedded in his religious dedication. The second channel involved his painful and continually frustrated efforts to find a place for himself among his fellow men that would allow him to feel a part of the human communion and that would offer him love, affection, and acceptance. This drama was played out on three separate stages: (1) his relationships with women, reflecting his tormented endeavor to find some meaningful love relationship, (2) his relationships with his family that were so intensely ambivalent and disruptive, and finally (3) his attachment and dependence on his brother Theo.

In all these areas, the resolution of the central issues had decisive consequences for his final immersion in art and for his evolving religious and spiritual life. In the first, the conflict involved the love of woman and the life of humanity and community it implied against the bitter isolation and total dedication of the artist's life; in the second, it involved the conflict between the devotion and service of the God of his father—and by implication his seeking for approval from his father-pastor—and the search for God outside of the churches and traditional religion, in art, in nature, in sincerity and truth. And in his relation to Theo, it was the conflict between his continued dependence on Theo that made his life as an artist possible and the ambivalent resentment against this symbiotic enmeshment that threatened his very existence. This second channel led down a path toward increasing isolation, alienation, and

despair. The first, tormented and turbulent as it was, provided the substance of his artistic vocation.

Disappointments in Love

Kee. Vincent had had his first disappointment in love with Eugenia Loyer in 1874; the second came in 1881. In April of that year, after his traumatic disappointment and failure in the Borinage, Vincent took refuge with his parents at Etten. That summer, his cousin Kee Vos came to visit the parsonage. Vincent had met her first in Amsterdam during visits to his Uncle Stricker's home. At that time her husband was dying of an incurable lung disease. Now she was widowed, with a four year old son. Vincent again became enamored. He wrote Theo:

> There is something in my heart that I must tell you; perhaps you know about it already and it is no news to you. I want to tell you that this summer a deep love has grown in my heart for Kee; but when I told her this, she answered me that to her, past and future remained one, so she could never return my feelings. Then there was a terrible indecision within me about what to do. Should I accept her "no, never never," or, considering the question not finished or decided, should I keep some hope and not give up? I chose the latter. And up to now I do not repent the decision, though I am still confronted by the "no, never never." (Letter 153)

True to his style, he could not take no for an answer. His persistence finally drove Kee back to her family in Amsterdam to escape him. He continued to force himself on her, writing again and again, always without reply. His uncle described his behavior as "disgusting obstinacy." Vincent resented the interference of the older generation,[1] whom he saw as trying to force him to give up his quest.

That December Vincent went to The Hague, determined to press his suit regardless of opposition. There were difficult scenes with Kee's parents, the Reverend Mr. Stricker and his wife. After one such confrontation, he wrote to Theo:

> I still felt chilled through and through, to the depth of my soul. . . . And I did not want to be stunned by that feeling. Then I thought, I should like to be with a woman—I cannot live without love, without a woman. I would not value life at all, if there were not something infinite, something deep, something real. . . . I need a woman, I cannot, I may not, I will not live without love. I am a man and a man with passions; I must go to a woman, otherwise I shall freeze or turn to stone—or in short, shall be stunned. (Letter 164)

The crowning episode took place when Vincent insisted on seeing her to press his suit, but she refused to appear. He persisted for two days and finally, in a fit of desperation, held his hand in the flame of an open lamp, swearing that he would keep it there until she appeared. After a few horrible moments, Vincent finally fainted, to the relief of all concerned.

Sien. In the wake of his rejection by Kee, it was not long before Vincent's desperate sexual need and yearning for love found another outlet. In answer to his father's demand for reason and logic, he wrote to Theo:

> Who is the master, the logic or I? Is the logic here for me or am I here for the logic, and is there no reason or sense in my unreasonableness and lack of sense? And whether I act rightly or wrongly, I cannot do otherwise But under the circumstances I fought a great battle within myself, and in the battle some things remained victorious One cannot live too long without a woman with impunity. And I do not think that what some people call God and others, supreme being, and others, nature, is unreasonable and without pity; and in short I came to the conclusion, I must see whether I can find a woman. And, dear me, I hadn't far to look. I found a woman, not young, not beautiful, if you like, but perhaps you are somewhat curious. She was rather tall and strongly built; she did not have a lady's hands like Kee, but the hands of one who works much; but she was not coarse or common, and had something very womanly about her. . . . She had had many cares, one could see that, and life had been hard for her; . . . It is not the first time I was unable to resist that feeling of affection, aye, affection and love for those women who are so damned and condemned and despised by the clergymen from the pulpit. I do not damn or condemn them, neither do I despise them. . . . That woman has not cheated me—oh, he who regards all such women as cheats, how wrong he is, and how little understanding he shows. (Letter 164)

Christine—or Sien, as he called her—was down and out, penniless, and pregnant. She already had a sickly daughter. Vincent befriended them and took them in off the streets to live with him in his little studio in The Hague. Soon he had to be hospitalized for gonorrhea; when he returned she had given birth to a son. He finally had the family and companionship he so yearned for.

But he had no means of supporting them; the money from Theo was hardly enough to sustain himself. The situation alienated everyone he knew, but Vincent cared nothing about his poverty, degradation, and disgrace. His friends were scandalized and distanced themselves. He protested to Rappard: "This is partly because I have taken the woman and her two children into my house, and they think that for decency's sake they must not associate with me at all. . . . I act in this way: if anybody avoids me on account of this, I do not seek his company; I prefer staying away somewhere to not being welcome.

The more so because I can make allowances a little, a very little, just a tiny wee little bit, for the prejudice of those who consider, or try to consider, only the social conventions, for which reason I leave them alone, especially as I look upon it as a weakness, so that I won't fight them, or at least I won't attack them. Acting thus, I certainly do save cartridges. Do you think this conceited?" (Letter R34). His shabby and filthy clothes, his vagabond behavior and appearance, must also have put them off.

Vincent was not at all oblivious to the social implications of his arrangement with Christine—especially the impact on his friends and family—but he rebelled against their conventional attitudes with vehemence. His letters to Theo carry on an extended diatribe defending his relationship with Sien, protesting his love, and debating Theo's objections and cautions.[2] Perhaps this was all a rebellious flaunting of convention and propriety, a thumbing of his nose in the face of his father, society, conventional morality, and traditional religion.[3]

The relationship with Sien seems to have been the closest and most meaningful involvement with a woman Vincent was ever able to achieve. Nonetheless, he was much given to frequenting prostitutes, particularly during his stay in Arles, but at other times as well. At one point, in a somewhat defensive, even provocative, tone, he wrote to Theo about his commerce with prostitutes: "I tell you frankly that in my opinion one must not hesitate to go to a prostitute occasionally if there is one you can trust and feel something for, as there really are many. For one who has a strenuous life it is necessary, absolutely necessary, in order to keep sane and well. One must not exaggerate such things and fall into excesses, but nature has fixed laws which it is fatal to struggle against" (Letter 173). There is good reason to think that prostitutes came to represent an aspect of Vincent's own sense of self-degradation and his identification with the victimized poor and downtrodden.[4]

In his eyes, prostitutes had a certain beauty and nobility. He wrote from Drenthe in 1883, after the relationship with Sien had ended:

> Women of her kind are certainly bad, but in the first place they are infinitely—oh, infinitely more to be pitied than condemned; and in the second place they have a certain passion, a certain warmth, which is so truly human that the virtuous people might take them as an example, and I for my part understand Jesus's words when He said to the superficially civilized, the respectable people of His time, "The harlots go into the Kingdom of God before you" I know full well that, frankly speaking, prostitutes are bad, but I feel something human in them which prevents me from feeling the slightest scruple about associating with them; I see nothing very wrong in them. I haven't the slightest regret about any past or present association with them. If our society were pure and well regulated, yes, then they would be seducers; but now, in my opinion, one may often consider them more as sisters of charity. (Letter 326)

The identification between artists and prostitutes played a significant role in Vincent's mind. His relationship with Sien was also involved in his rebellious defiance toward the conventional morality represented by his father and in his rejection of the religious stance Theodorus represented.

Was Vincent's defiant stance an expression of his masochism? revenge? self-degradation? unconscious guilt? Whatever the cost of this relationship, it was the closest thing Vincent ever had to a home and family of his own— something for which he desperately longed, but which seemed to elude his grasp. It may be, as Nagera (1967) avers, that Vincent was acting out his unconscious guilt and masochistic need for punishment in his relation with Sien, for it certainly brought him torrents of disapproval, isolation, suffering, rejection, and pain.

Vincent was deeply concerned that Theo would turn against him, as Mauve, Tersteeg, and others had. He wrote:

> I wish those who mean well by me would understand that my actions stem from a deep feeling and need for love, that recklessness and pride and indifference are not the springs which move the machine, and this step is proof of my taking root in a lowly station on the road of life. I do not think I should do well to aim for a higher station or to try to change my character. . . . Theo, will these things cause a change or separation between you and me? I would be so happy if they don't, and will be twice as glad of your help and sympathy as before; if it does, it is better for me to know the worst than to be kept in suspense. (Letter 197)

Vincent was also apprehensive that Tersteeg might poison Theo's attitude (Letter 282). Theo wrote quite frankly that Christine was making a fool of him, but Vincent would hear none of it.

Vincent protested his intention to marry Sien, to which Theo reacted quite negatively. In the face of Theo's strenuous protests, Vincent agreed to put off the ceremony until he had established himself somewhat more securely as an artist. But the yearning for companionship and a home was powerful. "I know how only a short time ago I came home to a house that was not a real home with all the emotions connected with it now, where two great voids stared at me night and day. There was no wife, there was no child. I do not think there were fewer cares for all that, but certainly there was less love. And those two voids accompanied me, one on either side, in the street and at work, everywhere and always. . . . See, I do not know whether you have had that feeling which forces a groan or a sigh from us at moments when we are alone: My God, where is my wife; my God, where is my child? Is living alone worthwhile?" (Letter 213). Despite warnings and antipathy from all sides, Vincent continued to talk of marrying Sien. She served as the model

for many of his sketches; she was presumably the model for his powerful sketch of Sorrow (F1655, JH259).

Gradually the telltale signs of his worsening relationship with Sien began to appear (Letters 268a and 288). The root of the difficulty seems to have been money. There is little doubt that he sincerely loved her in his fashion, but it remains questionable whether she really loved him. She did not even seem grateful for his efforts to rescue her from a life on the streets. It seems more likely that she took advantage of his innocence and sincerity to provide for herself and her children for a time. As Tralbaut (1969) observes: "Vincent found that the family life which he had so enjoyed at first had now become intolerable. Instead of a 'warm nest' kept by a kind and biddable woman, he had to live in a squalid studio with a coarse and dirty pock-marked hag, who spoke vilely and stank of liquor and tobacco; who involved him in her shady dealings and even relapsed into her old ways of prostitution" (p. 111).

At first Vincent blamed her mother and her family, but the more significant root of the difficulty seems to have been money. Vincent could not provide adequate food or housing, and such matters were of little concern to him. To this was added the continuing pressure from Theo. Sien's dissatisfaction grew. She became morose and irritable, frequently threatening suicide. She finally left him and returned to her life as a prostitute. It was a severe blow for Vincent; he was heartbroken, discouraged, lonely, and depressed. He finally left for Drenthe on September 11, 1883, his relationship with Sien finished for good (Letter 319). He wrote: "As I feel the need to speak out frankly, I cannot hide from you that I am overcome by a feeling of great anxiety, depression, a "*je ne sais quoi*" of discouragement and despair more than I can tell. And if I cannot find comfort, it will be too overwhelming. . . . the fate of the woman and the fate of my poor little boy and the other child cut my heart to shreds" (Letter 328). With the weight of this bitter disappointment and depression bearing down on his heart and mind, he rejoined his family at Nuenen where he stayed for roughly the next two years.

Margot Begemann. The affair with Sien ended toward the end of 1883, and Vincent subsequently rejoined his family, then living in Nuenen. The ordinary run of daily life was broken by an accident to Vincent's mother in January 1884. Stepping off the train, Anna slipped and fell on the platform, breaking her femur (Letters 352 and R39). Vincent was deeply affected by his mother's pain and dependency (Letter 355). He appointed himself her nurse and did whatever he could to be helpful. His experience nursing the poor miners of the Borinage must have served him well. His efforts were complemented by his sisters (Letter 358) and by the daughters of the church

elder Jacob Begemann, particularly the youngest daughter, Margot, who was ten years Vincent's senior. She and Vincent seemed to hit it off, and soon a relationship developed.

Margot Begemann was a spinster, a homely but nonetheless vivacious and charming woman. She was an admirable person, well regarded for her agreeable and kindly disposition. She had a good business head and was a partner in a linen manufacturing firm belonging to her brother. She befriended the vagabond artist, and gradually their relation grew into what seemed to be the healthiest of all Vincent's relationships with women. Their relationship probably became physical, and there was serious talk of marriage.

Apparently it did not progress very far, since her family was staunchly opposed. Her two sisters, also aging spinsters, were probably jealous. Her father was insistent that she continue to help with his business. They regarded Vincent as hardly a suitable mate—little more than a vagabond, a "bohemian," without prospects or income, who would undoubtedly drag Margot with him into the gutter. They made things quite uncomfortable for the poor woman, who had a somewhat unstable and neurotic character to begin with; she finally suffered a breakdown and ingested a large amount of strychnine in a suicide attempt. She collapsed while walking with Vincent, and he had to carry her back home, unconscious and near death's door. The outcome was the disruption of their relationship and her total alienation from him. Vincent again retreated in bitter disillusionment and depression.

Again Theo served as Vincent's confidant: "Something terrible has happened, Theo, which hardly anybody here knows, or suspects, or may ever know, so for heaven's sake keep it to yourself. To tell you everything, I should have to fill a volume—I can't do it. Margot Begemann took poison in a moment of despair; after she had had a discussion with her family and they slandered her and me, she became so upset that she did it (in a moment of decided *mania*, I think)" (Letter 375). Vincent did not waste the opportunity to vent his resentment toward his brother:

Theo, now that I know more than at first what made her so desperate—do you want to know what it was? That night *her family* spoke to *her* approximately in the same tone—as *you* did to *me*. Well, *then* I decidedly *lost my temper* with you—this is over now—and she would have taken it in extremely bad part if she had *my* temperament. Well, the things that were said—naturally *not* the things *you* said, but what *her sisters* said—made her so *desperate* and so excessively melancholy that she did what I wrote you about. Looking at it from *your* point of view, I, who am more of a philosopher, can say—at least on reflection, *He* now thinks *that way, let* him. But she, *when they expostulated with her, believed she had done something frightful. And this without having done anything she*

ought not to have done. She took it so much to heart that she felt deserted by everybody and everything. (Letter 377)

After the bitter disappointment with Sien and the frustration and bitter rejection of his affair with Margot Begemann, he seemed to give up on any hope for marriage and family. "I feel I am losing the desire for marriage and children, and now and then it saddens me that I should be feeling like that at thirty-five, just when it should be the opposite. And sometimes I have a grudge against this rotten painting. It was Richepin who said somewhere: 'The love of art makes one lose real love' " (Letter 462).

Family Alienation

Adding to the burden of Vincent's woe, his relationships with his family were a continuing calamity. The periods of most intense conflict with his family during his adult years came during those periods when he lived with the family—the first period from April till the Fall of 1881, after the failure of his religious mission, when the family was living at Etten, and the second after his failures in the art academy when the family was in Nuenen. The second period lasted nearly two years—from December 1883 until November 1885.

The situation in the family went from bad to worse. On each occasion they seemed to end in outbursts of rage and recrimination. These arguments were typically with his father, but included his mother as well—Vincent saw her as allied with his father and not empathic or emotionally available to him. On several occasions matters reached a head and Theodorus ordered Vincent to leave the house. Vincent poured out his grievances and resentments to Theo in a steady stream of letters, bemoaning the callousness and hardheartedness of his parents.

Relations with his family were complicated by Vincent's libidinal misadventures. The Kee affair was an embarrassment for the family and brought their conflicts to a boil. Vincent's complaints were directed not only at his father who rejected and could not understand him, but also at his mother's lack of compassion and affection:

> Father and Mother are very good at heart, but have little understanding of our inner feelings, and as little comprehension of your real circumstances as of mine. They love us with all their hearts—you especially—and we both, I as well as you, love them very much indeed; but alas, in many cases they cannot give us practical advice, and there are times when, with the best of intentions, they do not understand us. . . . Theirs is a system of resignation in many matters to which I cannot resign myself. . . . And she [mother] came to me with a face full of pity and with many comforting words, and I am sure she had prayed a beautiful prayer for me, that I might receive strength for resignation. But until now that prayer has found no hearing. . . . You understand that a man who wants to

act cannot quite approve of the fact that his mother prays for his resignation. And that he also thinks her words of comfort a little out of place as long as he does not despair, but, on the contrary, says from the bottom of his heart, "Je n'accepte point le joug du desespoir" [I won't accept the yoke of despair]. I wish she had not prayed for me, but had given me the chance of having an intimate conversation with *her*. (Letter 155)

Vincent tried to persuade Theo to intercede for him. He realized that Theo was the favored sibling and that there was considerably greater chance that his parents would listen to him. Theo's efforts to get Vincent to be more reasonable and accommodating were unavailing. Vincent could not conceal his irritation at Theo's unwillingness to help him in this matter. He grew more resentful and argumentative with his parents, and they grew increasingly impatient with him for disrupting family relationships.

Vincent's disruptive behavior and argumentativeness finally led to a violent argument with his parents. He poured out his bitterness against his father: "But the result was that Father grew very angry, ordered me out of the room with a curse, at least it sounded exactly like one! Father is used to having everyone give in to him when he's in a passion, even I, but this time I was quite determined to let him rage for once. In anger Father also said something like I had better leave the house and go elsewhere; but because it was said in a passion, I do not attach much importance to it" [Letter 158].

And soon after:

Of course you understand that I am not the man intentionally to grieve Father and Mother with anything. When I must do something contrary to their wishes and which often grieves them without cause, I feel very sorry for it myself. But do not think that the late regrettable scene was caused only by hot temper. . . . So there is, indeed, a lasting, deep-rooted misunderstanding between Father and myself. And I believe that it never can be quite cleared up. But on both sides we can respect each other because we agree in so many things, though sometimes we have quite different—ay, even opposite—views. So I do not consider Father an enemy, but a friend who would be even more my friend if he were less afraid that I might "infect" him with French "errors." I think if Father understood my real intentions, I could often be of some use to him, even with his sermons, because I sometimes see a text in quite a different light. But Father thinks my opinion entirely wrong, considers it contraband, and systematically rejects it. (Letter 161)

Little had changed for Vincent; at age thirty he was still clumsy, awkward, slovenly, filthily dressed, and incapable of complying with domestic arrangements and social mores. He was skilled at provoking and alienating the family's few friends, so that before long they insisted that Vincent remove himself from the house when anyone came to visit. As Jo van Gogh-Bonger

(1959) wrote in her Memoir, "In a small village vicarage, where nothing can happen without everybody's knowing it, a painter was obviously an anomaly; how much more a painter like Vincent, who had so completely broken with all formalities, conventionalities, and with all religion, and who was the last person in the world to conform himself to other people" (p. xxxv). It was a sentiment that Vincent himself echoed:

> Is it a loss to drop some notions, impressed on us in childhood, that maintaining a certain rank or certain conventions is the most important thing? I myself do not even think about whether I lose by it or not. I know only by experience that those conventions and ideas do not hold true, and often are hopelessly, fatally wrong. I come to the conclusion that I do not know anything, but at the same time that this life is such a mystery that the system of "conventionality" is certainly too narrow. So that it has lost its credit with me. (Letter 336)

Finally, at the end of 1881, frustrated and impatient, Theodorus ordered Vincent out of the house. On Christmas day Vincent and angrily confronted his father, denouncing the organized church to his father's face. He wrote to Theo:

> On Christmas Day I had a violent scene with Father, and it went so far that Father told me I had better leave the house. Well, he said it so decidedly that I actually left the same day. The real reason was that I did not go to church, and also said that if going to church was compulsory and if I was forced to go, I certainly should never go again out of courtesy, as I had done rather regularly all the time I was in Etten. But, oh, in truth there was much more at the back of it all I do not remember ever having been in such a rage in my life. I frankly said that I thought their whole system of religion horrible, and just because I had gone too deeply into those questions during a miserable period in my life, I did not want to think of them any more, and must keep clear of them as of something fatal. Was I *too* angry, *too* violent? Maybe—but even so, it is settled now, once and for all. (Letter 166)

In a rage Vincent moved to The Hague where he planned to study with Anton Mauve, a prominent painter of the day and his cousin. Theo sent a stern reprimand, scolding Vincent for his behavior and asking for some reconciliation (Letter 169), but Vincent remained adamant. He sent back a scorching rebuttal:

> The expression that it is my purpose *to embitter and spoil Father's and Mother's life* is in reality not your own; I know it, and have for a long time, as a Jesuitism of Pa's. . . . Every time you say something to Father which he hasn't an answer for, he produces an expression of this kind; for instance, he will say, "You are murdering me," meanwhile reading the paper and smoking his pipe in complete tranquillity. So I take such expressions for what they really are. Or

else father will fly into a frightful rage, and as he is accustomed to people being scared of him under such circumstances, Father is surprised if somebody does not give way to his anger. Father is excessively touchy and irritable and full of waywardness in his home life and thinks he is entitled to getting his own way. And literally everything that Father may happen to hit upon is included under the "rules and regulations of the house" which I should be obliged to conform to. . . . If this last row had been an isolated case, things would have been different; but it was preceded by many rows, in the course of which, in a more quiet but resolute manner, I told Father a good many things which his Honor saw fit to fling to the winds. . . . But when I flew into a rage, my diplomacy was swept away, and, well, on this occasion I really let fly. I will not apologize for this, and as long as Father and Mother persevere in this mood, I shall not take anything back. Should they make up their minds to be more humane, more delicate of feeling and more honest, then I shall be glad to take everything back. But I doubt whether this will happen That I shall regret it, etc. Before things reached the point they have come to now, I had many regrets and much grief, and I was sorely worried because there was so much hard feeling between Father and Mother, and myself. But now that things have gone so far, well so be it; and, to tell you the honest truth, I have no regrets any more, but involuntarily a feeling of deliverance. Should I later conclude that I did wrong, then I shall regret it, of course, but so far I have been unable to see how I could possibly have acted differently. When somebody says deliberately and resolutely to me, "Get out of my house, the sooner the better, and rather in half an hour than an hour," well, my dear fellow, it won't be a matter of an hour before I shall be gone, and I shall never return, either. It was too bad. For financial reasons, and in order not to cause you more trouble, I should not have left of my own accord on insufficient grounds—this you must understand; but now that the "Get out" is not on my side but on theirs, my road is indicated clearly enough I am not Father's enemy if I tell him some home truths occasionally—not even when I used some salty language in a fit of rage. Only it didn't help me, and Pa took offense. In case Pa alluded to my saying that the morality and religious system of ordained clergymen are not worth a fig to me since I have come to know so much of the *dessous des cartes*, I decidedly will not take this back, for I really mean it. However, when I am in a quiet mood, I don't speak of it; but when they want to force me to go to church or attach value to doing so, it is only natural that I tell them, This is out of the question. . . . (Letter 169)

The alienation between Vincent and his parents grew more poignant and bitter—to Vincent's pained recognition. He wrote Theo from the Hague:

Since last summer it has become clear to me that the disharmony between Father, Mother and myself has become a chronic evil because there has been misunderstanding and estrangement between us for too long a time. And now it has gone so far that we must suffer for it on both sides. . . . Now I have become little more than a half strange, half tiresome person to Father and Mother; and for my part, when I'm at home, I also have a lonesome, empty feeling. Opinions and professions differ so much that we unintentionally annoy each other, but I repeat,

it is quite *involuntary*. This is a very sad feeling, but life and the world are full of such unsatisfactory relationships, and it really does more harm than good to reproach each other—sometimes the best thing to do in such a case is to avoid each other. But I don't know what's best; I wish I did. (Letter 187)

Later he again complained:

> Just think, Theo, how different things might have been at home, for instance, if Father could have been less distrustful of me, a bit less suspicious; if, instead of considering me a person who could only do wrong, he had shown more patience and good will in order to understand my real intentions—in which he has always been sorely mistaken. In the first place, he would have felt less grief on my account, and would have been easier in his mind about me; and in the second place, he would have spared me much sorrow. For it is a great sorrow to think, This is worse than having no home at all, no father, no mother, no relations—and I have often thought so, as I do now. (Letter 201)

The deepest bitterness, that his father and mother would never understand him, retained its force:

> They will never be able to understand what painting is. They cannot understand that the figure of a laborer—some furrows in a ploughed field—a bit of sand, sea, and sky—are serious subjects, so difficult, but at the same time so beautiful, that it is indeed worth while to devote one's life to expressing the poetry hidden in them. . . . Well, I dare not allow myself any illusions, and I am afraid that Father and Mother may never really appreciate my art. This is not surprising, and it is not their fault; they have not learned to look at things as you and I have learned to look at them. They look at different things than we do; we do not see the same things with the same eyes, nor do the same thoughts occur to us. It is permissible to wish this were otherwise, but in my opinion it is not wise to expect it. (Letter 226)

After this, Vincent adopted the practice of signing his works with his Christian name only—his way of declaring his distance from his family and his rejection of them as he felt they had rejected him. To Theo he wrote: "Look, brother, in my opinion Father is forever lapsing into *narrow*-mindedness, instead of being bigger, more liberal, broader and more humane. It was clergyman's vanity that carried things to extremes . . . and it is still that same clergyman's vanity which will cause more disasters now and in the future. . . . In character I am rather different from the various members of the family, and essentially I am *not* a Van Gogh" (Letter 345a).

In the Bosom of the Family

In the wake of the bitter disappointment and depression of the Sien affair, in December 1883, Vincent rejoined his family at Nuenen, where he stayed for roughly the next two years. But they were troubled and conflict-ridden years. His father still could not forgive his odd behavior, and Vincent's attitude toward his father was almost totally antagonistic (Letter 348). Now situated in the poorest of parishes, Theodorus hardly cut an admirable figure. He was barely able to cope and make ends meet. After some weeks of tension, a truce was arranged between father and son that made it more possible for them to live under the same roof. It was agreed that Theodorus and the rest of the family would not pester him about his peculiarities in dress and behavior. It was also arranged that he could use the shed in the garden behind the parsonage as his studio.

But father and son soon started quarreling again. Meals at the parsonage must have been quite a scene. Vincent would not sit at the table with the rest of the family but ate crouching in a corner. He did not join in the general conversation, but if the subject turned to literature or art he would burst in suddenly with some argumentative or attacking point. He was regarded as a good-for-nothing, a failure, an eccentric, and people generally stayed out of his way. Vincent complained to Theo:

> I am sick at heart about the fact that, coming back after two years' absence, the welcome home was kind and cordial in every respect, but basically there has been no change whatever, not the slightest, in what I must call the most extreme blindness and ignorance as to the insight into our mutual position. And I again feel almost unbearably disturbed and perplexed. . . . Instead of a ready understanding and a certain eager contribution to my, and indirectly their own, well-being, I feel in everything a hesitation and delay which paralyze my own ardor and energy like a leaden atmosphere. . . . (Letter 345)

In the following letter, he went on:

> I feel what Father and Mother think of me instinctively (I do not say intelligently). They feel the same dread of taking me in as they would about taking a big rough dog. He would run into the room with wet paws—and he is so rough. He will be in everybody's way. And he barks so loud. In short, he is a foul beast. The dog feels that if they kept him, it would only be tolerating him in 'this house'. All right—but the beast has a human history, and though only a dog, he has a human soul, and even a very sensitive one, that makes him feel what people think of him, which an ordinary dog cannot do. And I, admitting that I am a kind of dog, leave them alone. Also this house is too good for me, and Father and Mother and the family are so terribly genteel (not sensitive underneath, however), and—and—and they are clergymen—a lot of clergymen. The dog feels that if they keep him, it will only mean putting up with him and tolerating him "in

this house," and so he will try to find another kennel. The dog is in fact Father's son, and has been left rather too much in the streets, where he could not but become rougher and rougher; but as Father already forgot this years ago, and in reality has never meditated deeply on the meaning of the tie between father and son, one need not mention that. And then—the dog might bite—he might become rabid, and the constable would have to come to shoot him. . . . I begin by saying, I think it noble of you that, thinking I hurt Father, you take his part, and give me a good scolding. I appreciate this in you, though you are fighting against one who is neither Father's nor your own enemy, . . . There is a desire for peace and reconciliation in Father and in you and in me. And yet we do not seem able to bring about peace. . . . I wish it could happen still, but you people do not understand me, and I am afraid you never will. (Letter 346)

Vincent was discouraged and his outlook seemed hopeless. He complained to Theo: "The shaggy shepherd dog which I tried to describe to you in yesterday's letter is my character, and the life of that animal is my life I am getting to be like a dog, I feel that the future will probably make me more ugly and rough, and I foresee that 'a certain poverty' will be my fate, but, but I shall be a painter. . . . I tell you, I consciously chose the dog's path through life; I will remain a dog, I shall be poor, I shall be a painter, I want to remain human—going into nature" (Letter 388).

The Pastor's Death
Quite unexpectedly, Theodorus dropped dead one afternoon after coming home from a walk. He was laid to rest in the parish graveyard near the abandoned church tower. To the end he lamented Vincent's lack of success. But Vincent seemed to be little affected; his letters hardly mention his father's death. He had cut many of the emotional ties to his family. He had renounced his inheritance and his relations with the rest of his family were a shambles (Letters 205 and R54). Theo remained the sole exception.

About this time, Vincent wrote to his friend Rappard:

I have had . . . trouble for a great number of years with a great number of people. When I protested against it once in a while and said that I didn't deserve it, things got worse and worse, and they wouldn't listen to another word about it. My parents and my whole family, Tersteeg, and along with him a lot of fellows who knew me when I was with Goupil & Co., went so far in their disapproval of all my doings that these last years, instead of wasting any more time on attempts to convince them, I, who have no time to waste, have simply given them the cold shoulder in my turn—and let them say, think, do whatever they like without minding it the least little bit. . . . As regards my family—on the occasion of my father's death, realizing that my difference of opinion with him would probably have been perpetual, I simply said—for the sake of clarity—that my views about practical matters and my way of life differed too much from theirs to enable us to come to a lasting agreement. That I absolutely insisted on

behaving according to my own views, however strictly on my own. And that I relinquished my share in the inheritance; inasmuch as during the last years I had lived in great discord with my father, I felt I did not have a right to anything that was his, and for that matter I did not covet it. (Letter R54)

In a sense, Vincent had stripped himself of all human attachments—with the single exception of his symbiotic and life-sustaining connection with Theo. On all other fronts, women, family, and to a great extent even his artistic colleagues, he was a stranger, an outcast, alienated and alone. There was little left for him in life except his art, and to that he gave himself wholely and without reserve.

Chapter IV
THEO

The Letters
Most of what we know about Vincent comes from the endless stream of letters he addressed to Theo: some 652 have been preserved, covering an 18-year period from August 1872 until July 1890. The last unfinished letter was found crumpled in Vincent's pocket after his suicide. Theo was in fact the primary object of Vincent's effort at self-communication. To Theo he poured out his heart, his hopes, his frustrations and disappointments, his self-doubts, his tormented struggles to become an artist, his ruminations about art and artists, his at times inspired reflections on art, love, the meaning of life, nature and God. And in a sense Vincent's paintings were also communications to Theo—

> Theo was his artistic brother's public. To view the letters as a handy commentary on the paintings will thus not do. It was only in his parallel activities of writing and painting, both of them addressed to a single person, Theo, that Vincent van Gogh saw significance in his own existence. Only there did he see himself as active, useful, and productive of things of value. And this is why his confessions (it is the aptest word for his paintings and letters alike) are so highly charged with emotion. (Walther and Metzger 1990, p. 26)

In the Family
In their early years, the two brothers occupied quite different positions in the family. While Vincent became the outcast, the intruder, the "black sheep," Theo was a favorite of his parents: he was compliant, obedient, more or less conventional, and certainly did nothing to flout his parents' wishes and expectations. He it was who took up the opportunity presented by his uncle's position in the Goupil firm. He was moderately successful in this career and made it his life's work. The differences between himself and his brother, particularly with regard to their relationships with their parents, were a painful matter for Vincent.

Vincent had inherited a name that was weighty with reverence and expectation; perhaps his name was the symbol of the heavy burden of narcissistic expectation that was embedded in the family mythology, centering around the prominent role in the family history of his grandfather Vincent and his uncle Vincent, both outstanding in the family history for their success—one in religion, the other in the art world. These narcissistic currents would have been channeled through the investments in the idealized image of the dead

Vincent and come to rest on the living Vincent's head. Theo, on the other hand, was named after his father.

We can wonder what dynamic configurations may have taken shape behind these names. Agger (1988) has noted: "Pathological family systems often are built on the use of splitting and projective identifications in which each child may represent a sibling from the parent's past (or for each parent a different sibling) and be subtly induced into playing sibling roles reminiscent of a previous generation. The inducement is powerful since the child develops according to the patterns that will garner approval and need satisfaction from early significant others" (p. 13).

We do not have the necessary material to trace these patterns of introjection and projection as they might have played themselves out in relation to the two brothers in the family matrix. There seems little question, however, that Vincent became the family scapegoat, the repository for negative, devalued, and hostile projections (Meissner 1978b). The splitting process placed him in this black-sheep position and, correspondingly, Theo was placed in the positive role. This became more apparent as Theo's fortunes rose while Vincent's were tumbling. A decisive event was the death of Cent, Vincent's wealthy art dealer uncle and namesake. The early expectation was that Vincent would succeed his uncle in the prosperous art trade, but that anticipation had been soundly defeated. Cent's will left nothing to Vincent and treated Theo handsomely. Theo must have felt the arrangement unfair since he sent an additional sum of money to Vincent, enabling him to set up the "yellow house" in Arles.

Vincent's resentment against his sibling rival was poorly concealed. He would often appeal to Theo to intercede for him with their parents, obviously recognizing Theo's privileged position. But he also resented the fact that Theo was favored by their father. In addition to this good-bad split in the family system, the persistence of the dead Vincent theme played a role as well. Vincent's failure to conform to the exalted standard of the dead and idealized Vincent opened the way for Theo's relative success. Theo escaped the narcissistic burden imposed by the dead Vincent and whatever projective onus came with it. Vincent's own hostile and murderous wishes may then have been transferred to Theo—impulses that he would have had to repress and to a degree successfully countered by concern for Theo's health and other reaction formations.

But the dead brother theme may have played a part in the relationship of the living brothers in another way. If Vincent's early psychic world had been dominated by the shadow of the dead brother, the entrance on the scene of the next brother may have represented a revivification, or another version, of threat to Vincent's narcissistic position—a reaction not at all unexpected in a

four-year-old in Vincent's position. This variation on the theme will play a possibly decisive role in their adult relations. But to the extent that Theo had stepped into the psychic niche of the dead Vincent in his brother's unconscious mind, the basic envy that permeated the association to the dead brother must have affected Vincent's relation to Theo. Theo was a usurper who had stolen the love and acknowledgment of their parents, and to Vincent's unconscious mind Theo owed him reparations. In some sense, Vincent felt entitled to the help and concern that Theo provided.

Mutual Dependence

In moments of deepest despair and crisis, Vincent invariably turned to Theo for support and consolation. After the failure of his religious mission, Vincent went through a period of depression and profound isolation. When he emerged from this crisis, all intimate ties with his family were broken. He determined that art was to be his life. Theo must have received the news with consternation—Vincent was charging off on another tangent for which he was without background or training. By that time Theo knew the art world well, its risks and dangers, and the importance of schools, styles and salons. He tried to warn Vincent, but to no avail; Vincent had set himself on his determined course. Theo could only try to do what he could help his wayward brother on his perilous journey.

Art, painting, and books became Vincent's life; any and all attachments were replaced by his painting. He had lost faith, had no friends and no prospects. The bond with Theo became even more intense and mutually dependent. Vincent wrote:

> Now, all jesting aside, I really think it would be better if the relation between us became more friendly on both sides. If I had to believe that I were troublesome to you or to the people at home, or were in your way, of no good to anyone, and if I should be obliged to feel like an intruder or an outcast, so that I were better off dead, and if I should have to try to keep out of your way more and more—if I thought this were really the case, a feeling of anguish would overwhelm me, and I should have to struggle against despair If it were indeed so, then I might wish that I had not much longer to live. (Letter 132)

Jacob Replaces Esau

Vincent himself referred to his father's comparison of the twinship relation between himself and his brother to the biblical prototype of the relation between Esau and Jacob (Letter 338). Esau, the older twin, was rough and hairy, a man of the fields, while Jacob the younger was more refined, quieter, a man who dwelt in tents. The Genesis 25–27 story is one of the displacement of Esau from his birthright and the usurpation of this privileged position

by the younger Jacob. The stealing of the blessing and birthright of the father Isaac is engineered by Rebecca the mother. As a result, Esau is disenfranchised and excluded from the chosen people. Isaac's curse on his elder son was, "Far from the richness of the earth shall be your dwelling-place, far from the dew that falls from heaven" (Gen 27: 39). Of the two brothers, Vincent was the rough and hairy one, Theo the milder and more subservient to their parents' wishes. After his father's death, Vincent had renounced his inheritance, sent his father's Bible to Theo, and moved out of the parsonage (Letters 411a and 430). His birthright had passed to Theo, the Jacob of the piece (Edwards 1989).

Theo was enjoying considerable success in Paris as an art dealer, and increasingly assumed the position of the stable, reliable, and responsible son. His position in the family was strengthened not only by his success and earning power but by the fact that around this time Theodorus seems to have washed his hands of Vincent and turned the case over to Theo to manage. No doubt the charge of laziness or idleness had been thrown in his face by his father and uncle, if not by his mother as well. Vincent seemed to have been somewhat sensitive about Theo's opinion of him, particularly about his dissolute and vagrant life style:

I should be very glad if you could see in me something more than an idle fellow. Because there are two kinds of idleness, which are a great contrast to each other. There is the man who is idle from laziness and from lack of character, from the baseness of his nature. If you like, you may take me for such a one. On the other hand, there is the idle man who is idle in spite of himself, who is inwardly consumed by a great longing for action but does nothing, because it is impossible for him to do anything, because he seems to be imprisoned in some cage, because he does not possess what he needs to become productive, because circumstances bring him inevitably to that point. Such a man does not always know what he could do, but he instinctively feels, I am good for something, my life has a purpose after all, I know that I could be quite a different man! How can I be useful, of what service can I be? There is something inside of me, what can it be? This is quite a different kind of idle man; if you like, you may take me for such a one!

A caged bird in spring knows quite well that he might serve some end; he is well aware that there is something for him to do, but he cannot do it. What is it? He does not quite remember. Then some vague ideas occur to him, and he says to himself, "The others build their nests and lay their eggs and bring up their little ones"; and he knocks his head against the bars of the cage. But the cage remains, and the bird is maddened by anguish. "Look at that lazy animal," says another bird passing, "he seems to be living at ease."

Yes, the prisoner lives, he does not die; there are no outward signs of what passes within him—his health is good, he is more or less gay when the sun shines. But then the season of migration comes, and attacks of melancholia—"But he has everything he wants," say the children that tend him in his cage. He

looks through the bars at the overcast sky where a thunderstorm is gathering, and inwardly he rebels against his fate. "I am caged, I am caged, and you tell me I do not want anything, fools! You think I have everything I need! Oh! I beseech you liberty, that I may be a bird like other birds!"

A certain idle man resembles this idle bird. And circumstances often prevent men from doing things, prisoners in I do not know what horrible, horrible, most horrible cage. There is also—I know it—the deliverance, the tardy deliverance. A justly or unjustly ruined reputation, poverty, unavoidable circumstances, adversity—that is what makes men prisoners. One cannot always tell what it is that keeps us shut in, confines us, seems to bury us; nevertheless, one feels certain barriers, certain gates, certain walls. Is all this imagination, fantasy? I don't think so. And one asks, "My God! is it for long, is it forever, is it for all eternity?" (Letter 133)

The way out of the emptiness and loneliness of this prison was human contact and affection: "Do you know what frees one from this captivity? It is every deep, serious affection. Being friends, being brothers, love, that is what opens the prison by some supreme power, by some magic force. Without this, one remains in prison. Where sympathy is renewed, life is restored. And the prison is also called prejudice, misunderstanding, fatal ignorance of one thing or another, distrust, false shame. . . . But I should be very glad if it were possible for you to see me as something more than an idle man of the worst type" (Letter 133).

A Special Relationship

Through it all, Theo continued to send whatever money he could. His own fortunes were on the rise—he advanced quickly in the company, was put in charge of a small gallery in Montmartre, and soon became the advocate of young artists who would become the artists of the future. It is not clear that he counted Vincent among this number. Nonetheless, Theo was unfailingly supportive, encouraging, and solicitous. That Vincent could maintain this special relationship with Theo is striking, especially since he seemed unable to stay on good terms with anyone else for any consistent period of time. As we shall see, the relation to Theo was not without ambivalence, but overall the tone remained positive and affectionate. Credit must go to Theo for sustaining the relationship. His kindness, consideration, thoughtfulness, and above all patience come through as important contributing factors. Hardly anyone else in Vincent's world could put up with his peculiarities and petulance. And Vincent acknowledged his debt, "Know it well, dear brother, how strongly and intensely I feel the enormous debt I owe you for your faithful help" (Letter 274).

It became clear that the onus of supporting Vincent would fall on Theo's shoulders. Theo had his own difficulties, particularly his tendency to periodic

melancholic moods that immobilized him. Although their temperaments were so diametrically opposed, they had formed a bond that linked their fates with ironclad determinism. Theo gradually assumed a position of respect and influence in the Parisian art world. He was aware before many of his contemporaries of the new Impressionist movement. His eyes were opened at the Fourth Impressionist Exhibition in 1879 when the impressionist revolution came into its own. He came to know the works of Pissarro, Cezanne, Gauguin and Seurat.

Tensions

The relationship between the brothers was not without its tensions. In the crisis that arose during his stay with the family in Nuenen, Vincent was angry and resentful not only at the rest of his family, but also with Theo for not supporting him in the argument with his father. But Vincent's dependence on Theo was a matter of life-and-death. He wrote to Theo expressing his anxieties about the monthly allowance he received, "To me it means models, studio, bread; cutting it down would be something like choking and drowning me. I mean, I can do as little without it now as I can do without air" (Letter 288). Paying for his art supplies and models, in addition to the expenses incurred in supporting Sien and her children, ran well beyond the amount Theo sent. And Vincent had no other source of income. When word came that Theo was having difficulties at Goupil's, he was stunned and terrified. Tension had arisen between Theo and the senior partners, presumably over Theo's ambitious plans for opening his department to more adventuresome forms of art—the Impressionists, for example. Theo was unhappy and talked of leaving Goupil's, perhaps starting his own business, perhaps throwing it all up and going to New York to seek his fortune. All this plunged Vincent into despair. Was he to be abandoned? Who would support him? Was the alternative to return to his parents at Nuenen, with all its difficulties?

Vincent even accused Theo of trying to manipulate him into living a more conforming and conventional life by using money as a control. He rebelled against his economic dependence and passivity, accused Theo of doing nothing to sell his work, and complained about the subtle pressure he felt Theo exerted on him. Caught up in their mutual and interacting transferences, Vincent and Theo played out the mutually sustaining roles of victim and victimizer (Meissner 1978b, 1986). Vincent played his part in the demanding, sadistic role, castigating Theo for not understanding him and for depriving him of the money he felt he was due. On receiving a delayed check for 150 francs, Vincent proclaimed indignantly, "Am I less than your creditors?—who must wait, they or I???" (Letter 443). His demands were at times petulant and querulous—each letter seemed to bring new requests. At one time

Theo tried to hold the line since complying with Vincent's demands would have strained his resources. But Vincent responded with a hardly veiled threat of suicide that Theo could not resist. Matters improved as Theo's differences with his employers seemed to fade.

It was Vincent's view that Theo should endure privation in order to support Vincent in his noble mission. He seems to have had little consideration of the burden imposed on Theo to continually supply his brother with money—money that Theo himself could have put to good use—although Vincent also worried that Theo might tire of the burden (Letter 257). We can guess that Vincent resented his brother's relative success and that his recriminations and demands were a way redressing old scores between the black sheep and the favored son, between Jacob and Esau. Theo, in his turn, tried to reprimand Vincent for his wayward ways—an echo or extension of the complaints of their parents against Vincent's eccentricities and deviant behavior. The Sien affair brought the latent antagonism between the two brothers close to eruption. But the tie between them was too strong, too necessary for both of them, to allow that to happen. For his part, Theo remained solicitous and reassuring, trying to relieve Vincent of his anxieties about money and his difficulties in selling his paintings.

To a degree, Vincent held it against his brother that his relations with the family had been so difficult—Theo was the personification of that respectability and conventionality that Vincent so envied and despised. He wrote in 1884, commenting on Delacroix's famous *Liberty in the Barricades*, that if they had been caught up in that revolution they would have found themselves on opposites sides of the barricades—

> And both remaining consistent, with a certain melancholy, we might have confronted each other as direct enemies, for instance on such a barricade, you before it as a soldier of the government, I behind it, as a revolutionary or rebel. . . . we are again confronting each other, though there are no barricades now. . . . And in my opinion it cannot be helped that we are in different camps opposed to each other. And whether we like it or not, *you* must go on, \underline{I} must go on. But as we are brothers, let us avoid killing each other. . . . No, if we should come near each other, we should be within each others range. *My* sneers are bullets, not aimed at you who are my brother, but in general at the party to which you belong once and for all. Nor do I consider *your* sneers aimed expressly at me, but *you fire* at the barricade and think to gain merit by it, and I happen to be there. (Letter 379)

The Rebellious Outcast

Vincent finally dropped out of the art academy in Antwerp and continued to struggle alone with his painting. His difficulties in the academy reflect his recurrent conflicts with authority figures of all kinds: with his bosses in his

various unsuccessful employments, with his religious superiors, with his teachers, even—or especially—with those who tried to teach him something about art. He suffered from a not uncommon authoritarian conflict—wishing desperately for approval and acceptance from those who were placed over him in whatever capacity, yet at the same time feeling the need to rebel against them and to deny his inner sense of vulnerability, weakness, and dependence. This paradoxical conflict between submission and defiance is a common configuration in patients with paranoid tendencies (Meissner 1978b).

He continued to live in the slums, surrounded by tramps, thieves and whores. His identification with the unfortunate, the poor, and the downtrodden of the earth nourished his rebellious individualism. He resisted formal education because it meant submission to the tyranny of discipline and the need to abide by conventional rules and regulations. Behind all these authority figures we can sense the image of Vincent's father. These conflicts and the repeated pattern of obstinacy and rebellion reflect Vincent's intense ambivalence in relation to his father—compounded of worshipful idealization and yearning for closeness and approval on one side, and hurt resentment and rageful hatred and rejection on the other.

Vincent had alienated himself from almost everyone he knew. Theo alone remained a constant fixture, his consistent and enduring significant other. Even this relationship was marked by ambivalence. But Vincent had no where else to turn. Despite the resistance and delays on Theo's part, Vincent finally left abruptly for Paris where he arrived on February 28, 1886.

Paris

Straightway he moved into Theo's small apartment. Theo quickly realized the desperate straits Vincent was in. His clothes were filthy and tattered, and his physical condition deplorable, the result of malnutrition, self-deprivation, and denial. Years of self-neglect had brought him to the brink of physical and mental collapse. Theo immediately took him to the doctor and began to repair his health. Soon the brothers moved into a larger apartment. Vincent's health improved, he became almost robust, his disposition brightened for the time being, and he applied himself with great energy to his work. Optimism was in the air. Theo wrote to their mother in June 1886:

> We are fortunately all right in our new apartment. You wouldn't recognize Vincent, so much he has changed, and it strikes others even more than me. He has had a major operation to his mouth, for he had nearly lost all his teeth as a result of the bad state of his stomach. . . . He is progressing tremendously in his work and this is proved by the fact that he is becoming successful. He has not yet sold paintings for money, but is exchanging his work for other pictures. In that way we obtain a fine collection which, of course, also has a certain value. . . . He is

also much more cheerful than in the past and people like him here. To give you proof: hardly a day passes [that] he is asked to come to the studios of well-known painters, or they come to see him. . . . If they are able to keep it up I think his difficult times are over and he will be able to make it by himself. . . . (Cited in Stein (1986), p. 105; also Letter T1a).

In the Art World

For the first time, Vincent had an opportunity to meet and exchange ideas with other artists of first rank. His closest association at the time was with Emile Bernard and Henri Toulouse-Lautrec, both young and struggling artists, yet to make a significant mark on the world of art. He also studied the work of Pissarro, Gauguin, Seurat, and the impressionists. There was a weekly gathering of avant-garde artists at Lautrec's studio to discuss and compare their work. Suzanne Valadon described Vincent in these meetings: "He would arrive carrying a heavy canvas under his arm, which he would place in a well-lighted corner, and wait for someone to notice him. No one was in the least concerned. He would sit down opposite his work, surveying the others' glances and sharing little of the conversation. Finally wearying, he would depart carrying his latest example of his work. Nevertheless, the following week he would return and commence the same stratagem again" (Cited in Sweetman 1990, p. 233).

Obstinate individualist that he was, Vincent nonetheless began somewhere in this period to evolve a dream of a community of artists who would provide one another with a sense of community and support. In particular, he and Gauguin discussed the possibility of joining forces in some form of artistic community. The members of this fellowship of artists could share the terrible responsibilities of the artist's vocation; together they could keep despair and frustration at bay by mutual support and the exchange of feelings and ideas. This was Vincent's utopia—an illusion never to be realized.

Problems

If things improved for a time for Vincent, the same could not be said for Theo. His health was precarious at best, since he was probably suffering from syphilis, and Vincent imposed a considerable burden on him. To his friends he started to look more and more burdened and ill. Andries Bonger, Theo's close friend and after 1889 his brother-in-law, noted the signs of strain. He wrote, "Theo is still looking frightfully ill; he literally has no face left at all. The poor fellow has many cares. On top of everything, his brother is making life rather a burden to him, and reproaches him with all kinds of things of which he is quite innocent" (Letter 462a). Vincent was messy, argumentative, demanding, and hostilely dependent—a combination calculated to strain any relationship. Jo, later Theo's wife, commented that the greatest

sacrifice Theo ever made for his brother was living with him these two years (van Gogh-Bonger 1959).

While Paris provided a source of enrichment for Vincent's artistic work, it brought problems in other areas. It was in this period that he began to drink more heavily. The companionship of Lautrec and other alcoholic friends did not help matters. Vincent's opinionated and argumentative disposition intensified, leading to a number of fights at the Café Tambourin, where he liked to hang out. The proprietress, Agostina Segatori, befriended Vincent and in time became his mistress. The relationship was never more than casual, but Vincent probably had her to thank for contracting syphilis—an affliction that was never treated and probably played a role in his eventual deterioration and psychotic collapse. Among his fellow artists, he was regarded as a difficult, stubborn and at times a frightening character. The few friendships he had were soon tested to the breaking point by his argumentativeness, his unbending opinions, and his harsh and critical attitudes toward the work of other artists.

In a letter from Theo to his brother Cor in March (11 March 1887) we begin to hear the strains of discontent:

> Vincent continues his studies and he works with talent. But it is a pity that he has so much difficulty with his character, for in the long run it is quite impossible to get on with him. When he came here last year he was difficult, it is true, but I thought I could see some progress. But now he is his old self again and he won't listen to reason. That does not make it too pleasant here and I hope for improvement. It will come, but it is a pity for him, for if we had worked together it would have been better for both of us. . . . (Cited in Stein (1986), p. 106)

By the time Theo sat down to write another letter to his sister Wil (14 March 1887), the breach had been made:

> It is certain that he is an artist and what he makes now may sometimes not be beautiful, but it will surely be of use to him later and then it may possibly be sublime and it would be a shame if one kept him from his regular studies. However impractical he may be, when he becomes more skillful the day will undoubtedly come when he will start to begin selling. You should not think either that the money side worries me most. It is mostly the idea that we sympathize so little any more. There was a time when I loved Vincent a lot and he was my best friend, but that is over now. It seems to be even worse from his side, for he never loses an opportunity to show me that he despises me and that I revolt him. That makes the situation at home almost unbearable. Nobody wants to come and see me, for that always leads to reproaches and he is also so dirty and untidy that the household looks far from attractive. All I hope is that he will go and live by himself and he has talked about this for a long time, for if I told him to leave that would only give him a reason to stay on. Since I cannot do any

good for him I only ask for one thing, and that is that he won't do any harm to me and that is what he does by staying, for it weighs heavily on me. It appears as if there are two different beings in him, the one marvelously gifted, fine and delicate, and the other selfish and heartless. They appear alternately so that one hears him talk now this way and then that way and always with arguments to prove pro and contra. It is a pity that he is his own enemy, for he makes life difficult not only for others but also for himself. I have firmly decided to continue as I have done up to now, but I hope that for some reason or other he will move to other quarters and I will do my best for that. Now, dear sister, you will say what a litany. Don't talk about it too much. . . . (Cited in Stein (1986), p. 106-107)

Under this kind of strain, the relationship between the brothers suffered. Vincent grew more and more irritated by Theo's quiet and orderly life, his conventionality and bourgeois life style. Arguments erupted. Vincent was too uncompromising, too unconventional, too impatient with the trivial concessions and pretenses of everyday life. Alcohol and absinthe did not help matters. Sober Vincent could be difficult, but drunk he became impossible. He would come home from his drinking bouts and accost Theo in bed, sitting there for hours haranguing him about art, his need for money, the difficulties in selling his work, and on and on. He grew more irascible and eccentric in his behavior. Despite advice and urging from many sides that he put Vincent out and let him make his own way, Theo did not have the heart to do it. He was trapped by his own ambivalence; he could not bring himself to force the issue.

A month later (25 April 1887), he wrote again to Wil:

A lot has changed since I wrote you last. We have made peace, for it didn't do anybody any good to continue in that way. I hope it will last. So there will be no change and I am glad. It would have been strange for me to live alone again and he would not have gained anything either. I asked him to stay. That will seem strange after all I wrote you recently, but it is no weakness on my side and as I feel much stronger than this winter, I am confident that I will be able to create an improvement in our relationship. We have drifted apart enough [so] that it would [not] serve any purpose to make the rift any larger. . . . (Cited in Stein (1986), p. 107)

Separation

Nonetheless, events reached a breaking point, and Vincent did move out. The depth of Theo's attachment to his brother is suggested in a letter to sister Wil (24 February 1887):

When he came here two years ago I had not expected that we would become so much attached to each other, for now that I am alone in the apartment there is a decided emptiness about me. If I can find someone I will take him in, but it is

not easy to replace someone like Vincent. It is unbelievable how much he knows and what a sane view he has of the world. If he has still some years to live I am certain that he will make a name for himself. Through him I got to know many painters who regarded him very highly. He is one of the avant-garde for new ideas, that is to say . . . for the regeneration of the old ideas which through routine have been diluted and worn out. In addition he has such a big heart that he always tries to do something for others. It's a pity for those who cannot or refuse to understand him. . . . (Cited in Stein (1986), p. 107)

The hostile and sadistic elements in their relationship—always a subtle but minor countermelody in the background of their interaction—came more to the fore. Vincent's continued dependence on his brother was a sore point. From Theo's side, Vincent was a burden, always demanding more money that Theo could ill afford. And Vincent could be quite entitled and demanding, always wanting things on his terms, often showing little regard for Theo's difficulties or circumstances. Theo felt he had to show constant tolerance and understanding for Vincent's eccentric views and difficulties—at least to remain sympathetic to Vincent's agonized appeals and demands. Anything short of unconditional acceptance and support would draw angry accusations and recriminations from Vincent. Somehow Theo's patience and concern remained steadfast.

But the strain could only increase. How much more could Theo tolerate? There was no small degree of aggression and sadism in Vincent's relation to his brother. However much Vincent needed and depended on Theo for both financial and emotional support, he also hated his dependency. His resentment and frustrated rage would all too often erupt. For Theo this must have been a trial—constantly at the beck and call of Vincent's needs, putting up with his peculiar ways and manners, his argumentativeness and rudeness to Theo's friends, his filthy and disorderly habits. When Vincent treated others in this manner, they were quick to ostracize or avoid him. But not Theo, who seemed capable of infinite patience and unfailing support. Theo must have had to struggle with his own ambivalence toward Vincent. Andries Bonger recounted afterward:

However tied to each other Vincent and Theo were, and even though one could not do without the other, they were never able to live together. At the end of eight days Vincent would begin interminable discussions about Impressionism, during which he would touch on all possible subjects. One day, Theo, exasperated, left the house and swore that he would only return when Vincent had a place to himself. Shortly thereafter, Vincent left for the South. Vincent was a stimulant for Theo in his work, but there was no question of collaboration between them. Vincent always wanted to dominate his brother. Theo often violently opposed Vincent's theories. (Cited in Stein (1986), p. 105)

As the difficulties mounted in Paris, Vincent more and more felt that he had to escape. He realized how difficult he was making life for Theo, and his relationships with many of his friends and fellow artists had deteriorated as well. His obsession with the idea of founding a colony of artists consumed him and his dream of a 'Midi Studio' turned his desires to the South, to the Midi that Toulouse-Lautrec had described in such glowing terms. He decided to stake everything on this one last ray of hope; nothing, he thought, was impossible to those who shared the same passionate vision. He abruptly left Paris for Provence.

When he arrived in Arles, on 21 February 1888, he was on the verge of a breakdown, an alcoholic with unsteady nerves. The decision had a life-and-death quality. He had two-and-a-half years left.

The Secret Sharer

Theo played a unique and extremely important role in Vincent's psychic life. But there was more to their symbiotic attachment. Without question Theo helped make Vincent's artistic mission possible and thus postponed the inevitable suicide (Gedo 1983). It is easy to overstate the case—there would be little argument about Theo's encouragement and financial support, but beyond that lies the further unconscious emotional bond that lies closer to the unconscious roots of the forces that were distilled into Vincent's art. Moreover this dynamic does not stand alone—if it had a contributory role in Vincent's creative life, it was not the only influence and must be measured against other contending factors.

Vincent had written, "If I were without your friendship, they would remorselessly drive me to suicide, and however cowardly I am, I should end by doing it" (Letter 588). Vincent would write again from the asylum at St. Remy:

> Old man—don't let's forget that the little emotions are the great captains of our lives, and that we obey them without knowing it. If it is still hard for me to take courage again in spite of faults committed, and to be committed, which must be my cure, don't forget henceforth that neither our spleen nor our melancholy, nor yet our feelings of good nature or common sense, are our sole guides, and above all not our final protection, that if you too find yourself faced with heavy responsibilities to be risked if not undertaken, honestly, don't lets be too much concerned about each other, since it so happens that the circumstances of living in a state so far removed from our youthful conceptions of an artist's life must make us brothers in spite of everything, as we are in so many ways companions in fate. (Letter 603)

If the first Vincent was a dead double, Theo served as a living double—Vincent's *alter ego*, his *dimidium animae*, his second self. They remained

closely attached throughout their lives. Theo alone of the family had any sense of Vincent's genius and devoted himself to helping Vincent in whatever way he could—usually in the form of money that at least kept Vincent alive for most of his life as an artist. He told Theo that their relationship meant more to him than words could express. He complained: "How often have we longed to be together, and how dreadful the feeling of being far from each other is in times of illness or care—as we felt it, for instance, during your illness—and then the feeling that want of money might be an obstacle to coming together if it would be necessary" (Letter 83). They spent a day together in Amsterdam, after which Vincent wrote:

> I want you to have a letter from me on your journey. What a pleasant day we spent in Amsterdam; I stood watching your train until it was out of sight. We are such old friends already—how many walks have we taken together since the time at Zundert in the black fields with the young green wheat, where walking with Father at this time of year, we heard the lark singing? (Letter 89)

And a few days later: "It is an old truth that the love between brothers is a strong support through life; let us seek that support. May experience strengthen the bond between us, let us be true and outspoken toward each other, and let us not have any secrets—just as it is now" (Letter 90).

After a visit from Theo, he wrote:

> When I saw you again and walked with you, I had the same feeling which I used to have more than I do now—as if life were something good and precious which one must value; and I felt more cheerful and alive than I have for a long time, because gradually life has become less precious, much more unimportant and indifferent to me—at least it seemed so. When one lives with others and is united by a feeling of affection, one is aware of a reason for living and perceives that one is not quite worthless and superfluous, but perhaps good for something: we need each other and make the same journey as traveling companions, but the feeling of proper self-esteem also depends very much on our relations with others. . . . I tell you this to let you know how much good your visit had done me. (Letter 132)

Vincent made Theo a partner in his work, as though his painting was the product of their partnership rather than Vincent's own effort. He wrote: "The future would seem brighter if I were less awkward in my dealings with people. Without you, finding buyers for my work would be almost impossible; with you, it will eventually be possible. And if we do our utmost, it will stand firm and not perish. But we must stick together" (Letter 305). And

> There is a bond between you and me which continuous work can only strengthen in the course of time—this is art, and I hope we shall continue to understand

each other after all. . . . Well, let nature simply follow its own course in this—you will become what you must, I too will not remain exactly the same as I am now; let's not suspect each other of absurd things and we shall get on together. And let's not forget that we have known each other from childhood, and that thousands of other things can bring us more and more together. (Letter 312)

And somewhat later, he wrote from Arles: "At present I do not think my pictures worthy of the advantages I have received from you. But once they are worthy, I swear that you will have created them as much as I, and that we are making them together" (Letter 538). By 1884 the brothers had struck a deal. That February Vincent began to match the flow of money from his brother with paintings—everything he produced was sent to Paris and became, as far as Vincent was concerned, Theo's. Theo, in turn, saw himself as a sort of steward of a valuable treasure rather than its owner.

Vincent could be touchingly solicitous for his brother's welfare, repeatedly asking whether and how he could be a help to Theo in managing his difficulties. He quite consciously acknowledged his dependence on Theo:

> I could not even do a stroke of work without you, and we must not go and get excited over what the two of us manage to produce, but just smoke our pipes in peace and not torment ourselves into melancholia because we are not productive separately and with less pain. . . . But since for the moment we can do nothing to change it, let's accept this fate, that you on your part are condemned always to do business without rest or change, and that I on my part also have a job without rest, wearing enough and exhausting to the brain. I hope that within a year you will feel that between us we have produced a work of art. (Letter 555)

And again: "What makes us work on is friendship for each other, and love of nature, and finally, if one has taken all the pains to master the brush, *one cannot leave painting alone*" (Letter 612).

This partnership may have been one of the more significant contributing factors that made Vincent's artistic mission possible; he did not take his extraordinary talent or his artistic vocation seriously until he and Theo had formed their partnership (Gedo 1983). Theo became a "secret sharer,"[1] the confidant with whom Vincent could pour out his soul and share his artistic visions. The model is not uncommon among creative geniuses—the relationship between Freud and Fliess comes readily to mind. Vincent's artistic productivity was not simply his own, but the product of his symbiotic connection with Theo. The threat posed by Theo's marriage and eventually fatal illness signalled the destruction of the symbiosis that provided the psychic basis for his creativity. He was haunted by "his self-destructive need to repeat the ex-

[1] The term was coined by Bernard Meyer, describing the relation between Joseph Conrad and Ford Maddox Ford. See Meyer (?).

perience of being unjustly rejected and despised—most dramati cally enacted in his legendary encounter with Paul Gauguin in Arles" (Gedo, 1983, p. 108). Vincent's suicide can be viewed as an act of desperation and a reaction to illness, destitution and utter loneliness (Meissner, 1992b). But Gedo (1983) argues that the pact between the two brothers served to postpone the suicide and made it possible for Vincent to exercise his creativity and place it in the service of a profound religious ideal. After the pact with Theo, his passion and devotion to his art was so intense that he neglected all other human needs. But the issue may extend beyond merely the capacity to maintain creative activity; it may have to do with the ongoing struggle to gain and sustain a sense of psychic integrity and identity. Not only was Vincent's intensely dependent relationship with Theo important for preserving Vincent's artistic life, it may have had important reverberations for preserving his life itself.

Dependent Ties
In his moments of deepest despair and crisis, Vincent invariably turned to Theo for support and consolation. After the dismal failure of his religious mission, Vincent went through a period of depression and profound isolation in which he had little contact with anyone. There is little doubt that Vincent saw his brother as his lifeline—that Theo's support not only made his work as an artist possible, but saved his very life. He wrote:

> You must understand me well . . . there was a crisis at home as well as in my own life when, as I sincerely believe, all of our lives were literally *saved* by you. We have been saved from ruin by the protection and support we received from you; the situation was critical, especially for me. If I have now reached such a point that, when I stand before an object or figure, I feel within me clearly, distinctly, unhesitatingly, the power to draw it—to render it—not perfectly, but true in its general structure and proportion . . . it has been primarily because your help was a kind of fence or shield between a hostile world and myself, and because I could in all calmness think almost exclusively of my drawing, and my thoughts were not crushed by fatally overwhelming material cares. (Letter 341; see also Letter 346)

If Theo failed to answer his letters, Vincent became anxious and uneasy (Letter 342). He wrote:

> But know this, brother, that I am absolutely cut off from the outer world— except from you—so that it made me *crazy* when your letter did not come at the moment when, far from "being well off," I was very hard pressed, *though I did not mention it*, because I feel I am rather above the cares that gnaw at my heart, which torture I can perhaps explain, but do *not* consider *merited*. . . . I say loneliness and not solitude, but that loneliness—which a painter has to bear, whom

everyone in some isolated place regards as a lunatic, a murderer, a tramp. . . . Indeed, this may be a small misery, but it is a sorrow after all: A feeling of being an outcast—particularly strange and unpleasant. (Letter 343)

Theo's part in this symbiotic arrangement is more uncertain, but it is not unreasonable to think that his own survival was in some measure tied up in this relationship. Vincent may have come in time to sense this reverse dependency in his brother; after his father's death, he wrote to his mother:

Well, Theo had more self-sacrifice than I, and that is deeply rooted in his character. And after Father was no more and I came to Theo in Paris, then he became so attached to me that I understood how much he had loved Father. And now I am saying this to you, and not to him—it is a good thing that I did not stay in Paris, for we, he and I, would have become too interested in each other. And life does not exist for this, I cannot tell you how much better I think it is for him this way than in the past, he had too many tiresome business worries, and his health suffered from it. (Letter 619)

After Vincent's departure to the south, Theo's health deteriorated further.[1] Vincent's letters are full of concern and tender solicitude. He adopts at times a tone of reassuring optimism: one day he and Theo will have their reward for all the pain and toil they have endured. They are both concerned about the other's health. Vincent reproaches himself for having been such a burden to his brother, and Theo regrets that he has not done enough and not been able to do more to help Vincent. The thought that Vincent would collapse from overwork and not taking care of himself terrifies him.

The Symbiotic Equation
The notion of symbiotic attachment stems from considerations of the early infantile merger between mother and child (Mahler 1952, 1958, 1968; Mahler and Gosliner 1955; Mahler and Furer 1961; Mahler et al. 1975; Pollock 1964). The wish for fusion is based on a denial of separateness (Modell 1961), but the separation ultimately carries with it the threat of total destruction. The anxiety may reflect varying degrees and quality. As Pollock (1964) commented: "Various symbiotic relationships in their dissolution show anxieties—the precise type of anxiety and what is feared relates to the degree of self and object differentiation as well as to the specific type and level of symbiosis. Both partners of the symbiosis are necessary components of this relationship, though it may have different significance for each participant" (p. 21).

At the same time, any symbiotic relation can reflect considerable variation, both developmentally and dynamically. Generally symbiosis denotes a type of relationship that can occur at all developmental levels, can involve

various activities, needs, gratifications, or frustrations, may be total or focal, may exist for shorter or longer periods, may be continuous or interrupted, conscious or unconscious, healthy or pathogenic. Consequently, it has the potential to facilitate development and maturity, or arrest, inhibit, and distort it for one or both participants (Pollock 1964). Thus the relationship between Vincent and Theo had its own inherent qualities that reflect their history and mutual interaction.

Both brothers had experienced the same family environment which would have had its impact on them in different ways, both for good and ill. Prescinding from possible genetic influences, the family milieu was overshadowed by the stern, moralistic, calvinistic figure of Theodorus, the minister-father, and the emotionally constrained, depressive, and emotionally unavailable and unempathic Anna, their mother. It would not strain the imagination to think that the two older boys found mutual support and reinforcement in each other, especially Vincent who was caught in the throes of his position as the replacement child (Meissner 1992a). One of the major tasks of masculine development is to achieve individuation in the face of regressive infantile pulls toward dependence on and fusion with the maternal figure (Rochlin 1980). The difficulty of that struggle increases when the supportive relationship facilitating individuation—with the mother on a pregenital level and with both parents on the oedipal level—is compromised. In their individual ways, this would have been the case for both brothers, more for Vincent than Theo; but it would have impelled them together as a matter of mutual survival.

If their mutual dependence was in some sense essential for the psychic survival of each of them, there had to be limits. The course of their relationship ran into rough sledding at certain points when the ambivalence, rivalry, and respective narcissistic need of one or other of them came to the fore. As Rose (1987) observes: "It would seem that the overendowment of creative sensitivity requires affirmation; the capacity to make immediate and intuitive empathic connections is able to provide such affirmation. However, the resulting intensity of the near-merger relationship, together with its homosexual implications, may be such that periodic withdrawals or ruptures become necessary to redelineate self-boundaries and shore up the sense of separate self or identity" (pp. 19-20). Walther and Metzger (1990) add a pertinent comment:

> We have the impression that van Gogh's entire will to live is being focussed on the addressee of his letter [Theo]; at the same time, it is his need to express himself to that person which establishes his will to live in the first place. The addressee is the point to which all his melancholy, but also all his confessional courage, tends. It is a precarious balancing act, since the writer becomes exis-

tentially dependent on his sense of the reader's interest, and out of that balance arises the desire for the two to become one. (pp. 29–30)

If we can make the argument that the symbiotic dependence between the two brothers was basic to their mutual psychic survival, we can wonder the extent to which the same symbiotic connection was a contributing factor to Vincent's remarkable artistic creativity. As Rose (1987) comments: "Supportive partnerships and working alliances along the way may be necessary to sustain creative productivity. What was once invoked as a prerequisite for creative fulfillment—namely, the blessing of the heavenly Muse—commonly has its more earthly equivalents: the need for the generous patron, supportive sponsor, or, at the very least, the encouragement of a colleague—even the constancy of a forgiving spouse. Perhaps the experience of the benevolent double should be seen in that context: it offers the comforting sense that one is not only not alone but even has a double" (pp. 18–19). Rose (1987) adds a further comment to this point:

> We know from other creative individuals that they often need to form twin-like partnerships with individuals with whom they can unconsciously feel merged. Is there a dynamic relationship between this need to form partnerships and the existence of various inner splits? If so, do the partnerships represent externalizations of the inner splits? In other words, are they the external counterparts of intrapsychic splitting and reintegration—attempts to heal [inner] splits by reenacting them [inter]personally? (p. 114)

The success of this attempt at symbiotic merger was precarious for Vincent due to the inherent ambivalence of the relationship and the persistent unconscious reverberations of the link between the merger with Theo and the merger with the dead Vincent in Vincent's unconscious (Meissner 1994).[2]

We can question the degree to which Vincent's late work reflected the looming threats to his tie with Theo. Some critics have pointed to the unevenness of his work, the apparent disorganization of some of it, the distortions in perspective for example (Elgar 1966), others point to the high level of artistic productivity he maintained to the end (Hulsker 1990).[3] Undeniably his remarkable output in the last two months he spent in Auvers speak to his ability to function at a relatively high level. But there may be room for a distinction between the objective quality of his work and his subjective experience of it. Subjectively he not only felt a sense of doom—he wrote Theo from Auvers after a short visit with Theo and his family in Paris:

> Back here, I still felt very sad and continued to feel the storm which threatens you weighing on me too. What was to be done—you see, I generally try to be

fairly cheerful, but my life is also threatened at the very root, and my steps are also wavering.

I feared—not altogether but yet a little—that being a burden to you, you felt me to be rather a thing to be dreaded, but Jo's letter proves to me clearly that you understand that for my part I am as much in toil and trouble as you are.

There—once back here I set to work again—though the brush almost slipped from my fingers, but knowing exactly what I wanted, I have painted three more big canvases since.

They are vast fields of wheat under troubled skies, and I did not need to go out of my way to try to express sadness and extreme loneliness. (Letter 649)[4]

There are ample precedents in the analytic literature for such creative symbiotic relations, based on the notion of the "double." The idea of the *Doppelgänger* or double was advanced by Rank (1914) as a extension of the self rooted in the mother-child symbiosis. The concept of mirroring in the mother-child interaction (Winnicott 1971; Kohut 1971) lies at the base of the fantasy of a twin or double (Arlow 1960; Glenn 1974a). For analysts, the role of doubles in Freud's experience and the connection with his creativity are fascinating questions. Besides his literary doubles—the list includes Arthur Schnitzler, Romain Rolland, Thomas Mann, and Arnold Zweig (Hamilton 1979a; Kanzer 1979a; Fisher 1991)—there is the profoundly influential, ambivalent, and problematic relation with Fliess, who became more than any other Freud's *alter ego* during Freud's most creative period (Gay 1988; Schur 1972).[5] Freud's doubles seem to have mirrored his relation to his envied younger brother Alexander, whom he thought was his mother's favorite (Kanzer 1979b).

The narcissistic union with the idealized fantasied double complements and enhances the fragile narcissistic equilibrium of the subject. Narcissistic losses—castration, maternal deprivation, alienation, isolation—lose their sting since connection with the double who can compensate for the loss by providing the necessary narcissistic substitute. The idealization of the object serves to sustain the grandiosity of the subject, and promotes the fantasy of gaining access to the power of the object—the replacement for the loss of maternal omnipotence and paternal phallic power (Glenn 1979). Through his symbiotic tie to Theo, Vincent found the creative capacity to continue his artistic quest. When that tie became more tenuous and threatened by emotional separation, it posed a threat not only to his artistic identity but to his very survival (Meissner 1992b).

Chapter V
IN THE MIDI

To Provence

As the train puffed its way to the South, Vincent's mind must have been filled with misgivings and dashed hopes—his wishes and dreams of how he and Theo would face the world with united strength and ambition. He did not know what fate lie ahead of him. Later he would write to Gauguin: "When I left Paris, seriously sick at heart and in body, and nearly an alcoholic because of my rising fury at my strength failing me—then I shut myself up within myself, without having the courage to hope" (Cited in Tralbaut 1969, p. 218).

He managed to find some cheap lodging and immediately plunged into painting with feverish intensity. He worked from morning to night, and sometimes into the night—sporting a broad-brimmed hat with candles stuck in it so that he could see the canvas. He labored incessantly, frantically, seemingly indefatigably. He seemed driven by a demon; he described himself as "a painting engine." He lived on little, often forgetting to eat, and when he did it was a meager meal of biscuits and milk. His only respite was a glass of absinthe at the end of the day and sometimes a night with one of the women at the local cafe. His health remained precarious (Letter 480). He was driving himself to the limit, and he knew it. He told Theo,

> But when I come home after a spell like that, I assure you my head is so tired that if that kind of work keeps recurring, as it has done since this harvest began, I become hopelessly absent-minded and incapable of heaps of ordinary things. . . . After that, the only thing to bring ease and distraction, in my case and other people's too, is to stun oneself with a lot of drinking or heavy smoking. (Letter 507)

He was not unaware of the depression that followed at his heels, "I think I should feel depressed if I did not fool myself about everything" (Letter 470). He wrote: "Now as for me, I am doing very well down here, but it is because I have my work here, and nature, and if I didn't have that, I should grow melancholy. . . . For loneliness, worries, difficulties, the unsatisfied need for kindness and sympathy—that is what is hard to bear, the mental suffering of sadness and disappointment undermines us more than dissipation—us, I say, who find ourselves the happy possessors of disordered hearts" (Letter 489). He seemed to have sensed the catastrophic course he was on. He wrote to Bernard, commenting on the genius of artists he admired, "It is possible that these great geniuses are only madmen, and that one must be mad oneself to

have boundless faith in them and a boundless admiration for them. If this is true, then I prefer my insanity to the sanity of the others" (Letter B13).

And he dreamed of the "Midi Studio." Concretely this took the form of his hope that Gauguin would soon join him in the little yellow house he had been able to rent; then he would no longer be alone, and the dream of a community of fellow artists would begin to be realized.

However much his hopes and illusions sustained him, it seems that Vincent's impact on the good people of Arles was not very unlike his reception in Paris, or anywhere he had been for that matter. His strange habits and appearance were disturbing. When he first arrived, the innkeeper was reluctant to admit him, and after he did there were the inevitable arguments, this time over the space Vincent was taking up with his brushes, paints, easels and canvases. The landlord demanded that he pay extra for the storage space for his canvases and seized Vincent's belongings (Letter 484). Vincent finally had to go to the justice of the peace to get them released (Letter 487). In the town he was an object of curiosity and ridicule. His only friends were the prostitutes at the cafe, and after a while a few kind hearted souls who befriended him, like the postman Roulin, or young Paul Milliet, the lieutenant of Zouaves.

Gauguin

Gauguin finally arrived on October 23, 1888. For him the visit was no more than an interlude before heading back to the tropics. He was disgruntled from the start, feeling that he had been manipulated by Theo and exiled to the desert where he could never find the success he sought. He resented Vincent and chafed at the arrangements. He would remain little more than two months. Vincent had a far different vision. The arrival of his friend revived Vincent's spirits and enthusiasm. His isolation was at an end and his precious dream was beginning to come true. He had prepared the little yellow house to receive Gauguin. Under Gauguin's guidance the 'Midi Studio' could not fail to materialize; other artists would quickly flock to his standard.

Gauguin did not hesitate to take charge. He quickly put the house in order, checked the chaotic finances, organized the routine of work and relaxation, even the nightly bouts of drinking and erotic adventures with the girls from the Bout d'Arles. He was authoritarian and arrogant; wherever he went he tended to hold court and brooked little opposition or contrary opinions. He dominated Vincent, gave him orders, scolded him for his slovenly and eccentric habits, and pronounced his theories of art and painting as if he were a master lecturing his pupil. We have Gauguin's watercolor of Vincent paint-

ing sunflowers. When Vincent saw it, he remarked, "It is certainly I, but it's I gone mad" (cited in Sweetman (1990), p. 288).

Vincent at first humbled himself and submitted to his friend's haughty and condescending manner. We can guess that this did not last long. It was only a matter of time, and not much, before Vincent began to resist, to argue back, to become resentful and argumentative. The arguments increased; Vincent became increasingly resentful and rebellious. The shrewd and exploitative stockbroker must have found Vincent's moralizing about the values of art simpleminded and Gauguin's more sophisticated views of aesthetics and the vocation of the artist must have seemed alien to Vincent. The arguments were at first highly charged, but in time became intolerable.

Vincent's dream of the 'Midi Studio' had blinded him to a degree. He quickly saw through Gauguin's haughty and superficial egotism, but he was prepared to make any sacrifice for the sake of his dream. But the illusion could not last. As the situation became more tense and antagonistic, Vincent could see his dream crumbling before his eyes. His choice of Gauguin, as with so many choices in Vincent's life, was disastrous. Gauguin's unbridled narcissism, entitlement, and pathological grandiosity hardly made him a suitable companion for Vincent nor a likely candidate for the projected collaboration. He quickly grew bored with Arles and contemptuous of Vincent and his dream. He made it known that he was fed up and planned to leave. For Vincent this was the ultimate catastrophe, one that he would not survive.

The Volcano Erupts
The smoldering volcano erupted suddenly and violently. On December 23, Vincent had written Theo that Gauguin was sick of Arles and the yellow house and was threatening to leave. The next day they had a violent quarrel that ended by Vincent throwing a glass of wine in Gauguin's face. The following day, Christmas, Gauguin packed his things and that evening left. As he made his way down the darkened street, he heard staggering footsteps behind him; he turned to see Vincent rushing at him with a razor in his hand. He stared at him, and Vincent stopped in his tracks, then turned and ran. He returned to the yellow house and there cut off the lobe of his left ear. Then wrapping it in a handkerchief, he rushed bleeding to the Bout d'Arles where he offered the severed lobe to one of the prostitutes there. He then went home and fell into bed. He was found the next morning unconscious in a pool of blood. He was taken to a hospital, but he was so uncontrollable that he had to be placed in a cell for dangerous lunatics.[1] The tragedy seems all but inevitable, like the playing out of a Greek tragedy in which the hero's fate is inexorable. We can only stand by, like a Greek chorus, and watch with hor-

rified eyes. Gauguin had destroyed his dream, the illusion, the vision that had given meaning and purpose to his life, that had held out the hope of some form of meaningful human connection. Vincent turned his murderous rage on himself, as he had all through his life—another Orestes, or perhaps another Christ? His decompensation was severe, psychotic; after three days of hallucinations, both aural and visual, he returned to his senses and could survey the ruin of his life.

Theo

When Theo got the news, he had rushed to Arles, but had to leave again before Vincent regained his senses. He and Gauguin returned to Paris together. After his visit, Theo wrote to Johanna, his fiancée:

> There were moments while I was with him when he was well; but very soon after he fell back into his worries about philosophy and theology. It was painfully sad to witness, for at times all his suffering overwhelmed him and he tried to weep but he could not; poor fighter and poor, poor sufferer; for the moment nobody can do anything to relieve his sorrow, and yet he feels deeply and strongly. If he might have found somebody to whom he could have disclosed his heart, it would perhaps never have gone thus far. (van Gogh-Bonger 1959, p. xlvi)

And the next day: "There is little hope, but during his life he has done more than many others, and he has suffered and struggled more than most people could have done. If it must be that he dies, so be it, but my heart breaks when I think of it" (van Gogh-Bonger, 1959, p. xlvi).

He continued with some observations about Vincent and his life style:

> As you know, he has long since broken with what is called convention. His way of dressing and his manners show directly that he is an unusual personality and people who see him say, 'He is mad.' To me it does not matter, but for mother that is impossible. Then there is something in his way of speaking that makes people either like or dislike him strongly. He always has people around him who sympathize with him, but also many enemies. It is impossible for him to associate with people in an indifferent way; it is either one thing or the other. It is difficult even for those who are his best friends to remain on good terms with him, as he spares nobody's feelings. If I had time, I would go to him and, for instance, go on a walking tour with him. That is the only thing, I imagine, that would do him good. If I can find somebody among the painters who would like to do it, I will send him. But those with whom he would like to go are somewhat afraid of him, a circumstance which Gauguin's visit did nothing to change.
>
> Then there is another thing which makes me afraid to have him come here. In Paris he saw so many things which he liked to paint, but again and again it was made impossible for him to do so. Models would not pose for him and he was forbidden to paint in the streets; with his irascible temper this caused many un-

pleasant scenes which excited him so much that he became completely unapproachable and at last he developed a great aversion for Paris. If he himself wanted to come back here, I would not hesitate for a moment . . . but again I think I can do no better than to let him follow his own inclinations. A quiet life is impossible for him, except alone with nature or with very simple people like the Roulins; for wherever he goes he leaves the trace of his passing. Whatever he sees that is wrong he must criticize, and that often occasions strife. (van Gogh-Bonger 1959, p. xlviii)

Within a week after his breakdown, Vincent returned to his senses and was discharged in the care of his friend Roulin. He immediately put his brushes in motion and produced two stunning representations of himself with his newly bandaged ear (F527, JH1657 and F529, JH1658).

Theo's Marriage

The events surrounding Vincent's collapse and psychotic breakdown took place in conjunction with the news of Theo's engagement. The prospect struck at the core of Vincent's ambivalence—he wanted desperately to support Theo marrying, out of his concern for Theo's wellbeing, but he also dreaded the idea because it would only draw Theo away from him and intensify his loneliness. Vincent would write, "It would be a great satisfaction to Mother if your marriage came off, and for the sake of your health and your work, you ought not to remain single" (Letter 462).

In the midst of his mental torments and hospitalizations, Vincent had to face the looming shadow of Theo's marriage to Johanna Bonger. Theo was his lifeline; without him Vincent would be lost, and his artistic life, even possibly his very life itself, would be threatened. Theo's financial support would be jeopardized by his need to support a wife and family, and his emotional support would be diverted and diffused by his affection for and commitment to his wife. When Theo finally did marry, it was traumatic for Vincent and may have contributed to his psychotic deterioration. A letter of congratulation at the time suggests his ambivalence: "A few lines to wish you and your fiancee very good luck these days. It is a sort of nervous affliction of mine that on festive occasions I generally have difficulty in formulating good wishes, but you must not conclude from this that I wish you happiness less earnestly than anyone else, as you well know" (Letter 583).

Theo had apparently had his own hesitations regarding the effect of his engagement and marriage on his brother. To some extent it put a crimp in Theo's wedding plans. He was engaged in December 1888, but kept the news from Vincent for some time. Nagera (1967) speculated that Vincent may have sensed some disengagement from Theo and compensated by intensifying his hopes and expectations for the arrival of Gauguin and the Midi

Studio—this possibly in the wake of the rupture of their relationship in Paris. He might have unconsciously hoped to replace his bond to Theo by a connection with Gauguin. Undoubtedly the subsequent news of Theo's plans meant further rejection and the threat of abandonment to Vincent. By the same token, the disappointment and resentment toward Theo may have contributed to Vincent's hostility to Gauguin in some measure. In any case, the conjunction of the events surrounding Theo's engagement, marriage, and Johanna's subsequent pregnancy may have played an important role in precipitating Vincent's psychotic regression (Stamm 1971).

The Gathering Clouds

Vincent readily recovered from his first psychotic attack and within a few days wrote a sad letter to Theo but without any note of bitterness or reproach for Gauguin: "My dear boy, I am so terribly distressed over your journey. I should have wished you had been spared that, for after all no harm came to me, and there was no reason why you should be upset. . . . What would I not have given for you to have seen Arles when it was fine; now you have seen it in mourning" (Letter 566). And the next day: "I shall stay here at the hospital a few days more, then I think I can count on returning quite to the house very quietly. Now I beg only one thing of you, not to worry, because that would cause me one worry *too many*. . . ." (Letter 567). And: "I hope I have just had simply an artist's fit, and then a lot of fever after very considerable loss of blood, as an artery was severed; but my appetite came back at once, my digestion is all right and my blood recovers from day to day, and in the same way serenity returns to my brain day by day. So please quite deliberately forget your unhappy journey and my illness" (Letter 569).

He hoped that the crisis was over and that he could return to his painting with the zeal and intensity he had known before. It was not to be. On January 9th, a letter from Johanna Bonger informed him of her engagement to Theo. At the beginning of February he had had another fit and returned to the hospital. His paranoia had burst to the surface—he was convinced that someone was trying to poison him. When he returned to his right mind, the bitter truth could not be ignored. The episode in December had not been an accident, a transient episode that could be forgotten. There was within him a hidden enemy, a powerful persecutor and exterminator with the power to destroy him.

Vincent himself had apprehensions and premonitions about his mental and emotional stability. He confessed to Theo:

> I am not ill, but without the slightest doubt I'd get ill if I did not eat plenty of food and if I did not stop painting for a few days. As a matter of fact, I am again

pretty nearly reduced to the madness of Hugo van der Goes in Emil Wauter's picture.[2] And if it were not that I have almost a double nature, that of a monk and that of a painter, as it were, I should have been reduced, and that long ago, completely and utterly, to the aforesaid condition. Yet even then I do not think that my madness could take the form of persecution mania, since when in a state of excitement my feelings lead me rather to the contemplation of eternity, and eternal life. But in any case I must beware of my nerves, etc. (Letter 556)

Desperate Hopes

His life and his dreams were in shambles. He was forced to move out of the Yellow House (Letter 570). His hope that he could be cured was all but eliminated, and he seemed doomed to a vicious cycle. Even if the psychosis permitted intervals of lucidity, it could return with violent and destructive effects at any time. There was no telling when the next relapse would take place, or what consequences it would have.

From time to time, the contrast between Theo's happy prospects and his own dismal ones sneaks through: "So it is more or less all the same to me what happens to me—even my staying here—I think that in the end my fate will be evened up. So beware of sudden starts—since you are getting married and I am getting too old—that is the only policy to suit us" (Letter 581). Occasionally there is an added note of ambivalence: "A few lines to wish you and your fiancée very good luck these days. It is a sort of nervous affliction of mine that on festive occasions I generally have difficulty in formulating good wishes, but you must not conclude from this that I wish you happiness less earnestly than anyone else, as you well know" (Letter 583). But at the same time he unleashed a bitter denunciation of marriage to his friend Signac—not to Theo, it should be noted—that ends ". . . mustn't one pity the poor wretch who is obliged . . . to repair to a locality, where, with a ferocity unequaled by the cruelest cannibals, he is married alive at a slow fire of reception and the aforesaid funereal pomp" (Letter 583b). Was this envy, bitterness at the failure of his own ventures into relationships with women, sour grapes?

The question was whether he should accept his fate and retire to an asylum. To Theo he wrote: "So many difficulties certainly do make me rather worried and timid, but I haven't given up hope yet. . . . We are all mortal, and subject to all the ailments that exist, and if the latter aren't of a particularly pleasant kind, what can one do about it? The best thing is to try to get rid of them" (Letter 573).

Between Sanity and Insanity

Between the psychotic episodes, there were intervals of lucidity in which he struggled to return to painting, which had been for some years the vehicle for the preservation of his sanity, of some semblance of selfhood and psychic integrity. Not only was he beleaguered by doubts about his capacity to recapture his artistic skills, but he was deeply concerned over the burden his illness would impose on Theo. Soon after the first attack, he wrote determinedly to Theo:

> Since it is still winter, look here, let me go quietly on with my work; if it is that of a madman, well, so much the worse. I can't help it. However, the unbearable hallucinations have ceased, and are now getting reduced to a simple nightmare, in consequence of my taking bromide of potassium, I think. . . . And once again, either shut me up in a madhouse right away—I shan't oppose it, I may be deceiving myself—or else let me work with all my strength, while taking the precautions I speak of. If I am not mad, the time will come when I shall send you what I have promised you from the beginning. (Letter 574)

We can gain some sense from this letter of the extent to which Vincent's self-esteem and the justification for his existence were tied up in his painting. Without it he felt worthless and his life was meaningless. Only in his continuing to work and turn out works of art could he justify accepting the continuing flow of money from Theo—at a time when he knew Theo was taking on the added responsibility of a wife and family. But his illness that prevented him from re-engaging in his work with the same intensity as before. "As far as my work goes, the month hasn't been so bad on the whole, and work distracts me, or rather keeps me under control, so that I don't deny myself it" (Letter 576).

An Island of Sanity

He continued to paint, but as his condition deteriorated slowly, the effort required grew greater. It was no longer an enthusiasm and pleasure; it was a necessity. It became occupational therapy, a way of escaping inner anguish and torment, an island of sanity and purpose in a sea of near psychotic turmoil. His life in Arles was not pleasant: the townspeople regarded him with fear and hostility. To them he was an eccentric tramp or beggar, a contemptible figure who in his craziness had cut off his ear and might be capable of any violence. Children taunted him and threw stones at him on the street—"Roux fou!" [redheaded madman] they called him.

Finally the townspeople circulated a petition addressed to the mayor requesting that Vincent be incarcerated for the public good. He was put in the hospital and his house officially sealed. It was a humiliating blow. His only

hope was in his painting. To Theo he complained: ". . . what a staggering blow between the eyes it was to find so many people here cowardly enough to join together against one man, and that man ill. . . . I am greatly shaken, but I am recovering a sort of calm in spite of everything, so as not to get angry. Besides, humility becomes me after the experience of the repeated attacks. So I am being patient" (Letter 579). And again: "As far as I can judge, I am not properly speaking a madman. You will see that the canvases I have done in the intervals are steady and not inferior to the others. I miss the work more than it tires me. . . . Believe me, if nothing intervenes, I shall now be able to do the same and perhaps better work in the orchards than I did last year" (Letter 580).

He was not without hope: "I am well just now, except for a certain undercurrent of vague sadness difficult to define—but anyway—I have rather gained than lost in physical strength, and I am working. . . . And now, my dear boy, I believe that soon I shall not be ill enough to have to stay shut up. Except for that, I am beginning to get used to it, and if I had to stay in an asylum for good, I should resign myself to it and I think I could find subjects for painting there as well" (Letter 583). Even so he had to struggle constantly against despair: "But at times it is not easy for me to take up living again, for there remain inner seizures of despair of a pretty large caliber. My God, those anxieties—who can live in the modern world without catching his share of them? The best consolation, if not the best remedy, is to be found in deep friendships, even though they have the disadvantage of anchoring us more firmly in life than would seem desirable in the days of our great sufferings" (Letter 583b).

To an Asylum
Finally he reached the decision to move to a mental asylum. He told Theo:

> At the end of the month I should like to go to the hospital in St. Remy, or another institution of this kind, of which M. Salles has told me. Forgive me if I don't go into details and argue the pros and cons of such a step. Talking about it would be mental torture. . . . I should be afraid of losing the power to work, which is coming back to me now, by forcing myself and by having all the other responsibilities of a studio on my shoulders besides. And temporarily I wish to remain shut up as much for my own peace of mind as for other people's. What comforts me a little is that I am beginning to consider madness as a disease like any other and accept the thing as such, whereas during the crises themselves I thought that everything I imagined was real. Anyway, the fact is that I do not want to think or talk about it. . . . Beginning again that painter's life I have been living, isolated in the studio so often, and without any other means of distraction than going to a cafe or a restaurant with all the neighbors criticizing, etc., I can't

face it. . . . Do not be grieved at all this. Certainly these last days were sad, with all the moving, taking away all my furniture, packing up the canvases that are going to you, but the thing I felt saddest about was that you had given me all these things with such brotherly love, and that for so many years you were always the one who supported me, and then to be obliged to come back and tell you this sorry tale—but it's difficult to express it as I felt it. . . . After all we must take our share, my boy, of the diseases of our time—in a way it is only fair after all that, having lived some years in comparatively good health, we should have our share sooner or later. As for me, you know well enough that I should not exactly have chosen madness if I had had a choice, but once you have an affliction of that sort, you can't catch it again. And there'll perhaps be the consolation of being able to go on working a bit at painting. (Letter 585)

He continues in the next letter:

I feel deeply that this has been at work within me for a very long time already, and that other people, seeing symptoms of mental derangement, have naturally had apprehensions better founded than my unfounded certainty that I was thinking normally, which was not the case. So that has much softened many of the judgments which I have too often passed . . . on people who nevertheless were wishing me well. . . . Poor egotist that I have always been and still am, I can't get the idea out of my head . . . that it is really for the best if I go into an asylum immediately. . . . And I think that in my case nature by herself will do much more for me than any remedies. (Letter 586)

Failure and Despair

Vincent felt his life had been a failure. He tried to recover some of the paintings he had stored in the yellow house, but even the elements had conspired against him: "Today I am busy packing a case of pictures and studies. One of them is flaking off, and I have stuck some newspapers on it; it is one of the best, and I think that when you look at it you will see better what my now shipwrecked studio might have been. This study, like some others, has got spoiled by moisture during my illness. The flood water came within a few feet of the house, and on top of that, the house itself had no fires in it during my absence, so when I came back, the walls were oozing water and saltpeter" (Letter 588).

Theo finally married and Vincent arranged to move to the mental asylum. His time in Arles had run out. He turned his face toward St. Remy and to the prospect of continued institutionalization as his lot in life. He had spent over two years in Arles. He wrote to Theo: "I have been 'in a hole' all my life, and my mental condition is not only vague now, but has always been so, so that whatever is done for me, I cannot think things out so as to balance my life. Where I have to follow a rule, as here in the hospital, I feel at peace. And it would be more or less the

same thing if I were in the army" (Letter 589). Soon after he wrote resignedly: "You must put aside any idea of sacrifice in it. . . . all through my life, or at least most of it, I have sought something other than a martyr's career, for which I am not cut out. If I find trouble or cause it, honestly, I am aghast I really must make up my mind, it is only too true that lots of painters go mad, it is a life that makes you, to say the least, very absent-minded. If I throw myself fully into my work again, very good, but I shall always be cracked" (Letter 590).

During his stay in the hospital in Arles, Vincent has left us some of his impressions (F646, JH1686; F519, JH1687). He remained a patient in the hospital from December 1888, experiencing a series of remissions and readmissions over the succeeding months, until May 1889 when he was transferred to the asylum at St. Remy.

St. Remy
On May 8, he boarded the train with Pastor Salles for Saint-Remy-de-Provence. The kindly pastor escorted Vincent to the asylum Saint-Paul-de-Mausole, where he was admitted by Dr. Peyron; he would remain there for a year. A week later he wrote to Theo:

> I think I have done well to come here; first of all, by seeing the reality of the life of the various madmen and lunatics in this menagerie, I am losing the vague dread, the fear of the thing. And little by little I can come to look upon madness as a disease like any other. Then the change of surroundings does me good, I think The idea of work as a duty is coming back to me very strongly, and I think that all my faculties for work will come back to me fairly quickly. Only work often absorbs me so much that I think I shall always remain absent-minded and awkward in shifting for myself for the rest of my life (Letter 591)

As his condition improved somewhat, he was able to view his situation with somewhat greater equanimity and even a touch of wry humor:

> Formerly I felt an aversion for these creatures, and it was a harrowing thought for me to reflect that so many of our profession . . . had ended like this. . . . Well, now I think of all this without fear, that is to say I find it no more frightful than if these people had had been stricken with something else, phthisis or syphilis for instance. . . . I am again—speaking of my condition—so grateful for another thing. I gather from others that during their attacks they have also heard strange sounds and voices as I did, and that in their eyes too things seemed to be changing. And that lessens the horror that I retained at first of the attack I have had, and which, when it comes on one unawares, cannot but frighten you beyond measure. Once you know that it is part of the disease, you take it like anything else. . . . But I have no will, hardly any desires or none at all, and hardly any wish for anything belonging to ordinary life, for instance almost no desire to see

my friends, although I keep thinking about them. That is why I have not yet reached the point where I ought to think of leaving here; I should have this depression anywhere. (Letter 592)

He could no longer delude himself regarding the severity of his illness. He struggled with despair, clinging to slender threads of hope:

It is queer that every time I try to reason with myself to get a clear idea of things, why I came here and that after all it is only an accident like any other, a terrible dismay and horror seizes me and prevents me from thinking. It is true that this is tending do diminish slightly, but it also seems to me to prove that there is quite definitely something or other deranged in my brain, it is astounding to be afraid of nothing like this, and to be unable to remember things. Only you may be sure I shall do all I can to become active again and perhaps useful, at least in the sense that I want to do better pictures than before. (Letter 594)

He struggled to resign himself to his fate:

It is just in learning to suffer without complaint, in learning to look on pain without repugnance, that you risk vertigo, and yet it is possible, yet you may even catch a glimpse of a vague likelihood that on the other side of life we shall see good reason for the existence of pain, which seen from here sometimes so fills the whole horizon that it takes on the proportions of a hopeless deluge. We know very little about this, about its proportions, and it is better to look at a wheat field, even in the form of a picture. (Letter 597)

During the year he spent in the St. Paul asylum, splendid paintings continued to pour from his brush during his lucid intervals. Nature in all its variety continued to be his favorite subject, but there were also humerous impressions of the asylum and its environs (F734, JH1698; F1531, JH1705; F531, JH1779; F730, JH1841; F1530, JH1806; F1529, JH1808).

The Third Vincent

After Vincent's move to Saint-Remy, the coherence and the majestic power of his painting in the Arles period disappeared. His work became uncertain and variable. He himself was not unaware of the change. Something had given way. Had he lost faith? Was he crazy to continue to paint and get nothing out of it? Excruciating religious ideas continued to haunt him along with profound episodes of morbid depression that came in the wake of each new attack. As he surveyed the ruins of his life, he saw nothing but noble ambitions defeated and defrauded; his plans had come to naught, defeat followed upon defeat. He despaired of the burden he felt he was becoming on Theo and his wife. On July 5, Vincent received a letter from Jo (Letter T11) announcing "a great piece of news." She and Theo were expecting a baby,

whom they intended to name after Vincent. She asked him to be the godfather. She also expressed her fears over her and Theo's poor health and the possible fate of the child.

When the news of Jo's pregnancy arrived Vincent wrote the proud parents: "Jo's letter told me a very great piece of news this morning, I congratulate you on it and I am very glad to hear it. I was much touched by your thought when you said that neither of you being in such good health as seems desirable on such an occasion, you felt a sort of doubt, and in any case that a feeling of pity for the child who is to come passed through your heart" (Letter 599). On the next day, Dr. Peyron permitted Vincent to visit Arles accompanied by the warder. He visited friends for several hours, and even saw Rachel, the prostitute to whom he had offered his severed ear. He also collected some of the pictures he had left there and returned to the asylum without incident. The next morning, however, another fit seized him; this time it was three weeks before his reason returned—the most violent and longest fit he had ever experienced. We cannot know whether the precipitants included the news from Paris or the stimulation of the visit to Arles or some combination of the two, but the reaction was profound and disturbing. Vincent made every effort to put an optimistic face on things, but something had been stirred that was deeply troubling. The clouds were darkening and things seemed increasingly hopeless. He wrote:

> I must let you know that it is very difficult for me to write, my head is so disordered. . . . You can imagine that I am terribly distressed because the attacks have come back, when I was already beginning to hope that it would not return. . . . For many days my mind has been absolutely wandering, as in Arles, quite as much if not worse, and presumably the attacks will come back again in the future; it is abominable. . . . I no longer see any possibility of having courage or hope, but after all, it wasn't just yesterday that we found this job of ours wasn't a cheerful one. . . . (Letter 601)

Vincent had difficulty in concealing his unconscious hostility to Johanna and the baby to come. He tried to put a pleasant and optimistic face on things, even though he knew Theo's health was failing and Jo was having difficulty with her pregnancy. Consciously he was tormented by obsessional concerns about her wellbeing and the safety of the child.

Declining Power

With desperate hope and determination he threw himself into his work—hoping against hope that reimmersion in the only medium of salvation he had ever found would save him from the ravages of his disease. He told Theo: "I am working like one actually possessed, more than ever I am in a dumb fury

of work. And I think this will help cure me. . . . in the sense that my distressing illness makes me work with a dumb fury—very slowly—but from morning till night without slackening." (Letter 604).

After this his work begins to reflect the inner turmoil of chaotic psychic world. As Elgar (1966) commented:

> After this date the artist's frenzy affects all he undertakes. The earth expands and cracks, mountains are convulsed, clouds whirl madly, stars gyrate like fireworks, trees writhe as if in rage, vegetation rolls forward like a breaking wave, distance overlaps foreground, clouds drop into trees and the ground leaps as though to assault the heavens. In this disjointed world of nature in delirium the rules of dimension, proportion and architecture explode under attacks of destructive violence. Perspective becomes fragmentary. Lines of sight fly in all directions. The brush strokes swing this way and that in furious curves or come to a sudden end. Colour is laid on in touches now broad, now threadlike. (pp. 202-205)

Vincent's letters continued in a hopeful vein, but it was hope smudged with the shadow of dark clouds: "Now my brain is working in an orderly fashion, and I feel perfectly normal, and if I think over my condition now with the hope of usually having between the attacks—if unfortunately it is to be feared that they will always return from time to time. . . . But I must firmly continue my poor career as a painter" (Letter 604). He seemed to be as eager to reassure Theo as to reassure himself that his mind and his talent are still as good as ever. But his final paintings were marked with discontinuity, dispersal, disorganization. As Elgar (1966) observed, these last works are ". . . dogged by impotence and at the same time in revolt against it. Yet in spite of this conflict, or because of it, they sometimes rise to sublimity. Formerly he had translated his ideal of health and serenity into stasis, balanced shapes, strictly modulated and organised, which represented solid, unshakable stability. But now he had turned to depict pain, love and death" (p. 211). He drew the great pine in the asylum grounds, noting the "proud unchangeable character" of that "sombre giant, arrogant in defeat" (Letter B21).

About this time Vincent's religious delusions and hallucinations increased in intensity. The fear of new attacks haunted him—and with them the threat of deterioration in his power to paint. He wrote:

> Life passes like this, time does not return, but I am dead set on my work, for just this very reason, that I know the opportunities of working do not return. Especially in my case, in which a more violent attack may forever destroy my power to paint. During the attacks I feel a coward before the pain and suffering—more of a coward than I ought to be, and it is perhaps this very moral cowardice which, whereas I had no desire to get better before, makes me eat like two now,

work hard, limit my relations with the other patients for fear of a relapse—altogether I am now trying to recover like a man who meant to commit suicide and, finding the water too cold, tries to regain the bank. . . . (Letter 605).

The news from Paris brought little relief: Theo's health was failing and the condition of his wife and child were also tenuous (Letters T13 and T14). We can hear how desperately Vincent clung to his art as the last thread of hope amid darkening clouds. In this 'optimistic' vein, he wrote:

All the same, I know well that healing comes—if one is brave—from within through profound resignation to suffering and death, through the surrender of your own will and of your self-love. But that is no use to me, I love to paint, to see people and things and everything that makes our life—artificial—if you like. Yes, real life would be a different thing, but I do not think I belong to that category of souls who are ready to live and also at any moment ready to suffer. . . . (Letter 605).

Religious Delusions

Caught in the throes of his illness, his religious preoccupations heightened. He felt more intensely the identification with the martyred and humiliated Christ. His mind was obsessed with delusional religious ideas. He attributed them to the environs in Provence: "When I realize that here the attacks tend to take an absurd religious turn, I should almost venture to think that this even *necessitates* a return to the North" (Letter 605).[3] And again: "I am astonished that with the modern ideas I have, and being so ardent an admirer of Zola and de Goncourt and caring for things of art as I do, that I have attacks such as a superstitious man might have and that I get perverted and frightful ideas about religion such as never came into my head in the North" (Letter 607).

About the same time he wrote to Wil in a spirit of bleak resignation: "Alas, we often get out of breath and faith, which is certainly the wrong thing to do—but there, now we return to our starting point; if we nevertheless want to go on working, we have to resign ourselves to the obstinate callousness of the times and to our isolation, which is sometimes hard to endure as living in exile. And so we have to expect, after the years that, relatively speaking, we lost, poverty, sickness, old age, madness, and always exile" (Letter W13).

Tragic Reverberations

Some of his paintings from this period express a sense of deep melancholy, unutterable loneliness, and a mournful tone of tragic presentiment. The monotonous and colorless atmosphere of the asylum could only intensify his sombre mood and attune him all the more to his inner world and the psychological forces that pervaded it. His painting was a diversion from this brood-

ing, but his introspective musings had also to find their way onto his canvas. His disillusionment and distress can be read in his painting of the asylum entrance hall (F1530, JH1806), in which the stark sombre simplicity of the hallway and door lead to bright sunlight and hope—a threshold that Vincent could not cross. The painting of the hospital corridor is even more depressing and hopeless (F1529, JH1808)—an image of endlessly monotonous passages, repetitive, confining, a prison from which there is no escape—a metaphor for Vincent's life.

Vincent became increasingly irritable and found it difficult to control his moods and rages. His need to paint became all the more desperate and imperative. To Theo he wrote: "I think M. Peyron is right when he says that I am not strictly speaking mad, for my mind is absolutely normal in the intervals, and even more so than before. But during the attacks it is terrible—and I lose consciousness of everything. But that spurs me on to work and to seriousness, like a miner who is always in danger makes haste in what he does" (Letter 610). Further: "And yet very often terrible fits of depression come over me, and besides the more my health comes back to normal, the more my brain can reason coldly, the more foolish it seems to me, and a thing against all reason, to be doing this painting which costs us so much and brings in nothing, not even the outlay. Then I feel very unhappy, and the trouble is that at my age it is damnably difficult to begin anything else" (Letter 611).

About the same time, he wrote to his mother:

> What makes us work on is friendship for each other, and love of nature, and finally, if one has taken all the pains to master the brush, one cannot leave painting alone. Compared with others, I still belong to the lucky ones, but think what it must be if one has entered the profession and has to leave it before one has done anything, and there are many like that. Given ten years as necessary to learn the profession and somebody who has struggled through six years and paid for them and then has to stop, just think how miserable that is, and how many there are like that! (Letter 612)

Vincent was undoubtedly voicing his own frustration, reflecting his dissatisfaction with his own attainments and artistic accomplishments, along with an ever intensifying premonition that his time was running out—too soon for him to reach the desired goal!

He poured out his anxieties to Theo:

> If my health remains stable, then, if while I work I again start trying to sell, to exhibit, to make exchanges, perhaps I shall succeed a little in being less of a burden to you on the one hand and on the other might recover a little more zest. For I will not conceal from you that my stay here is very wearisome because of its monotony, and because the company of all these unfortunates, who do abso-

lutely nothing all day long, is enervating. But what's to be done?—we must not make any pretensions in my case, I still make too many as it is. (Letter 614)

And later:

It is a year since I fell ill. But last year towards this time I certainly did not think that I should have got over it as much as this. In the beginning when I became ill I could not resign myself to the idea of having to go into a hospital. Now I agree that I should have been treated even earlier; but to err is human. . . . And if I could one day prove that I have not impoverished the family, that would comfort me. For now I am still full of remorse at spending money with no return. But as you say, patience and work are the only chance of getting away from that.(Letter 617)

Despite the difficulties, he seemed intent on getting on with his painting—it was his life, it was what gave meaning to his life and without it his life would be meaningless. He added to Theo: "You tell me not to worry too much, and that better days will yet come for me. I must tell you that these better days have already begun for me, as soon as I get a glimpse of the possibility of completing my work in some way or other, so that you would have a series of really sympathetic Provencal studies" (Letter 617).

About the same time, he wrote to his mother:

I often feel much self-reproach about things in the past, my illness being more or less my own fault, in any case I doubt if I can make up for faults in any way. But reasoning and thinking about these things is sometimes so difficult, and sometimes my feelings overwhelm me more than before. And then I think so much of you and of the past. You and Father have been, if possible, even more to me than to the others, so much, so very much, and I do not seem to have had a happy character. I discovered that in Paris, how much more Theo did his best to help Father practically than I, so that his own interests were often neglected. Therefore I am so thankful now that Theo has got a wife and is expecting his baby. Well, Theo had more self-sacrifice than I, and that is deeply rooted in his character. (Letter 619)

Then to Theo:

I wish you and Jo a happy New Year and regret that I have perhaps, though quite unwillingly, caused you worry, because M. Peyron must have informed you that my mind has once more been deranged. . . . Now what you say about my work certainly pleases me, but I keep thinking about this accursed trade in which one is caught as in a net, and in which one becomes less useful than other people. But there, it's no use, alas! fretting about that—and we must do what we can. Odd that I had been working perfectly calmly on some canvases that you will soon see, and that suddenly, without any reason, the aberration seized me again. (Letter 620)

He continued:

> I have never worked with more calm than in my last canvases For the mo-
> ment I am overcome with discouragement. But since this attack was over in a
> week, what's the use of thinking that it may in fact come back again? First of all
> you do not know, and cannot foresee, how or in what form. Let's go on work-
> ing then as much as possible as if nothing had happened. . . . And what would be
> infinitely worse would be to let myself slip into the same condition as my com-
> panions in misfortune, who do nothing all day, week, month, year My
> work at least lets me retain a little of my clarity of mind, and makes possible my
> getting rid of this some day. . . . Once more, I can foresee absolutely nothing, I
> see no way out, but I also see that my stay here cannot go on indefinitely.(Letter
> 622)

Birth of Another Vincent

Jo finally gave birth to her son on January 31st. When Vincent received the
news came that the child had been delivered and that mother and infant were
well, he was relieved. But another dreaded rival had come on the scene—
another Vincent who would displace him and compete with him for Theo's
affection. His unconscious hostility and death wishes were undoubtedly
stirred. His preoccupations with the child's health would be reinforced by
little Vincent's ensuing illness.

The child was named Vincent Willem after his uncle and godfather. Vin-
cent wrote on February 2 in warm and appreciative terms: "Today I received
good news that you are at last a father, that the most critical time is over for
Jo, and finally that the little boy is well. That has done me more good and
given me more pleasure than I can put into words. Bravo—and how pleased
Mother is going to be. . . . Anyhow, here it is, the thing I have so much de-
sired for such a long time" (Letter 625).

If a bright ray of sunshine had fallen into Theo's world, Vincent could
take pleasure and joy in it—but not for long. The contrast between Theo's
life and his own was depressing and gloomy. He wrote:

> I must tell you that there are, as far as I can judge, others who have the same
> thing wrong with them that I have, and who, after having worked part of their
> life, are reduced to helplessness now. It isn't easy to learn much good between
> four walls, that's natural, but all the same it is true that there are people who can
> no longer be left at liberty as though there were nothing wrong with them. And
> that means I am pretty well or altogether in despair about myself. Perhaps, per-
> haps I might really recover if I were in the country for a time. . . . (Letter 628)

Yet, despite his straining for hope, there seemed to be little to hope for. He
wrote: "What am I to say about these last two months? Things didn't go well

at all. I am sadder and more wretched than I can say, and I do not know at all where I have got to" (Letter 629).

Further Disposition

In the meanwhile, the question arose whether it was in Vincent's best interest to remain in the asylum at Saint Remy. Pissarro had suggested to Theo that Vincent put himself in the care of Dr. Gachet in Auvers. Gachet was known to be interested in the work of the impressionists and dabbled in painting himself. Perhaps he would be in a better position to understand Vincent's difficulties.

Vincent was impatient:

> I do not feel competent to judge the method of treating patients here, I do not want to go into details—but please remember that I warned you nearly six months ago that if I had another attack of the same nature, I should wish to change my asylum. And I have already delayed too long, having let an attack go by meanwhile; I was then in the midst of my work and I wanted to finish some canvases I was on. But for that, I should not be here now. . . . Now I should think it would be best to go and see this doctor in the country as soon as possible, and we could leave the luggage at the station. So I should not stay with you more than say two or three days, then I would leave for this village where I would stay at the inn to begin with. . . . My surroundings here begin to weigh on me more than I can say—my word, I have been patient for more than a year—I need air, I feel overwhelmed with boredom and grief. . . . I assure you it is something to resign yourself to living under surveillance, even supposing it were sympathetic, and to sacrifice your liberty, keep yourself out of society, and have nothing but your work without any distraction. . . . As for me, I can't go on, I am at the end of my patience, my dear brother, I can't stand any more—I must make a change, even a desperate one. (Letter 631)

And in the next letter:

> *I think the best thing will be for me to go myself to see this doctor in the country as soon as possible,* then we can soon decide if I shall go to stay with him or temporarily at the inn; and thus we shall avoid too prolonged a stay in Paris, a thing I dread. . . . it is enough that I feel that what still remains of my wits and of the power to work is absolutely in danger, whereas on the contrary, I undertake to prove to this doctor of whom you speak that I can still work rationally, and he will treat me accordingly, and since he likes painting, there is really a chance that a lasting friendship will result. (Letter 632)

He continued to experience episodes of psychotic derangement separated by intervals of lucidity and sanity in which he was able to continue to paint and produce masterful works of art. The move to Auvers-sur-Oise was finally made on May 16, 1890. Vincent had been in the asylum at Saint Remy for a

little more than a year. He boarded the train to Paris to visit Theo and his family. The patient was discharged as "cured."

The Last Act

As the train carried the "cured" Vincent toward Paris, he must have been in good spirits. Theo was to meet him at the Gare de Lyon, and he would meet his newborn nephew, little Vincent, for the first time. Jo was surprised to find him looking sturdy, smiling, and resolute. He seemed in far better shape than Theo, who was pale, thin, and coughing more than before. Both brothers had tears in their eyes when they gazed at little Vincent in his crib.

Vincent spent the next day anxiously studying his paintings, with which Theo had adorned the apartment. Together they visited Tanguy's shop, and a few old haunts—but he did not meet with any artists or even with his favorable critics, Aurier and Isaacson. The evening was spent visiting with Jo's brother, Andres Bonger. Through it all Saint-Remy was not mentioned. Theo wrote a letter of introduction to Dr. Gachet, and on the third day Vincent made his way to Auvers-sur-Oise outside Paris.

Vincent's reception by the good doctor seems to have been cordial enough. Gachet put him up at an inn, but Vincent thought it too expensive and found a cheaper place where he was able to rent an attic room. Vincent wrote his impressions to Theo:

> Auvers is very beautiful, among other things a lot of old thatched roofs, which are getting rare. So I should hope that by settling down to do some canvases of this there would be a chance of recovering the expenses of my stay—for really it is profoundly beautiful, it is the real country, characteristic and picturesque. I have seen Dr. Gachet, who gives me the impression of being rather eccentric, but his experience as a doctor must keep him balanced enough to combat the nervous trouble from which he certainly seems to me to be suffering at least as seriously as I. . . . His house is full of black antiques, black, black, black, except for the impressionist pictures mentioned. The impression I got of him was not unfavorable. When he spoke of Belgium and the days of the old painters, his grief-hardened face grew smiling again, and I really think that I shall go on being friends with him and that I shall do his portrait. Then he said that I must work boldly on, and not think at all of what went wrong with me. (Letter 635)

His hopes were on the rise and his desire to immerse himself once again in his art:

> There is a lot to draw here. Old fellow, having thought it over, I do not say that my work is good, but the thing is that I can do less bad stuff. Everything else, relations with people, is very secondary, because I haven't the gift for that. I can't help that. . . . I can do nothing about my disease. I am suffering a little

just now—the thing is that after that long seclusion the days seem like weeks to me. I felt that in Paris and here too, but serenity will come as my work gets on a bit. However that may be, I do not regret being back, and things will go better here. (Letter 636)

And there was more about Gachet: "Today I saw Dr. Gachet again . . . he is as discouraged about his job as a doctor as I am about my painting. . . . Anyway, I am ready to believe that I shall end up being friends with him. He said to me besides that if the melancholy or anything else became too much for me to bear, he could easily do something to lessen its intensity, and that I must not feel awkward about being frank with him. Well, the moment when I need him may certainly come, however up to now all is well. And it may yet improve. . ." (Letter 637).
And in the following letter:

He [Gachet] certainly seems to me as ill and distraught as you or me, and he is older and lost his wife several years ago, but he is very much the doctor, and his profession and faith still sustain him. We are great friends already, and as it happens, he already knew Brias (Bruyas) of Montpellier and has the same idea of him that I have, that there you have someone significant in the history of modern art. I am working at his portrait (F753, JH2007), the head with a white cap, very fair, very light, the hands also a light flesh tint, a blue frock coat and a cobalt blue background, leaning on a red table, on which are a yellow book and a foxglove plant with purple flowers. It has the same sentiment as the self-portrait I did when I left for this place. (Letter 638)[4]

Then again, writing to his sister Wil: "And then I have found a true friend in Dr. Gachet, something like another brother, so much do we resemble each other physically and also mentally. He is a very nervous man himself and very queer in his behavior. . . ." (Letter W22).
Vincent makes the comparison between himself and the good doctor for us, as well as comparing his portrait of Gachet with his own self-portrait. Even the facial resemblance is striking. He would exclaim to Gauguin, "Meanwhile I have a portrait of Dr. Gachet with the heart-broken expression of our time" (Letter 643). And again he wrote to Wil: "I painted a portrait of Dr. Gachet with an expression of melancholy, which would seem to look like a grimace to many who saw the canvas. And yet it is necessary to paint it like this, for otherwise one could not get an idea of the extent to which, in comparison with the calmness of the old portraits, there is an expression in our modern heads, and passion—like a waiting for things as well as a growth. Sad and yet gentle, but clear and intelligent—this is how one ought to paint many portraits" (Letter W23).
Graetz (1963) commented on these portraits:

In this last self-portrait the piercing look—once directed at himself in the mir-
ror—is now directed straight at us like a challenge from the other side of life.
There is no horizon, no life line; he appears virtually like an apparition. In the
same sentiment as his self-portrait, and as that of the distressed old man, the
melancholy in Dr. Gachet's portrait expresses Vincent's own state of mind dur-
ing those weeks at Auvers. In the few days in Paris he had been face to face
with the reality of Theo's family, the true and ideal life, that to him was denied.
Finally realizing that Theo belonged first of all to his wife and child, Vincent
must have felt his loneliness weighing ever heavier on him as he climbed the nar-
row stairs to the cage-like room in the miserable little inn at Auvers. (p. 262)

Vincent had in a sense found another double whose features are reflected in
the Gachet portrait.

The Gathering Storm

Anxiety about the illness of Theo's son was in the air. Vincent replied to
Theo's worried letter: "I have just received the letter in which you say that
the child is ill; I should greatly like to come and see you, and what holds me
back is the thought that I should be even more powerless than you in the pre-
sent state of anxiety. But I feel how dreadful it must be and I wish I could
help you. . . . I share your anxiety with all my heart" (Letter 646). But the
darkness hovered over his own head. He continued: "I myself am also trying
to do as well as I can, but I will not conceal from you that I hardly dare count
on always being in good health. And if my disease returns, you would forgive
me. I still love life and art very much, but as for ever having a wife of my
own, I have no great faith in that. . . . I am—at least I feel—too old to go
back on my steps or to desire anything different. That desire has left me,
though the mental suffering from it remains" (Letter 646).

Vincent's hesitations about Gachet seemed to dim his hopes even further.
He wrote to Theo and Jo with a touch of despair:

I think that Theo, Jo and the little one are a little on edge and are worn out—and
besides, I myself am also far from having reached any kind of tranquillity. . . .
On the other hand, I very much fear that I too was distressed, and I think it
strange that I do not in the least know under what conditions I left Would
there be a way of seeing each other again more calmly? I hope so. . . . I think
we must not count on Dr. Gachet at all. First of all, he is sicker than I am, I
think, or shall we say just as much, so that's that. Now when one blind man
leads another blind man, don't they both fall into the ditch? I don't know what
to say. Certainly my last attack, which was terrible, was in a large measure due
to the influence of the other patients, and then the prison was crushing me, and
old Peyron didn't pay the slightest attention to it, leaving me to vegetate with the
rest, all deeply tainted. . . . It is certain, I think, that we are all of us thinking of

the little one For myself, I can only say at the moment that I think we all need rest—I feel exhausted. So much for me—I feel that this is the lot which I accept and which will not change. (Letter 648)

The news from Paris was not encouraging. Jo was ill, and the baby sick, probably from infected cow's milk. Theo's health continued to be precarious, and to top it off, he was having difficulties in his business. He was poorly treated by his employers and was struggling with the idea of going into business for himself. The perilous news about the baby threw Vincent into a state of anxious preoccupation. He boarded the train for a visit to Paris. The atmosphere was strained since both Jo and the baby had only recently recovered, but this time Vincent saw many of his friends. Aurier the critic came to visit, and Toulouse-Lautrec. Vincent could not last much past lunch—exhausted and overstimulated, he rushed back to Auvers. The visit and the situation he had found in Paris were profoundly disturbing. He wrote from Auvers: "My impression is that since we are all rather stupified and besides a little overwrought, it matters relatively little to insist on having any very clear definition of the position we are in. You rather surprise me by seeming to wish to force the situation *while there are disagreements between you*. Can I do anything about it—*perhaps not—but have I done anything wrong*, or, finally, can I do anything that you would like me to do?" (Letter 647).

A few days later, he wrote again to Theo:

Back here, I still feel very sad and continued to feel the storm which threatens you weighing on me too. What was to be done—you see, I generally try to be fairly cheerful, but my life too is threatened at the very root, and my steps are also wavering. I feared—not altogether but yet a little—that being a burden to you, you felt me rather a thing to be dreaded, but Jo's letter proves to me clearly that you understand that for my part I am as much in toil and trouble as you are. There—once back here I set to work again—though the brush almost slipped from my fingers (Letter 649)

And again: "Perhaps I'd rather write you about a lot of things, but to begin with, the desire to do so has completely left me, and then I feel it is useless. . . ." (Letter 651).

Despite his desperate efforts to immerse himself in his art, things did not go well in Auvers. The situation became more desperate and hopeless, compounded by the gradual erosion of his artistic powers and his deepening depression. He was well aware that his condition was gradually worsening. There came a quiet Sunday morning. He walked out on the countryside and turned onto a small farm. He went behind the barn, and concealing himself behind a manure pile he pulled out a revolver and shot himself in the abdo-

men. With his hand pressed against the wound to control the bleeding, he
staggered back to the Ravoux cafe where he was staying, climbed the stairs to
his room and collapsed. Soon after the innkeeper found him near death and
rushed to get the local doctor. The bullet could not be removed, and there
was little to do but notify Theo.

Theo rushed to Auvers and spent the day at Vincent's bedside. Vincent
remained conscious; he told Theo, "Don't weep; what I have done was for
the best of all of us." He died peacefully on the 29th of July, 1890. In the
pocket of his jacket he was wearing when he fired the fatal shot, there was an
unfinished letter to Theo; it said,

> There are many things I should like to write you about, but I feel it is useless. . . .
>
> Well, the truth is, we can only make our pictures speak. But yet, my dear
> brother, there is this that I have always told you, and I repeat it once more with
> all the earnestness that can be expressed by the effort of a mind diligently fixed
> on trying to do as well as possible—I tell you again that I shall always consider
> you to be something more than a simple dealer in Corots, that through my me-
> diation you have your part in the actual production of some canvases, which will
> retain their calm even in the catastrophe.
>
> For this is what we have got to, and this is all or at least the main thing that I
> can have to tell you at a moment of comparative crisis. . . .
>
> Well, my own work, I am risking my life for it and my reason has half foun-
> dered because of it—that's all right . . . but what can one do? (Letter 652)

His friend and fellow artist, Emile Bernard, came for the funeral and two
days later wrote to Vincent's admiring critic, G.-Albert Aurier:

> My dear Aurier,
>
> Your absence from Paris must have left you unaware of a dreadful piece of
> news that, nevertheless, I cannot put off telling you: Our dear friend Vincent
> died four days ago.
>
> I imagine that you have already guessed that he killed himself. Indeed, Sun-
> day evening he went into the Auvers countryside, left his easel against a haystack
> and went and shot himself with a revolver behind the chateau. From the violence
> of the impact (the bullet passed under the heart) he fell, but he got up and fell
> again three times and then returned to the inn where he lived (Ravoux, Place de
> la Mairie) without saying anything to anyone about his injury. Finally, Monday
> evening he expired, smoking [the] pipe he had not wanted to put down, and ex-
> plaining that his suicide was absolutely calculated and lucid.
>
> Characteristically enough, I was told that he frankly stated his desire to die—
> "Then it has to be done over again"—when Dr. Gachet told him that he still
> hoped to save him; but, alas, it was no longer possible. . . .[5]

Epilogue

He was buried in the little cemetery at Auvers. Theo was grief stricken. He wrote to their mother: "One cannot write how grieved one is nor find any comfort. It is a grief that will last and which I certainly shall never forget as long as I live; the only thing one might say is that he himself has the rest he was longing for. . . . Life was such a burden to him; but now, as often happens, everybody is full of praise for his talents. . . . Oh Mother! He was so my own, own brother" (van Gogh-Bonger 1959, p. liii).

The brothers who had been so deeply united in life were not to be separated long by death. Within two months, Theo's illness worsened and he became feverish and delusional; he died of general paresis, the endstage of tertiary syphilis. His illness was compounded by the intensity of his grief. His increasing irritability and rage attacks led to episodes of uncontrollable violence that terrified Jo and Andries Bonger. At one point he threatened to kill Jo and his son. He soon suffered a complete mental breakdown and was put in an asylum because he was considered dangerous. His condition improved sufficiently for Jo to take him back to Holland, where he died on January 25, 1891, only six months after Vincent. Some years later, she had his remains transferred to Auvers-sur-Oise and buried beside Vincent where they remain united for all time.

The Curse of the Gods

The suicide looms in retrospect as an almost inevitable endpoint to the course of Vincent's life—as though the program had somehow been deterministically laid down at the moment of his birth so that his life was an inexorable reading out and realization of this curse of the gods. His hopelessness and desperation were compounded out of a deep sense of his own inadequacy and failure, mixed with a deep sense of resentment that those who were close to him, to whom he looked for support, love, affection and acceptance, had let him down, turned away from him and deserted him in his hour of direst need—Theo, mother, father, and the rest. Vincent's experience of the deterioration of his artistic powers coupled with the immense threat posed by Theo's marriage, which meant the dissolution of the intense symbiotic bond between them, were powerful contributing factors of both failure and loss. Vincent was caught in the throes of painful feelings of abandonment and loss that had reached an intolerable level. Perhaps the most important factor in all of this was the disruption of his symbiotic bond with Theo that became increasingly threatened by Theo's marriage, his wife's pregnancy, and the birth of their son, a third Vincent who was to replace Vincent himself from the center of Theo's attachment.

He had a dreaded premonition that haunted his footsteps. He told Theo:

> My words may sound gloomy, very well. For myself, there are moments when
> my own prospects seem very dark to me—but as I already wrote you, I do not
> believe that my fate depends on what seems against it. All kinds of things may
> be against me, but there may be one thing more powerful than what I see threat-
> ening me. I used the word fatality for lack of a better word—no one falls before
> his time—so as for me, I resign myself to fate, and act as if nothing were the
> matter.(Letter 342)

At another point he wrote to Theo:

> You understand so well that 'to prepare oneself for death,' the Christian idea
> (happily for him, Christ himself, it seems to me, had no trace of it, loving as he
> did people and things here below to an unreasonable extent, at least according to
> the folk who can only see him as a little cracked)—if you understand so well that
> for to prepare oneself for death is idle . . . can't you see that similarly self-
> sacrifice, living for other people, is a mistake if it involves suicide, for in that
> case you actually turn your friends into murderers. (Letter 492)

There is no question that Vincent lived on the border of suicide most of
his life and that the idea was often on his mind. "I then felt an inexpressible
melancholy inside, which I cannot possibly describe. I know that then I of-
ten, often thought of a manly saying of father Millet's: *Il m'a toujours semblé
que le suicide était une action de malhonnéte homme* [it has always seemed
to me that suicide was the deed of a dishonest man]. The emptiness, the un-
utterable misery within me made me think, Yes, I can understand people
drowning themselves" (Letter 212).

Vincent's life story is a saga of tragic proportions, a history of defeat,
failure, rejection, failures of understanding and empathy, disappointment, dis-
illusionment, and hopeless decline into the abyss of madness and suicide. In
the face of this tragic progression, Vincent found meaning and purpose and a
degree of sustaining strength in his relation to Theo, symbiotic and ambiva-
lently dependent though it was, and in his total immersion and dedication to
his art. In the course of our ensuing discussions I will offer a further hypothe-
sis—that it was the transformation of Vincent's religious inspiration and de-
votion into his art that became the driving and sustaining force for his restless
search for meaning in his life and for the uniquely personal quest for his own
tortured and fragmented identity.

Section III

THE ARTIST'S VOCATION

Chapter VI
ART AND THE ARTIST

Transition—From Religion to Art

We can return to the point at which Vincent's life course began to follow the second path that marked out his destiny—the path that led to his career as an artist. After the failure of his religious mission in the fall of 1880, Vincent seems to have emerged from the crisis with new resolve and determination. The death of his religious vocation was followed by a new birth of his existence as an artist. Rose (1987) describes the process in the following terms: "Van Gogh's annunciation of his identity as an artist might be taken as an instance of the motif in the symbolic mode of death and rebirth. Between October 1879 and July 1880 he was in silent misery and did not write a single letter. He concluded this gestating silence of nine months by informing brother Theo that he was emerging renewed like a bird after molting time, reborn as an artist who would 're-create' rather than imitate" (p. 122).

There were signs along the way of his increasing dissatisfaction with religion and a gradual turning toward art as the solace for his inner pain and loneliness. Each defeat and disappointment in life drove him further along the path. He took up sketching more and more frequently. He wrote Theo: "How rich art is; if one can only remember what one has seen, one is never without food for thought or truly lonely, never alone" (Letter 126). And further:

> Well, even in that deep misery I felt my energy revive, and I said to myself, In spite of everything I shall rise again: I will take up my pencil, which I have forsaken in my great discouragement, and I will go on with my drawing. From that moment everything has seemed transformed for me The too long and too great poverty had discouraged me so much that I could not do anything. . . . Though every day difficulties crop up and new ones will present themselves, I cannot tell you how happy I am to have taken up drawing again. I had been thinking of it for a long time, but I always considered the thing impossible and beyond my reach. But now, though I feel my weakness and my painful dependence in many things, I have recovered my mental balance, and day by day my energy increases. (Letter 136)

His letters are filled with talk about art; nursing the poor and sick no longer obsesses him. He wrote again: "I feel a power in me which I must develop, a fire that I may not quench, but must keep ablaze, though I do not know to what end it will lead me, and shouldn't be surprised if it were a gloomy one. In times like these, what should one wish for? What is relatively the happiest fate?" (Letter 242).

Art as Personal

As Schapiro (1983) observes, "What is most important is that van Gogh converted all this aspiration and anguish into his art, which thus became the first example of a truly personal art, art as a deeply lived means of spiritual deliverance or transformation of the self; and he did this by a most radical handling of the substance of his art" (p. 12). His paintings became the objects of his instinctual power, his loves, his sexual objects, his offspring. He told Theo, "The work is an absolute necessity for me. I can't put it off, I don't care for anything but the work; that is to say, the pleasure in something else ceases at once and I become melancholy when I can't go on with my work" (Letter 288). And he constantly experienced frustration at the slow pace of progress in the development of his technique. He wrote Theo:

> It remains a constant disappointment to me that my drawings are not yet what I want them to be. The difficulties are indeed numerous and great, and cannot be overcome immediately. Making progress is like miner's work: it doesn't advance as quickly as one should like, and also as others expect; but faced with such a task, patience and faithfulness are essential. In fact, I don't think much about the difficulties, because if one thought of them too much, one would get dazed or confused. (Letter 274)

He made no bones about the fact that his immersion in art was his hedge against the desperate depression that dogged his heels. As he told Theo: "The more I am spent, ill, a broken pitcher, by so much more am I an artist— a creative artist—in this great renaissance of art of which we speak. These things are surely so, but this eternally living art, and this renaissance, this green shoot springing from the roots of the old felled trunk, these are such abstract things that a kind of melancholy remains within us when we think that one could have created life at less cost than creating art" (Letter 514).

Vincent had spent the early years of his life searching desperately for that place in the world where he could find meaning, purpose and a sense of mission in his work and his life. Nothing had provided him the sense of dedication and total involvement for which he thirsted. Art became for him the vehicle for gaining some degree of satisfaction of these powerful needs and purposes. He told Theo:

> In my opinion, I am often *rich as Croesus*—not in money, but rich—because I have found in my work something to which I can devote myself to heart and soul, and which inspires me and gives a meaning to life. Of course my moods change, but the average is serenity. I have a firm *faith* in art, a firm confidence in its being a powerful stream which carries a man into a harbor, though he himself must do his bit too; at all events, I think it such a great blessing when a man has found his work that I cannot count myself among the unfortunate. I mean, I may be in certain relatively great difficulties, and there may be gloomy days in my life,

but I shouldn't like to be counted among the unfortunate, nor would it be correct if I were. (Letter 274)

I will suggest, as we go more deeply into this aspect of Vincent's inner life, that Vincent's art was driven by an almost demonic, even fanatical, need to find expression, to communicate himself in meaningful ways to his fellow-men and to the world, to find meaning, purpose and belonging through the medium of his art, and finally to pour into it all the intensity and fervor of his deeply religious instincts. It became his chosen vehicle for seeking not only his own identity and place in the world, but of seeking and finding God. Vincent's art was more than a career, more than the mastery of a technique—it was a mission, an apostolate, a crusade, a powerful impulse to create and express that drained his capacity to the depths and brought him to the brink of destruction.

The Childhood of an Artist
All of his searching was in the service ultimately of finding himself and bringing meaning into his life that would satisfy needs that had their roots deeply embedded in the soil of his early life experience. Some partial glimpses into these obscure developmental anlage can be found in the analysis of the role of the family romance in the development of the artist (Greenacre 1958). The family romance is a general developmental phenomenon, but seems to play a particularly significant role in creative artists. Greenacre describes the phenomenon in these terms: "The germ of the family romance is ubiquitous in the hankering of growing children for a return to the real or fancied conditions at or before the dawn of conscious memory when adults were Olympians and the child shared their special privileges and unconditional love without special efforts being demanded" (p. 10).

Such well organized fantasies emerge most clearly in the early latency period and reflect a strong degree of unresolved ambivalence toward the parents, usually corresponding to unresolved oedipal conflicts. The ambivalence is usually reinforced by the residues of unresolved ambivalence from the anal period, or equivalently the rapprochement crisis (Mahler et al. 1975), in which aspects of good and bad take extreme black-and-white forms as applied both to the child's sense of self and to the parents. If it is true that the potential artist brings to this development a special endowment of heightened perceptiveness and sensitivity, then the raw material out of which he fashions his emerging sense of himself and his parents will have somewhat different characteristics. If one of the parents can provide a model for identification that can sustain the burden of idealization and the marks of greatness and can maintain a satisfactory affective relation to the child, or even without the

stamp of greatness one of the parents can sustain a belief in the child's potential for greatness, the chances for the child to fulfill his creative destiny are enhanced (Greenacre 1958). For Vincent, these optimal conditions were entirely lacking. Yet, even in the face of his harsh devaluation from his father and the indifferent failure of maternal empathy, Vincent managed to create an idealized image of his father and sought desperately to gain approval and acceptance from this Olympian subdeity.[1] As Greenacre observes: "Yet the developing gifted child, even in very untoward circumstances, will sometimes be able to find a temporary personal adult substitute or even to extract from a cosmic conception some useful personalized god conception on which to project his necessary ideal for his father and himself to enable him to develop further" (p. 11). This seems closer to Vincent's pattern.

For the potential artist, the inborn qualities of greater sensory responsiveness and sensitivity carry with them effects of heightened intensity in interpersonal relations and a more imaginative and animated connection with inanimate objects. Greenacre (1958) refers to these as the "field of collective alternates." The psychological effects can be seen in precocious development, greater diffusion of boundaries between libidinal phases, greater intensity and prematurity of oedipal development, greater difficulty in relinquishing oedipal strivings, and possibly disturbances in the perception of the external world and of emotional involvements with other human beings. All of these implications would seem to have their place in Vincent's story.

The dynamics of the family romance carry an added burden in the child's sense of difference from his social group. As Greenacre (1958) comments: "Whether unusual precocity has developed or the reverse picture of blocking and pseudostupidity is uppermost, in either case the child of great potential creativeness often feels different and strange among his colleagues, and at a time when, as in adolescence, there is a strong wish to conform, the family romance furnishes a further rationalization for this sense of difference and is reinforced by it" (pp. 32–33).

Inevitably, the child of genius is a lonely child. His sense of difference makes him feel isolated, and often as a result inferior. When the artist finally finds the medium of creative expression and is able to immerse himself in it, only then does the sense of loneliness find relief. As Greenacre puts it: "I believe that this realization of ability is often of great relief to extremely talented people, not so much because of the narcissistic gratification of recognition and not because of realization of balance and harmony, but because of the temporary interruption of essential loneliness" (p. 35). These findings could hardly find more poignant application than to Vincent, and will have important implications for understanding the role of his art in his psychic life (Bak

1958). Vincent's love for and immersion in nature, for example, became one the collective alternates that played a significant role in his artistic life.

Artistic Values

At the time of his dismissal from Goupil's for incompetence in 1876, many of his attitudes toward art and particularly art dealers had already hardened. As Hamilton (1967) observes, ". . . he had learned to loathe the insincerity with which art dealers, to his mind, preferred the popular article to the true work of art; but his own conception of artistic value was queerly muddled. From the lessons he had heard from his father's pulpit and his own conception of Christian charity, he believed the best art was that which expressed the sufferings of the poor" (p. 94). As Elgar (1966) notes: "Everything he did at this period expressed grief, poverty, irremediable melancholy and the pitiable condition of labourers, helpless old men, deserted women and orphans" (p. 56).

In his mind's eye, art and life were indistinguishable, synonymous. As Walther and Metzger (1990) comment: "The vehemence with which he asserted his concept of art was simply an aggressive manifestation of a deep-rooted artistic insecurity. His very existence was alien to him. . . . It is pointless debating in which respect he felt more of a stranger, the aesthetic or the existential. The two were interdependent. If life should fall, it would take Art with it. And if Art were to fail, Life too would be at an end" (p. 315). Writing to the English painter Levens, he said: "I dare say as certain anyone who has a solid position elsewhere let him stay where he is. But for adventurers as myself, I think they lose nothing in risking more. Especially as in my case I am not an adventurer by choice but by fate, and feeling nowhere so much myself a stranger as in my family and country" (Letter 459a). For "fate," the psychoanalyst would read "the unconscious."

The sense of empathy and desperation that permeates the sketch of a crushed and weeping old man (F702, JH1967), the pathos and depth of human feeling that stares out at us from the face of a peasant woman (F74, JH648), these tell us more profoundly than any words of Vincent's sense of identification with the poor, the downtrodden, the outcasts of this world. He felt a deep sense of communion and identification with peasants and those who worked with their hands (F41, JH513; F129a, JH727). He told Wil:

> Don't misfortune and disease do the same thing to us and to our health; and if fate ordains that we be unfortunate or sick, are we not in that case worth more than if we were serene and healthy according to our own vague ideas and desires with regard to possible happiness? When I compare them with others, some of my pictures certainly show traces of having been painted by a sick man,

and I assure you that I don't do this on purpose. It's against my conscious will that all my calculations end in broken tones. (Letter W16)

He felt a sense of communion and identification with the poor and humble, with those who worked in the sweat of their brows and carried the burdens of the world—especially miners and weavers:

> The miners and the weavers still constitute a race apart from other laborers and artisans, and I feel a great sympathy for them. I should be very happy if someday I could draw them, so that those unknown or little-known types would be brought before the eyes of the people. The man from the depth of the abyss, *de profundis*—that is the miner; the other, with his dreamy air, somewhat absent-minded, almost a somnambulist—that is the weaver (F30, JH479; F24, JH500). I have been living among them for two years, and have learned a little of their unique character, at least that of the miners especially. And increasingly I find something touching and almost sad in these poor, obscure laborers—of the lowest order, so to speak, and the most despised—who are generally represented as a race of criminals and thieves by a perhaps vivid but very false and unjust imagination. (Letter 136)

He learned much from Rembrandt and especially Millet whose conception of the heroic aspects of peasant life he embraced fully. He told Theo, ". . . yet I am trying to get at something utterly heartbroken and therefore utterly heartbreaking" (Letter 503).

Mauve

In the wake of the Kee affair and the confrontation with his parents, Vincent moved out and decided to return to The Hague. He immediately contacted Anton Mauve, a prominent painter of the day who was also a distant relative, to begin learning the craft of the artist. Mauve was close to the Hague School, devoting his efforts to capturing the mysteries of nature in paintings of woods and beaches, even groups of laboring peasants in the fields. He was a strong-willed man, self-assured and confident—to the point of arrogance. Mauve presented a strong and forceful personality, but this hypomanic facade had its darker side. Mauve, much like Vincent himself, suffered from periodic bouts of depression that often made him irritable and petulant, and at times brought with them the threat of suicide.

Mauve tried to urge Vincent to move from sketching and drawing to painting in oils. Vincent was reluctant and held back. The hesitation was in part due to his fear of failing in a new and more difficult form of art. He was quick to defend himself, emphasizing as always drawing from real subjects rather than from memory (Letter 221).

The transition from drawing to painting posed a significant obstacle for him. The highly personal style he had developed in his drawing would translate only uncertainly to the medium of oil. It would actually take years before the combination of coloring and draftsmanship that marked his unique style would be realized. As he increasingly withdrew from any meaningful connection with his fellowmen, he became more and more immersed in his art and in his communion with nature. Nature became increasingly alive for him, as though it were endowed with human characteristics and emotions. At the same time, his feeling for the poor and downtrodden deepened and became colored with religious overtones. He undertook study of the Bible with a tutor and attached the greatest importance to it. The links between his religious thinking and his art were beginning to be forged.

In the Hague, Vincent continued his isolated and eccentric ways. He did not find an easy relationship with his fellow artists either. Hulsker (1990) writes of him at this period:

> In spite of his social ideals and his longing for friendship, Vincent remained a lonely worker. He was not an easy character to deal with, and he often repelled his colleagues by the force of his convictions and his stubbornness. In addition, he called himself a laborer and wanted to be one; he felt more at ease among workmen and peasants than in "salons" or among artists. Moreover, in his opinion there was not a friendly atmosphere between the artists in The Hague. (p. 150)

He wrote Theo: "Here in The Hague there are clever, great men, I readily admit it; but in many respects what a miserable state of affairs—what intrigues, what quarrels, what jealousy. And in the personality of the successful artists who, with Mesdag at their head, set the tone, material grandeur is certainly substituted for moral grandeur" (Letter 252). Part of the difficulty stemmed from Vincent's involvement with Sien which was playing itself out during this same period from late 1881 until the end of 1883.

Trouble with Mauve

For a time things seemed to go well, but not for long. Mauve's patience wore thin, and we can guess that his arrogance and sharp irritability wore on Vincent. Vincent's style was so unorthodox, his sensitivity so delicate, his resistance to any suggestion or advice so reactive and violent that Mauve couldn't tolerate it for long. Vincent did try to follow Mauve's advice and his suggestion that he practice sketching from plaster casts, but when Mauve criticized Vincent's drawings, Vincent's patience quickly wore thin and in a fit of temper he smashed the casts to bits proclaiming that he wanted to draw from real life, "And I thought, I will draw from those casts only when they

become whole and white again, and when there are no more hands and feet of living beings to draw from" (Letter 189). Understandably Mauve's patience also began to wear thin and he began to put Vincent off. Vincent, for his part, was far from a receptive or appreciative student.

As the rift deepened, Mauve refused to see or have anything to do with Vincent. When Vincent finally left the Hague in September 1883, rebelling and abandoning this attempt at artistic training, he had come to hate the world with all its conventions, artificialities, and superficialities. He was at the same time agonized over the loss of his relationship with Sien. He presented himself as a misfit, a fanatic, one who was not fit to live in this world. There is so much in Vincent's life that speaks to his powerful struggles to rid himself of depression and loneliness. The motif of loneliness pervaded his existence; he saw himself as "a prisoner who is condemned to loneliness." He yearned for closeness and intimacy, but these blessings posed their own threat to his innermost being. It meant absorption, merger, loss of self and integrity. Yet his determination was so intense, so ferocious, that it repelled those to whom he turned for solace and connection; it led inevitably to conflict and disillusionment, to frustration and disappointment. It drove people away from him, even those who came closest to him in the course of events—the members of his family, his fellow artists, the women he became attached to, and so on.

The Art Academy

Vincent moved to Drenthe, where he struggled to continue his artistic efforts, only to realize that his efforts to master technique without help were doomed to frustration and delay. His next move was to Antwerp where he determined to study in the art academy. His existence was meager: art materials were expensive, and he had to choose between weakness and hunger, and the expenditure of the little money he received from Theo for art supplies. Art came first. He lived on nothing but a little bread, some cheese and coffee. He suffered continually from internal pains, a persistent cough, and soon lost ten of his teeth (Letters 221 and 448). He was literally starving. He also discovered that he had contracted a venereal disease, and had to be hospitalized for a time.

Unfortunately, he could never conceal his antipathy to academic instruction. To Theo he wrote: "In fact, in my opinion the drawings that I see there are all hopelessly bad and absolutely wrong, and I know for sure that mine are totally different. Time will tell who is right" (Letter 445). His instructors did not know what to do with this rebellious student; their criticisms were met with resistance and stubborn independence. The people he knew in his childhood were poor, rustic, and relatively primitive, and he grew to respect and

teeth

love their peasant virtues and strengths. His identification with them as downtrodden and outcast nourished his rebellious individualism. He resisted formal education because it meant submission to the tyranny of discipline and abiding by conventional rules and regulations. Throughout his career he resisted and rebelled against efforts of others to teach or advise him, particularly where it impinged on the area of his genius.

An Artist Among Artists
He finally dropped out of the academy and continued to live in the slums, surrounded by tramps, thieves and whores. And he continued to struggle with his painting, trying to master it without instruction. In the face of his impoverished and starving condition, he decided that he had no recourse but to go to Paris and seek help from Theo. He arrived on February 28, 1886 and moved in with Theo.

For the first time, Vincent had the opportunity to associate with and exchange ideas with other artists of first rank. Perhaps his closest association at the time was with Emile Bernard and Toulouse-Lautrec, both young and struggling artists, yet to make their significant mark on the world of art. But he also able to study the works of Pissarro, Gauguin, Seurat, and the initiators of the impressionist movement. Particularly, he and Gauguin seemed to hit it off and to talk about prospects for joining forces in some form of artistic community together.

Obstinate individualist that he was, Vincent nonetheless began somewhere in this period to evolve a cherished idea—a dream of a community of artists who would provide each other a sense of community and support. The members of this fellowship of artists could share with each other the terrible responsibilities of the artist's vocation; together they could run the same risks and keep despair and frustration at bay by their mutual sharing of support and their exchange of feelings and ideas. This was Vincent's utopia—an illusion never to be realized.

Among his fellow artists, he was regarded as a difficult, stubborn and at times frightening character. The few friendships he had were soon tested to the breaking point by his argumentativeness, his unbending opinions, and his harsh and critical attitudes toward the work of other artists. But he himself had little tolerance for criticism. After Rappard's criticism of "The Potato Eaters" (F82, JH764), his response was hurt, resentful, angry, and bitter (Letters R52 and R57). He ended his diatribe with the following:

> Nevertheless it makes life difficult at times, and—I think it quite possible that later on some fellows will regret either the things they said of me or the opposition and indifference which they have pestered me with. The way I see it is this: I withdraw from people to such an extent that I literally don't meet anybody ex-

cept—the poor peasants—with whom I am directly concerned because I paint them. And this will remain my policy, and it is quite possible that I shall give up my studio before long and go live in a peasant's cottage, so as not to hear or see educated people—as they call themselves—any longer. (Letter R57)

The last words make it clear that the object of Vincent's wrath was not simply Rappard, the most immediate cause of his wounded narcissism, but all those who had failed him, disappointed him, rejected him along the way. The unconscious or at least implicit targets of his wrath were his parents, other members of his family, and those who had rejected or ignored him and his deep yearning for acceptance and love. As he told Rappard:

I have had the very same kind of trouble for a great number of years with a great number of people. When I protested against it once in a while and said that I didn't deserve it, things got worse and worse, and they wouldn't listen to another word about it. My parents and my whole family. Tersteeg, and along with him a lot of fellows who knew me when I was with Goupil & Co., went so far in their disapproval of *all* my doings that these last years, instead of wasting any more time on attempts to convince them, I, who have no time to waste, have simply given them the cold shoulder in my turn—*and let them say, think, do whatever they like without minding it the least little bit.* (Letter R54)

In the summer of 1887 Vincent fell into a deep depression: he had nowhere to go, no friends, no home. He complained to Theo:

At times I already feel old and broken, and yet still enough of a lover not to be a real enthusiast for painting. One must have ambition in order to succeed, and ambition seems to me absurd. I don't know what will come of it; above all I should like to be less of a burden to you . . . for I hope to make such progress that you will be able to show my stuff boldly without compromising yourself. And then I will take myself off somewhere down south, to get away from the sight of so many painters that disgust me as men. (Letter 462)

Vincent was a mystery to his fellow artists; many thought his work strange and eccentric, if not at the same time interesting. His style was so direct, totally unconcerned with any artistic conventions, so unorthodox in technique, brushwork, use of colors, the intensity, the unbridled expression and intensity of feeling that permeated his canvases. To many his work seemed rough, unrefined, unskilled, and undisciplined—as though there were little to distinguish between the works and the man. Gauzi, Toulouse-Lautrec's close friend, recalled: "He worked with a disorderly fury, throwing colors on the canvas with feverish speed. He gathered up the color as though with a shovel, and the globs of paint, covering the length of the paintbrush, stuck to his fingers. When the model rested, he didn't stop painting. The

violence of his study surprised the atelier; the classically oriented remained
bewildered by it" (Cited in Stein (1986), pp. 71-72).

Despite his poverty and isolation, he continued his self-denying and as-
cetical path. If he inspired criticism and antagonism in some, he drew more
sympathy and even admiration from others. Even Gauguin, whose relation-
ship with Vincent was complex and troubled, has left us his own poetized im-
pression of Vincent:

> Avant. Winter '86—The snow is beginning to fall, it is winter; I will spare you
> the shroud, it is simply the snow. The poor people are suffering: often the land-
> lords do not understand that.
>
> Now, on this December day, in the rue Lepic of our good city of Paris, the
> pedestrians hasten more than usual without any desire to dawdle. Among them a
> shivering man, bizarrely outfitted, hurries to reach the outer boulevard. Goatskin
> envelops him, a fur cap—rabbit, no doubt—the red beard bristling. Like a cow-
> herd. Do not observe him with half a glance; do not go your way without care-
> fully examining, despite the cold, the white and harmonious hand, the blue eyes
> so clear, so childlike. Surely this is a poor beggar.
>
> His name is Vincent van Gogh. Hastily, he enters the shop of a dealer in
> primitive arrows, old scrap iron, and cheap oil paintings. Poor artist! You put a
> part of your soul into the painting of this canvas that you have come to sell. It is
> a small still life—pink shrimps on pink paper. "Can you give me a little money
> for this canvas to help me pay my rent?" "My God, my friend, the clientele is
> becoming difficult, they ask me for cheap Millets; then, you know," the dealer
> adds, "your painting is not very gay. The Renaissance is in demand today. Well,
> they say you have talent, and I want to do something for you. Here, take a hun-
> dred sous." And the round coin clinked on the counter. Van Gogh took the
> coin without a murmur, thanked the dealer, and went out.
>
> Painfully, he made his way back up the rue Lepic. When he had almost
> reached his lodgings, a poor woman, just out of Saint-Lazare, smiled at the
> painter, desiring his patronage. The beautiful white hand emerged from the
> overcoat: Van Gogh was a reader, he thought of la fille Elisa, and his five-franc
> piece became the property of the unfortunate girl. Rapidly, as if ashamed of his
> charity, he fled, his stomach empty. (Cited in Stein (1986), pp. 95-96)

And we might wonder if Vincent had not seen in the face of the poor woman
a vision of Sien whom he had loved and lost, who had been in his eyes the
very embodiment of sorrow (F1655, JH259).

The Artist's Vocation

Vincent's pride and fierce independence were continually at stake. He re-
fused to comply with the conventions of acceptability in the art world, refused
to paint for the satisfaction of buyers or dealers, refused to compromise his
principles for the sake of success. He told Rappard: "Art is jealous, and de-
mands our whole strength; and then, when one devotes all one's powers to it,

to be looked upon as a kind of unpractical fellow and all kinds of other things—yes, that leaves a bitter taste in one's mouth" (Letter R9). And to Theo he proclaimed:

> Art is jealous, she does not want us to choose illness in preference to her, so I do what she wishes. . . . I want you to understand clearly my conception of art. One must work long and hard to grasp the essence. What I want and aim at is confoundedly difficult, and yet I do not think I aim too high. I want to do drawings which *touch* some people. . . . In either figure or landscape I should wish to express, not sentimental melancholy, but serious sorrow. In short, I want to progress so far that people will say of my work, He feels deeply, he feels tenderly—notwithstanding my so-called roughness, perhaps even because of it. . . . What am I in most people's eyes? A nonentity, or an eccentric and disagreeable man—somebody who has no position in society and never will have, in short, the lowest of the low. Very well, even if this were true, then I should want my work to show what is in the heart of such an eccentric, of such a nobody. This is my ambition, which is, in spite of everything, founded less on anger than on love, more on serenity than on passion. It is true that I am often in the greatest misery, but still there is a calm pure harmony and music inside me. I see drawings and pictures in the poorest huts, in the dirtiest corner. And my mind is drawn toward these things by an irresistible force. (Letter 218)

He often complained to Theo of the burden of the artist's vocation, of the pain it caused him, the sacrifices he had to make for the sake of producing pictures, the threat it posed to his very life: "But my dear boy, my debt is so great that when I have paid it, which all the same I hope to succeed in doing, the pains of producing pictures will have taken my whole life from me, and it will seem to me then that I have not lived" (Letter 557).

His life became an unremitting saga of deprivation, isolation, and rejection. His health suffered seriously. His only thought was for his art, and nothing else seemed to matter. To Theo he wrote:

> Not only did I begin drawing relatively late in life, but it may also be that I shall not live for so very many years. . . . as to the time ahead in which I shall still be able to work, I think I may safely presume: that my body will keep a certain number of years . . . between six and ten, for instance. . . . I do *not* intend to spare myself, nor to avoid emotions or difficulties—I don't care much whether I live a longer or a shorter time; . . . So I go on like an ignoramus who knows only this one thing: *"In a few years I must finish a certain work."* (Letter 309)

A Crisis

The conjunction of several events had a severe impact on Vincent in his last months. The first was the sale of his painting "The Red Vineyard" for about 400 Belgian francs, the equivalent of about $80, a fair price for the time. This was the only painting he sold during his lifetime. The painting was purchased

by Anna Boch, sister of Eugene Boch and a painter in her own right. It was the first glimmer of the success that Vincent yearned for so desperately, yet dreaded so profoundly.

The second came in the form of critical acclaim. Some of his paintings were included in the exhibition of "Les Vingt" in Paris early in the year and came to the notice of art critics—a favorable review by J. J. Isaacson, a Dutch artist and critic, appeared in the fall of 1889. The struggle between Vincent's narcissistic and exhibitionistic wishes to find recognition and praise from the Parisian art critics and his abiding sense of unworthiness, inadequacy, and shame-faced inferiority found decisive expression here. Vincent could accept no praise unless his work were to reach and even surpass the lofty heights of artistic perfection that he envisioned and ambitioned. His impulse was to dismiss Isaacson's praise and to beat a humble retreat into obscurity. Vincent wrote to his sister Wil: "That good fellow Isaacson wants to write an article about me in one of the Dutch papers, on the subject of pictures which are exactly like those I am sending you, but reading such an article would make me very sad, and I wrote to tell him so. . . ." (Letter W15).

About the same time he wrote to Theo: "No need to tell you that I think what he says of me in a note extremely exaggerated, and that's another reason why I should prefer him to say nothing about me. And in all these articles I find, side by side with very fine things, something, I don't quite know what, that seems to me unhealthy" (Letter 611). Finally he wrote to Isaacson himself:

> Back in Paris I read the continuation of your articles on impressionism. Without wanting to enter into a discussion of the details of the subject that you have attacked, I wish to inform you that it seems to me that you are conscientiously trying to tell our fellow-countrymen how things are, basing yourself on facts. As it is possible that in your next article you will put in a few words about me, I will repeat my scruples, so that you will not go beyond a few words, because it is *absolutely certain* that I shall never do important things. (Letter 614a)

Aurier

If Isaacson's praise had discomfited Vincent, the worst was yet to come; the next salvo would wreak a severe impact—an onslaught of crisis proportions. In the beginning of the year, a young Parisian art critic, Albert Aurier, published an article on Vincent in *Mercure de France*. Aurier had studied the paintings Vincent had left in Theo's apartment and wrote a review that was "quite laudatory" (Letter T21). Aurier's comments were in fact an outpouring of praise; he first described Vincent's painting in dazzling terms and hailed his artistic genius:

Beneath skies that are now cut into the dazzling of sapphires and turqoises, now molded out of some unknown, infernal sulfurs, hot, pernicious, and blinding; beneath skies similar to rivers of blended metals and crystals, where, sometimes, incandescent torrid solar disks blaze out; beneath the unending and formidable shimmering of all possible lights; in the heavy, flaming, burning atmosphere, which seems to be exhaled by fantastic furnaces in which gold, diamonds, and singular gems are volatilized—it is a disquieting and disturbing display of a strange nature, at once truly true and quasi supernatural, of an excessive nature, where everything, beings and things, shadows and lights, forms and colors, rears up and rises in a raging desire to howl its own essential song, in the most intense and the most savagely shrill tone: there are trees, twisted like giants in battle, proclaiming with the gesture of their gnarled, menacing arms, and with the tragic soaring of their green manes, their indomitable power, the pride of their musculature, their sap warm like blood, their eternal defiance of the hurricane, of lightning, of malevolent nature; there are cypresses shooting up their nightmarish silhouettes of blackened flames; mountains arching their backs like mammoths or rhinoceroses; white and pink and blond orchards, like the idealizing dreams of virgins; squatting houses, passionately contorted, as if they were beings who rejoice, suffer, and think; rocks, lands, undergrowths, lawns, gardens, rivers that one would have said were sculpted from unknown minerals, polished, reflecting, iridescent, magical; there are flaming landscapes like the effervescence of multicolored glazes in some diabolical crucible of the alchemist, foliage that one would say was antique bronze, new copper, spun glass; beds of flowers which are less flowers than the richest jewelry made from rubies, agates, onyxes, emeralds, corundrums, chrysoberyls, amethysts, and chalcedonies; there is the universal and mad and blinding coruscation of things; it is matter, it is nature frantically twisted, in paroxysm, raised to the extreme of exacerbation; it is form becoming nightmare, color becoming flames, lavas and precious stones, light setting fire to itself, life a burning fever.

And of the artist himself:

What characterizes his work as a whole is excess, excess of strength, excess of nervousness, violence in expression. In his categorical affirmation of the character of things, in his often fearless simplification of forms, in his insolence in challenging the sun face to face, in the vehement passion of his drawing and color, right down to the smallest particulars of his technique, a powerful figure reveals himself, a man, one who dares, very often brutal, and sometimes ingenuously delicate. And even more, this is revealed in the almost orgiastic excesses of everything he has painted: he is a fanatic, an enemy of bourgeois sobrieties and petty details, a kind of drunken giant, better suited to moving mountains than handling knickknacks, a brain in eruption, irresistibly pouring its lava into all the ravines of art, a terrible and maddened genius, often sublime, sometimes grotesque, always close to the pathological. . . . (Cited in Pickvance, 1986, pp. 310-312)

He finished with a prophetic flourish:

Vincent van Gogh, indeed, is not only a great painter, enthusiastic about his art, his palette and nature; he is, furthermore, a dreamer, a fanatical believer, a devourer of beautiful Utopias, living on ideas and dreams. . . . The external and material side of his painting is absolutely in keeping with his artistic temperament. In all his works, the execution is vigorous, exalted, brutal, intense. His drawing, excited, powerful, often clumsy and somewhat heavy-handed, exaggerates the character, simplifies, leaps—master and conqueror—over detail, attains a masterful synthesis and sometimes, but by no means always, great style. . . . This robust and true artist, a thoroughbred with the brutal hands of a giant, the nerves of a hysterical woman, the soul of a mystic, so original and so removed from the milieu of our pitiful art of today, will he one day know—anything is possible—the joys of rehabilitation, the repentant flatteries of fashion? Vincent van Gogh is at once too simple and too subtle for the contemporary bourgeois spirit. He will never be fully understood except by his brothers, the true artists (Cited in Stein (1986), p. 193)

Aurier seems to have captured one of the salient features of Vincent's work as an artist—the strange quality of fusion between Vincent's inner psychic world, his psychic reality, and the world of forms and color he created on the canvas. The boundaries between the man and his work seem to have dissolved, inner conflicts seem to find their way into graphic and pictorial representation, color and form and texture seem to be suffused with inner meaning and power, the dynamic forces that contended within Vincent's inner world seem to have erupted onto the canvas with vividness and vitality rarely seen in the world of art. Aurier's vivid and dramatic description of Vincent's work seems to reflect the power and force of this quality.

Vincent's Reaction

Aurier's article appeared in January 1890, and in the beginning of February Vincent wrote to Theo:

I was extremely surprised at the article on my pictures which you sent me. I needn't tell you that I hope to go on thinking that I do not paint like that, but I do see in it how I ought to paint. . . . he simply tells me that there is something good, if you like, here and there in my work, which is at the same time so imperfect; and that is the comforting part of it which I appreciate and for which I hope to be grateful. Only it must be understood that my back is not broad enough to carry such an undertaking, and in concentrating the article on me, there's no need to tell you how immersed in flattery I feel So if some sort of reputation comes to you and me, the thing is to try to keep some sort of calm and, if possible, clarity of mind. (Letter 625)

Soon after, Vincent suffered a severe relapse into another period of psychosis from which he did not recover for several weeks. He then wrote home: "As soon as I heard that my work was having some success, and read

the article in question, I feared at once that I should be punished for it; this is how things nearly always go in a painter's life: success is about the worst thing that can happen" (Letter 629a). He wrote later to Wil: "But when I had read that article I felt almost mournful, for I thought: I ought to be like that, and I feel so inferior. And pride, like drink, is intoxicating, when one is praised, and has drunk the praise up. It makes one sad, or rather . . . the best work one can do is what is done in the privacy of one's home without praise" (Letter W20). Vincent was finally able to write to Aurier himself; the tone is self-effacing:

> Many thanks for your article in the Mercure de France, which greatly surprised me. I like it very much as a work of art in itself, in my opinion your words produce color, in short, I rediscover my canvases in your article, but better than they are, richer, more full of meaning. However, I feel uneasy in my mind when I reflect that what you say is due to others rather than to myself. . . . *For the part which is allotted to me, or will be allotted to me, will remain, I assure you, very secondary.* (Letter 626a).

His letters to other family members reflect the shame that pervaded his sense of his own work and his value as an artist (Letters 627 and W20).

And finally, with a note of desperation and anguish, he wrote to Theo: "Please ask M. Aurier not to write any more articles on my painting, insist upon this, that to begin with he is mistaken about me, since I am too overwhelmed with grief to be able to face publicity. Making pictures distracts me, but if I hear them spoken of, it pains me more than he knows. . . ." (Letter 629).

Clearly Aurier's article and the attention it drew to Vincent's work made the artist uncomfortable and distressed in no small degree. These reactions seem to suggest the components of shame and the fear of success that pervaded Vincent's artistic efforts and his identity as an artist—as we shall see, all expressions of the relatively pathogenic narcissistic issues that were such a dominant part of Vincent's personality and pathology.[2]

Chapter VII
CREATIVITY

Art as Creative

Nagera (1967) has speculated that painting for Vincent was not only an act of creation, but in unconscious terms an act of procreation. He spoke often of "giving birth" to his pictures, and his unconscious fantasy may have been that Theo was his partner in the creation of these "babies." This view would connect Vincent's creativity with underlying passive, feminine, homosexual wishes, so that Theo becomes a replacement for the lost father as an object of Vincent's homosexual yearnings. Vincent had had his own impulses to marry, but these had all miscarried—either because he had been rejected or his choices were doomed to an unfortunate outcome. His move to Arles apparently signaled a decisive change—he had renounced all hopes and wishes for marriage and a family. Does it make sense to think that this energy now became focused on his canvases so that they became the objects of the intensity and fury of his emotional and libidinal life? In the last two years of his life, after all, he produced more than half of his prodigious output, and many of them his greatest works.

He wrote to Theo:

> Ah! portraiture, portraiture with the thoughts, the soul of the model in it, that is what I think must come. . . . So I am always between two currents of thought, first the material difficulties, turning round and round to make a living; and second, the study of color. I am always in hope of making a discovery there, to express the love of two lovers by a wedding of two complementary colors, their mingling and their opposition, the mysterious vibrations of kindred tones. To express the thought of a brow by the radiance of a light tone against a sombre background. To express hope by some star, the eagerness of a soul by a sunset radiance. Certainly there is no delusive realism in that, but isn't it something that actually exists? (Letter 531)

Art—The Mirror of the Man

Vincent's art is noteworthy for its intensely personal quality and for the powerful sense of communication with nature it conveys—whether that be in the sweep of open fields of wheat, the tortured ruggedness of torn and twisted trees, the majestic panorama of the sky and its burning candles of light, or the delicate beauty and vibrant color of flowers. But all Vincent's painting carries the stamp of Vincent: it is an expression of something within himself, emanating in some unfathomable way from the tip of his brush. He wrote Theo, "I still can find no better definition of the word art than this, '*L'art*

c'est l'homme ajoute à la nature' [art is man added to nature]—nature, reality, truth, but with a significance, a conception, a character, which the artist brings out in it, and to which he gives expression, *'qu'il degage,'* which he disentangles, sets free and interprets" (Letter 130). Or, as he put it in a later letter, "Not always literally exact, or rather never exact, for one sees nature through one's own temperament" (Letter 399).

All of Vincent's painting is in this respect biographical. Even the objects that appear in his canvases contain a symbolic meaning. Discussing the meaning of the books in his paintings, Walther and Metzger (1990) remark:

> These books are not attributes. They are not signs of erudition or great scholarliness such as we see in portraits time and again. They represent van Gogh himself—just as the chairs or shoes do. . . . Van Gogh's symbols, though, no longer have any universal relevance; . . . If we are to decode their meaning we need to be familiar with the life of the artist and the significance he saw in them; . . . In van Gogh, this referential immediacy now makes sense only in relation to the artist himself. He alone possesses the key to the deeper meanings. Those who would fathom them will need his help. (p. 312).

His canvases reflect Vincent's sense of union with the idealized and godlike imagery of his artistic vision and emphasize once again the intensity and pervasiveness of his religious preoccupations—that his palette and brush were the instruments of his communication with and immersion in the divine. His art became the replacement for the fanatical devotion with which he pursued his religious vocation. Gedo (1983) comments:

> Without an understanding of Vincent's religious convictions, as reflected both in his writings and his visual art, it is extremely difficult to assess the impact of his religiosity on his creative activities. Even a superficial reading of the correspondence reveals van Gogh's maximally serious involvement with cosmological issues; consider, for example, his penetrating statement in the fall of 1888, just three months before his psychotic episode, that he was continuously in danger of losing himself in the contemplation of Eternity. (p. 117).

And Tralbaut (1969) noted: "Vincent's first aim was to 'serve' mankind, even though he had relinquished his religious ambitions. He intended his art to add to the dignity of man, and not merely to be a means of earning his living. It was a high and rare ambition. Moreover there was bound to be a conflict between any artistic technique, whether taught in an academy or learnt from a manual, and Vincent's strong and ever-growing sensibility" (p. 75).

At one point Vincent wrote to Rappard:

> art is something greater and higher than our own adroitness or accomplishments or knowledge; that art is something which, although produced by human

hands, is not created by these hands alone, but something which wells up from a deeper source in our souls; and that with regard to adroitness and technical skill in art I see something that reminds me of what in religion may be called self-righteousness. . . . Let us try to master the mysteries of technique to such an extent that people are deceived by it and will swear by all that is holy that we have *no* technique. Let our work be so savant that it seems naive and does not stink of our sapience. (Letter R43)

The Visual

Attention has been drawn to Vincent's intense visual sensitivity. He himself noted his acute reactions to color: ". . . in general all the impressionists are . . . under the same influence, and we are all of us more or less neurotic. This renders us very sensitive to colors and their particular language, the effect of complementary colors, of their contrasts and harmony" (Letter W20). As Lubin (1972) put it, in his art Vincent became an eye. Vision became for him a devouring, consuming, omnivorous capacity and passion—it was his preferred sensory modality for contact with the world around him, especially the world of nature. This unusual visual sensitivity seems to reflect an inborn aspect of Vincent's unusual talent.

Greenacre (1957) has argued that exceptional artistic potential is accompanied by heightened sensory sensitivity, exceptional capacity to sense relations between various stimuli, a capacity for empathy that is wider and deeper than the normal, and sufficient sensorimotor intactness to allow for expressive motor discharge. These abilities contribute an enhanced awareness of similarities and differences, greater reactivity to the form and rhythm of incoming stimulus patterns, and in consequence a greater sense of organization or gestalt, actual or potential. The empathy reflects a sensory attunement not only to external objects but to one's own bodily states, leading to a capacity for imaginative animation of the inanimate and for projective anthropomorphizing of the world of Nature. This phenomenon is by no means foreign to normal children, but it is usually lost in the course of development; in the creative artist it remains active in some form (Greenacre 1957).

One might almost think that Greenacre had Vincent in mind. Vincent's attunement to the form and rhythm of the external world was cast in a mold of imaginative animation that even influenced his depiction of space and perspective. Heelan (1972), for example, commented:

There are a number of paradoxes about Van Gogh's forms . . . and the space in which they are pictured: the forms are often distorted but look intensely 'real'; they are created in a perspective system that is not controlled by an abstract set of rules with which we are familiar, although we sense that it is connected with the structure of Van Gogh's active looking or sighting or involvement with things; the space looks realistic, organized with respect to an observer, like a

stage space, but it is not objective like one constructed according to Euclidean rules, since it is dynamically created by the artist and for him; foreground objects protrude but depth lines plunge to a finite horizon. (p. 478)

This view is reinforced by Schapiro's (1983) observation that

Van Gogh . . . hastens convergence, exaggerating the extremities in space, from the empathic foreground to the immensely enlarged horizon with its infinitesimal detail. . . . Linear perspective was for him no impersonal set of rules, but something as real as the objects themselves, a quality of the objects he was sighting. This paradoxical device—both phenomenon and system—at the same time deformed things and made them look more real: it fastened the artist's eye more slavishly to appearance but also brought him more actively into play in the world. . . . in many of Van Gogh's first landscape drawings, the world seems to emanate from his eye in a gigantic discharge with a continuous motion of rapidly converging lines. (pp. 29-30).

Enhanced sensory sensitivity can both intensify particular experiences or broadened them to include secondary objects that may be related to the primary object of infancy in regard to their potential to produce similar sensory experiences. Greenacre (1957) uses the example of the infant's experience of the mother's breast. The complex of sensory elements might impinge on the gifted infant more intensely than his normal counterpart, and he might consequently react more intensely to similar elements of sight, sound, smell, taste, and touch stemming from other rounded objects in his sensory field. The reaction that this sets off, the greater need for harmonizing inner object relationships with sensory impingements, opens the way to the "collective alternates" that are meant to describe this range of expanded experience.

Seeing and Being Seen

In Vincent these factors were compounded with defensive needs that reflected important aspects of his psychopathology. For him seeing was better than being seen: in his self-portraits he felt the power to present himself as he wished to be seen, while the models in the other portraits he painted were exposed rather than himself. He transformed the pain of being looked at into the power of looking—shame was translated into awe. Lubin (1972) explains:

The transformation of the visual core of shame, the pain of being looked at, into the awe of looking was especially important in his artistic development. Awe signifies a sense of being overwhelmed by the greatness and majesty of a person or object; feelings of reverence, wonder, or fear often accompany it. Shame and awe are related. Both are concerned with contrasts between superior and infe-

rior and with vision, although in shame one is observed while in awe one is the observer. (pp. 209-210).

Vincent often expressed his feelings of awe in relation to idealized figures in his life as well as in the presence of nature. Such awe made him feel small and insignificant in contrast to the power and magnificence of the object. Greenacre (1956, 1957) has connected this phenomenon to the experience of penis awe, presumably related to the child's visual exposure to the adult tumescent penis. This sense of awe easily translates into a displacement and communication to external forms in the manner of collective alternates.

Painting was a device for mastering and containing these distressful feelings of inferiority and helplessness. The object could be visualized and captured on canvas, so that in mastering the object Vincent was able to contain his own inner feelings of shame and fear. In his mastery of the object on the canvas, he no longer had to experience the painful awesomeness of the real object and could escape his own feelings of insignificance and impotence. Greenacre (1957) observed with regard to the transformations of the object of awe:

> In the gifted one, however, the individual object may be only apparently relinquished, to appear rather in a glorified collective form which becomes the object of the love for a time. The ideals seem to be extended even more than the prohibitive conscience is developed, as the oedipal wishes are expanded, apparently desexualized by their deflection from a personal genital aim, but not renounced. . . . it does not produce an abandonment of the oedipal object but only a bypassing of this in favor of the larger collective, more powerful one. (pp. 58-59).

Nature became Vincent's collective alternate, the object of displacement for these powerful psychic themes.

Greenacre (1957) emphasized a point that may have maximal import for our understanding of Vincent. The balance of these influences in the gifted child has a powerful influence on incipient ego development, particularly on the development of the child's self-image or representation, or on the structural components that form the core around which his sense of self is constructed (Meissner 1978b). Unfortunately for Vincent, he did not have available appropriate objects that would allow him to consolidate a healthy and positive sense of himself by appropriate and constructive internalizations. Following Greenacre, Rose (1987) postulates a characteristic split in the artistic sense of identity:

> . . . the urgency of these pressures emanating from the creative self competes for attention and commitment with the person's ordinary world of social stereotype. This struggle between the conventional or social self and the creative self often

causes yet another kind of split: a split in the sense of identity. It is one which may well continue into the adult life of the future artist. Depending on changing circumstances, the balance may swing now toward the urgency of creative needs, now toward the demands of ordinary life. . . . there is a lively if often adversarial [two-way conscious] communication between the self-organizations—both between the conventional and creative identity, as well as within the private world where the reality sense is held in temporary abeyance until it is reinstated. (pp. 112-113).

I would add to this view of the splitting in the artistic consciousness and sense of self that Vincent's inner world was afflicted by other forms and degrees of splitting and internal fragmentation, especially during the period of his acute illness toward the end of his life. But the inner uncertainty and dissociative quality of his personality structure was a feature of his life adjustment well before its tragic close.

Experimentation

Vincent's sojourn in Paris was in many ways an eye-opening experience for him. His contacts with the group of inventive and radical young artists there literally opened his eyes to new dimensions and possibilities in art. He learned much from Bernard, Denis, Pissarro, and Gauguin. He began to experience and assimilate the revolutionary techniques and attitudes toward color that were being developed by the Impressionists. Seurat particularly impressed him. He propounded a theory of esthetics in which ". . . a sense of calm and order in painting is obtained by a balance of light and dark tones, of cool and warm colors, and by establishing an equilibrium between horizontal and vertical forms. Gaiety results from a dominance of light or luminous tones, warm colors and lines that seem to spring upward; sadness by the opposite" (Wallace 1969, p. 74).

Vincent understood and admired Seurat's theory, even though emotionally the two occupied quite opposite positions. For a time he tried to emulate Seurat's work and adopt some of his techniques. But Vincent's painting instincts lay in different directions. What he learned from Seurat (or more likely from Paul Signac, Seurat's close friend and advocate) was a new approach to the rendering of light and color, especially the use of complementary colors, a skill he developed with great effect in some of his later paintings.

During his stay in Paris he experimented with different techniques and styles in the use and mixing of colors. The tone and quality of his palette changed dramatically. He experimented with brilliant colors and different brush techniques. But in Arles, under the brilliant sun of the Midi, his use of

colors broke out into riotous and exuberant expression. There his immersion in and communion with Nature reached its apogee.

The "Night Cafe"

I have suggested that for the most part Vincent's paintings can be viewed as expressions of his inner psychic life, self-portraits after a fashion, distilling his inner turmoil into vivid forms and brilliant colors. Lubin's (1972) analysis of "The Night Café" (F463, JH1575) reflects something of this process. First, Vincent's own description of the painting: "In my picture of the 'Night Café' I have tried to express the idea that the café is a place where one can ruin oneself, go mad or commit a crime. So I have tried to express, as it were, the powers of darkness in a low public house, by soft Louis XV green and malachite, contrasting with yellow-green and harsh blue-greens, and all this in an atmosphere like a devil's furnace, of pale sulphur" (Letter 534).[1]

The scene is "like a devil's furnace," suggestive of hell and damnation, terrible passions and sinfulness—"a place where you can be ruined, go mad and commit crimes." The patron-father stands by the billiard table on which there lies a long cue with billiard balls at its base, its tip pointed at the soft-tender counter with its vaginal opening behind. Lubin suggests the primal scene quality of these images, the fantasy of parental intercourse as a brutal and destructive, but nonetheless exciting, assault. Hamilton (1967) suggests that there is something violent even about the technique: "In its very execution the painting is a demonstration of passion, so thickly are the impastos built up, so violent the discrepancies between the original visual experience and the pictorial interpretation. The harsh and tragic expressiveness of the Night Café is a clue to Vincent's inner turmoil at the time" (p. 100). The sexually stimulating atmosphere of Arles and its climate of violence, typified by the frequent bullfights, may have stirred these unconscious residues in Vincent's unconscious.

The lights in the café are surrounded by dazzling halos of contrasting orange and green. The effect can be associated to a visual effect described by Greenacre (1947) in children suddenly exposed to a frightening and bewildering sight. She writes: "There is generally the sensation of lights, flashes of lightning, bright colors or of some sort of aurora. This may seem to invest the object, or objects seen, or it may be felt as occurring in the subject's own head experienced literally as seeing lights or seeing red. This is depicted in comic strips as seeing stars. The initial experience always produces the most intense emotions, whether of awe, fear, rage, or horror" (p. 132).

Was Vincent's painting of the café expressing a regressive and traumatic experience based on a repressed memory of an early primal scene experience? The character pathology Greenacre describes in these traumatized

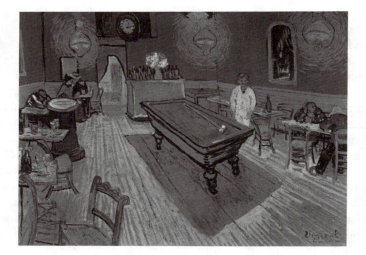

Figure 1. "The Night Café" (F463, JH1575)
Yale University Art Gallery, New Haven

children is a fair description of Vincent: "Mastery is attempted by . . . the development of several binding superego reaction-formations of goodness which are supplemented by or converted into lofty ideals. . . . Figuratively, the child develops a halo to which, if it remains too burdensome, he reacts either by throwing it defiantly away—conspicuously in some psychopathic and psychotic states—or by endowing someone else with it" (p. 133). Vincent certainly fills the bill—his "lofty ideals" were distilled into his identification with Christ, an identification that he both lived out unconsciously and that he rebelled against in angry defiance. Likewise he invested these lofty ideals in his father whom he idolized and sought to emulate. This ideal too he turned against in anger and bitter disappointment.

His painting of his own bedroom (F482, JH1608) was done soon after, and deliberately contrasted with the café. If the one was violent, the other was quiet, relaxing, and tranquil.[2] Was the bedroom scene intended to deny the passions aroused and expressed in the café painting? There are no performers, no one in the bed, only the framed pictures of a man and a woman above the bed—perhaps a neutralizing displacement from the bed to containing frames above it. Does the one painting represent an attempt to master and contain the anxieties unleashed in the other?

There is also a curious detail—Vincent did two sketches of the bedroom as well as the painting. The first sketch has a portrait of a woman above the bed, but in the second sketch, done the next day, it is replaced by a landscape. The composition and general impression of the woman's head corresponds to a drawing of his mother that he finished about the same time (F477, JH1600). The drawing of his mother's face was then replaced by a painting of nature. Do we catch a glimpse here of a basic process in Vincent's mind in which his own mental image of his mother was replaced by the imagery of Mother Nature? Was it in the bosom of Nature that he found the only surcease and tranquillity that he was to know?

Art as Transitional

Within the psychoanalytic framework, the quality by which the art object is suffused and transformed by personal ingredients of the artist himself would seem to reflect an understanding of the work of art as resulting from the artist's creative involvement in transitional experience. The notion of transitional experience and transitional phenomena emerged from the work of Donald Winnicott, who originally described the child's use of transitional objects in negotiating the shift from dependence on the mothering object to gradual involvement with reality. The origins and implications of transitional experience and the significance of the realm of illusion have a special place in the

developmental life of the infant as well as in the creative experience of the artist.

The infant's capacity to create illusory experience emerges even in the earliest context of breast feeding. The good mother is empathically attuned to and identified with the child in a way that allows her to respond to the child's emerging need, providing what is needed in the right place, in the right amount, and at the right time. Her responsiveness sets the stage for the infant's use of illusion, without which, in Winnicott's terms, any meaningful contact between psyche and environment becomes impossible. The empathic mother presents the breast to the child's mouth at just the moment when the child creates a corresponding illusion of the breast. Her response facilitates the illusion for the child that he has indeed created the breast. This optimal adaptation between mother and child fosters an illusion that there is a world corresponding to the infant's needs and to his capacity to create.

This perspective on transitional experience is echoed by Gombrich (1963), who wrote:

> In the language of the nursery the psychological function of 'representation' is still recognized. The child will reject a perfectly naturalistic doll in favour of some monstrously 'abstract' dummy which is 'cuddly'. It may even dispose of the element of 'form' altogether and take to a blanket or eiderdown as its favourite 'comforter'—a substitute on which to bestow its love. . . . Once more the common denominator between the symbol and the thing symbolized is not the 'external form' but the function. (p. 4)

The child's transitional object is any object—often a blanket, or a stuffed animal, a piece of cloth, usually something soft and cuddly—that the child becomes attached to and holds as a valued possession. In Winnicott's view, the transitional object is a substitute for the mother, the first possession in the external world that enables the child to begin to turn from his infantile attachment to the mother toward the outside world. No human being is ever free from the tension of relating inner to outer reality. The transitional notion can even be further extended to embrace the idea that human psychological development and functioning can be envisioned as a life-long "transitional process" involving a dynamic oscillation and process of interchange in which the self is viewed as an open system continuously engaged in influencing and being influenced by the outside world (Rose 1978). The term "transitional process" suggests that there is a dynamic equilibrium between a more or less fluid self and an external reality, not limited to the transitional object experience of childhood, but continuing into adult life.

Moreover, this view would envision that the process of adaptation in everyday life demands an element of creative originality and imagination that re-

flects a continuing transitional interplay between self and reality. This is reminiscent of the capacity to "imagine the real" (Lynch 1960). Each human being selects, abstracts, and creates an idiosyncratic and unique *Umwelt* of his own by which he integrates his sense of reality. The exchange between the inner and the outer worlds takes place in unique and important ways in the realm of cultural experience.

Winnicott (1971) further argues that relief from this unending tension is gained only in the intermediate area of illusory experience, which remains unchallenged even in the life of the adult as, for example, in the arts and religion. He comments: "Should an adult make claims on us for our acceptance of the objectivity of his subjective phenomena we discern or diagnose madness. If, however, the adult can manage to enjoy the personal intermediate area without making claims, then we can acknowledge our own corresponding intermediate areas, and are pleased to find a degree of overlapping, that is to say common experience between members of a group in art or religion or philosophy" (p. 14).

Play can also become part of the child's transitional experience. Winnicott emphasizes certain aspects of the playing experience that underscore its illusory character. The playing of the young child is marked by preoccupation; content is secondary but the state of relative withdrawal plays an important role. This withdrawal is analogous to states of concentration in older children and adults; through it the child enters an area that neither is easily left nor easily admits intrusion. This area of playful illusion is not part of the child's inner psychic reality; it is at the same time external to the individual and not part of the external world.

There the child gathers external objects, investing them with meanings and feelings derived from his subjective world—Gombrich's (1963) hobby horse. Play also has an inherent excitement that derives not from instinctual arousal but from the precariousness of the interplay between the child's subjectivity and what is objectively perceived and received. Winnicott notes that there is a direct development from the appearance of transitional phenomena to the capacity for play and from isolated play to shared playing, and hence from shared playing to the capacity for cultural experience. The creative impulse requires the capacity to invest in the products of one's activity while at the same time retaining the capacity to surrender them, even to destroy them, to make way for new creations. Both the creating and the destroying have their place in the play of children and serve to consolidate the child's capacity to be in, make use of, and at the same time retreat from the area of illusion.

Essential to the notion of transitional experience is the place it holds as neither a piece of objective reality nor a purely subjective phenomenon; rather it holds a middle ground in which it simultaneously participates in both. This

notion of transitional phenomena can be applied to various aspects of adult experience. As in the case of the child's transitional object, transitional phenomena in the adult stand midway between the inner and outer worlds. As Modell (1968) observed: "The transitional object is not completely created by the individual, it is not a hallucination, it is an object 'in' the environment. It is something other than the self, but the separateness from the self is only partially acknowledged, since the object is given life by the subject. It is a created environment—created in the sense that the properties attributed to the object reflect the inner life of the subject" (p. 35).

The adult residues of transitional phenomena find their most significant expression in the realm of cultural experience. Winnicott (1971) approaches this problem by locating cultural experience in the potential space that arises between the experiencing individual and his environment. Here the analysis of play is especially pertinent, since cultural experience has its origin in the play of children. The capacity of each individual to create and use this potential space is different and is determined by his early life experiences, particularly his earliest experience with objects, out of which the capacity for transitional experience evolves. The cultural life of any human individual, then, is determined by the fate of the potential space that arises between the baby and the human (that is, fallible) mother.

The Transitional and the Creative
This area of cultural experience joins the individual's personal psychic reality and the actual world of activity and interaction that constitutes the individual's environment and can be objectively perceived, as the vital areas of human experience and psychically meaningful activity. This is initially the area of childhood play, which subsequently expands into a capacity for creative living and for cultural experience.

Basic to the cultural experience is the manner in which man transforms or transfigures his environment and the objects it contains by attributing to objects, shapes, and figures in the real world a symbolic value and meaning. Through culture, man introduces the external realm into the inner world of personal significance. In this fashion, all art involves permeating external forms with subjective meaning. This creative transformation can be seen in the earliest human art forms, for example, the cave art of Cro-Magnon man (Modell 1968, 1970). The appearance of these paleolithic relics corresponds with the appearance of *Homo sapiens* on the European continent. The paintings are found in the dark recesses of limestone caves and were created under the sparse illumination of oil lamps. Undoubtedly, they were incorporated into the performance of magical and religious rites, so that these caves may

be regarded as sacred places of an archaic religion. They are among the earliest examples of the blending of art and religion.

Moreover, the paleolithic artist utilized the characteristics of the actual surface of the cave walls to create his representations. The cavities produced by the dripping of water on the stone are sometimes used to represent animals' wounds. Rounded protuberances of rock are transformed into bison; stalagmites, into bison rearing on their hindquarters. A hole in the rock becomes the pupil of a bison's eye. As Modell (1970) pointed out, the created environment fuses with the real environment, so that the cave art becomes a creative illusion that provides the participant in the magical religious rite with a sense of mastery over the elemental forces of life and death. In the logic of the magical sphere, acting on the symbolic animal representation would influence the real world and what happened to the real animal, thereby creating a world of illusion in which all distinction between symbol and object was lost and omnipotent magical wishes had their play.

Art in our modern world and culture no longer carries the primitive magicoreligious expectation and the wish for omnipotence that seem to have been essential to paleolithic cave art. But the artist still creates an illusion, still brings together in imaginative fusion the created and the real environments to produce an area of illusory experience. The potential space of which Winnicott speaks arises in the process of artistic creation itself, as a place where the real materials with which the artist works—canvas and oils, wood, stone, cloth, clay, and so on—can receive the imaginative vision, the creative impulse by which he transforms material from the real, external environment into something that has meaning, value, implication.

The creative capacity of any artist seems linked with his capacity to maintain the continuity of transitional experience. The prolongation of transitional experience provides the psychic matrix within which the artist can ". . . explore the external and the internal anew and to invent, play with, and enact symbols akin to the initial discovering we all experienced as the differentiation of self from nonself progressed" (Oremland 1989, p. 27). Oremland (1989) summarizes this perspective in a lapidary formula: "Creativity parallels the transitional period. The creative object, like the transitional object, is part self, part primal other (the mother), and yet separate from both" (p. 119).

Vincent's Creative Experience

What does this digression into transitional experience and artistic illusion have to do with Vincent? It seems reasonable to say that Vincent lived his life more immersed in illusion than in reality. Reality was toxic for him—he could not tolerate it, he did not know how to deal with it, it only brought him pain, disappointment, bitterness and frustration. He struggled desperately to

mold the world to his needs, to see it in terms of his wishes and hopes rather than in terms of the harsh realities of sacrifice and disappointment it held for him. His illusions dominated every phase of his life, and brought with them the inevitable burden of disappointment, frustration, failure and disillusionment. The *Umwelt* that he created around him was not a pleasant place to live; it was colored by the dynamic forces that shaped his psychic life from the beginning, forces that left him feeling that he was the outcast, the stranger on the earth, the unloved, rejected, unwanted, inadequate and disappointing failure to all he knew and tried to love. In a sense, Vincent lived in a transitional space of tragic illusion.

When he picked up his palette and brushes and approached the canvas, he entered another transitional space that held special qualities for him. That space was a refuge from the harsh world of reality and human expectations and demands that he so passionately rejected and scorned. For Vincent to draw or to paint was to retreat from the world and to enter a sphere of special and magical relevance, a sphere in which he could create his own world, re-shape the world of nature to fit his own inner vision and express the pathos and powerful contortions of his soul. Aurier's description of Vincent's painting[3] opened a window to that world of creative illusion that possessed Vincent's heart, mind and soul. It is difficult to draw a line between the man and his works—they are the same, or at least seem to be mutual reflections of each other. All of Vincent's paintings are a projective expression and realization, through the medium of his art, of himself, of the pain, the power, at times of the delicacy, the sensitivity, as well as the inner struggle and force of his tormented psyche. As he stood before the easel, the canvas became a kind of projective device that revealed as well as any projective test the dynamic forces at work within him, a kind of spontaneously created Rorschach on which he poured himself out in a torrent of creative activity.

Section IV

ART AND RELIGION

Chapter VIII
RELIGIOUS THEMES

Art as Religion

Vincent struggled heroically throughout most of his life with his inner pain and torment. He sought desperately, with fanatic intensity, to find solace, meaning, hope, and some way of salvaging his shattered sense of self in his religious devotion and dedication. These hopes were shattered and left him even more tormented and tortured, disillusioned and depressed. He tried to medicate himself with alcohol and absinthe, drugging himself night after night to the edge of oblivion, but the pain always returned with the same relentless intensity.

The only surcease from this agony was in painting. It became his religion. He painted with intensity, ferocity, unstinting devotion, impervious concentration and endurance. He was at his drawing board or easel for seemingly endless hours. Painting became his consuming passion, his obsession, his world, his life. There was nothing else in this world that he seemed to be concerned about. He seemed to escape from life into his painting. Only the slenderest threads tied him to reality—his attachment and dependence on Theo, his residual feelings for his family—and these were fraught with painful ambivalence. He cared nothing for himself, his food, his clothes, only his work, his art, his need to create and paint. As his sometime friend Rappard wrote to Vincent's mother after his death, "Whoever had witnessed this wrestling, struggling and sorrowful existence could not but feel sympathy for the man who demanded so much of himself that it ruined body and mind. He belonged to the breed that produces the great artists" (Cited in Tralbaut 1969, p. 71).

Art became the replacement for all other attachments, all other goals, all other meaningful involvements in his life. It became an all-consuming passion that displaced and dissolved all others. It became the substitute and displacement for the most powerful drives and commitments of any human life—sex and religion. Vincent poured into his art all the intensity of his instinctual life, both libidinal and aggressive, and made his devotion to his art a substitute religion to which he committed himself with total abandon and unreserved self-immolation. He commented, "An artist needn't be a clergyman or a churchwarden, but he certainly must have a warm heart for his fellow men" (Letter 240).

Nature

The first arena in which Vincent's profound religious impulse found expression was his immersion in and love of nature. Vincent's love affair with nature began in childhood. He was drawn to it, admired it, was fascinated and absorbed by it at least from his latency years. His immersion and delight in contemplating nature remained a constant feature of his experience at all phases of his passage. Almost every page of his voluminous letters carries observations and at times poetic reflections on nature. He was never without a sense of the beauty of nature and never far from contemplative immersion in it. This devotion and almost mystical absorption was displayed in his canvases, so many of which portray not only the beauty and power of nature, but Vincent's uniquely personal and idiosyncratic immersion in nature.

In his latency years, he developed a love of nature and collected natural specimens as a hobby (Elizabeth du Quesne-Van Gogh, cited in Stein (1986), p. 32). Vincent's early fascination with nature was reflected in some of his early artistic efforts. His sensitivity to the complexity and beauty of nature and his absorption in it would become hallmarks of his mature art.

Vincent's remarkable immersion in and devotion to nature has possible connections to the dynamics of the family romance as noted by Greenacre (1958).[1] One consequence of the family romance is the identification of the artist with God and nature, or the assimilation of nature to God. This occurs "through the force of the own body feelings which respond to and cause a kind of amalgamation of body imagery with outer forms in the world" (p. 34). Vincent's immersion in nature, through which nature was recreated on his canvases, may have brought about an unconscious sense of fusion between his own sense of self and the power and beauty of nature as it revealed itself to his eyes. This dynamic may involve what Greenacre calls a "collective alternative," a kind of "cosmic emotional relationship" that serves as a basic component of the family romance of the artist—the idealized cosmic image or abstraction becomes a substitute or replacement for the image of the idealized parent of the family romance. It is in this same vein that nature came to embody Vincent's profound religious impulse.

The intensity of the emotional relationship between the artist and his art, as Oremland (1989) points out, ". . . for most creative individuals is lifelong, and although easily romanticized by the less gifted, is as beset with jealousy, disappointment, feelings of abandonment by, ecstatic union with, replenishment from, finding fulfillment in, and searching for verification through as is the interpersonal relationship for the less gifted" (p. 25). The artist's art can be regarded as a developmental derivative from and transformation of the primary object, a form of transitional relatedness to the mother of infantile experience. If so, it offers some understanding of the peculiar relation be-

tween Vincent and his canvases, particularly the studies of nature and the in-
animate world, and the manner in which they seem to take on an inner life
that is communicated and shared through the artist's brush.

Nature became personalized, humanized, ensouled—so to speak. He
wrote:

> Sometimes I have such a longing to do landscape, just as I crave a long walk to
> refresh myself; and in all nature, for instance in trees, I see expression and soul,
> so to speak (F394, JH1379; F652, JH1843; F586, JH1854; F403, JH1378). A
> row of pollard willows sometimes resembles a procession of almshouse men
> (F122, JH522). Young corn has something inexpressibly pure and tender about
> it, which awakens the same emotion as the expression of a sleeping baby, for in-
> stance (F1024, JH336). The trodden grass at the roadside looks tired and dusty
> like the people of the slums. A few days ago, when it had been snowing, I saw a
> group of Savoy cabbages standing frozen and benumbed, and it reminded me of
> a group of women in their thin petticoats and old shawls which I had seen
> standing in a little hot-water-and-coal shop early in the morning. (Letter 242).

For him paintings done from the immediacy of nature had a special personal
quality.

We can entertain at this point an hypothesis regarding Vincent's profound
immersion in nature and its deeper unconscious meaning for him. After the
failure of his religious mission, he had turned in bitter disappointment, disil-
lusionment, and rebellious antagonism against the convention religion of the
established churches and, more poignantly, his father. His failure to gain ac-
ceptance and acknowledgment from his overly idealized, even idolized, father
turned him against all conventional religion. His abandonment of traditional
forms of religion coincided with his turning from religion to art as the locus of
his vocation. The god of the churchmen was replaced by the god of nature—
the god of the father, I would argue, was replaced by the god of the mother.
The mother, whose unconscious image in Vincent's mind was linked with
echoes of unempathic remoteness and depressive withdrawal, became the
collective alternative embodied in nature—the fulfillment of the metaphor of
Mother Nature. Vincent's devotion to and lifelong quest for immersion in the
beauty and power of Nature was a reverberation and displacement of his un-
satisfied and unremitting quest for closeness, union, affective acknowledg-
ment, and loving acceptance that he had continually been denied in his rela-
tion with his real mother. In the depths of his unconscious, these infantile
longings had been distilled into his love of Nature and became amalgamated
to the parallel yearning for loving acceptance from his God. This statement
of the hypothesis can be little more than tentative at this point, but subsequent

reflections may provided additional support. However, a suggestive line of thought comes from Ernst Kris (1952), who observed:

> The artist does not "render" nature, nor does he "imitate" it, but he creates it anew. He controls the world through his work. In looking at the object that he wishes to "make," he takes it in with his eyes until he feels himself in full possession of it. Drawing, painting, and carving what has been incorporated and is made to reemerge from vision, is a two-pronged activity. Every line or every stroke of the chisel is a simplification, a reduction of reality. The unconscious meaning of this process is control at the price of destruction. But destruction of the real is fused with construction of its image: When lines merge into shapes, when the new configuration arises, no "simile" of nature is given. Independent of the level of resemblance, nature has been recreated. . . . In analytic observation of individuals who turn to art as a profession or preferred occupation, dynamics akin to those summarized here can occasionally be traced far into childhood. . . . Furthermore, manipulatory performances in painting and sculpture are .likely to stimulate aggressive and libidinal strivings, which are both part and parcel of the archaic "making" of things. The perceptual process which precedes and accompanies the actual production, the process in which the model becomes the artist's own, revives even earlier instinctual impulses; power over the model may have the unconscious meaning of its incorporation. (pp. 51-53)

Vincent's struggles to immerse himself into and master the mysteries of Nature may have reflected not unsimilar dynamics and meanings.

Vincent had thrown off the conventions of academic art and insisted that the artist's vision embraced things not as they seemed or were perceived, but as they felt. Replying to criticisms of his work, he wrote Theo:

> Tell Serret that *I should be desperate if my figures were correct*, tell him that I do not want them to be academically correct, tell him that I mean: If one photographs a digger, *he certainly would not be digging then*. Tell him that I adore the figures by Michelangelo though the legs are undoubtedly too long, the hips and the backsides too large. Tell him that, for me, Millet and Lhermitte are the real artists for the very reason that they do not paint things as they are, traced in a dry analytic way, but as *they*—Millet, Lhermitte, Michelangelo—feel them. Tell him that my great longing is to learn to make those very incorrectnesses, those deviations, remodelings, changes in reality, so that they may become, yes, lies if you like—but truer than the literal truth. (Letter 418).

His painting of "The Potato Eaters" (F82, JH764) is one of his most poignant expressions of his effort to bring the reality and simplicity of peasant life into being on canvas. He told Theo:

> I have tried to emphasize that those people, eating their potatoes in the lamplight, have dug the earth with those very hands they put in the dish, and so it speaks of *manual labor*, and how they have honestly earned their food. . . . But

he who prefers to see the peasants in their Sunday best may do as he likes. I personally am convinced I get better results by painting them in their roughness than by giving them a conventional charm. . . . If a peasant picture smells of bacon, smoke, potato steam—all right, that's not unhealthy; if a stable smells of dung— all right, that belongs to a stable; if the field has an odor of ripe corn or potatoes or of guano or manure—that's healthy, especially for city people. (Letter 404)

The Creative Experience

He has left us some suggestion of what his experience of this artistic communication with nature was like:

In a certain way I am glad I have not *learned* painting, because then I might have *learned* to pass by such effects as this. Now I say, No, this is just what I want— if it is impossible, it is impossible; I will try it, though I do not know how it ought to be done. *I do not know myself* how I paint it. I sit down with a white board before the spot that strikes me, I look at what is before my eyes, I say to myself, That white board must become something; I come back dissatisfied—I put it away, and when I have rested a little, I go and look at it with a kind of fear. Then I am still dissatisfied with what I made of it. But I find in my work an echo of what struck me, after all. I see that nature has told me something, has spoken to me, and that I have put it down in shorthand. In my shorthand there may be words that cannot be deciphered, there may be mistakes or gaps; but there is something of what wood or beach or figure has told me in it, and it is not the tame or conventional language derived from a studied manner or a system rather than from nature itself. (Letter 228)

He explained to Rappard:

It must not surprise you that some of my figures are so entirely different from the ones that I sometimes make after the model. I very seldom work from memory—I hardly practice that method. But I am getting so used to being confronted immediately with nature that I am keeping my personal feelings unfettered to a far greater extent than in the beginning—and I get less dizzy—*and I am more myself just because I am confronted with nature*. If I have the good fortune to find a model who is quiet and collected, then I draw it repeatedly, and then at last a study turns up which is different from an ordinary *study*—I mean more characteristic, more deeply *felt*. . . . When once I *feel*—I *know*—a subject, I *usually* draw three or more *variations* of it—whether it is figure or landscape—but every time and for each one I consult nature. And I even *do my best not to give details*—for then the dreaminess goes out of it. And when Tersteeg and my brother, and others, say, "What is this, is it grass or cabbage?"—then I answer, "*Delighted* that *you* can't make it out." (Letter R37)

At times the intensity of his concentration drew him into a dream-like state of almost mystical contemplation. "I have a terrible lucidity at moments, these days when nature is so beautiful, I am not conscious of myself any more, and the picture comes to me as in a dream. I am rather afraid that this

will mean a reaction and depression when the bad weather comes, but I will try to avoid it by studying this business of drawing figures from memory" (Letter 543). Even landscapes required a depth of understanding and an intimacy born of long immersion and contemplation. He wrote: "Many landscape painters do not possess the same intimate knowledge of nature as those who have looked lovingly at the fields from childhood on. Many landscape painters give something which (though we appreciate them as artists) satisfies neither you nor me as human beings. . . . The real thing is not an absolute copy of nature, but to know nature so well that what one makes is fresh and true—that is what so many lack" (Letter 251).

Nature and God

Early on, the conflict between his religious inclinations and his love of nature played itself out—a conflict that would translate into the related conflict between his adherence to the religion of his father and his love of art and nature. In 1875 he wrote: "A feeling, even a keen one, for the beauties of nature is not the same as a religious feeling, though I think these two stand in close relation to one another. Almost everybody has a feeling for nature—some, more; some, less—but a few feel that God is a spirit and whoever worships Him must worship Him in spirit and in truth" (Letter 38). He continued to struggle for years over the relationship between religion and the love of nature and art that became an ever more dominating theme in his experience. The margins of the prints that he hung on his bedroom wall were filed with biblical quotations—presumably an effort to wed art and religion. He wrote, "When you say in your last letter, 'What a mystery nature is,' I quite agree with you. Life in the abstract is already an enigma; reality makes it an enigma within an enigma. And who are we to solve it? However, we ourselves are an atom of that universe which makes us wonder: Where does it go, to the devil or to God?" (Letter 242).

He sought to find the face of God in Nature—in the fields, the sea, the trees and waving sheaves of wheat. He wrote Theo:

> It seems to me it's a painter's duty to try to put an idea into his work. In this print I have tried to express (but I cannot do it well or so strikingly as it is in reality; this is merely a weak reflection in a dark mirror) what seems to me one of the strongest proofs of the existence of *"quelque chose la-haut"* [something on high] in which Millet believed, namely the existence of God and eternity— certainly in the infinitely touching, expression of such a little old man, which he himself is perhaps unconscious of, when he is sitting quietly in his corner by the fire (F1662, JH268).
>
> At the same time there is something noble, something great, which cannot be destined for the worms. . . . This is far from theology, simply the fact that the poorest little woodcutter or peasant on the heath or miner can have moments of

emotion and inspiration which give him a feeling of an eternal home, and of be-
ing close to it. . . . At times there is something indescribable in those aspects—
all nature seems to speak; . . . As for me, I cannot understand why everybody
does not see it and feel it; nature or God does it for everyone who has eyes and
ears and a heart to understand. For this reason I think a painter is happy because
he is in harmony with nature as soon as he can express a little of what he sees.
And that's a great thing—one knows what one has to do, there is an abundance
of subjects, and as Carlyle rightly says, "Blessed is he who has found his work."
(Letter 248)

And again:

Our purpose is in the first place self-reform by means of a handicraft and of in-
tercourse with nature, believing as we do that this is our first duty in order to be
honest with others and to be consistent—our aim is walking with God—the op-
posite of living in the midst of the doings of the big cities. . . . Though some
people may think it hypocritical to say, our belief is that God will help those who
help themselves, as long as they turn their energy and attention in this direction,
and set to work *to this end*. I see that Millet believed more and more firmly in
"Something on High." He spoke of it in a way quite different than, for instance,
Father does. He left it more vague, but for all that, I see more in Millet's vague-
ness than in what Father says. And I find that same quality of Millet's in Rem-
brandt, in Corot—in short, in the work of many, though I must not and cannot
expatiate on this. The end of things need not be the power to explain them, but
basing oneself effectively upon them. (Letter 337)

Kodera (1990) offers a telling observation:

Such a healing power for religious melancholy . . . can be understood in a
broader historical context. . . . Basil Wiley points out that the poets and writers
who most powerfully felt the healing influence of "Nature" were often those who
were most subject to gloominess and nervous depression He further stated:
". . . we may conjecture that it was owing to the commanding authority of the
idea of Nature at that time, as well as to the most obvious sanative virtues of the
open-air, that they could find amongst fields and mountains a substitute relig-
ion—even, as with Cowper and Rutherford, a *cure* for religion, or at least for
religious melancholy." In his inclination to find a substitute for traditional
Christianity and to seek a "cure" for religious melancholy, Van Gogh undoubt-
edly belonged to this group of artists. (p. 49)

In trying to persuade Theo to leave his job in Paris and join him in paint-
ing nature, he explained:

. . . with an unutterable feeling I see God, Who is the White Ray of Light, and
Who has the last word; what is not good through and through is not good at all,
and will not last—He, in whose eyes even the Black Ray[2] will have no plausible
meaning. What is before you is something terrible, something 'awful,' those
things are so inexpressible that I can find no words for them; and if I were not

your brother and your friend, who considers being silent ungrateful as well as in-human, I should say nothing. But seeing that you say, first, inspire me with courage, and second, do not flatter me, I say now, look, I see all these things here on the silent moor, where I feel God high above you and me. (Letter 337)

And again, it was in nature that he found what was for him most meaning-ful in life:

What life I think best, oh, without the least shadow of a doubt it is a life consist-ing of long years of intercourse with nature in the country—and Something on High—inconceivable, "awfully unnamable"—for it impossible to find a name for that which is higher than nature. Be a peasant—be, if it should be considered possible nowadays, a village clergyman or a schoolmaster—be—and in my opinion this ought to be thought of first, the present times being what they are—be a painter, and as a human being, after a number of years of living in the coun-try and of having a handicraft, as a human being you will in the course of these years gradually become something better and deeper in the end. (Letter 339a)

Japanese Art

Vincent had a great admiration for Japanese art—he collected Japanese prints and even tried his hand at copying the style (F371, JH1296; F372, JH1297). One of the features of Japanese art that Vincent found so attractive was the painters' capacity to grasp the essence of nature and portray it. Undoubtedly one of his reasons for moving to Arles was his wish to emulate Japanese art-ists in their immersion in nature—he felt the topography of Provence would mimic that depicted in the Japanese works he knew (Letters 605 and B2). He wrote Theo:

If we study Japanese art, we see a man who is undoubtedly wise, philosophic and intelligent, who spends his time doing what? In studying the distance between the earth and the moon? No. In studying Bismark's policy? No. He studies a single blade of grass. But this blade of grass leads him to draw every plant and then the seasons, the wide aspects of the countryside, the animals, then the hu-man figure. So he passes his life, and life is too short to do the whole. . . . And you cannot study Japanese art, it seems to me, without becoming more joyful and happier, and we must return to nature in spite of our education and our work in a world of convention. (Letter 542)

In the portrait of himself he sent to Gauguin (F476, JH1581), he identified himself as a Japanese monk rather than an artist, and observed, ". . . isn't it almost a *true religion* which these simple Japanese teach us, who live in na-ture as though they themselves were flowers?" (Letter 542).

The Struggle with Nature

In Vincent's mind, nature had a life of its own, which the artist was called to grapple with and conquer, but one that resisted and eluded his grasp. He wrote:

> Nature always begins by resisting the artist, but he who really takes it seriously does not allow that resistance to put him off his stride; on the contrary, it is that much more of a stimulus to fight for victory, and at bottom nature and a true artist agree. Nature certainly is "intangible," yet one must seize her, and with a strong hand. And then after one has struggled and wrestled with nature, sometimes she becomes a little more docile and yielding. I do not mean to say that I have reached that point already—no one thinks so less than I—but somehow I get on better. The struggle with nature sometimes reminds one of what Shakespeare calls "the taming of the shrew" (that means conquering the opposition by perseverance, *bon gre et mal gre*). In many things, but especially in drawing, I think that "*serrer de pres vaut mieux que lacher*" [pressing hard is better than letting go]. (Letter 152)

He wrote frequently of the artist's struggle with nature. He wrote Rappard: "I fell in love the same way too—desperately, I tell you—with a certain Dame Nature or Reality, and I have felt so happy ever since, though she is still resisting me cruelly, and does not want me yet, and often raps me over the knuckles when I dare prematurely to consider her mine. Consequently I cannot say that I have won her by a long shot, but what I *can* say is that I am wooing her, and that I am trying to find the key to her heart, notwithstanding the painful raps on the knuckles" (Letter R4). And to Theo: "You do not expect to find something soft or sweet, no, you know that it is impossible to conquer nature and to make her more amenable without a terrible struggle and without more than ordinary patience" (Letter 339a). Regarding his sketch of "Sorrow" (F1655, JH259), he said, "I wanted to express something of the struggle for life in that pale, slender woman's figure. . . . Or rather, because I tried to be faithful to nature as I saw it, without philosophizing about it, involuntarily . . . something of that great struggle is shown. . . . But before any success there must first come the hand-to-hand struggle with the things in nature" (Letter 195).

And we can guess that his dogged insistence on the study of nature was opposed to his father's theological mentality. He told Theo:

> I tell you, I consciously choose *the dog's path through life*; I will remain a *dog*, I shall be *poor*, I shall be a *painter*, I want to *remain human*—going into *nature*. In my opinion the man who goes *out* of nature, whose head is always stuffed with thoughts of maintaining this and maintaining that, even if this causes him to go out of nature to such an extent that he cannot but acknowledge it—oh—in this way one is apt to arrive at a point where one can no longer distinguish white

from black—and—and one becomes the exact opposite of what one is considered and of what one thinks oneself to be. (Letter 347)

His reference is to his role as the unwanted and untamed dog[3] in the family; we might infer that "the man who goes out of nature" is his father, who so rigidly maintained his dogmatic theological opinions.

Art for Religion

Vincent's absorption in nature was in some sense a replacement for his absorption in religion, but perhaps more a transformation than a replacement. His dissatisfaction with orthodox Christianity, complicated by his rebellious struggle with his minister father, led him to seek religious fulfillment outside the traditional church structures—like many others who could not accommodate to the dogmatism of the churches. For them God became synonymous with the universe or nature; their church was the temple of nature; the Bible gave way to contemporary literature, and the saints of the past were replaced by more modern idealized figures. The process of naturalizing religion was as much a part of Vincent's experience as anything, even at the height of his most fervent and unrestrained devotion. But after the failure and disappointment of the Borinage, this tendency took firmer hold and found expression in his work. Referring to Millet and Corot, he wrote: "There I see greater calm and serenity of a higher quality. Once again: I am far removed from this myself. However, every study I make, every attempt in the direction of painting, every new love for or struggle with nature, successful or unsuccessful, gets me one little unsteady step nearer. As far as religion is concerned, . . . I think Father the opposite of a man of faith" (Letter 347). He wrote, "I prefer painting people's eyes to cathedrals, for there is something in the eyes that is not in the cathedral, however solemn and imposing the latter may be—a human soul, be it that of a poor beggar or of a streetwalker, is more interesting to me" (Letter 441). And again in Arles, "I can very well do without God both in my life and in my painting, but I cannot, ill as I am, do without something which is greater than I, which is my life—the power to create. . . . I want to paint men and women with that something of the eternal which the halo used to symbolize, and which we seek to convey by the actual radiance and vibration of our coloring" (Letter 531).

His path to God lie through nature, or perhaps in nature. He found God in the sun, in waving fields of wheat, in laborers (F701, JH1847), plowmen (F1142, JH512), potato diggers (F9, JH385), women at work (F95, JH827; F95a, JH899; F97, JH876), in the cradle, and even in the footsteps of little children (F668, JH1883). These became the recurrent themes of his busy sketching: "Diggers, sowers, plowers, male and female, they are what I must

draw continually. I have to observe and draw everything that belongs to country life—like many others have done before, and are doing now. I no longer stand helpless before nature, as I used to" (Letter 150). He wrote Theo:

> When one is in a sombre mood, how good it is to walk on the barren beach and look at the grayish-green sea with the long white streaks of the waves. But if one feels the need of something grand, something infinite, something that makes one feel aware of God, one need not go far to find it. I think I see something deeper, more infinite, more eternal than the ocean in the expression of the eyes of a little baby when it wakes in the morning, and coos and laughs because it sees the sun shining on its cradle. If there is a "ray from on high," perhaps one can find it there. (Letter 242)

The Bible

Vincent's religious thinking was steeped in the Bible. The Bible occupied a central position in Calvinist belief—it was the sole source of religious truth and guidance, the one and only authority recognized in Calvinist churches, prescribed as such by Calvin himself in his *Institutes of the Christian Religion*. This high valuation on scripture, particularly the New Testament, was shared by the Dutch Reform churches and by the Groningen Party, to which Pastor van Gogh belonged.

Vincent's investment in the Bible was a byproduct of his idolization of his father and his desire to follow his father's footsteps. He wrote from Paris, commenting on the phrase "Wings, wings over life! wings over grave and death!": "That is what we want and I am beginning to understand that we can get them. Don't you think Father has them? And you know how he got them, by prayer and the fruit thereof—patience and faith—and from the Bible that was a light unto his path and a lamp unto his feet" (Letter 37). Soon after he reported that he had determined to burn all his books, retaining only his Bible (Letter 39). During his time at Isleworth, he read the Bible with his students daily (Letter 74).

During his tenure in Dordrecht as a bookseller's clerk, he devoted himself to studying and translating the Bible, to the detriment of his work. He wrote Theo, "You do not know how I am drawn to the Bible; I read it daily, but I should like to know it by heart and to view life in the light of that phrase, 'Thy word is a light unto my path and a lamp unto my feet' " (Letter 88). And again, "I have such a longing to possess the treasure of the Bible, to study thoroughly and lovingly all those old stories, and especially to find out what is known about Christ" (Letter 89). He continued this pattern in Amsterdam; as he told Theo, "I have begun to study the Bible already, but only at night when the day's work is done or early in the morning—after all, it is

the principal thing—though my duty is to devote myself to the other study, which I do" (Letter 96).

From Bible to Literature
His staunch adherence to the traditional Christian view, as exemplified in the theology espoused by his father, was transformed into his own brand of religious inspiration, which found God embodied in nature and art (Edwards 1989; Kodera 1990). From his early intense devotion to the Bible, Vincent moved to a position of relative disregard for the good book, and sought to replace it with religiously meaningful works from the literature of his day. The shift from Bible to literature was part of his quest for a way to replace the religious views of his father with a spiritual orientation that was more authentically his own. As he told Theo, "Father cannot understand or sympathize with me, and I cannot be reconciled to Father's system—it oppresses me, it would choke me. I too read the Bible occasionally just as I read Michelet or Balzac or Eliot; but I see quite different things in the Bible than Father does, and I cannot find at all what Father draws from it in his academic way" (Letter 164). From a man of the Book, he became a man of many books (Edwards 1989).

Vincent tried to convert Theo to his point of view: "As for me, I could not do without Michelet for anything in the world. It is true the Bible is eternal and everlasting, but Michelet gives such very practical and clear hints, so directly applicable to this hurried and feverish modern life in which you and I find ourselves, that he helps us to progress rapidly; we cannot do without him. . . . Michelet even expresses completely and aloud things which the Gospel whispers only the germ of" (Letter 161). Some years later, in recommending some modern works to his sister Wil to read, he put the argument in even more decisive terms:

> Is the Bible enough for us? In these days, I believe, Jesus himself would say to those who sit down in a state of melancholy, It is not there, get up and go forth. Why do you seek the living among the dead? If the spoken or written word is to remain the light of the world, then it is our right and our duty to acknowledge that we are living in a period when it should be spoken and written in *such* a way that—in order to find something equally great, equally good, and equally original, and equally powerful to revolutionize the whole of society—we may compare it with a clear conscience to the old revolt of the Kristians.[4]
>
> I myself am always glad that I have read the Bible more thoroughly than many people nowadays, because it eases my mind somewhat to know that there were once such lofty ideas. But because of the very fact that I think the old things so beautiful, I must think the new things beautiful "*à plus forte raison*," seeing that we can act in our own time, and the past as well as the future concern us only indirectly. (Letter W1)

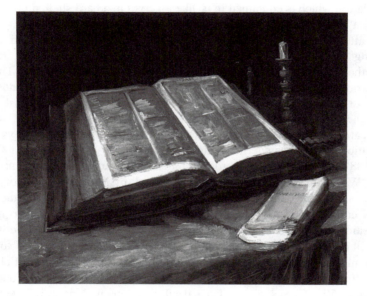

Figure 2. "Still Life with Open Bible and Zola Novel" (F117, JH946)
Rijksmuseum Vincent van Gogh, Amsterdam

For him there was little or no difference between art and life—he felt the same compassion for the characters in Zola's novels as for real people, the same sympathy for the heroine of *La Fille Elisa* as for the hungry prostitute in the street.

He was particularly offended by the exclusivism and sense of privilege of the chosen people as he found it expressed in the Old Testament. His comments to Bernard seem even more acerbic: "But the consolation of that saddening Bible which arouses our indignation—which distresses us once and for all because we are outraged by its pettiness and contagious folly—the consolation which is contained in it, like a kernel in a hard shell, a bitter pulp, is Christ" (Letter B8).

Soon after Vincent's father's death in October 1885, a sketch and later a painting "Still Life with Open Bible and Zola Novel" (Fig. 2; F117, JH946) made their appearance—an open Bible, a Zola novel, and a candle. The title of the novel is legible—*La Joie de Vivre*. The symbolism would not have been lost on Theo: the Bible was his father's and stood for Theodorus' religiosity, the candle was a *memento mori*, and the novel Vincent's defiant and provocative proclamation that he had departed from his father's ways. The opposition had been underlined during their violent confrontation at Christmas 1881, when Theodorus ordered him out of the house. Vincent wrote then, "When father sees me with a French book by Michelet or Victor Hugo, he thinks of thieves and murderers, or of 'immorality'; but it is too ridiculous, and of course I don't let myself be disturbed by such opinions. So often I have said to father, then just read it, even a few pages of such a book, and you will be impressed yourself; but Father obstinately refuses. . . . I told Father frankly that under the circumstances I attached more value to Michelet's advice than to his own, if I had to choose which of the two I should follow. . . ." (Letter 159). Even so, his father's death had done nothing to relieve him of his religious conflicts.

In the painting, the open Bible stands in striking contrast to the novel of Zola, one of Vincent's favorite authors. The bright yellow color of the novel contrasts with the dark and somber hue of the Bible. Kodera (1990) relates this to the theme of "light in the darkness," which preoccupied Vincent. The theme derives from John 1: 4-5—"All that came to be had life in him and that life was the light of men, a light that shines in the dark, a light that darkness could not overpower." Vincent had referred to this in a letter, written in 1878, before his apprenticeship in the Borinage, as "one of the roots or foundations, not only of the Gospel, but of the whole Bible" (Letter 126).

He told Wil: ". . . and if with good intentions we search the books which it is said shed light in the darkness—though inspired by the best will in the world, we find extremely little that is certain, and not always the satisfaction of being

comforted personally. . . . If on the contrary one wants truth, life as it is, then there are for instance de Goncourt in *Germinie Lacerteux, la Fille Elisa,* Zola in *La Joie de Vivre* and *L'Assommoir* and so many other masterpieces. . . ." (Letter W1). Kodera (1990) comments, "French naturalist literature is considered as something which shed 'light in the darkness', and with the word darkness Vincent is apparently indicating the 'melancholy and pessimism' in the old dogmatic, conventional Christianity of his father" (p. 44). Vincent's effort to replace the Bible with modern literature, to substitute the lightsomeness of Zola for the melancholy and suppressive world of the Protestant theologians of his day—and especially the theological views and the oppressive rigidity of his father—was motivated by Vincent's deep religious impulses and convictions. But the substitution was by no means simple or uncomplicated. As Kodera (1990) notes: "As students of Zola have pointed out, Zola was, far from being an atheist, a deeply religious man and a pantheist hovering between doubt and faith. In this sense he still shared the problem which haunted Van Gogh all through his life, but as a French novelist he had experienced the waning of Christianity and the rise of positivism much earlier than Van Gogh. He could keep enough distance to observe and study the conflict between Christianity and nature" (Kodera 1990, p. 92).

Edwards (1989) suggests another interpretation of this painting and the juxtaposition of the Bible and Zola's *Joie de Vivre,* namely that Vincent chose the novel to express his sense that it was a restatement of the Servant Song of Isaiah[5] in modern garb. He writes:

> At one level it appears that Vincent painted what has the external appearance of a contrast: the virtuous and sturdy Bible over against a garish and flimsy novel. That would be the shallow level at which Vincent's father, clergymen and their disciples of the cold academic approach would have made their judgment. At at a more profound level, the painting affirms that significant novels express the truths of the Bible for a contemporary audience. In a single painting, Vincent has revealed the misunderstanding of the old generation, the new generation's attraction to the novel, and his own theory regarding the relationship of modern novels to the Bible's Truth. (p. 49)

Vincent would have seen his own need for suffering in Zola's characters, as he did in the suffering faces of the peasants that found their way onto his canvas.

But the story was by no means onesided—as we have come to recognize in Vincent's highly ambivalent and diversified thinking. If his fanatical devotion to the Bible had once sounded a falsely excessive note, his equally intense and violent rejection of it in favor of contemporary literature also rang hollow. Both sides of his ambivalence seem to surface in his remarks to Bernard:

It is a very good thing that you read the Bible. I start with this because I have always refrained from recommending it to you. Whenever I read the numerous sayings of Moses, St. Luke, etc., I couldn't help thinking to myself, Look, that's the only thing he lacks, and now there it is in full force . . . the artistic neurosis. For the study of Christ inevitably calls it forth, especially in my case where it is complicated by the staining black of unnumerable pipes. The Bible is Christ, for the Old Testament leads up to this culminating point. St. Paul and the evangelists dwell on the other slope of the sacred mountain. (Letter B8)

"The Old Church Tower"

One can make a case that Vincent's religious vocation was never really abandoned, but merely transformed into an artistic medium so that his work became an expression of powerful and deeply religious themes. Walther and Metzger (1990) have observed:

His art's ability to touch the hem of the Eternal was not the result of any determination to fit romantic images of the Artist; rather, it derived from a profound and genuine longing for the sheltered security of religious faith. He painted his works for the sake of that moment when, through devotion to the tiniest detail, the artist experiences a sense of total order: the very small and the onmipotently vast could only be grasped from one and the same standpoint. Deeply religious, van Gogh believed that that point lay in God. (p. 50)

His intense religious sentiments found their way into his work, almost despite himself. He painted the old tower behind the parsonage, focusing on the little churchyard it inhabited (F84, JH772). A letter to Theo contained his meditation:

I have omitted some details—I wanted to express how this ruin shows that for ages the peasants have been laid to rest in the very fields which they dug up when alive—I wanted to express what a simple thing death and burial is, just as simple as the falling of an autumn leaf—just a bit of earth dug up—a wooden cross. The fields around, where the grass of the churchyard ends, beyond the little wall, form a last line against the horizon—like the horizon of the sea. And now this ruin tells me how a faith and a religion moldered away—strongly founded though they were—but how the life and the death of the peasants remain forever the same, budding and withering regularly, like the grass and the flowers growing there in that churchyard. *"Les religions passent, Dieu demeure"* [Religions pass away, God remains], is a saying of Victor Hugo whom they also brought to rest recently. (Letter 4ll)

He did several studies of the old church tower—in all seasons and weather—that were admired by Kerssemaker and Rappard (F34, JH459; F88, JH490; F87, JH600; F67, JH604). Tralbaut (1969) commented on them: "He felt pity for the old church—pity despite the fact that it was a thing of stone—for it seemed to him to have a sort of immemorial wisdom, which was very

close to him and almost echoed his own life. His fellow-men treated him much as the 'vandals' treated the church. He too felt he was being slowly destroyed. For this reason these pictures do not seem like ordinary landscapes; they are more like self-portraits that express the painter's own unhappiness" (p. 146). One of his early renditions of the little chapel at Nuenen (F25, JH521) shows the churchgoers on a Sunday morning, but the artist remains at a distance—as though repudiating his parents' wish that he join the worshippers and expressing his withdrawal from conventional religion and his isolation from communion with his fellow men. All these portrayals of the old church include the graveyard, some with black crows circling the church tower that provide an added element of threat. These crows are the ominous harbingers of death; they will return with more deadly intent in one of his last paintings.

Kodera (1990) draws attention to the church tower as a motif in Vincent's painting. In his early work, the church tower appears as a religious allusion. In one drawing the tower appears behind the head of a sower (F842, JH5), combining religious and natural themes—likewise for a plowman (JH37), a reaper (F1301, JH917), a weaver (F24, JH500), and even miners' wives (F994, JH253). These figures carry subtle religious implications for him. After his move to Provence, this church tower motif, so dominant in his Dutch period, yields its place iconographically to the sun. The place that the church had occupied earlier is now occupied by the sun that came to occupy a central position in Vincent's religious understanding. As Kodera (1990) summarizes, "Van Gogh knew that it was impossible to reconstruct the ramshackle old church, but he had believed too deeply and too long in Christianity to erect a totally new construction. What he could do was to build a temple of art on the ruins of his father's church" (p. 97). The old church tower that appeared so frequently in Vincent's work of the earlier Dutch period was replaced by the sun in later works, especially at Arles (F422, JH1470). Thus the sun took on a religious connotation, reflecting the naturalization of his religious impulse that became characteristic of his work.

"The Raising of Lazarus"

There is some suggestion of this same motif in Vincent's painting of "The Raising of Lazarus" (Fig. 3; F677, JH1972), where the face of Lazarus with its red beard may be that of Vincent himself. The painting is a partial copy of a Rembrandt etching. In it Lazarus is awakening from the dead and is received into the outstretched arms of a woman in a green dress. Vincent's comments about the painting to Theo establish the connection between the woman in this painting and the figure of "La Berceuse" (F505-508, JH1669-1672)—the woman who had stood for Vincent's mother in that series of

paintings[6] now assumes the character of an angelic figure welcoming Lazarus from the grave and back to life. He wrote:

> On the back of this page I have scribbled a sketch after a painting I have done of three figures which are in the background of the etching of "Lazarus": the dead man and his two sisters. The cave and the corpse are white-yellow-violet. The woman who takes the handkerchief away from the face of the resurrected man has a green dress and orange hair, the other has black hair and a gown of stripped green and pink. In the background a countryside of blue hills, a yellow sunrise. . . . I should still have at my disposal the model who posed for 'La Berceuse,' and the other one whose portrait after Gauguin's drawing you have just received, and I shall certainly try to carry it out in a large size, this canvas, as the personalities are the characters of my dreams. (Letter 632)[7]

It was only through the Christlike torments of suffering and death that one could achieve the blessings of resurrection and loving acceptance from his mother—something that he had endlessly sought and always been denied.

The Sun

The old church tower that appeared so frequently in Vincent's work of the earlier Dutch period was replaced by the sun in later works, especially at Arles (Kodera 1990). Thus the sun took on a religious connotation, reflecting the naturalization[8] of his religious impulse that became characteristic of his work. A further implication of the sun emerged in his painting of "The Raising of Lazarus" (F677, JH1972), a copy of a Rembrandt etching. The figure of Christ in the Rembrandt was replaced by the sun in Vincent's rendition. Kodera (1990) writes:

> The . . . rising sun in the painting is probably connected with the theme of resurrection, but the sun of the Midi meant more to Van Gogh. . . . The following passages from his letter bear witness to the fact that the sun of the Midi was deified in his mind: "Oh! those who don't believe in this sun here are real infidels. Unfortunately, along with the good god sun three quarters of the time there is the devil mistral" (Letter 520). The sun of the Midi was for Van Gogh something to be "believed in," "the good god sun," and something to be loved by painters. If we keep in mind these connotations of the Midi sun and the tendency toward naturalization in Van Gogh's thematics, it does not go too far to see a substitution of the sun for Christ in the *Raising of Lazarus*. (pp. 34-35)

We are reminded of traditional references to Christ as the *Sol invictus*—a theme that Vincent would have been well aware of.

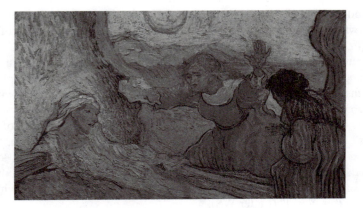

Figure 3. "The Raising of Lazarus" (F677, JH1972)
Rijksmuseum Vincent van Gogh, Amsterdam

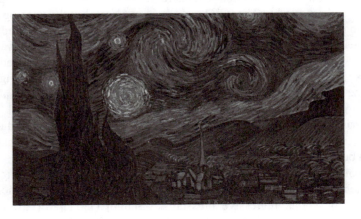

Figure 4. "The Starry Night" (F612, JH1731)
Museum of Modern Art, New York

"The Starry Night"

The painting of "The Starry Night" (Fig. 4; F612, JH1731) may serve as an example of how powerful religious, even mystical, themes may be contained in Vincent's art—despite his disclaimer.[9] The painting is not a landscape in the usual sense of representing some real scene; it is rather an expression of something in Vincent's heart and mind. One expert critic of Vincent's work commented on this canvas, "From inner suffering this artist has expressed with overwhelming power the mysticism which was the supreme mark of his genius" (in Tralbaut 1969, p. 279, citing de Gruyter).

Vincent was fairly explicit about the almost mystical appeal he found in the contemplation of the heavens. He confessed that when he contemplated the heavens he felt the power of his own inner religious impulse rise within him (Letter 520). And again, "Then I go out at night to paint the stars, and I am always dreaming of a picture like this with a group of living figures of our comrades" (Letter 543). He told Wil urging her to read Walt Whitman, "He sees in the future, and even in the present, a world of healthy, carnal love, strong and frank—of friendship—of work—under the great starlit vault of heaven a something which after all one can only call God—and eternity in its place above this world" (Letter W8).

For Vincent, there was an added element that may also play a part in the overdetermination of this painting. On his return to Etten in 1877, he stopped at Zundert and reported to Theo: "The sky was overcast, but the evening star was shining through the clouds, and now and then more stars appeared. It was very early when I arrived at the churchyard in Zundert; everything was so quiet; I went over all the dear old spots, and the little paths, and waited for the sunrise there. You know the story of the Resurrection—everything reminded me of it that morning in the quiet graveyard" (Letter 91). A salient part of the graveyard was the headstone that bore the name of the dead Vincent, the same as his own. The association alerts us to the possibility that in Vincent's mind there were connecting links between the stars and the graveyard, and between the churchyard and the theme of resurrection.

The painting may also have served an important function in allowing the artist to achieve some degree of meaningful compensation and integration in the face of psychotic regressive pressures. Stamm (1971), for example, placed the painting in the context of Joseph's dreams in *Genesis* (37: 5–11) and associated the eleven stars to the eleven stars of Joseph's dream in the *Genesis* account (Gn 37: 9):

> In his work, Van Gogh is trying, like Joseph, to prove his identity, to become the center of attention and achieve worldwide recognition and immortality. The eleven stars are a reminder of the eleven brothers in Joseph's dream. The tall cypress symbolizes Van Gogh's sheaf, his staff, his virility; even more, his immor-

tal self,literally reaching the starry firmament and, like the Christ figure he admired, forming the bridge between earth and heaven. Van Gogh, symbolized in the cypress, is now in the foreground. Now he is king like Joseph; now he, with his tall staff, has finally won out over his threatening father depicted in the small church spire to the rear. (p. 370)

Other religious motifs latent in Vincent's painting of "The Starry Night" are drawn out by Soth (1986). He points out that the idea of painting the starry night had haunted Vincent's imagination for some time. On several occasions during that year he had written Bernard about it. For example, in April he wrote: "The imagination is certainly a faculty which we must develop, one which alone can lead us to the creation of a more exalting and consoling nature than the single brief glance at reality—which in our sight is ever changing, passing like a flash of lightning—can let us perceive. A starry sky, for instance—look that is something I should like to try to do" (Letter B3). And again: "But when shall I paint my starry sky, that picture which preoccupies me continuously?" (Letter B7, also 543).

Soth (1986) points out that the painting was done between June 16 and 18, 1889, but that it is connected with Vincent's abortive effort in the preceding summer to paint a picture depicting Christ with the Angel in Gethsemane, also known as "The Agony in the Garden." He wrote to Theo, "I have scraped off a big painted study, an olive garden with a figure of Christ in blue and orange, and an angel in yellow. . . . I scraped it off because I tell myself that one should not do figures of that importance without models" (Letter 505, also B19). And again soon after: "For the second time I have scraped off a study of Christ with the angel in the Garden of Olives. You see, I can see real olives here, but I cannot or rather I will not paint anymore without models; but I have the thing in my head with the colors, a starry night, the figure of Christ in blue, all the strongest blues, and the angel blended citron-yellow. And every shade of violet, from a blood-red purple to ashen in the landscape" (Letter 540).

We might wonder why he had abandoned the Agony. Was the portrayal of the suffering Christ too close to home, too painful, too overburdened by the vicissitudes of Vincent's tormented identification with that intensely meaningful figure? As Soth (1986) comments:

In the summer of 1888, Van Gogh attempted to put on canvas an image of the Gethsemane story which meant so much to him. Not surprisingly, he chose the episode from Saint Luke of the angel strengthening Christ. But he could not bring himself to finish it. Twice, in July and September, he scraped off the canvas. He rationalized that he could not paint a figural composition without models, but in my opinion the block was as much psychological as visual. The erst-

while evangelist who had abandoned conventional religious belief could not paint a conventional religious image. (p. 312)

Vincent protested in criticizing Bernard's religious works, ". . . to remind you that one can try to give an impression of anguish without aiming straight at the historic Garden of Gethsemane; that it is not necessary to portray the characters of the Sermon on the Mount in order to produce a consoling and gentle motif" (Letter B21). Was this anything more than his turning away from traditional religion to find his God in the world around him, or was there more ambivalence and conflict involved in painting the Christ figure than Vincent was aware of?

Whatever the reason for his destroying that attempt, it may be that the unresolved religious impulse found its displaced expression in "The Starry Night." In it he achieved a degree of religious expression that had eluded him in his frustrated effort to paint the Agony. Soth writes:

> The Agony in the Garden would have had a strong appeal for Van Gogh in any case. He viewed human existence as a long suffering. The most one could give or receive during life was consolation for its sadness and strength to accept it. Saint Luke's account of "the angel who, in Gethsemane, gave strength unto him whose soul was sorrowful even unto death" was for Van Gogh a natural metaphor of life. Indeed, as the conclusion of the very first sermon he ever gave, in England in 1876, he used an image clearly borrowed from Saint Luke: "Has not man a strife on earth?" But there is consolation from God in this life. An Angel of God comforting man—that is the Angel of charity. (pp. 311-312)

The swirling images of the stars seem to come so close that one could reach out and touch them. They represent the heavens, divine transcendence, and man's destiny. The giant cypress seems to leap up to heaven like a huge tongue of fire straining to reach and join the fiery stars above. In the background the only other feature that reaches toward the heavens is the spire of the little church. Were the magnificent cypress and the spire the displaced representations of Christ and the angel (Moffett 1979)? Or, at another level of symbolic impression, does the juxtaposition of cypress and spire harken back to the relation between Vincent himself and his pastor-father? In different contexts the image of the cypress seems to have served as a vehicle for Vincent's self-expression; does its appearance in this context reflect Vincent's deeper identification with the Christ figure? Does the unbending and rigid spire express Vincent's view of his father and his religious views? The church has no dome, as was the style in the south, but a steeply pitched roof and tall spire, rare in Provence but common in the north, especially in the Brabant, where Vincent grew up (Soth 1986). Soth concludes his analysis: "Unable to paint The Agony in the Garden, Van Gogh projected its emotional

content onto nature and created a sublimated image of his deepest religious feelings. At its most profound level, the Starry Night is Van Gogh's Agony" (p. 312). To this I would add that the combination of stars and church reverberates with the memory of Vincent's visit to the graveyard at Zundert, the image of the gravestone with his name on it, echoes of the dead Vincent and the shadow he had cast over Vincent's path.

In a sense, then, the scraping off of the Christ in Gethsemane and the paining of "The Starry Night" enunciated a common theme of Vincent's conflict over his religious feelings and the tension he felt between a more traditional Christian belief and nature. His conflict made him recoil from painting explicitly religious subjects, such as those of Gauguin and Bernard. He could not accept the legitimacy of such subjects—Gauguin's "Yellow Christ," for example—since they challenged his rejection of established church authority and his abandonment of traditional theological views. He could not deny the path he had chosen to follow, the very rationale of his artistic existence that provided him with whatever sense of purposeful existence he could maintain.

"The Church at Auvers"

The painting of "The Church at Auvers" (Fig. 5; F789, JH2006)—done in the month before he died—carries its own burden of religious significance. This painting contains the same cruciform convergence of paths as is found in "The Crows over the Wheatfield" (F779, JH2117)—certainly one of Vincent's last efforts. The presence of this convergence in his painting of the church from the same period suggests its religious relevance. The connecting links with the painting of the crows suggests another association to death and possibly immortality.

Tralbaut (1969) offers an interpretation of this painting that underlines its possible religious significance:

> The church dominates the composition, for it covers two-thirds of the area of the canvas. Vincent has painted the apse and not the front of the church, and the porch is out of sight. This church without a door reminds us that Vincent was no longer a member of the Church, either as minister or worshipper. But the Church existed, and in its existence it represented an ideal, a perfect unity of thought and action concealed within the vicissitudes of a tumultuous life: the ideal of serving mankind, whether by religion or by art. . . . In the foreground the road divides in two. On the left a woman is walking away with her back to the painter. She is more than a casual Auvers peasant, and seems to be a nameless symbol representing Ursula [sic] Loyer, Kee Vos, Sien and Margot Begemann [and one can add possibly also at a deeper level the affectively withdrawn and unempathic grieving mother of childhood]. On the right the road leads toward the graveyard. Above the church and this dividing of the ways a violently

blue sky seems to threaten a storm. Vincent could not remain where he was. He must decide whether he would go back—but it is impossible to have one's life over again—or to turn left, towards the village and towards life, or to turn right towards the graveyard. (pp. 331-334)

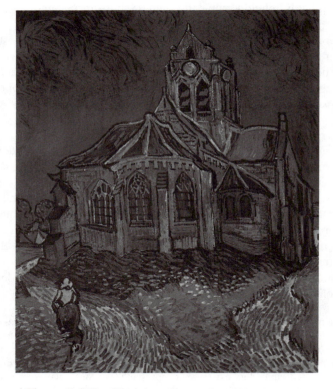

Figure 5. "The Church at Auvers" (F789, JH2006)
Musée d'Orsay, Paris

Chapter IX
THEOLOGICAL PERSPECTIVES

Theological Context

Vincent's early religious experience and training were harsh, rigid, ruled by a strict Calvinistic outlook. His father embodied all the virtues and convictions of that rigorous religious tradition. Calvinist theology was dominated by ideas of predestination and reliance on the authority of the Bible as the sole source of religious truth. The basic sinfulness of man and the need to seek one's destiny through self-sacrifice and service to God's will were primary tenets. All goodness comes from God; all wickedness and evil from man. Man is sinful and can be raised only by divine grace to a salvation that he in no way merits. The good pastor and his wife would have impressed their children with the evil of the world and the narrow path to salvation.

Vincent's father identified himself with neither the extremes of the orthodox wing nor the modernist wing of the Dutch church but was an adherent of the Groningen School of Dutch Protestantism, a movement that was evangelistic, humanistic and nondogmatic—a more modest and less tortured evangelical wing of the Reformed Church, following a more or less middle-of-the-road policy and strongly influenced by the views of Schleiermacher. Religion was a matter of individual devotion and emotion. Doubtless Theodorus saw to it that these religious perspectives were passed on to his offspring. One might expect that Vincent and his siblings would have acquired a heavy burden of guilt and anxiety—as he put it, "There is much evil in the world and in ourselves—terrible things; one does not need to be far advanced in life to fear much" (Letter 98). Sin looms large in the Calvinist ideology, and Vincent took it in with vengeance. Favorite sayings were "Fear God, and keep his commandments: for this is the whole duty of man," "Thy will be done," and "Lead us not into temptation, but deliver us from evil" (Letter 34).

The Burden of Guilt

The burden of guilt and concern for the judgment of watching eyes, parental and divine, weighed heavily on him. He told Theo: "A phrase in your letter struck me: 'I wish I were far away from everything; I am the cause of all, and bring only sorrow to everybody; I alone have brought all this misery on myself and others.' These words struck me because that same feeling, exactly the same, neither more nor less, is also on my conscience" (Letter 98). And further:

In your letter you write about the conflict one sometimes has about whether one is responsible for the unfortunate results of a good action—if it wouldn't be better to act in a way one knows to be wrong, but which will keep one from getting hurt—I know that conflict too. If we follow our conscience—for me conscience is the highest reason—the reason within the reason—we are tempted to think we have acted wrongly or foolishly; we are especially upset when more superficial people jeer at us, because they are so much wiser and are so much more successful. Yes, then it is sometimes difficult, and when circumstances occur which make the difficulties rise like a tidal wave, one is almost sorry to be the way one is, and would wish to have been less conscientious. (Letter 306)

The pervasive sense of guilt may have had its origin in his religious upbringing, but we can suggest that the roots go deeper. In his obsession with guilt, do we hear the echoes of the guilt of the survivor, the one who was left alive while his rival was condemned to death, the one who snatched the gift of life away from his unfortunate brother, the one whose hostile and murderous wishes would have been responsible for the death of the other Vincent? We can only speculate, but evidence from similar clinical cases suggests that such unconscious motivations cannot be discounted.

Vincent was saturated in Victorian and Dutch revivalist traditions and symbolism. Many of the themes in his paintings reflect these nineteenth century religious influences. Early in his career he was a devoted church-goer and tried to persuade Theo to do the same. The undogmatic quality of his attachment to religion is revealed in his practice of attending churches of different persuasions. He told Görlitz, "Well, in every church I see God, and it's all the same to me whether a Protestant pastor or a Roman Catholic priest preaches; it is not a matter of dogma but of the spirit of the Gospel, and I find this spirit in all churches" (Cited in Kodera 1990, p. 19; see also Letter A7).

God of His Fathers
Vincent's early acceptance of the faith of his fathers—grandfather, father, and Uncle Stricker—was pietistic and literal. His God was the God of Dutch Calvinism, filtered through his aggregate father figures. God was the lawgiver and judge who set forth the narrow path of virtue and provided the guidelines through His scripture for blameless behavior. The blessings are bestowed on those "who walk in the law of the Lord" (Psalm 119: 1). In his sermon,[1] delivered to the congregation at Richmond in 1876, he made it clear that in his mind the authority of God and the authority of his parents were mingled, if not synonymous. One of the powerful motivating forces of his religious drive was to gain the love and approval of his religiously minded father—". . . we want a Father, a Father's love and a Father's approval." But

for Vincent it was not clear who the father in question was—his own human father, God the father, or both?

His desire was to follow in his father's footsteps and to become a clergyman—a path that would bring him the solace he was seeking, the acceptance, approval of an as yet disapproving and distrusting father, as well as escape from the burden of sinfulness he felt. His idealization and admiration of his father seemed to reach the level of near idolatry. Nagera (1967) saw this as evidence of an unconscious and conflicted passive homosexual surrender to the powerful phallic father. In this essentially Freudian view, God becomes a substitute for the father, and the religious impulse an attempt to sublimate passive homosexual yearnings. But it is also clear that important narcissistic dynamics are at work as well. It had become essential for the maintenance of Vincent's internal psychic equilibrium that he set up a highly invested ideal with which he could identify and thus redress his underlying sense of narcissistic depletion and lack. One might also see in this pattern the need to fend off and undo a hidden view of Vincent buried in the unconscious of his parents—a view of him as odd, different, the intruder, strange and defective.

Seeking God
In Vincent's heart, there was a deep yearning for God. He wrote Theo:

> The heart of an ordinary mortal sometimes "sinks within him for yearning" at the sight of those who work for, and devote themselves to, Him who baptized them with the Holy Ghost and with fire; and their eyes sometimes moisten with sadness when they look back on their youth and the "good things with which He satisfied them." Yet their sublime peace is better than the deceptive calm of former days. The real quiet and peace begins only "when there is nothing left in which to rest" and when "there is no other desire than for God." Then their heart cries "Woe is me," and they pray, "Who shall deliver me from the body of this death?" (Letter 72)

And from Dordrecht: "I hope and believe that my life will be changed somehow, and that this longing for Him will be satisfied. I too am sometimes lonely and sad, especially when I am near a church or parsonage" (Letter 88). Again from Amsterdam: "Such a fire of spirit and love is a force of God's opposed to the dark and evil and terrible things of the world and the dark side of life; it is a force of resurrection stronger than any act and a ray of hope which gives consciousness and security to the depths and the secret of the heart. It is expressed in words which are simple but eloquent, 'I never despair' " (Letter 111).

Trust in God was his sustaining force. He told Theo in another letter:

Happy is he who has faith in God, for in the end he will overcome all the diffi-
culties of life, albeit not without trouble and sorrow. One cannot do better than
hold onto the thought of God through everything, under all circumstances, at all
places, at all times, and try to acquire more knowledge about Him, which one
can do from the Bible as well as from all other things. It is good to continue be-
lieving that everything is more miraculous than one can comprehend, for this is
truth; it is good to remain sensitive and humble and tender of heart, even though
sometimes one has to hide this feeling, which is often necessary; it is good to be
learned in the things that are hidden from the wise and intellectual ones of the
world but are revealed, as if by nature, to the poor and simple, to women and lit-
tle children. For what can one learn that is better than what God has given by
nature to every human soul—which is living and loving, hoping and believing, in
the depth of every soul, unless it is wantonly destroyed? (Letter 121)

Through all his tribulations, and especially after his failure in the
Borinage, he struggled to find and know God. Part of the struggle had to do
with his sense of self-worth and worthiness before God—"How can I be of
use in the world? Can't I serve some purpose and be of any good? How can
I learn more and study certain subjects profoundly?" (Letter 133). He sought
to find God in the beauty of man and nature—"In the same way I think that
everything which is really good and beautiful—of inner moral, spiritual, and
sublime beauty in men and their works—comes from God, and that all which
is bad and wrong in men and their works is not of God and God does not ap-
prove of it" (Letter 133). As he rejected church and traditional authorities, he
sought God in his own inner experience, in love—"It is good to love many
things, for therein lies true strength; whosoever loves much, performs and can
accomplish much, and what is done in love is well done" (Letter 121).

Love became his path to God. "But I think that the best way to know
God is to love many things. Love a friend, a wife, something—whatever you
like—you will be on the way to knowing more about Him; that it what I say
to myself. But one must love with a lofty and serious intimate sympathy, with
strength, with intelligence; and one must always try to know deeper, better
and more. That leads to God, that leads to unwavering faith" (Letter 133).
And in one, sweeping, magisterial proclamation to Theo:

But it certainly is my conviction that your attention, your best, your most con-
centrated, attention must be centered at this time on the development of a vital
force which is still slumbering within you—Love. For indeed, of all powers it is
the most powerful—it makes us dependent in appearance only; the truth is, there
is no real independence, no real liberty, no steady self-reliance, except through
Love. I say, our sense of duty is sharpened and our work becomes clear to us
through Love; and in loving and fulfilling the duties of love we perform God's
will. In the Bible it is not written in vain, "Love will cover a multitude of sins"
[see I Pet 4: 8], and again, "In Thee O God will be mercy, that Thou wilt be

feared" [see Ps 130: 4]. But I think you will derive more profit from rereading Michelet than from the Bible. (Letter 161)

Vincent referred to God as "Father," but the God he portrayed in his letters was more often an idealized and loving mother (Lubin 1972). This love is purchased, however, only through suffering and the disowning of earthly pleasures. At the height of his religious fervor, he wrote:

> This Charity is Life in Christ, this Charity is our Mother; all the good things of the earth belong to Her, for all is good if enjoyed with thankfulness, but She extends much further than those good things of the earth. To Her belongs the draught of water from a brook on a hike or from a fountain in the hot streets of London or Paris, to Her belong also "I shall make thy bed in sickness," "as one whom his mother comforteth, so I will comfort you," and to Her belongs: "Constancy unto death toward Christ, who giveth us the strength to do all." . . . "Can a woman forget her suckling child, that she should not have compassion on the son of her womb? Yea, they may forget, yet I will not forget thee." (Letter 82a)

When the real mother has failed to provide love, succor, support and nurturant empathy, these can be found in God—God as compensating and healing Mother. Nouwen wrote of Vincent's letters, "Their haunting, passionate expression of longing for a God who is tangible and alive, who truly comforts and consoles, and who truly cares for the poor and the suffering brought us in touch with the deepest yearnings of our soul. Vincent's God, so real, so direct, so visible in nature and people, so intensely compassionate, so weak and vulnerable, and so radically loving, was a God we all wanted to come close to" (In Edwards 1989, p. x).

Against the Pharisees

He referred to his depressive isolation after the Borinage as a time of molting. When he emerged from this "molting," his religious fanaticism had been replaced by a burning wrath against the organized church: "I must tell you that with evangelists it is the same as with artists. There is an old academic school, often detestable, tyrannical, the accumulation of horrors, men who wear a cuirass, a steel armor, of prejudices and conventions. . . ." (Letter 133). He had broken all ties to organized religion.

In a letter to Rappard, he inveighed against the resignation that his father and uncle demanded of him in the face of Kee's rejection:

> . . . there exists a system of resignation with mortification. . . . And if this were a thing that existed only in the imagination and the writings or sermons of the theologians, I should not take notice of it; but alas, it is one of those insufferable burdens which certain theologians lay on the shoulders of men, without touching

them themselves with their little finger. And so—more's the pity—this resignation belongs to the domain of reality, and causes many great and *petites miseres de la vie humaine*. But when they wanted to put this yoke upon my shoulders, I said, "Go to hell!" And this they thought very disrespectful. Well, so be it. Whatever may be the *raison d'etre* of this resignation, it—the resignation, I mean—is only for those who *can* be resigned, and religious belief is for those who *can* believe. And what can I do if I am not cut out by nature for the former, i.e. resignation, but on the contrary for the latter, i.e. religious belief, with all its consequences? (Letter R5)

Art, painting, and books became his life; any and all attachments were replaced by his painting. He had lost faith, had no friends and no prospects. He had declared his separation, once and for all, from his family. During the period of his religious fervor, his father and grandfather—both ministers of the word—were idealized and were praised as paragons of good. After he had turned his back on them and religion, he wrote, " . . . they were people like Father and Grandfather . . . people with a very venerable appearance, deep—serious—but if one looks at them a little more closely and sharply, they have something gloomy, dull, stale, so much so that it makes one sick. Is this saying too much???" (Letter 379).

He turned in impotent rage and bitterness against the religion that his father represented—the religion of church and clergy that had frustrated and rejected his self-immolating efforts to become a man of God and to follow the path of Christ. When his parents objected to the notion that he or Theo might marry a woman of a poorer class, Vincent wrote caustically to Theo:

I can only say that I think it unutterably pretentious and downright ungodly. In point of fact, clergymen are the most ungodly people in society and dry materialists. Perhaps not right in the pulpit, but in private matters. . . . But coming from Father and Mother, who ought to be humble and contented with simple things, I think their speaking that way very wicked, and I feel something like shame at their behavior. . . . I should like to be proud of Father, because he is truly a poor village preacher in the pure sense of the Gospel, but I think it so rotten that Father stoops to such considerations as something not being in keeping with "the dignity of his calling." . . . it is inhuman for anyone to do such a thing; doubly so, however, if he is a servant of the Gospel. . . . Oh, I know very well that nearly all clergymen would use the same language as Father—and for this reason I reckon the whole lot of them among the most ungodly men in our society. (Letter 288)

When Vincent finally left the Hague in September 1883, he had come to hate the world with all its conventions, artificialities, and superficialities. He

presented himself as a misfit, a fanatic, one who was not fit to live in this world. He poured out his agony to Theo:

> The clergymen call us sinners, conceived and born in sin, bah! What dreadful nonsense that is. Is it a sin to love, to need love, not to be able to live without love? I think a life without love a sinful and immoral condition. If I repent of anything, it is the time when mystical and theological notions induced me to lead too secluded a life. . . . For me that God of the clergymen is as dead as a door-nail. But am I an atheist for all that? The clergymen consider me so—so be it— but I love, and how could I feel love if I did not live and others did not live; and then if we live, there is something mysterious in that. Now call it God or human nature or whatever you like, but there is something which I cannot define systematically, though it is very much alive and very real, and see, that is God, or as good as God. (Letter 164)

Again: "To me, to believe in God is to feel that there is a God, not dead or stuffed but alive, urging us toward *aimer encore* with irresistible force—that is my opinion" (Letter 161).

At the same time, he continued his struggle with his religious conflicts: "That does not prevent me from having a terrible need of—shall I say the word?—religion. . . . I only wish that they would succeed in proving to us something that would tranquillize and comfort us so that we might stop feeling guilty and wretched, and could go on just as we are without losing ourselves in solitude and nothingness, and not have to stop at every step in a panic, or calculate nervously the harm we may unintentionally be doing to other people" (Letter 543).

Art for Religion

After the failure of his religious mission, he increasingly turned to art as a substitute. His fanatic devotion to art had to rise from the ashes of his religious vocation. His art was transformed into a spiritual mission. As Schapiro (1980) comments: ". . . art was for him . . . a choice made for personal salvation, after he had failed in another hope, a religious mission as an evangelist among the poor miners of the Borinage. . . . art as a deeply lived means of spiritual deliverance or transformation of the self" (pp. 11-12).[2] Gradually the two currents that had shaped his life—art and religion—were beginning to flow into a single channel in which they became indistinguishable. He wrote Theo:

> To try to understand the real significance of what the great artists, the serious masters, tell us in their masterpieces, *that* leads to God; one man wrote or told it in a book; another, in a picture. Then simply read the Gospel and the Bible: it makes you think, and think much, and think all the time. Well, think much and

think all the time, it raises your thoughts above the ordinary level without your knowing it. We know how to read—well then, let us read! (Letter 133).

If Vincent could throw off the yoke of his idealizing attachment to his father and if he could rebel in scorn against the authority of the established church, he could not abandon his deeper attachment to and identification with Christ. Art and painting became his faith. He wrote to Rappard that art was created by more than technique, but by "something which wells up from a deeper source in our souls; and that with regard to adroitness and technical skill in art I see something that reminds me of what in religion may be called self-righteousness" (Letter R43). And to Theo, writing from St. Remy, "You need a certain dose of inspiration, a ray from on high, that is not in ourselves, in order to do beautiful things" (Letter 625).

Art became his religion and paintings his sermons. In his efforts to persuade Theo to join him in his artistic life, he wrote: ". . . I will take the risk, I will push off to the open sea. And you will immediately get a certain sombre earnestness—something mighty serious will rise up within you—one looks at the quiet coast, all right, it is pretty enough—but the secret of the depth, the intimate, serious charm of the Ocean of an artist's life—with Something on High over it—will take hold of you" (Letter 339). He thought of God as the supreme artist whose painting was the world—a study that was far from successful:

> I feel more and more that we must not judge of God from this world, it's just a study that didn't come off. What can you do with a study that has gone wrong?—if you are fond of the artist, you do not find much to criticize—you hold your tongue. But you have a right to ask for something better. We should have to see other works by the same hand though; this world was evidently slapped together in a hurry on one of his bad days, when the artist didn't know what he was doing or didn't have his wits about him. All the same, according to what the legend says, this good old God took a terrible lot of trouble over this world-study of his. (Letter 490)

Resurrection

His devotion to art was a martyrdom in which the sacrifice of his life carried with it the promise of resurrection and rebirth. He told Rappard: "I reasoned like this, 'Life means painting to me and not so much preserving my constitution.' Sometimes the mysterious words, 'Whosoever shall lose his life shall find it' are as clear as daylight" (Letter R34). Vincent was prepared to lose his life in the service of a higher goal, a nobler vision, that brought with it the hope of restitution and the salvaging of powerful narcissistic needs, the fulfillment of which alone could serve as the basis of life for him. He saw himself as a martyr for art—and sought to find God and eternity in the starry

heavens that he sought to capture on canvas. He associated the stars with the idea of immortality:

> I have just read Victor Hugo's *L'Annee Terrible*. There is hope there, but . . . that hope is in the stars. I think it is true, and well told, and beautiful, and indeed I should be glad to believe it myself. But don't let's forget that this earth is a planet too, and consequently a star, or celestial orb. And if all the other stars were the same!!!! That would not be much fun; nothing for it but to begin all over again. But in art, for which one needs *time*, it would not be so bad to live more than one life. And it is rather attractive to think of the Greeks, the old Dutch masters, and the Japanese continuing their glorious school on other orbs. (Letter 511)

It does not strain the imagination to think that these reflections were stirring in his mind as he painted his "Starry Night" (F612, JH1731).

His concept of life after death took a somewhat independent turn. He wrote Wil:

> Now I know that it is hardly to be supposed that the white potato and salad grubs which later change into cockchafers should be able to form tenable ideas about their supernatural existence in the hereafter. And that it would be premature of them to enter upon supernatural researches for enlightenment about this problem, seeing that the gardener or other persons interested in salad and vegetables would crush them underfoot, considering them harmful insects. But for parallel reasons I have little confidence in the correctness of our human concepts of a future life. We are as little able to judge of our own metamorphoses without bias and prematureness as the white salad grubs can of theirs, for the very cogent reason that the salad worms ought to eat salad roots in the very interest of their higher development. In the same way I think that a painter ought to paint pictures; possibly something else may come after that. (Letter W2)

Religion as Transitional

I have described the role of Vincent's transitional experience as he faced the canvas. But the place of transitional experience in his life was not restricted to his painting; it found a significant place in his religious experience as well. Art in all its forms and religion are the primary areas where transitional experience finds a place (Meissner 1984, 1987). The notion of transitional phenomena in this sense incorporates areas of human understanding in which the symbolic function plays a role. Symbols play a vital role not only in cultural phenomena, but also in important areas of human social commitment and affiliation. Art and religion are prime examples of where symbols play a central role—particularly in the art of van Gogh, in which symbolic representation plays such a central role (Graetz 1963).

The infantile vicissitudes of transitional phenomena lay the basis for the child's emerging capacity for symbolism. In a sense, the piece of blanket symbolizes the mother's breast, but, as Winnicott (1971) suggests, its actual transitional function is as important as its symbolic value. He observes, "Its not being the breast (or the mother), although real, is as important as the fact that it stands for the breast (or mother)" (p. 6). The use of transitional objects, then, is more a step toward the symbolic function than itself a form of symbolism. When symbolism is achieved, the infant has already gained the capacity to distinguish between fantasy and fact, between internal and external objects, between primary creativity and perception, between illusion and reality—or in Lacan's terms, between the imaginary and the symbolic. For purposes of the present discussion, I would argue that the use of symbols takes place within the intermediate area of experience that Winnicott designated as illusion. For Vincent the area of illusion was both artistic and religious.

The exercise of the symbolic function takes place at at least two levels, the conscious and the unconscious (Godin 1955). Consciously, we can express meanings by actions (gestures, behaviors) or by attributing meaning to external objects. Unconsciously, the meaning of the action or attribution is not immediately evident and can only be ascertained by interpretation within a broader social or historical context. An animal phobia expresses a fear, but the object of the fear is masked. As Godin remarked:

> These two levels of symbolic expression are closely linked and complementary to one another. The symbolic function is always exercised by an encounter between an interior urge, which results from the whole organization of a personality, and its actualization in exterior expressions of which most (but not all) are modelled by the surrounding culture, traditions and social conventions. The symbolic act, therefore, unites, not only several degrees of reality (matter and spirit), but several levels of human reality (conscious and unconscious, individual and social). (p. 279)

This capacity for symbolic experience makes culture possible since it provides the matrix within which the cultural experience takes place. That experience is not merely subjective (as derivative of and determined by intrapsychic dynamics only), nor is it exclusively objective (as a reflection of extrinsic and objectively determined qualities of the object); it is compounded of objective qualities, as of a painting or statue or piece of music, and the subjective experience that the individual psyche brings to it. It is neither subjective nor objective, but both subjective and objective. I will suggest that the same compounding of subjective and objective are characteristic of religious experience (Meissner 1984).

All religions make use of religious symbols—the crucifix, the Torah, the bread and wine, the menorah, the star of David, and so on. Such objects become the vehicles for the expression of meanings and values that transcend their physical characteristics. This symbolic dimension, however, is not a product of the objects themselves; it can come about only by some attribution to them by the believer. Consequently, the objects as religious symbols are neither exclusively perceived in real and objective terms nor simply produced by subjective creation. Rather, they evolve from the amalgamation of what is real, material, and objective as it is experienced, penetrated, and creatively reshaped by the patterns of meaning attributed to the object by the believer. We are once again in the transitional space in which the transitional experience is played out in the context of religious illusion. Such symbols, even in their most primitive and material sense, serve the articulation and maintenance of belief that are important for the human experience of believing. Human beings are, by and large, incapable of maintaining a commitment to something as abstract as a religious belief system without some means of real—sensory, visual, or auditory—concretization.

Religious symbolic systems are, at least in the Judeo-Christian tradition, derived from a twofold source that is at once subjective and objective. The subjective dimension comes from the dynamic constituents of human understanding and motivation, while the objective dimension is contributed by a revelation with the presumption of a divine presence and action behind it. Leavy (1986) articulates this dimension of religious belief systems as follows: "Faith is by nature—human nature—presented symbolically, and religions are symbol systems. The believer, knowingly or not, owes his or her religious language to a revelation that is the spring of the tradition, coming from outside the believer's mind. The ultimate reference of faiths are not themselves products of regressive fantasies, but symbolic representations of ultimate truths" (p. 153).

These elements assumed an idiosyncratic form in Vincent's mind. Faith had become a matter of conflict and uncertainty for him. He rejected his father's faith and sought his own religious meaning through his art. The central point at this juncture is that in his artistic experience Vincent entered a realm of transitional experience that involved different elements than he found in his everyday life. That transitional space became the repository of his intense needs and desires—into it were funneled all the frustrations, the disappointments, the disillusionments, the hopelessness and despair, the desperate searching for meaning and a sense of self and identity that he so poignantly and painfully yearned for, all his wishes and hopes, the illusions that he cherished so intensely and fanatically. It is no surprise that within this illusory space his religious yearnings and desires should have found their way. These

religious concerns permeated his artistic efforts and transformed them into meditations, acts of worship of his God, and expressions of his powerful searching for meaning and purpose, and for the resolution of the agonizing conflicts that plagued his existence and tormented his soul.

Chapter X
THE IMITATION OF CHRIST

Devotion to Christ

Clearly Vincent's religious outlook was Christocentric. Christ was the centerpiece of his early devotion. He wrote from Paris: "Have more hope than memories. Whatever has been valuable and blessed in your past is not lost, you will meet it again on your path; so don't think about it any more, but go forward. . . . All things have become new in Jesus Christ" (Letter 37). And again: "This Charity is Life in Christ for the one who loves Christ the world is what it is, and all things seem to fall to his share. . . . For myself, I will strive after the Love of Christ and after working for Him all my life; though it fail and though I fall, there will always remain that standing from afar and longing for the heights away from the misery here below" (Letter 82a).

Two prints of Christ sent by Theo—the *Christus Consolator* and the *Christus Remunerator*—hung on his wall in Dordrecht (Letter 84). And his old roommate Görlitz reported that Vincent decorated the walls of their rooms with biblical sketches and *Ecce Homo* representations. Under each of the Christs, he had inscribed the phrase "in sorrow yet ever joyful" (Walther and Metzger 1990, pp. 45-46).

In his sermon, he came back with monotonous regularity to the figure of Christ:

> There is one who has said: I am the resurrection and the life, if any man believe in Me though he were dead, yet shall he live. . . . Our nature is sorrowful, but for those who have learnt and are learning to look at Jesus Christ there is always reason to rejoice. It is a good word that of St. Paul: as being sorrowful yet always rejoicing. For those who believe in Jesus Christ, there is no death or sorrow that is not mixed with hope—no despair—there is only a constantly being born again, a constantly going from darkness into light. . . . Teach us to do Thy will and influence our hearts that the love of Christ may constrain us and that we may be brought to do what we must do to be saved. . . . You who have experienced the great storms of life, you over whom all the waves and all the billows of the Lord have gone—have you not heard, when your heart failed for fear, the beloved well-known voice with something in its tone that reminded you of the voice that charmed your childhood—the voice of Him whose name is Saviour and Prince of Peace, saying as it were to you personally, mind to you personally: "It is I, be not afraid." Fear not. Let not your heart be troubled. And we whose lives have been calm up till now, calm in comparison of what others have felt—let us not fear the storms of life, amidst the high waves of the sea and under the grey clouds of the sky we shall see Him approaching, for whom we have so often longed and watched, Him we need so—and we shall hear His voice: It is I, be

not afraid. . . . And let us keep that heart full of the love of Christ and may from thence issue a life which the love of Christ constraineth, Lord Thou knowest all things, Thou knowest that I love Thee; when we look back on our past we feel sometimes as if we did love Thee, for whatsoever we have loved, we loved in Thy name. . . . The old eternal faith and love of Christ, it may sleep in us but it is not dead and God can revive it in us. (Letters I, 87–90)

The Imitation of Christ

One of the spiritual writings that seems to have been his constant companion during his devotional years was Kempis' *The Imitation of Christ*, perhaps the most famous work of Dutch-German spirituality.[1] It is little wonder that with Vincent's sympathies he would have found the *Imitation* a treasure—especially for its emphasis on the following of the suffering Christ and the imitation of his virtues of humility and self-abnegation. He took for his motto the words of Paul "in sorrow yet ever joyful" from 2 Corinthians—"St. Paul's characteristic thought of struggles in this world for salvation in the next was re-interpreted by van Gogh in universally applicable style as a paradox—a paradox that applied to his own state of mind, which trod an ill-defined line between melancholy and remorse, lovesickness and humility, world-weariness and sadness, in a word: between a quite commonplace inability to cope with everyday life and a Christian rejection of everyday preoccupations" (Walther and Metzger 1990, p. 38). As he told Theo: "Thomas à Kempis' book is peculiar; in it are words so profound and serious that one cannot read them without emotion, almost fear—at least if one reads with a sincere desire for light and truth—the language has an eloquence which wins the heart because it comes from the heart" (Letter 108).[2]

Pilgrim's Progress

The other work that played a significant role in his religious vision was Bunyan's *Pilgrim's Progress*. He told Theo, "If you ever have an opportunity to read Bunyan's Pilgrim's Progress, you will find it greatly worth while" (Letter 82). The adventures of its hero, Christian, read like a blueprint for Vincent's own life story. He escaped from his family and neighbors who thought that he was mad and followed the light that led to heaven—like the light of the Midi. He then fell into the Slough of Despair. He was not tempted by the vices of sloth, presumption, or hypocrisy, but remained the most humble of men. The people of Vanity Fair arrested him for refusing to conform to their expectations and standards. Finally, he crossed the river of death—as did Vincent on that final day in Auvers on the river Oise (Lubin 1972).

In his sermon, his text was Psalm 119: 19 "I am a stranger on the earth, hide not Thy commandments from me." It was not without reason that Vincent chose this text, since it was central to his religious convictions. He pictured life as a pilgrim's progress—"that we are strangers on the earth, but that though this be so, yet we are not alone for our Father is with us. We are pilgrims, our life is a long walk or journey from earth to Heaven."

The Man of Sorrows

Vincent's identification with Christ lay at a deeply unconscious level, but was accompanied by a more conscious wish to imitate the Savior. Under one of the prints on his wall at Dordrecht, he wrote: "Take my yoke upon you, and learn of me; for I am meek and lowly of heart. . . . if any man will come after me, let him deny himself and take up my cross and follow me—in the kingdom of Heaven they neither marry, nor are given in marriage." The Christ Vincent envisioned in himself was "the Great Man of Sorrows Who knows our ills." He wrote from the Borinage:

> How we must think of him [the Macedonian] as a laborer with lines of sorrow and suffering and fatigue in his face—without splendor or glamour, but with an immortal soul—who needed the food that does not perish, God's word. How Jesus Christ is the Master who can comfort and strengthen a man like the Macedonian—a laborer and working man whose life is hard—because He is the Great Man of Sorrows Who knows our ills, Who was called a carpenter's son though He was the Son of God, Who worked for thirty years in a humble carpenter's shop to fulfill God's will. And God wills that in imitation of Christ man should live humble and go through life not reaching for the sky, but adapting himself to the earth below, learning from the Gospel to be meek and simple of heart. (Letter 127)

The themes enunciated were to become the dominant motifs of Vincent's religious pilgrimage. The beginning of life takes place in sorrow and anguish, and the end of life is death. The sermon continued:

> There is sorrow in the hour when a man is born into the world, but also joy, deep and unspeakable, thankfulness so great that it reaches the highest Heavens. . . . There is sorrow in the hour of death, but there is also joy unspeakable when it is the hour of death of one who has fought a good fight. There is one who has said: I am the resurrection and the life, if any man believe in Me though he were dead, yet shall he live. . . . Sorrow is better than joy—and even in mirth the heart is sad—and it is better to go to the house of mourning than to the house of feasts, for by the sadness of the countenance the heart is made better. Our nature is sorrowful, but for those who have learnt and are learning to look at Jesus Christ there is always reason to rejoice. It is a good word that of St. Paul: as being sorrowful yet always rejoicing. For those who believe in Jesus Christ, there is no death or sorrow that is not mixed with hope—no despair—there is

only a constantly being born again, a constantly going from darkness into light. They do not mourn as those who have no hope—Christian Faith makes life to evergreen life.

We are pilgrims on the earth and strangers we only pass through the earth, we only pass through life, we are strangers and pilgrims on the earth. The world passes and all its glory. Let our later days be nearer to Thee, and therefore better than these. . . . We must love God with all our strength, with all our might, with all our soul, we must love our neighbours as ourselves. These two commandments we must keep, and if we follow after these, if we are devoted to this, we are not alone, for our Father in Heaven is with us, helps us and guides us, gives us strength day by day, hour by hour, and so we can do all things through Christ who give us might. We are strangers on the earth, hide not Thy commandments from us. . . . We want to know that we are Thine and that Thou art ours, we want to be Thine—to be Christians—we want a Father, a Father's love and a Father's approval. . . .

Our life is a pilgrim's progress. . . . And the pilgrim goes on sorrowful yet always rejoicing—sorrowful because it is so far off and the road so long.

Sorrowing for God

The same themes had echoed in his letters even before his tenure in the English pulpit. From Paris he had written to Theo:

Narrow is the path which leadeth unto life, and those that find it are few. Struggle to enter by the narrow gate, for many will seek to enter, and will not be able [see Matt. 7: 14]. My brother, let us be prudent; let us ask of Him Who is on high, Who also prayeth for us, that He take us not away from the world, but that He preserve us from evil. . . . that He teach us to deny ourselves, to take our cross every day and follow after Him; to be gentle, long-suffering and lowly of heart. . . . and God hath made me sorrowful yet always rejoicing. (Letter 39b)

Vincent's yearning for God led to a deepening desolation that became a spiritual trial. He wrote Theo:

It may be that there is a time in life when one is tired of everything and feels, perhaps correctly, as if all one does is wrong—do you think this is a feeling one must try to avoid and to banish, or is it "the sorrowing for God," which one must not fear, but cherish to see if it may bring some good? Is it "the sorrowing for God" which leads us to make a choice which we never regret? . . . If we let ourselves be taught by the experience of life, and led by the sorrowing for God, vital strength may spring from the weary heart. If only we are truly weary, we shall believe in God all the more firmly, and shall find in Christ, through His word, a friend and a Comforter. . . . For God so loved the world, that he gave his only begotten Son, that whosoever believeth in him should not perish, but have everlasting life. Nothing shall separate us from the Love of Christ, neither things present nor things to come. (Letter 85)

His heart yearned to be a worthy servant, and so find acceptance and ful-fillment. He wrote: "Oh, that I may be shown the way to devote my life more fully to the service of God and the Gospel. I keep praying for it and, in all humility, I think I shall be heard. Humanly speaking, one would say it cannot happen; but when I think seriously about it and penetrate the surface of what is impossible to man, then my soul is in communion with God, for it is possi-ble to Him Who speaketh, and it is, Who commandeth, and it stands firmly" (Letter 92). Under a Rosenthal print, he inscribed, "Take my yoke upon you, and learn of me; for I am weak and lowly in heart: and ye shall find rest unto your souls. For my yoke is easy, and my burden is light; if any man will come after me, let him deny himself, and take up my cross, and follow me" (Letter 93). He even quoted Carlyle, "Knowest thou that worship of sorrow, the temple thereof founded some eighteen hundred years ago, now lies in ru-ins, yet its sacred lamp is still burning" (Letter 295).

The Cross
Much of his correspondence during this religious period is dominated by themes of religious asceticism and martyrdom. He emphasizes biblical pas-sages that speak of sorrow, suffering and self-denial. He wrote from Isle-worth:

> Who is there to see when the first years of life, life of youth and adolescence, life of worldly enjoyment and vanity will perforce wither—and they shall, even as the blossom falls from the tree—and vigorous new life shoots up, the life of love unto Christ Who is importunate and of sorrowing that is unrepenting, unto God; how then in our close dependence on God, and in the unmistakable and keen sensation of it, we find more favor in His eyes, which are too pure to see evil, and He can and will entrust His Holy Spirit more safely to our weakness, His Holy Spirit, Which grants life, and urges us to do good works. (Letter 82a)

And again, "Let us ask of Him that He teach us to deny ourselves, to take our cross every day and follow after Him: to be gentle, long-suffering and lowly of heart." His life style was ascetical, denying himself food and even simple pleasures. Mendes da Costa recalled that even as a student he would beat himself with a cudgel and punish his body by lying on the cold floor of his shack at night without bed or blanket (Letter 122a).

Time and again in Vincent's life, the pattern emerges of turning the rage provoked by narcissistic injury against himself. The burned hand in the Kee episode turns the rage of frustrated love against himself. Vincent never took very good care of himself. For most of his adult life, he ate little, was chroni-cally undernourished, usually preferring to spend money on models and art supplies rather than food. He would subsist, at times for days, on nothing but

crusts of bread and coffee. He undoubtedly suffered from one or other form of vitamin-deficiency disease, possibly pellagra; by his early thirties his teeth began to break off. He also probably suffered from syphilis as a result of his involvement with prostitutes. Vincent's whole life was a form of turning of rage against himself—the punishment of his body by penances, flagellations and deprivations, his manner of life with its malnutrition, poverty, filth, and degradation, his rejecting any opportunities for friendship, admiration, help or solace—Theo was the only exception. The motif of self-torment and punitive self-deprivation would continue to the end of his life and would end in the ultimate attack on the self—suicide. Underlying this severe self-abnegation and self-denial was his fanatical desire to follow in the footsteps of his master, to identify with the suffering Christ.

To this powerful motif of the imitation of Christ can be added the theme of oedipal rivalry with the father that would have meant taking the father's place and surpassing him as a minister of Christ. We can also add the deeper need for self-punishment as a result of his guilt-ridden and tormented relation to the dead Vincent. The motif of self-torment and punitive self-deprivation would continue to the end of his life and would end in the ultimate attack on the self—suicide. And throughout this pervasive pattern there persists the identification with the suffering Christ.

Identification with Christ

Vincent's self-inflicted privations had injured his health, and his exorbitant zeal had come to naught. But along with the Christ who was obedient to the will of the Father, Vincent carried in him an obstinate will to rebel against any and all authority. Particularly after his London humiliation, he became increasingly difficult, obstinate, critical, and opinionated.

He identified particularly with the suffering Christ, who was crucified and died and was thus resurrected and raised to heavenly sublimity. He advised Theo, "If we could make ourselves a crown of the thorns of life, wearing it before men and so that God may see us wearing it, we should do well" (Letter 112). When Vincent painted his "Open Bible with Book and Candle" (F117, JH946) after his father's death, the Bible was opened to Isaiah 53, the passage containing the famous "Suffering Servant Song." This became the predominant theme in Vincent's sense of his religious mission and his imitation of Christ. Vincent's mission to the miners of the Borinage was his attempt to follow in the footsteps of his Master, to preach the gospel to the poor and to comfort those who mourn and suffer. He strove to realize in himself the ideal of the suffering servant.

He even saw the painter's vocation as a perilous and burdensome task that he did not feel he had the strength to bear. He wrote Theo:

This is also something unbearable for many a painter, or at least almost unbearable. One wants to be an honest man, one is that, one works as hard as a slave, but still one cannot make both ends meet; one must give up the work, there is no chance of carrying it out without spending more on it than one can get back, one gets a feeling of guilt, of shortcoming, of not keeping one's promises, one is not honest, which one would be if the work were paid for at its natural, reasonable price. One is afraid of making friends, one is afraid of moving; like one of the old lepers, one would like to call from afar to the people: Don't come too near me, for intercourse with me brings you sorrow and loss. With all that huge burden of care on one's heart, one must set to work with a calm every-day face, without moving a muscle, live one's ordinary life, get along with the models, with the man who comes for the rent—in fact, with everybody. With a cool head, one must keep one hand on the helm in order to continue the work, and with the other hand try not to harm others. And then storms arise, things one has not foreseen; one doesn't know what to do, and one has a feeling that one may strike a rock at any moment. One cannot present oneself as somebody who comes to propose an advantageous deal or who has a plan which will bring great profit; on the contrary, it is clear that it will end in a deficit. And yet one feels a power surging within—one has work to do and it must be done. (Letter 248)

The sense of sorrow and isolation—the psychoanalyst would say abandonment—ran deep. He wrote his mother, "As far as sorrow, dear Mother, is concerned which we have and continue to have in separation and loss, it seems to me it is instinctive, that without that we could not resign ourselves to separations, and that probably it will help us to recognize and find each other again later. It seems impossible for things to remain in their place" (Letter 598). The solution was to be found in courage and self-sacrifice (Letter 249).

Vincent was likewise preoccupied with the image of the Sower. This fascination was built on his identification with the image of the sower and its implicit connection with the figure of Christ.[3] In his religious mission, Vincent had hoped to become a "sower of God's word," but his failure and disappointment in this attempt turned his ambition to art and channeled his fixation on the figure of Christ into an identification with Christ the artist. The attempts to portray the sower were in effect portrayals of Christ and at the same time self-portraits.

Vincent's identification with the suffering Christ served its unconscious purposes only to the extent that it won for him a measure of love and admiration—especially from his mother. In his Christlike role, he could maintain his aloofness, but continue to win the love and admiration of his fellowmen—and thus avoid the taint of loneliness and rejection. Suffering and death were the heralds of a glorious resurrection, as well as winning the tearful embrace of the *mater dolorosa*.

The identification with Christ thus served many functions. It justified his chronic depression and need to seek self-punishment. Masochism was ele-

vated to martyrdom, and self-denial and asceticism were ennobled to new levels of narcissistic gratification. Failures in sexuality were transformed into virtues of Christlike abstinence. As Lubin (1972) observed:

> The figure of Christ was a ready-made mask of goodness behind which he could hide the badness he felt inside, thereby appeasing a conscience steeped in the ways of Calvinistic orthodoxy. As Christ, Vincent not only could compete with his dead brother; he could outdo him. When he became disillusioned with his father, he could consider his father a Pharisee and surpass him as a man of God. The figure of Christ both helped to shape his symptoms and became a blueprint for shaping his life's work. (p. 107)

"Pietà"

In some of his paintings, two powerful unconscious fantasies come into conjunction. One is the fantasied reunion with the wished-for mother who would receive him in her arms and lovingly embrace him. He is critical of Rubens' depictions of the *mater dolorosa* because they lack a depth of real feeling: ". . . even his most beautiful weeping Magdalenes or Mater Dolorosas always simply remind me of the tears of a beautiful prostitute who has caught a venereal disease or some such small misery of human life" (Letter 444). The other was a powerful but unconscious identification with Christ.

There is conjecture that in his painting of the "Pietà" (Fig. 6; F630, JH1775) he painted his own features on the face of Christ. The grieving mother stretches her arms out to embrace her dead son; he is loved because he has suffered and died. The message is clear: it is better to be dead than alive, only in death does the good mother love her suffering child.

Vincent described this painting in detail to his sister Wil:

> The Delacroix is a "Pietà," that is to say the dead Christ with the Mater Dolorosa. The exhausted corpse lies on the ground in the entrance of a cave, the hands held before it on the left side, and the woman is behind it. It is the evening after a thunderstorm, and that forlorn figure in blue clothes—the loose clothes are agitated by the wind—is sharply outlined against a sky in which violet clouds with golden edges are floating. She too stretches out her empty arms before her in a large gesture of despair, and one sees the good sturdy hands of a working woman. . . . And the face of the dead man is in the shadow—but the pale head of the woman stands out clearly against a cloud—a contrast which causes those two heads to seem like one somber-hued flower and one pale flower, arranged in such a way as mutually to intensify their effect. . . . I thought fit to send you a sketch of it in order to give you an idea of what Delacroix is. . . . you may see from it that Delacroix does not draw the features of a Mater Dolorosa after the manner of the Roman statues, but that there is in it the grayish white countenan-

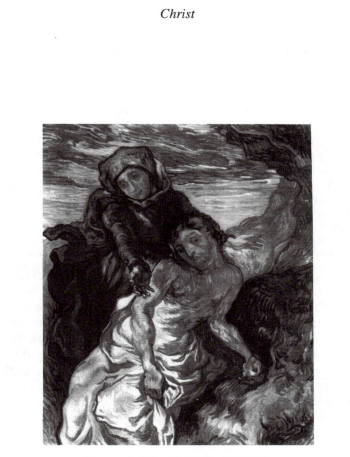

Figure 6. "Pietà" (F630, JH1775)
Rijksmuseum Vincent van Gogh, Amsterdam

ce, the lost, vague look of a person exhausted by anxiety and weeping and waking . .
.(Letter W14)

Do we hear in these words echoes of childhood memories of a depressed, un-
available, unempathic mother weeping for her lost son?

Christ the Artist
To Vincent, Christ was the greatest of artists:

> Christ alone—of all the philosophers, Magi, etc.—has affirmed, as a principle of
> certainty, eternal life, the infinity of time, the nothingness of death, the necessity
> and the *raison d'être* of serenity and devotion. He lived serenely, *as a greater
> artist than all other artists*, despising marble and clay as well as color, working
> in living flesh. That is to say, this matchless artist, hardly to be conceived by the
> obtuse instrument of our modern, nervous, stupefied brains, made neither statues
> nor pictures nor books; he loudly proclaimed that he made . . . *living men*, im-
> mortals. This is serious, especially because it is the truth. (Letter B8)

And again: "But Christ, I repeat, is more of an artist than the artists; he works
in the living spirit and the living flesh, he makes men instead of statues"
(Letter B9). Lubin (1972) comments: "Vincent's identification with Christ
enabled him to carry on as an artist convinced that he too was great, an ex-
traordinary being who tolerated the blows and cruelty of life on earth know-
ing that he would eventually be venerated as mankind's favorite. Day by day
failure and rejection would not slow him down; he would devote the same re-
ligious fervor to art that he had formerly invested in missionary work" (p.
113).

The Severed Ear
The amputation of his ear in the face of Gauguin's threatened departure
brings many of these pathological themes into conjunction. It serves as an-
other striking example of Vincent's capacity to turn his frustrated rage against
himself in destructive and masochistic fashion. Interpretations of this self-
mutilation have been various.[4] A more classic interpretation would see it in
oedipal terms, as an act of self-punitive expiation for his murderous rage at
Gauguin, the replacement for the rejecting father-figure. More contemporary
views would add a consideration of the immediate adaptive function of any
piece of disturbed behavior and the role of childhood determinants in contrib-
uting to the potentiality for regression and loss of self-cohesion. The meaning
of his action must be integrated with the implications of his connection with
Gauguin and his intense disappointment at Gauguin's decision to leave. The
aggressive and destructive impulses that he could not channel into an attack
on Gauguin were turned on himself—following his well established pattern of

turning his frustrated rage against himself. Based on the view of the ear as a phallic substitute, Vincent's mutilation has been interpreted as an act of castration—possibly reflecting an unconscious masochistic and homosexual wish for castration (Holstijn 1951; Schneider 1950; Schnier 1950).

The horrible events of Christmas, 1888, were cast in a context of deep religious preoccupations and obsessions. Consciously he rejected his former religious convictions and cast aspersions on the church and its minions. But he also felt a terrible need "of love and religion which must appear among men as a reaction to skepticism, and to that desperate suffering that makes one despair" (Letter 543). We can probably also discern in these events a religious motif that is not uncommon in such psychotic self-mutilations. Matthew 18 reads: "If your hand or your foot should cause you to sin, cut it off and throw it away: it is better for you to enter into life crippled or lame, than to have two hands or two feet and be thrown into eternal fire. And if your eye should cause you to sin, tear it out and throw it away: it is better for you to enter into life with one eye, than to have two eyes and be thrown into the hell of fire" (Mt 18: 8–9). As Lubin (1972) pointed out, this ominous and self-destructive admonition occurs in the same context in which Jesus takes a little child into his arms and says, "I tell you solemnly, unless you change and become like little children you will never enter the kingdom of heaven" (Mt 18: 3). The little child who had entered the kingdom of heaven in Vincent's mind was the dead Vincent; was his self-amputation in some sense an expression of the wish to become like that little child who became perfect in death?

The identification with Christ and the amputation of the ear may have reverberated with the gospel episode in which Peter cut off the ear of Malchus the servant of the High Priest in the garden of Gethsemane. Gauguin would become his Judas who betrayed and deserted him. The prostitute, Rachel, becomes the mother substitute, specifically in her Pietà role. Rachel was an antecedent of the *mater dolorosa* in the Old Testament that finds its echo in the New: "A voice was heard in Ramah, wailing and loud lamentation, and great mourning, Rachel weeping for her children; she refused to be consoled because they were no more" (Matthew 2: 18). The first Vincent was no more, and the mother of the Pietà was in mourning for his death. Vincent's painting of the Pietà expresses his identification with the first Vincent in death. His identification through death was in the first instance with the dead Vincent, and in the second instance with Christ. He sought unconsciously the loving devotion of his mother to the dead Vincent, and at another level of the Virgin Mother to her murdered son.

The peculiar detail of Vincent's carrying the severed ear to Rachel, the prostitute, reminds us that this behavior may be a piece of symbolic action. We can first note that these terrible events took place at Christmas. Christ-

mas seems to have been a favorite time for Vincent to erupt in some form of destructive behavior. We can recall that it was at Christmas, in the wake of his painful rejection by Kee Vos, that he had his ultimate violent scene with his father and had to leave home once and for all. Christmas evidently had special meaning for him. He often wrote in pleasurable anticipation of Christmas, especially in the letters from the earlier years. But after 1877, all such anticipations of Christmas seem to have disappeared (Lubin 1972). Rather he seemed to identify with the poor and the outcast, the aged and the crippled, who were excluded from the joy of Christmas.

The Christmas theme ties in with the question of his identification with Christ—particularly the identification with the suffering and dead Christ. He may have suffered from a form of "Christmas neurosis" in which the symptoms derive from unresolved rivalries and hostilities with siblings. As Boyer (1956) commented regarding such cases: "In them the birth of Christ, a fantasied competitor against whom they were unable to successfully to contest, reawakened memories of unsuccessful rivalries with siblings, real or fantasied, in their pasts. . . . There was some indication that they at times identified with Christ in an attempt to deny their own inferiority and to obtain the favoritism which would be His just due" (p. 257). The theme is one that we have seen before; it ties in with the theme of the dead Vincent against whose idealized image Vincent could never compete, the unsuccessful and unresolved sibling rivalry that cast such a long shadow over Vincent's inner life.

Crucifixion Fantasy

At another level of symbolic reference, Edelheit (1974) has suggested that Vincent's amputation was related to the imagery of the bullring, and at a deeper level to a crucifixion fantasy that would have been an expression of Vincent's deepseated identification with Christ. Edelheit (1974) interpreted the Christmas gift of the ear as a symbolic enactment of the ritual of the bullring—Vincent would have seen a number of these performances during his stay at Arles.[5] The cutting off of the bull's ear is a symbol of the matador's triumph and vanquishing of the bull; he celebrates that triumph by carrying the severed ear as a trophy which he presents to the lady of his favor. In this symbolic action Vincent becomes both the victorious matador and the vanquished bull. In the confusion of his psychotic imagery, Vincent becomes both vanquished and vanquisher, victim and aggressor. Edelheit cited a letter from Olivier (1951) to Vincent's nephew; after describing the bullfight ritual, he continues:

> I am absolutely convinced that van Gogh was deeply impressed by this practice. So that the two acts (namely cutting off the ear and later offering it to a lady) are

not incoherent at all, but constitute a normal sequence to everyone who is acquainted with the custom. Van Gogh cut off the ear, his own ear, as if he were at the same time the vanquished bull and the victorious matador, a confusion in the mind of one person between the vanquished and the vanquisher. (p. 193)

Edelheit suggested that the mingling of libidinal and aggressive themes may refer back to primal scene material, so that the imagery of the bullring becomes a displacement of impulses and fantasies that were originally stirred in the primal scene encounter. In any case, the same quality of double identification that can be associated with primal scene experiences can be identified in this material; it is not clear who is victim and who is aggressor, but the identification and internalization of both is involved.

At a further level of symbolic meaning, the severing of the ear comes to represent a crucifixion fantasy related to Vincent's identification with the suffering Christ—the crucified Christ who becomes victorious in death. Christ on the cross comes to represent a combined image of the parents and simultaneously the helpless child. Another derivative of this fantasy is in the image of the Madonna and Child, most poignantly in the Pietà—the Virgin Mother holding the dead Christ in her arms. These motifs played an important role in Vincent's psychic life and seem to have come into particular conjunction in the events surrounding his self-mutilation and later suicide.

The Christ theme undoubtedly carried a significant weight in Vincent's psychic life and served as a powerful motivational determinant for his behavior and life style, even his religious-like devotion to his artistic vocation and work. It is possible to push the metaphor beyond its limits, but nonetheless the parallels are striking—as though Vincent were enacting a religious drama following the gospel script. Lubin (1972) details the parallels: Rachel becomes the Virgin Mother of the Pietà, the mater dolorosa, the Rachel who weeps for her children and cannot be consoled; the severed and dead part of his body is like the dead body of the Crucified presented to His mother. In this enactment of Gethsemane, the scheming and greedy Gauguin becomes his Judas; he was jeered and taunted by the crowd just like Christ on the cross, and like Christ he was unjustly condemned.

Chapter XI
DEATH AND THE *MATER DOLOROSA*

Tragic Thread

For those of us who stand in awe ands admiration of the vibrant beauty, the vitality and expressive power of Vincent van Gogh's paintings, it is difficult to encompass the tragic overtones of his life and to connect the power and beauty of his work with his fatal decline into madness and suicide (Nagera, 1967; Lubin, 1972; Hulsker, 1990). The Parisian art critic, Albert Aurier, wrote of him six months before his death, while he was still an inmate in the asylum of St. Paul-de-Mausole in St. Remy:

> What characterizes his work as a whole is excess, excess of strength, excess of nervousness, violence in expression. In his categorical affirmation of the character of things, in his often fearless simplification of forms, in his insolence in challenging the sun face to face, in the vehement passion of his drawing and color, right down to the smallest particulars of his technique, a powerful figure reveals himself, a man, one who dares, very often brutal, and sometimes ingenuously delicate. And even more, this is revealed in the almost orgiastic excesses of everything he has painted: he is a fanatic, an enemy of bourgeois sobrieties and petty details, a kind of drunken giant, better suited to moving mountains than handling knickknacks, a brain in eruption, irresistibly pouring its lava into all the ravines of art, a terrible and maddened genius, often sublime, sometimes grotesque, always close to the pathological. (Pickvance, 1986, p. 312)

This certainly mirrors the sense one obtains from perusing many of Vincent's powerful paintings—the impression of vigor, strength, power. But there are other works that express something quite different—a sense of pathos, sadness, poignancy, pain, and almost infinite depths of sorrow. Among the brilliant colors of his canvases, one rarely catches a glimpse of the profound depression and dramatic tragedy that was his life.

Death runs like a persistent motif through the entire course of Vincent's life. The shadow of death was cast over his very birth as the replacement for the dead Vincent, and the shadow of his identification with the inhabitant of the small grave in the churchyard at Groot Zundert reached all the way to the little farmyard where he fired the fatal shot ending his life. The theme that came to dominate his life was that to be loved, cherished, and valued, one had to be dead—or at least one had to suffer in this life and ultimately die. Only in death could the wish for love and acceptance find fulfillment.

We can read his life story as a stunning example of what Kohut (1977) referred to as "tragic man," who is contrasted with the guilty man of classical psychoanalysis. Guilty man "lives within the pleasure principle; he attempts

to satisfy his pleasure-seeking drives, to lessen the tensions that arise in his erogenous zones" (Kohut 1977, p. 132). Inner conflicts over these goals give rise to guilt. Tragic man lives in the shadow of death:

> Tragic man's defeat and death do not, however, necessarily signify failure. Neither is he seeking death. On the contrary, death and success may even coincide. I am not speaking here . . . of a deep-seated active masochistic force which drives man to death, i.e., to his ultimate defeat, but of a hero's [triumphant] death—a victorious death, in other words, which (for the persecuted reformer of real life, for the crucified saint of religion, and for the dying hero on the stage) puts the seal of permanence on the ultimate achievement of Tragic Man: the realization, through his actions, of the blueprint for his life that had been laid down in his nuclear self. (p. 13)

For Vincent, that blueprint was determined from his birth, and became an unconscious motivating force that drove him along his tortured way—from one abortive venture to the next, from one wrenching disappointment in love to another, from one failure to the next in his efforts to find a career, through the vicissitudes of his religious fanaticism, finally to his all consuming dedication to his artistic vision. Great artist that he was, and as powerfully expressive and revealing of himself in his many letters as he was, Vincent possessed that unique capacity of artistic geniuses to remain in touch with the deepest realms of their often troubled psychic experience and to distill it into their art in a way that communicates something invaluable to those who struggle to understand something further and deeper about the human spirit.

Death and transience seem to have pervaded Vincent's mental horizons from early on. He burst into tears at the sight of the empty chair where his father had sat during his visit to Amsterdam. The empty chairs, one symbolizing himself (F498, JH1635) and the other Gauguin (F499, JH1636), call to mind the rupture of their fragile relationship and the destruction of Vincent's dream of an artists' colony under the warm sun of the Midi. The apprehensions of death pervaded his conscious mind and remained a persistent theme in the unconscious depths of his heart. His life became a *via dolorosa* that led inexorably to death. He was cast in the mold of the suffering artist, lonely, isolated, misunderstood, hopeless and despairing, tottering on the brink of suicide.

"Almost Smiling Death"
Death was never far from Vincent's consciousness, particularly from his religious preoccupations. In his sermon, preached as the pastor's assistant in Richmond, he said, "There is sorrow in the hour of death, but there is also joy unspeakable." We can understand in some small way what he meant—there was little joy in life for him; there was promise of joy only in death. That was

his destiny, but it did not mean that he was insensitive to the pain of death and loss for those around him. The message of his sermon, however, was one of hope and faith in the "almost smiling death" that brought with it the promise of rebirth and immortality—"there is no death and no sorrow that is not mixed with hope—no despair—there is only a constantly being born again."

Death was for him an integral part of the human situation. He would write to Theo reflecting on a picture of a dead horse:

> It is a sad and very melancholy scene, which must affect everyone who knows and feels that one day we too have to pass through the valley of the shadow of death, and *"que la fin de la vie humaine, ce sont les larmes ou des cheveux blancs"* [the end of human life is tears or white hair]. What lies beyond is a great mystery which only God comprehends, but He has revealed absolutely through His word that there is a resurrection of the dead. . . . It always strikes me, and it is very peculiar, that whenever we see the image of indescribable and unutterable desolation—of loneliness, poverty and misery, the end or extreme of all things, the thought of God comes into our minds. At least it does with me, and doesn't Father also say, "There is no place I like to speak in better than a churchyard, for we are all standing on equal ground; furthermore, we always *realize* it." (Letter 126)

The churchyard is also a graveyard, and death is the great equalizer. Do we hear the echoes of the sorrow in the graveyard at Zundert, and the fantasy in Vincent's mind that he can gain equal footing with the dead Vincent only through his own death?[1]

Mater Dolorosa

Vincent came into the world under the shadow of a severe maternal depression that found expression in the replacement syndrome that seems to have had a decisive influence on his early years. His subsequent development was cast in a setting in which he was regarded as strange, different, eccentric, difficult, and a constant heartache to his parents. He came to feel himself a stranger, an alien presence, an unwanted encumbrance on family conventionality and emotional tranquillity. These elements came to play a vital role in Vincent's artistic life, found their poignant expression in his paintings, and finally drew him down the path to his fateful suicide. One component found expression in his immersion in nature—a fascination that issued in an outpouring of masterful landscapes, brilliant visions of the powerful sun, wheatfields and gardens, still lifes and flowers. But I would wish to focus here on another powerful motif that found its way from the traumata of his childhood onto his canvases—the motif of the *mater dolorosa*.

The *mater dolorosa* is another of those profoundly religious themes that played an important part in Vincent's religious vision and especially in his

unconscious fantasy system related to it. A picture of the *mater dolorosa* hung on the wall of his room in Dordrecht—the same picture that had held such a prominent place in his father's study at Zundert (Letter 88). The *mater dolorosa* was his own mother caught in her unending grief over the death of her firstborn; she was the mother who was possessed by the powerful father-god and remained in some degree affectively unavailable to Vincent. Vincent had never gained the sense of loving approval and acceptance that he had so desperately sought. He could not find it in any of his relationships, even from those who brought him into this world.

Vincent has left us only one portrait of his mother. He received a photograph of her in Arles and this prompted him to paint two pictures—one of the parsonage in Etten, and the other of his mother. The portrait of his mother (F477, JH502) was painted in "ashen gray," a deadly and depressive shade. It presents an image of an old woman staring with an enigmatic expression with cold glaring eyes.[2] He associated it to a poem:

> Who is the maid my spirits seek
> Through cold reproof and slanders blight?
> . . . wan and sunken with midnight prayer
> Are the pale looks of her I love . . . (Letter W18)

These are not the words of warm and loving attachment, but of the failure of maternal empathy.

We also have another less direct representation of Vincent's mental imagery regarding his mother. His painting of two women walking through a garden in Etten (F496, JH1630), where they had lived for a time, was not intended to immediately represent his mother and sister, but there is no doubt that he had them in mind. He wrote about it to his sister Wil:

I have just finished painting, to put in my bedroom, a memory of the garden at Etten; here is a scratch [sketch] of it. It is rather a large canvas. . . . The old lady has a violet shawl, nearly black. But a bunch of dahlias, some of them citron yellow, the others pink and white mixed, are like an explosion of color on the somber figure. . . . I know this is hardly what one might call a likeness, but for me it renders the poetic character and the style of the garden as I feel it. All the same, let us suppose that the two ladies out for a walk are you and our mother; let us even suppose that there is not the least, absolutely not the least vulgar and fatuous resemblance—yet the deliberate choice of the color, the somber violet with the blotch of violent citron yellow of the dahlias, suggests Mother's personality to me. . . . I don't know whether you can understand that one may make a poem only by arranging colors, in the same way that one can say comforting things in music. In a similar manner the bizarre lines, purposely selected and multiplied, meandering all through the picture, may fail to give the garden a

vulgar resemblance, but may present it to our minds as seen in a dream, depicting its character, and at the same time stranger than it is in reality. (Letter W9)

The figure of the old woman—his mother—not only was cast in somber colors, flavored with a pinch of violence, but her bent figure and tragic face speak of despair, pain, bereavement and a deep and lasting mourning, if not depression. She is absorbed in her grief, solitary, withdrawn—despite the companion at her side, to whom she does not speak. The image of this sad, withdrawn and sorrowing woman comes out of the depths of Vincent's unsatisfied yearning and frustrated desire for love from a mother whose love and affect lie elsewhere.

"La Berceuse"

The various renditions of the postman Roulin's wife in "La Berceuse" (F505–508, JH1669–1672) offer another expression of the *mater dolorosa* theme. Madame Roulin is a substitute for Vincent's mother: Roulin's transfer to Marseilles left his wife and family alone and left Vincent without the support of his good friend. These circumstances had stirred some residues of Vincent's sympathy for his mother, who had been deserted by his father's death, and brought with them renewed wishes for some semblance of love and affection from her. Mme. Roulin was a representation of his mother who was so affectively distant and in so many ways unempathic.

At the time Vincent's own losses were mounting. Gauguin had abandoned him and left his dream of the Midi Studio in ruins. He was being put out of his yellow house, and to top it all off Theo was engaged to be married. Mme. Roulin is not only a representation of his mother but of Gauguin—the soft, feminine Gauguin, so effectively portrayed in the painting of Gauguin's empty chair, whom Vincent idolized and to whom he sought to yield himself in caring dependence. As Heiman (1976) comments:

> The painting of La Berceuse may be seen as a—desperate—attempt to regain his lost security through regression. In the context of what preceded the La Berceuse painting and what will follow, the attempt was not successful. He is still unable to master the raging instinctual forces of aggression within himself. He cannot look at the reality of his life—he is as uncompromising as ever before. . . . But the round, soft, big bosom of "La Berceuse" should not deceive us—neither should the inviting lullaby. When we meet them again, later, during July 1890 in Auvers, the haven for the abandoned and lonely will have changed into a threatening and terrifying image, and the lullaby into a siren–call to death. (p. 73)

Vincent painted "La Berceuse," the "Lullaby," no fewer than five times from January to March 1889. He told Theo, "I am working on the portrait of

Roulin's wife, which I was working on before I was ill" (Letter 573). He commented about the picture:

> I have just said to Gauguin about this picture that when he and I were talking about the fishermen of Iceland and of their mournful isolation, exposed to all dangers, alone on the sad sea—I have just said to Gauguin that following those intimate talks of ours the idea came to me to paint a picture in such a way that sailors, who are at once children and martyrs, seeing it in the cabin of their Icelandic fishing boat, would feel the old sense of being rocked come over them and remember their own lullabys. (Letter 574)

And if there was any doubt that in Vincent's mind Roulin and his wife represented his own parents, and that Madame Roulin bore the psychic marks of his mother, Vincent goes on to say in the same letter:

> I shall never forget Mother at Father's death, when she said only one little word: it made me begin to love dear old Mother more than before. In fact, as a married couple our parents were exemplary, like Roulin and his wife, to cite another instance. Well, take that same road. During my illness I saw again every room in the house at Zundert, every path, every plant in the garden, the views of the fields outside, the neighbors, the graveyard, the church, our kitchen garden at the back—down to a magpie's nest in a tall acacia in the graveyard. It's because I still have earlier recollections of those first days than any of the rest of you. There is no one left who remembers all this but Mother and me. (Letter 573)

We are not surprised at the recurring references to the graveyard—the same graveyard in which the first Vincent had been laid to rest and through which Vincent passed every day of his young life.

This painting also can be seen in a more specifically religious perspective. Madame Roulin can be seen here as a sort of modern madonna—an impression strengthened by Vincent's letter, in which he wrote:

> And I must tell you—and you will see it in "La Berceuse," however much of a failure and however feeble that attempt may be—if I had had the strength to continue, I should have made portraits of saints and holy women from life who would have seemed to belong to another age, and they would be middle-class women of the present day, and yet they would have had something in common with the very primitive Christians.. (Letter 605)

Preoccupations with Death

The idea of death was never far from his consciousness. He wrote to Theo from Amsterdam on August 5, 1877, "In the midst of life we are near death, that is a phrase which touches each one of us personally. . . . Oh! what sorrow, what sadness and suffering there is in the world, in public as well as in

private life" (Letter 105). He had a dreaded premonition that haunted his footsteps. He told Theo:

> My words may sound gloomy, very well. For myself, there are moments when my own prospects seem very dark to me—but as I already wrote you, I do not believe that my fate depends on what seems against it. All kinds of things may be against me, but there may be one thing more powerful than what I see threatening me. I used the word fatality for lack of a better word—no one falls before his time—so as for me, I resign myself to fate, and act as if nothing were the matter. (Letter 342)

At another point he wrote to Theo:

> You understand so well that "to prepare oneself for death," the Christian idea (happily for him, Christ himself, it seems to me, had no trace of it, loving as he did people and things here below to an unreasonable extent, at least according to the folk who can only see him as a little cracked)—if you understand so well that to prepare oneself for death is idle—let it go for what it's worth—can't you see that similarly self-sacrifice, living for other people, is a mistake if it involves suicide, for in that case you actually turn your friends into murderers. (Letter 492)

Death Anxiety

Vincent's death anxiety is projected onto the canvas in his painting of the "Skull with Cigarette" (F212, JH999). The grinning skull has a lighted cigarette dangling from its bony lips. The painting seems almost like a grim joke—all the more poignant in view of the modern association of smoking and cancer. Some have seen it as his first self-portrait—"a cynical, merciless comment on an unkempt and unattractive appearance that had been a sign of solidarity with the peasants back in Nuenen but was now an embarrassment and a problem in the city [Paris]" (Walther and Metzger 1990, p. 219). It does reflect Vincent's death anxiety—a kind of poem to death (Tralbaut 1969). The theme never seemed far from his mind. He wrote Theo:

> It certainly is a strange phenomenon that all artists, poets, musicians, painters, are unfortunate in material things. . . . That brings up again the eternal question: Is the whole life visible to us, or isn't it rather that this side of death we see only one hemisphere? Painters—to take them alone—dead and buried speak to the next generation or to several succeeding generations through their work. Is that all, or is there more to come? Perhaps death is not the hardest thing in a painter's life. For my own part, I declare I know nothing whatever about it, but looking at the stars always makes me dream, as simply as I dream over the black dots representing towns and villages on a map. Why, I ask myself, shouldn't the shining dots of the sky be as accessible as the black dots on the map of France? Just as we take the train to get to Tarascon or Rouen, we take death to reach a star. One thing undoubtedly true in this reasoning is that we *cannot* get to a star while we are *alive*, any more than we can take the train when we are dead. So

to me it seems possible that cholera, gravel, tuberculosis and cancer are the ce-
lestial means of locomotion, just as steamboats, buses and railways are the terres-
trial means. To die quietly of old age would be to go there on foot. (Letter 506)[3]

The preoccupation with death seems to have been intensified after his
father's death. Although he showed little outward reaction to that event, as
though he had severed all emotional ties so that his father's demise meant lit-
tle or nothing to him, it would be inconsistent with what we know about his
feelings about death to think that the effect was not more farreaching and se-
vere. He would not have been able to escape the sting of guilt for his mur-
derous wishes and angry attacks against his father. It is not too farfetched to
imagine that much of his self-starvation and self-flagellation were in the
service of this unconscious guilt—a gamble with death seeking for atonement
(Lubin 1972).

We have explored the oedipal and rebellious aspects of his manner of life
and self-deprivation. Success in his religious vocation was overburdened by
the vicissitudes of emulation of his idealized father together with a competi-
tive need to outdo and surpass the disapproving and disciplining father of the
oedipal period. Success in the world, either as a minister of religion or as an
artist, held too many dangers for Vincent—his only recourse was retreat and
self-diminution. At another and deeper level, his guilt at replacing the ideal-
ized dead Vincent may have meant that success was equivalently an attack on
the dead brother, perhaps an attempt to replace him in the eyes of his parents.
In Vincent's unconscious death and success may have been synonymous, re-
inforced by his unconscious striving to identify with the idealized dead
brother.

Death and Resurrection

Vincent's identification with Christ centered particularly on the suffering
Christ, who was crucified and died and was thus resurrected and raised to
heavenly sublimity. There is some suggestion of this motif in his painting of
"The Raising of Lazarus" (F677, JH1972), where the face of Lazarus with its
red beard may be that of Vincent himself. Lazarus is awakening from the
dead and is received into the outstretched arms of a woman in a green dress.
Vincent's comments about the painting to Theo establish the connection be-
tween the woman in this painting and the figure of "La Berceuse"—the
woman who had stood for Vincent's mother in that painting now assumes the
character of an angelic figure welcoming Lazarus from the grave and back to
life. It was only through the Christlike torments of suffering and death that
one could achieve the blessings of resurrection and loving acceptance from
his mother—something that he had endlessly sought and always been denied.

There is another connection to be considered. Vincent had returned to visit Zundert in 1877, and took the occasion to visit the old churchyard.[4] He associated the graveyard, with its telltale headstone of the dead Vincent, not only with the stars but with the theme of resurrection. Is it possible that the resurrection of Lazarus who bears the face of Vincent represents not only a wish for his own resurrection from death into the arms of a loving mother, but the unconscious reference to the dead Vincent who found love and acceptance through death? Vincent's identification with the suffering Christ served its unconscious purposes only to the extent that it won for him a measure of love and admiration—especially from his mother. Suffering and death were the heralds of a glorious resurrection, as well as winning the tearful embrace of the *mater dolorosa*.

"The Reaper"

Other paintings that most graphically express the motif of death are his portrayals of "The Reaper" (F618, JH1773; F687, JH1782). While he was working on the first painting, the news arrived that Theo and Johanna were expecting a child, and that if it turned out to be a boy they intended to name him after Vincent. This was followed by a severe recurrence of his illness that incapacitated him for several weeks. The images of death came ever closer during these attacks which were accompanied by suicidal ideas. We can infer that the image of the reaper was to this extent autobiographical.

The reaper is a frequent symbol of death and seems to have been one of Vincent's favorite subjects. His early paintings of reapers are dark and melancholic; those painted in the Midi are full of light and color suggesting the more joyous aspects of death to his mind (F559, JH1479; F618, JH1773; F688, JH1783). Of one such portrayal he wrote:

> I am struggling with a canvas begun some days before my indisposition, a "Reaper" (F615, JH1753); the study is all yellow, terribly thickly painted, but the subject was fine and simple. For I see this reaper—a vague figure fighting like a devil in the midst of the heat to get to the end of his task—I see in him the image of death, in the sense that humanity might be the wheat he is reaping. . . . But there's nothing sad in this death, it goes its way in broad daylight with a sun flooding everything with a light of pure gold it is an image of death as the great book of nature speaks of it—but what I have sought is the "almost smiling.". . . I find it queer that I saw it like this from between the iron bars of a cell. (Letter 604)

The wheat as a metaphor for humanity is expressed in his letter to Wil:

> What else can one do, when we think of all the things we do not know the reason for, than go look at a field of wheat? The history of those plants is like our

own; for aren't we, who live on bread, to a considerable extent like wheat, at least aren't we forced to submit to growing like a plant without the power to move, by which I mean in whatever way our imagination impels us, and to being reaped when we are ripe, like the same wheat? What I want to tell you is that the wisest thing to do is not to long for complete recovery, not to long to get back more strength than I have now, and I shall probably get used to the idea that I shall be broken a little sooner or a little later—what does it matter after all? (Letter W13)

Vincent's notion of an "almost smiling" death reflects his passionate faith in rebirth and immortality—an idea that found early expression in his sermon: ". . . there is no death and no sorrow that is not mixed with hope—no despair—there is only a constantly being born again."

"The Sower"

The themes of death and rebirth were often mingled in Vincent's mind and found frequent expression in his painting. Along with the image of the reaper, the image of the sower assumed a dominant position in his unconscious—paired and complementary images of death and rebirth, symbols of infinity and eternity. The themes come from the bible and have both personal and religious implications in Vincent's thinking. His attraction to the sowers of the fields began early—he had already drawn five sowers by the time he left the Borinage and the theme continued to fascinate him at Arles (F494, JH1617; F575a, JH1596) and St. Remy (F690, JH1837). Two major versions of the sower were done in the summer and fall of 1888. In the first, done in June (Fig. 7; F422, JH1470), the contrast between the upper and lower halves of the painting is striking—the bright yellow sky, the brilliant sun and the glowing band of wheat are filled with light and life. Below the dark violet earth lies in stark contrast. It is a division and tension between light and dark, between life and death. He wrote to Bernard: "I won't hide from you that I don't dislike the country, as I have been brought up there—I am still charmed by the magic of hosts of memories of the past, of a longing for the infinite, of which the sower, the sheaf are the symbols—just as much as before. . . ." (Letter B7).

The second version of the Sower (Fig. 8; F450, JH1627) was done in October 1888. While he was working on this version, he wrote to Theo:

Yesterday and today I worked on the sower, which is done completely differently. The sky is yellow and green, the ground violet and orange. There is certainly a picture of this kind to be painted of this splendid subject, and I hope it will be done someday, either by me or by someone else. This is the point. The "Christ in the Boat" by Eugene Delacroix and Millet's "The Sower" are absolutely different in execution. The "Christ in the Boat"—I am speaking of the sketch in blue and green

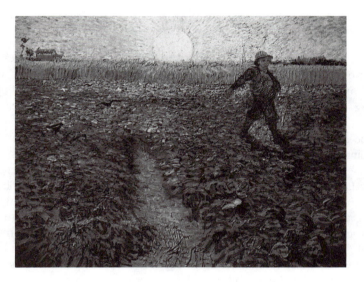

Figure 7. "The Sower" (F422, JH1470)
Rijksmuseum Kröller-Müller, Otterlo, Netherlands

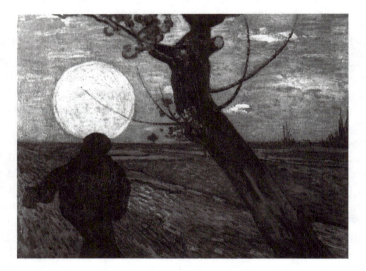

Figure 8. "The Sower" (F450, JH1627)
E. G. Buehrle Collection, Zurich

with touches of violet, red and a little citron-yellow for the nimbus, the halo—
speaks a symbolic language through color alone. (Letter 503)

We can hear the reverberation of multiple lines of association here—the
"sower of the seed" is the father in his procreative role, impregnating "mother
earth," intersecting with the sun symbolically representing the father—all
echoing the patterns of identification dominating Vincent's inner world
(Schnier 1950).

The contrast between the two versions is interesting. The earlier version
is dominated by the brilliant sky and the light of the sun—life holds the upper
hand over death. But in the autumnal version, the colors have deepened, the
sky is darker, the sun less brilliant, the earth darker and more somber, the
contrasting colors more vehement, the figure of the sower thrust into the fore-
ground, and finally the tree that had been a hardly noticeable feature of the
background in the earlier version now becomes a powerful and dominating
symbol. In terms of the tension between light and darkness, between life and
death, the autumnal version seems to suggest that the light of life is fading,
that the forces of darkness and death loom ever more ominously and threaten-
ingly on Vincent's mental horizon.

Vincent's paintings of "The Sower" must be regarded as powerful self-
portraits in their representing the struggle and tension that pervaded the core
of his being between the forces of light and darkness. The symbolic implica-
tions of the image of the sower continued to haunt him on his way. Dividing
the paintings into two parts was an attempt to deal with the ambiguity and
ambivalence that haunted his soul. The paintings suggest that more and more
in these final years the forces of darkness, murderous rage and death were
playing an increasingly powerful and influential role in his unconscious mind.[5]

Cypresses

These same themes of life and death, particularly in self-referential terms,
came into play in Vincent's portrayal of trees. Often the trees became reflec-
tions of himself. In his painting of St. Paul's Park (F660, JH1849) in which
he portrays part of the garden of the hospital in St. Remy, he says of the great
pine: "Now, the nearest tree is an enormous trunk, struck by lightning and
sawed off. But one side branch shoots up very high and lets fall an avalanche
of dark green pine needles. This somber giant—like a defeated proud man—
contrasts, when considered in the nature of a living creature, with the pale
smile of a last rose on the fading bush in front of him" (Letter B21).

Cypresses played a particularly important role in this connection. He was
constantly preoccupied with them, particularly so during his stay at St. Remy.
He wrote Theo:

The cypresses are always occupying my thoughts, I should like to make some-
thing of them like the canvases of the sunflowers, because it astonishes me that
they have not yet been done as I see them. It is as beautiful of line and propor-
tion as an Egyptian obelisk. And the green has a quality of such distinction. It is
a splash of *black* in a sunny landscape, but it is one of the most interesting black
notes, and the most difficult to hit off exactly that I can imagine. (Letter 596)

The association to the obelisk and the emphasis on blackness forges a link to
the themes of life and death, a common connection in the Mediterranean area.

His cypresses are massive structures of whirling and dancing darkness
and light. They are like living, leaping, contorting, whirling, twisting and
dancing flames that seem to leap from earth to heaven in a powerful display
of undulating force (F1525, JH1747; F613, JH1746). Yet the cypress from
ancient times has been the symbol of death. Vincent did several studies of
cypresses that seem to integrate in symbolic terms the themes of life and
death.[6] The dark note and blackness suggest the overtones of death that was
linked in Vincent's mind with his identification both with the dead Vincent
and with the Christ crucifed on the tree of life.

Vincent's Suicide

All of these themes, with their constant undercurrent of religious implication,
came together with tragic impact in Vincent's suicide. During the period of
Vincent's illness, suicide was never far from his mind. If we regard his self-
deprivation and self-mortifications as suicidal equivalents (Menninger 1938),
the idea must have even had its unconscious place through most of his life.
From time to time he had touched on the subject of suicide in his letters, often
making light of it: "Then I breakfasted on a piece of dry bread and a glass of
beer—that is what Dickens advises for those who are on the point of commit-
ting suicide, as being a good way to keep them, at least for some time, from
their purpose" (Letter 105). And again, writing to his sister Wil:

Every day I take the remedy which the incomparable Dickens prescribes against
suicide. It consists of a glass of wine, a piece of bread with cheese and a pipe of
tobacco. This is not complicated, you will tell me, and you will hardly be able to
believe that this is the limit to which melancholy will take me; all the same, at
some moments—oh dear me. . . . Well, it is not always pleasant, but I do my
best not to forget altogether how to make contemptuous fun of it. I try to avoid
everything that has any connection with heroism or martyrdom; in short, I do my
best not to take lugubrious things lugubriously. (Letter W11)

He was often at pains to deny suicidal thoughts or wishes, but the
thoughts kept resurfacing and found their way into his letters to Theo. It was
actually his relationship with Theo that may have tipped the balance in favor

of the forces of death against those of life. His dependence on Theo, as already suggested, was a matter of life and death. On more than one occasion Vincent was clear about it—his life depended on Theo's continued financial assistance. If Theo was unable to maintain the level of his financial support, it "would be like choking or drowning me." This desperate dependence was threatened in the last months. Theo's marriage, the birth and illness of his little son, and finally Theo's own precarious health posed multiple and serious threats to Vincent's sense of wellbeing. Theo's own anxiety over these events served only to draw his emotional investment and attachment away from Vincent to his wife and child. They also began to absorb more of Theo's meager income. In a word, there was less of everything for Vincent. There must have been some resentment on Vincent's part, resentment that could not be expressed toward Theo, on whom he already felt dependent and needy. Vincent's envy must also have been immense: Theo had many of the goods of this life that Vincent secretly desired—money, a family, and the good opinion and favor of the rest of the family. Theo was the fair-haired boy, while Vincent was the ugly duckling, the outcast, the stranger, the black sheep.

Nor was Vincent any stranger to suicidal gestures. Certainly the amputation of his ear was a suicidal gesture, or the equivalent. Paul Signac recalled another attempt during his visit in March 1889, when Vincent tried to drink some turpentine. On several occasions in the sanitarium, he tried to swallow kerosene or oil paints and had to be forcibly restrained. It was not as though death came upon Vincent by stealth; he actively pursued it, sought it out.

A Shadow from the Graveyard

Vincent's suicide can be viewed as an act of desperation and a reaction to illness, destitution and utter loneliness. Vincent killed himself on the threshold of public recognition and acceptance (Gedo 1983). His life had been a series of failures and humiliations. His artistic productivity was not simply his own, but the product of a joint effort—as he saw it—with Theo. The threat of Theo's eventually fatal illness may have signalled the destruction of the symbiosis that provided the psychic basis for his creativity. He was haunted by "his self-destructive need to repeat the experience of being unjustly rejected and despised—most dramatically enacted in his legendary encounter with Paul Gauguin in Arles" (p. 108).

Gedo (1983) argues that the bond between the two brothers served to postpone the suicide and made it possible for Vincent to exercise his creativity and place it in the service of a profound religious ideal. After the pact with Theo, his passion and devotion to his art was so intense that he neglected all other human needs. His art became the replacement for the fanati-

cal devotion with which he pursued his religious vocation. But at one point he had written Theo, "If I did not have your friendship, I should be remorselessly driven to suicide, and, cowardly as I am, I should commit it in the end" (cited in Tralbaut 1969, p. 270). The possibility looms that Theo's marriage and involvement in the difficulties of his little family, the threats to Theo's professional position at Broussod et Valadon, and finally the ominous course of Theo's life-threatening illness, all conspired to cast a dark shadow over Vincent's horizon.

The shadow of the dead Vincent may have fallen across the relationship between the two brothers. The connection between the dead Vincent and Theo may have provided a powerful motif in Vincent's unconscious, reinforced by the fact that Theo was the favorite of his parents and thus became in Vincent's mind's eye the inheritor of the idealization of the dead Vincent. This circumstance was painful to Vincent, a fact that he referred to occasionally in his letters. To the extent that this dynamic played a role in their relationship it would have been the basis for a deepseated envy and resentment in Vincent against his younger brother, as well as against the most recent Vincent—Theo's son. These sentiments would have been unconsciously transferred from the dead Vincent. This would also explain his sense of entitlement to Theo's help and his constant demands for more from Theo than he was receiving. Vincent's entitlement reflected his deeper sense that this usurping and favored brother had taken something away from him that was his birthright. The hostility may also have included death wishes that Vincent had to defend against, wishes that had originally arisen toward the dead Vincent but subsequently found their target in the usurpers.

Vincent's suicide, then, was the final and consummatory act of a religious drama that had encompassed his life and led him inexorably to death. In it he consummated his identification with Christ—Christ suffering and crucified—and brought to a close his life of martyrdom and pain, of hurt and rejection, of the failure of love and life. In it he achieved the final realization of that which he had sought for a long as he could remember, the realization of love and filial acceptance in death. Behind his identification with the Crucified lay the deeper unconscious identification with the dead Vincent.

"Crows Over the Wheatfield"

These reflections draw us back to one of Vincent's most important landscapes. Vincent felt that his very life was being threatened by his disease, by Theo's illness and his own sense of diminishing powers. In the midst of these torments, he turned again to painting—"though the brush almost slipped from my fingers. . . ." (Letter 649). His painting of the "Crows over the Wheatfield" (Fig. 9; F779, JH2117) came from his hand during the last month of his

life. Some even claim it to be his last work—a sort of painted suicide note.
The perspective is inverted—the three roads dissect the fields in two triangles
that converge menacingly toward the viewer. The roads do not meet at a
vanishing point in the distance—the vanishing point is the point of death.
This painter can no longer bear with life; he has come to the end, and "death
has come to claim his life: to claim it aggressively—murderously" (Heiman
1976, p. 76). Heiman (1976) sees this change in perspective not as a loss of
command of perspective, but as an unconscious device to communicate his
suicidal message.

One critic wrote of it:

> And then a long, horizontal painting. A field of grain in strong, dark yellow.
> The yellow stalks of grain sway savagely against one another; they are ruggedly
> and crudely painted, filling the entire length of the piece, more than half its
> height. And above this stark, somber yellow, a heavy dark blue sky of a terrible,
> deathly blackish blue. A flock of large pitchblack birds flutters on high in the
> dark blue from out of the tempest of yellow grain. This, to me, was a violent
> expression of the utmost desperation.[7]

The black crows are symbols of death (Schapiro 1952), ominous, menac-
ing, attacking. Heiman (1976) commented: "Through the black birds which
symbolize not just death but violent death, the message contained in this sui-
cide painting is not that of a person ready to surrender himself to death—like
drowning—but of someone who is confronted with and afraid of being at-
tacked, killed—and possibly devoured" (p. 78). The soothing and caring
melody of the lullaby can no longer be heard. The mother's embrace be-
comes threatening, the welcoming arms enfold in death, the mother's womb
becomes a tomb. The vast field of corn is cut in two, two piercing and
pointed triangles—the mother's body with its menacing breasts. Instead of
the round soft, inviting breasts of "La Berceuse" we are confronted with "two
huge, menacingly pointed, sharply-edged breasts directed at and ready to at-
tack and kill the painter-spectator" (Heiman 1976, p. 78). The painting was
quite possibly still on his easel when he took his pistol and went out to the
fields where he shot himself.

The images of wheat and death were mingled in his unconscious. He had
written from St. Remy: "I feel so strongly that it is the same with people as it
is with wheat, if you are not sown in the earth to germinate there, what does it
matter?—in the end you are ground between the millstones to become bread.
The difference between happiness and unhappiness! Both are necessary and
useful, as well as death or disappearance . . . it is so relative—and life is the
same!" (Letter 607).[8] There are signs of loss of control over his medium:
composition and perspective are out of joint. "Crows over a Wheatfield" is

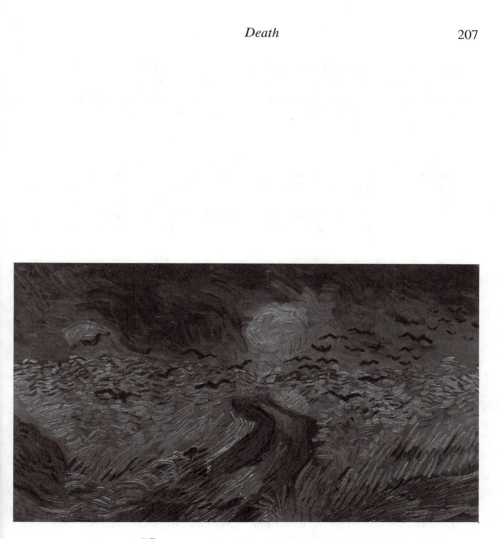

Figure 9. "Crows over the Wheatfield" (F779, JH2117)
Rijksmuseum Vincent van Gogh, Amsterdam

the last of several landscapes painted at Auvers. Vincent refers to them in one of his last letters to Theo: "They are vast fields of wheat under troubled skies, and I did not need to go out of my way to try to express sadness and extreme loneliness" (Letter 649). It reflects a terrible premonition of his suicide. As Schapiro (1952) described it:

> . . . a field opening out from the foreground by way of three diverging paths. . . . the lines, like rushing streams, converge toward the fore ground from the horizon, as if space had suddenly lost its focus and all things turned aggressively upon the beholder. . . . [the crows unite] in one transverse movement the contrary directions of the human paths and the sinister flock. . . . It is as if [the artist] . . . saw an ominous fate approaching. The painter-spectator has become the object. (pp. 87–89)

And again:

> If the birds become larger as they come near, the triangular fields, without distortion of perspective, rapidly enlarge as they recede. Thus the crows are beheld in a true visual perspective, which coincides with their emotional enlargement as approaching objects of anxiety; and as a moving series they embody the perspective of time, the growing imminence of the next moment. But the stable, familiar earth, interlocked with the paths, seems to resist perspective control. The artist's will is confused, the world moves towards him, he cannot move towards the world. It is as if he felt himself completely blocked, but also saw an ominous fate approaching. The painter-spectator has become the object, anguished and divided, of the oncoming crows, whose zigzag form, we have seen, recurs in the diverging lines of the three roads. (Schapiro 1983, p. 37)

The mood of ominous despair that pervades the atmosphere of this painting may resonate with Vincent's underlying fantasy of crucifixion in the image of Christ. The paths are arranged in cruciform pattern, so that the picture suggests the moment of crucifixion when there was darkness over the earth and despair in the heart of the Crucified—"My God, my God, why hast thou forsaken me?" As Lubin (1972) noted:

> The painting [Crows] remains a gloomy warning of impending doom. But as a Crucifixion, it served a more important, wish-fulfilling function for Vincent. It heralded the joyful rebirth and the welcomed ascension into heaven of God's favorite child. . . . the focus in this painful yet hopeful event must remain divided between the death of the martyr on the cross and the everlasting joy that awaits him and all who believe in him. The crows descend to seal his fate, but they also accompany him to his eternity in heaven. (p. 240)

Section V

VINCENT AND GOD

VINCENT'S PERSONALITY

Diagnostic Considerations

With all the pieces of this puzzle scattered on the table, we can try to fit them together to form a meaningful picture. Vincent's religious odyssey presents a number of aspects that challenge any attempt to integrate the pieces into a simple or straightforward account. The first difficulty is that both Vincent's artistic endeavors and his religious outlook are permeated with his pathology. The temptation is reduce his religious immersion to the pathological. And pathology there certainly was! The psychiatrist would immediately think of a significant genetic loading for mental disturbance, especially given the abundance of derangement in the van Gogh family. He would also be fascinated by the problem of diagnosis—into what diagnostic category or categories might we fit the clinical course that would include childhood behavioral difficulties, recurrent depressions, chronic irritability and paranoid aloofness, psychotic episodes, and finally suicide?[1]

Impulsive acts of episodic dyscontrol (self-mutilation, suicide attempts) were frequently associated with Vincent's attacks: rage attacks, argumentative tirades, some physical attacks, occasional brawls in Paris, and later attacks on attendants in the asylum. Most of the people who befriended him, especially the artists in Paris, were afraid of him. For the most part, these episodic rage attacks were uncharacteristic and quite alien to his sensitivity, gentleness, and love of the poor and downtrodden. None of these earlier manifestations had a psychotic quality; that seemed to emerge later during the Arles period—the attack on Gauguin is the first we know of.[2] All these possibilities have been suggested and may have partial validity. The diagnostic picture is complicated by his alcoholism, his addiction to absinthe,[3] and the strong possibility that he had contracted syphilis. Add to this the possibility of a variety of vitamin deficiencies, brought on by his fasts and self-deprivations, that could have contributed to his psychological dysfunctioning and his decline into psychosis. To psychiatric eyes Vincent's religious obsessions would have seemed symptomatic and expressive of a possible underlying psychotic process.

The psychoanalyst would take note of the fact of his being a replacement child, his position as the family scapegoat, his difficulties in relating to a depressed and unempathic mother and a severe, distant, and judgmental father, the peculiar behavioral difficulties during childhood, the idealization of his father the minister, the repeated traumata of rejection, disappointment and failure, his symbiotic dependence on Theo, as driving him toward the search

for solace and meaning in his religious immersion. Again there is merit to all these factors—each contributing its share of burden to the accumulated weight of existential anxiety that affected the very core of his being. The picture that might emerge from these considerations would contribute another classic case to confirm Freud's view of religion. Vincent's religious concerns would then be seen as infantile and regressive fantasies based on the compensation of his narcissistic needs and yearning for surcease from pain and isolation. However, we can question whether we should accept this reductionistic portrayal at face value, or whether there may not be more to the story.

Narcissistic Issues
Vincent had severe difficulties in accepting and adapting to the world around him; he was able to see it only through the filter of his wishes. The line of differentiation between reality and wishful fantasy or illusion was highly permeable at best. Time and again, when he exposed his wishes to reality, they were disappointed and trampled. Depression dogged his footsteps—it was always by his side, a constant companion that would never allow him to escape the burdens of guilt and conscience and permeated every facet of his troubled life.

He sought solace in religion and the Bible, but as in everything else he found his resolution in the extremes of fanaticism. After his rebellion against the religion of his father, his art became the focus of his fanatical intensity, driven by his need to escape from the curse of his depression—as a way to avoid "that melancholic staring into the abyss." Particularly after his London humiliation, he became increasingly difficult, obstinate, critical and opinionated. As Nagera (1967) commented:

> Yet any criticism gravely affected his self-esteem. Thus he was forced to turn violently against those people in authority whose demands he did not feel capable of fulfilling to their satisfaction. To preserve a bare minimum of self-esteem and well-being he would have considered, if necessary, that the whole world was wrong and against him, but much of this aggressive, defiant and obstinate behavior was due largely to a basic feeling of insecurity and was his only means of coping and defence. (p. 172).

However much he yearned for friendship and companionship, Vincent was not a man to whom it came easily. His artist friend Rappard wrote to his mother after his death:

> Whoever had witnessed this wrestling, struggling and sorrowful existence could not but feel sympathy for the man who demanded so much of himself that it ruined his body and mind. He belonged to the breed that produces the great artists. . . . Whenever in the future I shall remember that time, and it is always a

delight for me to recall the past, the characteristic figure of Vincent will appear to me in such a melancholy but clear light, the struggling and wrestling, fanatic, gloomy Vincent, who used to flare up so often and was so irritable, but who still deserved friendship and admiration for his noble mind and high artistic qualities. (van Gogh-Bonger, 1959, p. xxxi)

Vincent himself, writing to Theo at one point, was able to demonstrate some insight into his own personality:

Do not imagine that I think myself perfect or that I think that many people's taking me for a disagreeable character is no fault of mine. I am often terribly melancholy, irritable, hungering and thirsting, as it were, for sympathy; and when I do not get it, I try to act indifferently, speak sharply, and often even pour oil on the fire. I do not like to be in company, and often find it painful and difficult to mingle with people, to speak with them. But do you know what the cause is—if not of all, of a great deal of this? Simply nervousness; I am terribly sensitive, physically as well as morally, the nervousness having developed during those miserable years which drained my health. Ask any doctor, and he will understand at once that nights spent in the cold street or in the open, the anxiety to get bread, a continual strain because I was out of work, estrangement from friends and family, caused at least three-fourths of my peculiarities of temper, and that those disagreeable moods or times of depression must be ascribed to this. But you, or anyone who will take the trouble to think it over, will not condemn me, I hope, because of it, nor find me unbearable. I try to fight it off, but that does not change my temperament; and even though this may be my bad side, confound it, I have a good side too, and can't they credit me with that also? (Letter 212).

Exhibitionistic Conflicts

Vincent's narcissistic conflicts also found their way into the considerable difficulty he experienced in making efforts toward putting his paintings out for sale. When interested dealers approached him to solicit paintings they thought would sell, Vincent spurned their offers and attacked them and their conceptions of art. He may have felt self-righteous but his principles brought in no money for rent or bread. If there were times when he reproached Theo for not doing enough to promote his work, there were also occasions when he retreated from opportunities with the excuse that he was not ready. He put Theo off with the excuse, "If I were only a little more advanced. . ." (Letter 312). He wrote Rappard that "I certainly hope to sell in the course of time, but I think I shall be able to influence it most effectively by working steadily on, and that at the present moment making desperate 'efforts' to force the work I am doing now upon the public would be pretty useless" (Letter R41).

Vincent was certainly his own severest critic. To his eye, many of the works now considered to be masterpieces were no more than uncertain and imperfect studies (Stein 1986). His attitude toward exhibiting and selling was

highly ambivalent. His love for painting and for the creating of pictures did not extend to the marketing of them. For this he relied on Theo. Exhibiting, and even more selling, required that he present himself to others for their evaluation and acceptance. For Vincent this was not easy, and he had several strikes against him. He knew well enough that he made "an unfavorable impression" (Letter 312). His shabby and filthy clothing, his eccentric behavior, his labile and vitriolic temperament, the sordid circumstances of his life, and later his mental illness, his remaining in the mental asylum in Saint-Remy, all worked against him. He had placed himself outside the mainstream of the artistic world of his time.

It was not that he did not make efforts—with art dealers in The Hague, Antwerp, and Paris, and organizing cafe-exhibitions in Paris in 1887—but in each instance it was done only with great reluctance, resentment, and struggle. But, his attitudes were not encouraging to successful sales: "If I were not forced to do it, I should very much prefer to keep the studies myself, and I would never sell them" (Letter R44). He wrote Theo: "My opinion is that the best thing would be to work on till art lovers feel drawn toward it of their own accord, instead of having to praise or to explain it" (Letter 312). At another juncture he wrote to his friend Rappard consoling him for the rejection of one of his pieces for exhibit. Vincent never exposed himself to such disappointment: ". . . for the simple reason that I don't even dream of exhibiting my work. The idea leaves me absolutely cold. Now and then I wish some friend could have a look at what I have in my studio—which happens very seldom; but I have never felt the wish and I think I never shall—to invite the general public to look at my work. I am not indifferent to appreciation of my work, but this too must be something silent—and I think a certain popularity the least desirable thing of all" (Letter R16).

He expressed indifference about exhibiting his work with the Independants in Paris and Les Vingt in Brussels in 1889, but preferred showing his works to a small group of friends rather than displaying them publicly. Kerssemakers, to whom Vincent had given lessons in 1884, later reminisced:

> He never spoke about art with those who were totally uninformed, and he was terribly upset when a so-called art lover from this area liked one of his works; he always said that then he knew for sure that it was bad, and as a rule such studies were destroyed or repainted. Only with certain friends, among whom I had the fortune to be included, did he readily speak about painting, drawing, etching, etc., although in those days they could not completely accept his manner of painting. (cited in Stein (1986), p. 53)

Public exhibition seemed to frighten him, and he found many reasons to avoid it (Letter R32). Stein (1986) observes:

> From 1882 to 1889, he gave various reasons for his professed indifference: a disillusionment with the results of exhibitions, based on his five years' employment at Goupil's, an idealism that favored the collective, as opposed to the individual, success of artists, a sensitivity to the "old files of superficial judgments, generalizations, conventional criticism" that came from the trade (R44), an aversion to being "dependent on the opinion of others" simply to be "awarded a prize or a medal like a 'good boy' " (W4), a let's-wait attitude that placed greater stock in his future work than in his present efforts, an assigning of greater importance to producing pictures over working expressly for notoriety, a fear of "being an obstacle to others" (Letter 534), and outright feelings of "inferiority" beside painters "who have tremendous talent" (Letter 604). (p. 23)

He tried to enlist Theo's help in the face of his self-doubts and inhibitions: "The future would seem brighter if I were less awkward in my dealings with people. Without you, finding buyers for my work would be almost impossible; with you, it will eventually be possible. And if we do our utmost, it will stand firm and not perish. But we must stick together" (Letter 305). He complained further:

> And now I will tell you once more what I think about selling my work. . . . I am so afraid that the steps I might take to introduce myself would do more harm than good, and I wish I could avoid it It is practically always so painful for me to speak to other people. I am not afraid of it, but I know I make an unfavorable impression. The chance of changing this is sometimes destroyed by the fact that one's work would suffer if one lived differently. And by sticking to one's work, things will come out right in the end. (Letter 312)

And a little later: "But, brother dear, human brains cannot bear everything; there is a limit. . . . Trying to go and speak to people about my work makes me more nervous than is good for me. And what is the result? Rejection, or being put off with fair promises. It would not make me nervous if it were you, for instance—you know me and I am used to speaking with you" (Letter 315).

Fear of Success

The laudatory reviews by Isaacson and then Aurier brought into sharp relief Vincent's fear of success and its psychological implications. He was certainly obsessed by the fear of failure, but the fear of success seems to have loomed larger and more threatening to his mind's eye. His wish for success, fame and fortune, was intense—a wish that was continually frustrated and denied by his repeated failures in nearly every undertaking. He had consistently failed as an art dealer, as a preacher, as a lover, and finally considered himself as unworthy of communion with the rest of mankind. He spoke of his "horror of success," and quoted Carlyle: "Even stronger than this is what

Carlyle says: 'You know the glowworms in Brazil that shine so that in the evening ladies stick them into their hair with pins; well, fame is a fine thing, but look you, to the artist it is what the hairpin is to the insects. You want to succeed and shine, but do you know what it is you desire?' So I have a horror of success" (Letter 524).

He felt gloom and remorse at the idea that all of his work would never be regarded as worth very much. Yet he feared and was suspicious of success. At the same time, the slightest criticism of his work had a devastating effect and made him shrink even further from any exposure. He wrote to thank Aurier, but disavowed the critic's excessive praise: "For the part that is allotted to me, or will be allotted to me, will remain, I assure you, very secondary" (Letter 626a).

These difficulties may well have been rooted in the oedipal rivalry with his father: Theodorus had never been much of a success, and much of the antipathy between father and son derived from Vincent's rebellious insistence on his bohemian life and artistic career. Success at that would have declared once and for all Vincent's abandonment and rejection of his father's calling, as well as the legitimation of the rebellion implicit in his artistic vocation. Vincent's idealization of his father and his corresponding efforts to gain acceptance and recognition from him by following father's footsteps in a religious vocation had come to naught. Vincent's guilt at failing in his religious calling and disappointing his father may have dictated that he should not achieve success or recognition as an artist either.

The problem may also involve narcissistic difficulties in self-esteem regulation and unresolved grandiosity (Gedo 1983). The wish for success and acclaim was too strong, too intense, too fraught with narcissistic peril for Vincent to tolerate much of it. This is a common narcissistic dilemma: any praise or recognition cannot be tolerated because it is not enough, does not measure up to the standards dictated by the patient's grandiosity and inflated expectations, and therefore must be denied, undone, discounted, even avoided. Such patients will entertain endless fantasies of power, success and fame, but cannot put their abilities to the test of reality because the fantasies may not be realized. This often guarantees failure and defeat, but that does not seem to matter because the self-preserving narcissistic fantasy can remain intact and untouched.

Perhaps Vincent's "horror of success" was his way of overcoming the sense of guilt, shame and inferiority from his replacing the dead Vincent—a loss and stain that he could never blot out. At another and deeper level, his guilt at replacing the idealized dead Vincent may have meant that success was equivalently an attack on the dead brother, perhaps an attempt to replace him in the eyes of his parents. In Vincent's unconscious, death and success may

have been synonymous, reinforced by his unconscious striving to identify with the idealized dead brother.

Vincent's own precarious narcissism was compounded out of striking opposites. There was the hidden grandiosity revealed in his fierce belief and investment in his own artistic creativity and his repeated assurances to Theo of a nonspecific but future immortality. In the opposite vein, there was his self-demeaning behavior, his unwillingness to show his work and offer it for public scrutiny and sale, and his seeming need to fend off and discount any praise or appreciation of his work. The laudatory article by Aurier created a severe disequilibrium in the delicate balance of his internal narcissistic economy. As Gedo (1983) comments, "In fact, Vincent's repetitive depressive episodes seem to have resulted from his inability to live up to his towering ideals; indeed, I regard the need to achieve the impossible in order to maintain self-esteem as the core of van Gogh's psychopathology" (p. 135).

The Shame Dynamic

Shame is a prime expression of narcissistic pathology and formed a significant aspect of Vincent's psychic difficulties. Wurmser (1981, 1987) describes three different aspects of shame. The first is the fear of disgrace or contempt from others. The second is the direction of such an affect of contempt against the self, the fear of the exposure of one's inferiority, flawedness, and failure, fear of exposure to scorn from others, especially others whose opinions are valued or respected, and even from oneself, from one's own conscience or ideals. This aspect of shame produces a protective reaction of hiding or wishing to disappear. The last element takes the form of a protective character trait that seems to defend against the dread of shameful exposure, a stance of reverence or awe directed either toward oneself or toward idealized others. These three aspects comprise shame anxiety, shame affect, and shame as a preventive attitude. Shame anxiety translates as "I am afraid that I will be exposed and subjected to painful humiliation"; shame affect as "I have been exposed and humiliated and must protect myself by hiding"; and shame as a form of reaction formation as "I am always in danger of exposure and disgrace and must therefore always keep hidden." The result is often a need to remain hidden out of the fear of rejection or being found wanting and inferior (Levin 1971; Morrison 1989).

Shame was a pervasive part of Vincent's experience. We have indications of it early in his childhood experience—his isolation, his lonely pursuits that could not be shared with the other children, the humiliating effects of being seen as different and eccentric, his acute embarrassment at any praise of his work, especially his artistic work. His response was to set himself apart, to play out the role of the outcast, to be different and rejected. These

were all reflections of his basic sense of himself as unaccepted and unaccept-
able, as inferior and inadequate. And in response he generated the constella-
tion of typical defenses that have become familiar to clinicians over the years
as reactions to underlying shame. As Morrison (1989) notes: "Patients recoil
from facing their shame—and the failures, senses of defect, inferiority, and
passivity that engender it. Patients often express, instead, defenses against,
and displaced manifestations of, shame—certain depressions, mania, rage,
envy, and contempt" (p. 5).

We can easily envision the factors in Vincent's life that contributed to his
basic shame dynamic. There is little from his family background that speaks
to the development of a sense of reasonable self-acceptance and self-esteem.
Rather what comes down to us from the various accounts of his early life ex-
perience tells us more about his sense of increasing alienation, constant criti-
cism, parental dissatisfaction, isolation, and an emerging picture of Vincent as
eccentric, different, odd, and peculiar. The ultimate dictum of his parents
seems to have been that he would accomplish nothing, that he was lazy, good
for nothing, recalcitrant and rebellious—all ingredients that could readily be
compounded into a sense of deep humiliation and shame. He was in short the
family scapegoat, a disgrace and embarrassment to them.

Vincent's personality demonstrated an extreme degree of shame vulner-
ability—a sensitivity to and readiness to experience shame. The shame dy-
namic is linked to issues of narcissistic vulnerability (Meissner 1986). Morri-
son (1989) observes that "Narcissistic vulnerability is the 'underside' of ex-
hibitionism, grandiosity, and haughtiness—the low self-esteem, self-doubt,
and fragility of self-cohesion that defines the narcissistic condition" (p. 15).
This shame dynamic played itself out throughout Vincent's life. The same
motifs continued in the subsequent stages of his life, almost without relief re-
inforcing his inner sense of failure, inadequacy, humiliation, inferiority, and
shamefulness. There was no place in all that he undertook where he could
point to success, acceptance, approval from others, praise; there was only an
unrelenting stream of rejections, condemnations, criticisms, and negative
judgments.

His narcissistic integrity was under continual assault. He was a failure,
rejected and outcast, in his own family. His efforts to establish himself, first
as an art dealer, then as a teacher, then as a preacher of the gospel came to
naught—ended in miserable and humiliating failure. Even his efforts to es-
tablish some sort of meaningful love relation came to abortive and disastrous
conclusions. His rejection by Eugenia and Kee were devastating humiliations
and disappointments that cast him into severe and incapacitating depressions.
The failure of his relationship with Sien added another insult to the mounting
burden of catastrophes that served only to underline and confirm his sense of

inadequacy, inferiority, and his inability to love or be loved. The affair with Margot Begemann was in its brief flight more satisfying and hopeful, but these hopes were dashed on the cruel rocks of her family's repulsion against Vincent and her abortive suicide attempt. His religious mission ended in dismal failure and rejection, and even his art, the last resort for the salvaging of his damaged and defeated narcissism, met only criticism, devaluation and frustrated corrective efforts from his mentors.

Each of these disappointments were in effect crises of humiliation. One aspect of the narcissistic concern is a seeking after absolute uniqueness and central importance to another person—the "significant other". Morrison (1989) comments:

> Such a feeling reverberates with primitive fantasies of symbiotic merger, om-nipotence, and grandiosity and yet, paradoxically, it implies as well the presence of an object for whom the self is uniquely special or who offers no competition or barriers to the self in meeting needs for sustenance. The narcis-sistic demand for uniqueness is expressed directly, as assertions of entitlement; defensively, as haughty aloofness and grandiosity; or affectively, through de-jected or rageful responses to its absence and failure. Inevitably, shame follows a narcissistic defeat. . . . The other paradox, of course, is that such a yearning for uniqueness—by its very nature—can never be satisfied fully or for long. (p. 49)

Vincent sought to maintain the sustaining relation with the "significant other" in his relationship with Theo. We can conjecture that when that vital rela-tionship was threatened, his abortive effort to engage Gauguin in that role was one contributing element in his suicide.

Vincent's demand for uniqueness comes clearly into view in the context of his refusal to submit to the norms and criteria of university learning or of academic instruction in art. He had to be different and unique; he could not conform to the usual standards and expectation of mentors or instructors who imposed a uniform standard of performance and excellence. Despite his ide-alizing and near idolizing of his father, he could not endure or accept the im-plicit demand for conformity to acceptable and traditional religious roles and functions that the place of religious minister required. Again he had to rebel, to seek his own idiosyncratic and deviant path to the achievement of religious ideals, especially in the imitation of the suffering Christ.

Neglect and Narcissistic Rage
The narcissistic conflicts involving grandiosity and entitlement as over against shame and humiliation extended to his paintings as though they were exten-sions of himself—containers of his sense of grandiosity and potential hu-miliation. He projected onto them the feelings of neglect and abandonment that were so intensely a part of his own sense of himself. When his paintings

were treated with neglect or indifference, Vincent would erupt in a spasm of rage. We remember the neglectful fate of the paintings left with his mother—treated as worthless. If Theo did not pay Vincent sufficient attention because of his own worries or if he did not exercise himself enough to sell Vincent's paintings, Vincent would become enraged but was fearful of risking his relationship to Theo, his lifeline. When he discovered a number of canvases, both his own and other artists, lying around unframed in Gachet's house, he could not contain his wrath. The care of these paintings was a matter of life and death for Vincent—they were his children, his life's work, his claim on a degree of wholeness and self-esteem.

This perception reflected Vincent's sense of his own inner self and his sense of impoverished self-esteem as the rejected, abandoned and unwanted son, based on a fantasy that provides an inner core of self-perception. It reflects the underlying function of a persistent and resistant introject derived from the internalization of rejecting, unloving, and even devaluing parents. This internalization gives the child a sense of inner evil, destructiveness and worthlessness, and subsumes the inner instinctually derived impulses of hateful destructiveness and infantile wishes to hurt and damage. This internalized destructiveness builds a negative sense of self that permeates the rest of the individual's life experience. It colors all the rest and remains stubbornly resistant to any alteration by the influence of reality factors. This sense of inner evil means that the individual cannot perform good acts, cannot set useful goals, has no right to hope or strive, for what it produces must bear the stamp of its origin: worthlessness and evil. This pattern of self-devaluation and degradation was repeated with stunning consistency in Vincent's life story and found its way onto his canvases. Vincent's childhood indeed cast a long shadow over the works of art that came from his hands—even to the end of his life.

The Theme of Doubles
The theme of the "double" carries us to deeper levels of the unconscious stratum where often unknown and unrecognized motifs can play themselves out in determining the fate of unsuspecting humans as they make their way along the path of life. The "double" theme and its reverberations provide a recurrent motif in Vincent's life history. Not only did this central motif influence many aspects of Vincent's life experience, but it came to find expression in his art as well.[4]

It was Otto Rank (1914) who brought the theme of the double to our attention. In his view, the double arose in the primitive mind as symbolic of immortality, but gradually became a reminder of individual mortality and even a presage of death itself. From a symbol of eternal life, the double motif de-

veloped into an omen of death. It then further evolved into a symbol of evil that threatened the existence of the self. This took form in the idea of a devil who steals the souls of good men—a projective personification of a moralized double, as in the Faust legends. The "double" theme returned in various guises in Vincent's odyssey.

The first of Vincent's doubles was his stillborn brother of the same name. The dead Vincent cast a long shadow across the path of the living Vincent. We have traced the implications of these circumstances in terms of the issues of the replacement child syndrome, the result being that the living Vincent had a double from the moment of his birth. As Wilson (1988) comments: "The unconscious fantasy of the dead child serves as a narcissistic double and becomes the recipient of a host of conscious and unconscious fantasies whose operations in the replacement child accounts for the extreme vulnerability of that sibling position. The fantasy is universal as are its effects on identification and narcissism" (p. 126). In consequence, the replacement child finds himself, throughout his life, struggling against an unseen, unknown, but always present and powerful double.

This motif not only exercised a powerful influence on his psychic development, but came to influence his depressive and alienated sense of self as well as his persistent pattern of idealization and disappointment, the pursuit of high ideals and consequent disillusionment, and the inevitable sense of failure and defeat that dogged his heels throughout. It also played a major role in several critical areas of his experience—especially in the creation of substitute "doubles" whom he invested with special meaning and importance and who played critical roles in both sustaining and destroying his psychic integrity.

Psychic Survival

Vincent killed himself at the very point at which the recognition and acceptance he yearned for might have been forthcoming. To whatever degree his art found success, to his mind it was not simply his own, but the product of a joint effort with Theo. Walther and Metzger (1990) comment on one of Vincent's letters to Theo:

> We have the impression that van Gogh's entire will to live is being focussed on the addressee of his letter; at the same time, it is his need to express himself to that person which establishes his will to live in the first place. The addressee is the point to which all his melancholy, but also all his confessional courage, tends. It is a precarious balancing act, since the writer becomes existentially dependent on his sense of the reader's interest, and out of that balance arises the desire for the two to become one. (pp. 29-30)

The threat of Theo's eventually fatal illness may have signalled the destruction of the symbiosis that provided the psychic basis for his creativity. He was haunted by "his self-destructive need to repeat the experience of being unjustly rejected and despised—most dramatically enacted in his legendary encounter with Paul Gauguin in Arles" (p. 108). Vincent's suicide can be viewed as an act of desperation and a reaction to illness, destitution and utter loneliness. But Gedo (1983) argues that the pact between the two brothers served to postpone the suicide and made it possible for Vincent to exercise his creativity and place it in the service of a profound religious ideal. After the pact with Theo, his passion and devotion to his art was so intense that he neglected all other human needs.[5]

The thread of sexuality runs through the relation with Theo—for Vincent, painting was associated with an unconscious fantasy of procreation that may have also included Theo as his partner in the creation of these "babies." This view would connect Vincent's creativity with underlying passive, feminine, homosexual wishes, a common component of the relation to the double. Vincent grew increasingly jealous of Theo's attention to other artists, but the sexual tensions grew severe when Theo's intentions to marry became clear. Vincent's own impulses to marry had all miscarried, and his move to Arles apparently signaled a decisive change—he had renounced all hopes and wishes for marriage and a family. Does it make sense to think that this energy now became focused on his canvases so that they became the objects of the intensity and fury of his emotional and libidinal life? In the last two years of his life, after all, he produced more than half of his prodigious output, and many of them his greatest works.[6]

But there must have been more to their symbiotic attachment to each other. Vincent had written, "If I were without your friendship, they would remorselessly drive me to suicide, and however cowardly I am, I should end by doing it" (Letter 588). Vincent would write from the asylum at St. Remy:

> Old man—don't let's forget that the little emotions are the great captains of our lives, and that we obey them without knowing it. If it is still hard for me to take courage again in spite of faults committed, and to be committed, which must be my cure, don't forget henceforth that neither our spleen nor our melancholy, nor yet our feelings of good nature or common sense, are our sole guides, and above all not our final protection, that if you too find yourself faced with heavy responsibilities to be risked if not undertaken, honestly, don't lets be too much concerned about each other, since it so happens that the circumstances of living in a state so far removed from our youthful conceptions of an artist's life must make us brothers in spite of everything, as we are in so many ways companions in fate. (Letter 603)

We can speculate about the degree to which Vincent's creative power rested on this symbiotic connection with Theo. Vincent's creative work did not really find expression until he and Theo had formed their partnership. But the issue may extend beyond merely the capacity to maintain creative activity; it may have to do with the ongoing struggle to gain and sustain a sense of psychic integrity and identity. Not only was Vincent's intensely dependent relationship with Theo important for preserving Vincent's artistic life, it may have had important reverberations for preserving his life itself.

The Shadow of the "Double"
The shadow of the dead Vincent may have fallen across the relationship between the two brothers. The connection between the dead Vincent and Theo may have provided a powerful motif in Vincent's unconscious that may have been reinforced by the fact that Theo was the favorite of his parents, and thus became in Vincent's mind's eye the inheritor of the idealization of the dead Vincent. This circumstance was painful to Vincent, a fact that he referred to occasionally in his letters. To the extent that this dynamic played a role in their relationship it would have lain the basis for a deepseated envy and resentment in Vincent against his younger brother, as well as against the most recent Vincent Willem—Theo's son. These sentiments would have been unconsciously transferred from the dead Vincent.

This would also explained the sense of entitlement to Theo's help and the constant demands for more from Theo than he was receiving. Vincent's entitlement reflected his deeper sense that this usurping and favored brother had taken something away from him that was his birthright—à la Jacob and Esau. The hostility may also have included death wishes that Vincent had to defend against, wishes that had originally arisen toward the dead Vincent but subsequently found their target in the usurpers. But the basic envy that permeated the connection to the dead brother must have found its way into Vincent's relation to Theo. Theo had stolen the love and acknowledgement of their parents, and to Vincent's unconscious mind Theo owed him reparations. In some sense, Vincent felt entitled to the help and concern that Theo provided him.

The events involved in Vincent's mental breakdown are thus highly overdetermined and involve the intersection of many skeins of motivational influence. In this tangled web of fate, place must be found for the role of the shifting ground in Vincent's relation to Theo. Theo, who had been his constant support and unwavering source of emotional and material succor, was drifting away from him. The untoward events of that fatal Christmas took place soon after Theo announced his engagement to Johanna Bonger. His betrothal followed within a few months, and in due course the birth of his son.

These events signaled the end of Vincent's favored position with Theo and by implication placed Vincent's life and work in jeopardy. More to the point, the shift in Theo's devotion and investment away from Vincent and towards Johanna and their little son created a rupture of the symbiotic bond between the two brothers. It would prove fatal to both (Runyan 1987).

The relationship of the two brothers was intense, mutually entangled and dependent, ambivalent and symbiotic. They were tied to each other by the closest bonds, and when that connection was ever threatened by circumstance, conflict, separation or hostility, both suffered pangs of separation and abandonment. They could not live without each other, and as the events proved, they could not live with each other. But their fates were intertwined from the beginning—they were in a sense psychic twins, mutual mirrors each to the other, doubles in a profound psychic sense. For Vincent, it was his connection with Theo that preserved his life and made his artistic creativity possible. For Theo, it was his connection with his eccentric, erratic, troubled and dependent brother that gave meaning and sustenance to his life as well. They could share an artistic vision and a fantasy of mutual involvement in the creative process that consumed them both.

Gauguin

One figure who stands out among Vincent's artistic colleagues as a potential double is Paul Gauguin. Vincent met Gauguin during his stay in Paris and the two became friends. The common bond was art—but beyond that it was a curious relationship. Gauguin was domineering, arrogant, narcissistic to a markedly pathological degree, and exploitative—not one who would find an easy time with Vincent. But it was Gauguin whom Vincent chose to join him in his fantasied vision of the artists colony.

We can reasonably question the degree to which Vincent's homosexual inclinations might have played a role in his attraction to and friendship with Gauguin. The suggestion of Vincent's homosexual conflicts seems to resurface at various points in his life. There is never any suggestion of overt homosexual activity, but the unresolved residues in his unconscious are another story. Certainly there was a strong, if barely repressed, current of homosexual attachment to Theo. Gauguin was also very likely a strong homosexually invested libidinal object. Vincent's wish to have Gauguin come and live with him was a little too intense, a little too charged, to regard it as a matter of convenience. Their arguments were charged and intense, more like lovers' quarrels than artistic discussions. Vincent himself called them "terribly electric."

Vincent often enough referred to Gauguin in more or less feminine terms, as pretty and delicate, like an artistic woman. The painting of Gauguin's

chair (F499, JH1636) conveys this sense of feminine softness—the soft curved bottom of the chair conveys a feminine quality. Graetz (1963) commented: "Gauguin's chair is shaped in an easy, curved movement and painted mainly brown-red and violet; it stands as if on a fancy carpet glimmering in lively colors with red and yellow against a green background. The elegant armchair well fits Gauguin's room, the lady's boudoir" (p. 139). This feminine theme is broken by the erect upright image of the burning candle—a phallic image that converts the painting into an image of the phallic woman, the woman with a penis, a fantasy that protects against the dangers of castration. Such anxieties are often the stuff of homosexual resolutions.

The companion picture of Vincent's chair (F498, JH1635) is a study in contrasts. The chair is heavy, rough, made of plain unfinished wood, straightbacked and without arm rests. It is a peasant's chair, simple and sturdy, much as Vincent must have seen himself in comparison to his flamboyant and egotistical companion. The simple pipe and the crumpled pouch of tobacco can hardly hold a candle to the more phallic expression of the Gauguin chair. These twin paintings embrace multiple levels of meaning and bear eloquent testimony to the self-revelatory aspect of so much of Vincent's painting. He could hardly have painted a more telling expression of the contrasting personalities between the high-flown Gauguin and his own simple and rough-hewn sense of himself. The image of his own chair portrays his powerful identification with the poor, the simple, the rough and unrefined—the qualities that made him such a desperate outcast among the civilized and conventional ones to whom he had so often looked in vain for love and support. In his defiance and bitter rejection, he had made these qualities his hallmark; he bore them with pride and defiance and made them the touchstone of his inadequate, uncertain and troubled self. At a more unconscious and symbolic level the painting expresses his sense of phallic inadequacy and impotence.

We can speculate on the motives and desires that undergirded the attachment to Gauguin. Needless to say Vincent's dream of the Midi Studio arose from his desperate need for acceptance, recognition, companionship, and love. The community of fellow artists would have answered these needs. Gauguin's resistance and finally rejection had dashed these hopes to the ground. As Kodera (1990) points out, the Yellow House was linked to his regard for Japanese art. Nature had by that time become his substitute religion. He envisioned a community of artists devoted to the worship of Nature, a community that would substitute for the lost religious community that had been a significant part of his life experience from the beginning. He dreamed of painting the stars, but with a group of companions. Kodera concludes, "Thus Van Gogh is grasping at nature, at the starry sky, and is trying to es-

tablish a new community, the Yellow House, under the new God, the sun of the Midi" (p. 96).

Gauguin's departure destroyed this utopian vision and struck a desperate blow at the very root of Vincent's artistic life. Further elements may have been Vincent's growing sense of alienation from Theo as Theo moved in the direction of marriage and family. The attachment to Gauguin may have represented an attempt to replace the threatened tie with Theo. In any case, Gauguin's departure was a blow to Vincent—in one sense narcissistic, but in another sense it was like cutting the rope to a drowning man. It left Vincent in desperate straits, without hope or solace. Once again, he was left the unwanted outsider, rejected and abandoned, unloved and unvalued. Once again, the shadow of the dead Vincent! Each new defeat, each new disappointment drove him deeper into his isolation and toward the pit of despair, deepening his need to seek solace and meaning in his religious preoccupations and in his mystical absorption in the God of nature.

The Shadow on the Canvas

The theme of the "double" and the dead Vincent seemed to hover in the background of Vincent's consciousness, but on occasion seemed to move closer to the foreground to offer some suggestion of their influence. Vincent did several studies of cypresses that seem to integrate in symbolic terms the themes of the double and death. In the study he sent to Aurier (F620, JH1748), there are two women in the foreground of the picture; Vincent had delayed finishing it for nearly a year and then only felt a sense of completion when the figures had been added. He wrote Aurier:

> In the next batch [of paintings] that I send my brother, I shall include a study of cypresses for you, if you will do me the favor of accepting it in remembrance of your article. . . . Until now I have not been able to do them as I feel them; the emotions that grip me in front of nature can cause me to lose consciousness, and then follows a fortnight during which I cannot work. Nevertheless, before leaving here I feel sure I shall return to the charge and attack the cypresses. The study I have set aside for you represents a group of them in the corner of a wheat field during a summer mistral. So it is a note of a certain nameless black in the restless gusty blue of the wide sky, and the vermilion of the poppies contrasting with this dark note. (Letter 626a)

The dark note and blackness suggest the overtones of death that was linked in Vincent's mind with the image of the double—represented by the two figures—reflecting his identification with the dead Vincent.

Vincent's last treatment of cypresses was his "Road with Cypress" (F683, JH1982), done in May 1890 just before his departure from St. Remy. The tall somber cypress summons associations to the somber and defeated

proud giant pine in the hospital garden. In this rendition, the double theme becomes particularly salient. There are two figures in the horse-drawn cab in the background; there are two figures walking side by side on the road in the foreground; and finally the two trees are fused together such that only at the base can the two trunks be seen. The dark note and blackness suggest the overtones of death that was linked in Vincent's mind with his identification both with the dead Vincent and with the Christ crucified on the tree of life. Lubin (1972) offered an interpretation of this doubling and the dual motifs of death and the double: "Together the two Vincents form a unity endowed with magical qualities and immortality. Vincent and his double travel through life's journey together, and in death—symbolized by the cypress trees— ascend to a distant star. Vincent's own remarks indicate he knowingly depicted heaven in this way: "Why, I say to myself, should the shining dots of the sky be less accessible than the black dots on the map of France? Just as we take the train to get to Tarascon or Rouen, we take death to reach a star" (p. 97).

Chapter XIII
VINCENT'S RELIGION

Person and Belief

The complex aspects of Vincent's personality and the difficult circumstances of his life story provided the dynamic substructure that determined the character of his religious experience. The stage on which he played out his religious odyssey was a uniquely marked with the stamp of his personality as any of the artistic masterpieces that were the products of his genius or the highly personal statements of the flood of letters that gushed from his pen. In this sense, Vincent provides us with a unique opportunity to study the intimate connection between the inner psychic life of the individual and the nature of his religious beliefs and experience. In Vincent's case, that connection has its own inherent interest, but carries with it an added bonus—that it was reflected in visual and graphic terms in the hundreds of paintings and sketches that not only constituted his life work, but became the uniquely expressive medium of Vincent himself.

The psychoanalytic interest in this distinctive character of Vincent's religious involvement lies in its uniquely personal quality and the variant it introduces into the traditional psychoanalytic view of religious experience. In a sense, Vincent's story fits the Freudian mold, and it doesn't. Our interest lies in discerning the degree to which classical psychodynamic factors played themselves out in his religious development and life, and the extent to which certain aspects of his religious odyssey cannot be contained within traditional explanatory concepts, but lead us on to further modifications and even revisions of the traditional themes (Meissner 1984). Certainly Vincent's religious life was uniquely his own—one that was devoted to an unremitting search for God, a journey that carried him through the rough seas of painful disappointment, disillusionment, the trials of loss of faith, and the interminable struggles to find his own way to God and salvation. The tragedy is that he never found the sense of fulfillment and satisfaction that he sought, and that the path of alienation, isolation, and despair led inexorably to the final term of suicide. We are left to ponder—was Vincent's suicide the final defeat of his relentless religious quest, or was it in some sense the final act of his search for God?

Freud's Religion

Freud viewed religion as a form of illusion, if not delusion, that reflected the infantile needs of mankind to depend on a powerful and protective superior being as a way of warding off the harsh realities of life. He set himself against illusion in any of its guises and cast himself more or less self-

consciously in the role of the destroyer of illusions (Meissner 1984). In his letter to Romain Rolland in 1923 he wrote, "a great part of my life's work (I am ten years older than you) has been spent 'trying to' destroy illusions of my own and those of mankind" (E. Freud 1960, p. 341). Rolland had his own illusions, particularly about religion, that Freud felt compelled to attack (Freud 1930, 1936; Fisher 1991). If Rolland was a creator of illusions, particularly religious and mystical illusions, Freud would be their destroyer. Belief in the goodness of human nature was too much of an illusion for Freud to stomach (1933b). Even the Marxist vision of a classless society was for Freud just another idealistic illusion—another variant on the religious theme (1933a).

The strongest, and therefore the worst, illusions were those of religion. They were a dragon to be slain with the hard steel of the sword of science. In his view religious beliefs were opposed to reality and provided one form of withdrawal from painful reality:

> [Religion] regards reality as the sole enemy and as the source of all suffering, with which it is impossible to live, so that one must break off all relations with it if one is to be in any way happy. The hermit turns his back on the world and will have no truck with it. But one can do more than that; one can try to re-create the world, to build up in its stead another world in which its most unbearable features are eliminated and replaced by others that are in conformity with one's wishes. But whoever, in desperate defiance, sets out upon this path to happiness will as a rule attain nothing. Reality is too strong for him. He becomes a madman, who for the most part finds no one to help him in carrying through his delusion. It is asserted, however, that each one of us behaves in some respect like a paranoic, corrects some aspect of the world which is unbearable to him by the construction of a wish and introduces this delusion into reality. A special importance attaches to the case in which this attempt to procure a certainty of happiness and a protection against suffering through a delusional remoulding of reality is made by a considerable number of people in common. The religions of mankind must be classed among the mass-delusions of this kind. No one, needless to say, who shares a delusion ever recognizes it as such. (Freud 1930, p. 81)

The Case of Vincent

We could readily apply this appraisal of religion to Vincent. Vincent's retreat from the harsh realities of his life, from the failures, disappointments, rejections, the painful hurts and humiliations that he suffered repeatedly long his way, would then have sought compensation and solace in his religious devotion and fervor. The driving force would have been the instinctual needs, both libidinal and narcissistic, for which he could find no satisfaction or gratifying fulfillment in the world in which he lived. His religious convictions could be seen as a form of delusion, related to the delusions that formed the

core of his psychotic states. Vincent's religion would be thus reduced to a matter of infantile psychodynamic needs and pathological structures.

Again, following Freud, Vincent's religious travails center around the figure of his minister-father, in both the positive and negative phases of his religious involvement. Given the conflictual and traumatic origins with which he entered the world and the patterns of estrangement and isolation that developed within the bosom of his family, Vincent was left with a sense of not belonging, of being a stranger, an outcast, in relation to his family. In his father's eyes he met only bewilderment and disapproval; from his mother there was distance and unempathic, if concerned, maternal solicitude—no warmth, acceptance, loving communion, or approval. There came about a desperate need in Vincent to find acceptability, approval, even caring endorsement from his parents.

The path he chose to achieve this objective was to follow in the footsteps of his minister-father. Theodorus became the object of idealizing idolization by Vincent. To become a minister and preach the word of God would have provided the answer to all his difficulties, his inner pain and anguish, and would have brought him the acceptance and sense of communion with his fellow beings that seemed to elude him. His god at this juncture was the father-God of strict, moralistic, predetermining Calvinism, as preached in the Dutch Reform Church and from his father's pulpit. Such a god was demanding, accepting nothing less than perfection and total devotion, a judging god who was quick to indict and pass judgment against the sinner. Such was not a god of peace and joy, but a god of suffering and pain, of justice rather than charity, a god who measured virtue by the standards of a mercantile world in which wealth was virtue poverty vice, success was virtue failure vice, honors virtue and dishonor vice. Vincent's god—as Freud would have dictated—was none other than his severe and judgmental father raised to olympian heights.

But if we follow the story of Vincent's efforts to follow in his father's vocation, we are impressed by the degree to which it is immersed in ambivalence. From the very beginning of his religious quest, the ambivalence is manifest. We do not here of any focusing on Dutch Calvinism or even Protestantism. His attitude is patently ecumenical—as far as he was concerned, God could be found just as well in any church, Dutch Reform, Congregational, Anglican, even Catholic. The ambivalence rises to a climax in his preparations for theological study—the effort is stymied from the start and ends in disaster. If there was a part of Vincent that sought salvation by pursuing a ministerial vocation à la Theodorus, there was also part of him that resented having to submit himself to this expectation in order to gain any degree of affection or acceptance. The result was rebellion and sabotage of the

effort. The demands for theological training were modest in the school for preachers, but the result was the same—a rebellion against any theological discipline and a rejection of the traditional ministerial role.

As he left the confines of theological training, he despised and condemned the pharisaical theologians and ministers who had served as his mentors and superiors. He pictured himself as a Christ-figure, whose mission was to serve the poor and sick, as opposed to the Pharisees who were only interested in their own comfort and trivial theological disquisitions. They were the prototypes of the traditional church ministers, the prime example of which was his father. Instead of following the prescribed path of ministerial training and ministry, Vincent followed his own path based on the model of ascetical denial and self-sacrifice that he associated with the figure of Christ. His identification with Christ became a powerful and dominant motivational force within him. He could tolerate and accept nothing that was not congruent with this fantasied image which became amalgamated with his own self-image. The disastrous outcome of his mission in the Borinage and the dismissal by the church authorities was the final blow. It destroyed any semblance of traditional religious belief and any sense of attachment to the religion of his father and traditional church belief and ritual. For him it all became a sham, an inauthentic parading of pious practices that were hypocritical and without value. As Vincent turned from the first phase of his religious odyssey, his dedication to a religious mission within traditional religious forms, to the second and final stage that found its expression in his artistic endeavors, the whole process was based on his attachment and final rejection and rebellion against his father and father's religion.

There is some validity to this argument and the reconstruction on which it rests. Thus far we can grant Freud the laurel. But is this the whole story? Can Vincent's religious quest be reduced to a piece of infantile and rebellious acting out against a resented and rejecting father-figure? Or is there possibly more to it? Do the dynamics of a negative oedipal attachment to the father and subsequent rebellious rejection preclude other perspectives, other understandings of Vincent's religious ordeal, that might enrich and deepen our understanding of man's religious experience and his search for God?

If we take the view—as I shall argue here—that Vincent's religious orientation was a form of transitional experience, then the matter takes on an entirely different look. Following Winnicott's (1965, 1971) analysis of the developmental experience of transitional objects and the extension of transitional experience into the realm of transitional phenomena,[1] we can regard Vincent's religious experience as an aspect of his creative drive to seek meaning, purpose, and relationship—not only in connection with the establishing of his own sense of self and identity, but also in intimate conjunction

with that powerful intrapsychic need the need to determine his purpose in life, his personal destiny, and his relationship with God (Meissner 1984, 1987). The two dominant foci within which Vincent was able to enter the realm of transitional experience and to probe the depths of illusion were the artistic and the religious. Thus, we can argue that that three separate and distinct lines of thematic interaction came into powerful conjunction in Vincent's psychic odyssey—his search for personal identity, his struggle to achieve the fullness of artistic expression, and his quest for the divine.

Art and the Search for Identity

Vincent's life story is a saga of narcissistic needs repeatedly denied, traumatized, and wounded. At each step along the path, he became more isolated, alienated, and withdrawn. In the depths of his despair, he finally determined that he would turn his back on all convention, social amenities, and communion with his fellow men; he would devote himself to art and to that alone. He channeled all the energy, concentration, devotion, and fierce determinism that had marked his adventures in saintly asceticism in his service of the poor miners and his attempt to don the mantel of Christ suffering. His artistic career spanned a mere decade, yet those ten years saw as much or more self-sacrifice, self-denial, fanatical immersion in the exercise and development of his artistic skills, than can be found in the life story of all but a handful of artists. Vincent's immersion in art was total, uncompromising, throwing all caution for health, wellbeing, or the effects on his relations with others to the winds, and plunging himself in unremitting zeal into the struggle for artistic mastery and the achievement of his lofty artistic goals. He did not count the cost—health, wealth, and the respect of the world did not matter to him. All that mattered was his art!

We may wonder, then, what meaning had he found in the application of pigment to canvas that drove him on with such ferocious intensity and desire. I would argue that art and painting became a medium of self-expression and self-discovery for Vincent; it was the vehicle for his extended search for self-definition and identity determination—a quest that was driven by his deep need to find and define a sense of self that would carry the burden of personal meaning, purpose, and belonging that so agonizingly eluded him, and which he was never able to attain. As he stood before his easel, Vincent became absorbed in the effort to capture the essence of his subject in color and form, but the subject was always—or almost always—the same, namely Vincent himself. His paintings are almost without exception autobiographical and self definitional—a persistent and repetitious drive toward creating a sense of self that would resolve the tormented and tortured fragments of hi sinner self that

resisted all efforts at meaningful integration and purposeful involvement in the world. As Erikson (1959) observed:

> The sense of ego identity, then, is the accrued confidence that one's ability to maintain inner sameness and continuity (one's ego in the psychological sense) is matched by the sameness and continuity of one's meaning for others. Thus, self-esteem, confirmed at the end of each major [developmental] crisis, grows to be a conviction that one is learning effective steps toward a tangible future, that one is developing a defined personality within a social reality which one understands. (p. 89)

We might be more inclined in current usage to substitute "self" for "ego" in this formulation, but the point seems clear. Vincent, for a variety of reasons, was denied these contributions to his emerging identity.

The opposite side of the coin of the formation of his negative identity was also evident. Erikson (1959) again wrote:

> Identity formation is dependent on the process by which a society (often through subsocieties) *identifies the young individual*, recognizing him as somebody who had to become the way he is, and who, being the way he is, is taken for granted. The community, often not without some initial mistrust, gives such recognition with a (more or less institutionalized) display of surprise and pleasure in making the acquaintance of a newly emerging individual. For the community, in turn, feels "recognized" by the individual who cares to ask for recognition; it can by the same token, feel deeply—and vengefully—rejected by the individual who does not seem to care. (p. 113)

Vincent found none of the recognition and acceptance that would be required for the formation of any meaningful sense of identity; rather he met mistrust, rejection, disapproval, disappointment and failure. He was more in the position of one who did not seem to care, or who adopted a deviant and rebellious stance that met rejection with rejection, disappointment with disappointment, disapproval with disapproval.

All of these factors were at play when Vincent faced the canvas. As he approached the easel, Vincent entered a different psychic space, a transitional space in which he could begin to find some resolution for these psychic uncertainties and deeply personal conflicts. In that transitional space, Vincent entered into what might fairly be called an altered state of consciousness in which he became immersed and absorbed in concentration on the subject of his study and in the artistic process through which he could bring it to life on the canvas. In this intense focusing and concentration, elements of his inner psychic life permeated the experience so that what came to life on the canvas was in no sense merely a representation of the object, but incorporated some part of Vincent himself. It did not matter what the subject was, whether a

poor miner bent over by the weight of his toils, a farmer digging his field, a beggar on the street, a peasant woman with a face worn by the ravages of time and sorrow, an old man bowed over in grief, trees in their infinitely varying shapes and shadows, cypresses, fields of wheat, flowers, irises—on and on. They all became expressions in some manner or form of Vincent himself.

The Self-Portraits
But the genre, in which the issues of self-definition and the search for identity came into sharpest and most telling relief, was his self-portraits. He painted over forty of these portraits—a number that puts him in the first rank of self-portraiture. These self-portraits were impelled by a profound inner psychic need, a desperate and recurring demand, that not only brought him to the easel and before the mirror, but made these canvases a vehicle for self-expression and self-definition that otherwise eluded him in life. They became not merely the pinnacle of his art, but a reflection of his deepest and most powerful yearnings (Meissner 1993).

In comparing any two portraits, one is immediately struck by a feature that pervades all of Vincent's paintings of his own face—they are not the same. Beyond superficial resemblances, the differences are such that one would hardly guess that the features belonged to the same man. The shape of the head changes, the angle of the nose, the position of the eyes, the elevation of the cheekbones, the molding of the nose, and so on. There are similarities but also interesting differences in them all, but they are never the same. To a surprising degree, the observer finds it difficult to identify this face as the same from portrait to portrait. What might this reflect? Was it Vincent's tormented and conflicted way of trying desperately to find his own self-image? Was it his effort to establish some form of coherent identity in the midst of the inner turmoil and chaos, the shifting configuration of the elements of his unsettled identity that never seemed adequate to the demands of life and reality and never found recognition and value in the eyes that gazed into the mirror.

In a psychoanalytic perspective, Vincent's self-portraits become a reflection of his inner psychic reality, of the sense of self that he unwittingly and unwillingly reveals with every stroke of his brush. Taken together, they provide a composite picture reflecting the internal organization of the introjective configuration that formed the core of his self (Meissner 1978b, 1981). That configuration bears the marks of the internalized elements that were imprinted on him during the course of his earliest encounters with a probably depressed and unempathic mother, with years of failed understanding and sympathy, with a continuing saga of rejection and disappointment. They reflect the inner

torment and anguish of one who was doomed to walk the earth as a stranger, alienated and unwanted—unwanted from birth, rejected in love, and a failure in all he undertook, even in the works of art in which he poured out his heart and soul. His life was that of the martyr that found its deepest meaning and ultimate fulfillment in suffering and death.

These self-portraits were all done in mirror perspective, painted as Vincent saw himself in the mirror. We can wonder what determinants might have been at play as Vincent gazed into the mirror, and what influence they may have had on the portrait that emerged on the canvas. What psychic influences drawn from his inner world came into play as his brush applied the oils to the blank and staring surface? What elements were drawn from his own inner world and projected into the reflected image? What did he see? Was it his double—the dead double of the other Vincent? or a living double drawn from his own inner world and projected into the reflected image?

Vincent's self-portraits were done in mirror perspective so that the picture actually presents a mirror image. This places the self-portrait in psychological terms in touch with the mirror experience as developed in the thinking of Lacan and Winnicott. Lacan (1953) called attention to the developmental significance of the infant's first moment of recognition of his own image in a mirror and the child's delight in this discovery. He located the phenomenon in the register of the imaginary, the sensuous perceivable aspect of experience that involves an essential point-to-point correspondence. The behavior reflects a developmental milestone marking the origins of the capacity to distinguish between the image of oneself as opposed to the images of others. But for Lacan the reflected image is essentially 'other,' a reflection of an illusion of sameness that masks the other within the self, the unacknowledged, dissociated, and unattainable aspects of the self (Goldberg 1984; Muller 1985).

Winnicott (1971) enlarged on this theme from a somewhat different perspective by focusing on the mirroring that takes place in the interaction between mother and child in which the child sees himself mirrored in the mother's eyes. Mirroring provides some of the infantile components of later capacities for imitation and identification. Can we infer that the mirroring that takes place in self-portraiture may reactivate the residues of the original mirror-phase transference that are now projected onto the image of oneself? What appears on the canvas would be a transformed version of the image of the self that was originally experienced in the exchange of gazes between mother and child —the image echoes the mirroring of the child's image of himself in the mother's eyes. And what of Vincent's mirroring experience— what sense of self was to be found in the depressed and unempathic gaze of his grieving mother? How much did his search for a sense of self reach back to the failure of self-recognition and self-mirroring in his mother's eyes?

The mirroring phenomenon, in the Narcissus myth, is a reflection of the earliest interactions between mother and child that lay the foundation for the emergence and sustaining of identity. As Shengold (1974) noted: "Narcissus asks of his reflection, in Ovid's version of the myth: 'Am I the lover or the beloved—the one who wants or the one who is wanted?' The mirror image can stand for some aspect of the self, or of the object (the prototype is the parent), or of the self as pictured in the parent's eyes" (p. 98).

Mirroring may also involve a narcissistically and aggressively motivated effort to maintain a fragile and threatened sense of self-cohesion and control (Elkisch 1957; Muller 1985). The mirror thus can adapt itself for portraying parts or divisions of the mind: ego, superego, the self, self-representations, introjective configurations, object representations of various kinds. Pathological aspects of the self-organization can be displayed in the mirror; it can serve to hold together the fragmenting strains of a disintegrating self. It can become the vehicle for the projection and reintrojection of images of the self and significant objects, often introjections and object representations stemming from parents and other significant developmental objects.

In the somewhat mysterious chemistry that takes place in the illusory space between the artist's gaze and the reflection of the mirror, the boundaries between self and object can yield to the pressures for merger and psychotic identification. This is one place where the terminology of "projective identification" may have its legitimate application. In the drawings of some psychotic patients, the drawing comes to represent the fragile and precarious identity of the subject, such that whatever appears in the picture reflects the sense of identity of the subject. The painter is transformed, in terms of his psychic reality, into whatever he paints on the canvas (Villareal 1988).

The mirror of the self-portrait, then, can become a reflection or metaphor of the mind. The record of the artist's inner conflicts can be read there, as well as the reflection of his self image or images. Shengold (1974) wrote: "All the main psychic dangers (ego disintegration, separation and the loss of love, castration, guilt) as well as the specific reassurances that aim toward counteracting them motivate mirror acts and fantasies. The mirror's magic, good and bad, stems from its linkage with the narcissistic period when identity and mind are formed through contact with the mother; the power of mirror magic is a continuation of parental and narcissistic omnipotence" (p. 114).

Sense of Self and Identity

In the face of all these conflictual issues, Vincent carried on the struggle to find meaning and purpose in his life. These strivings were intimately related to his need to seek and establish some sense of integral self that would sustain him on his way. His art became the arena in which these dynamic forces

came to play out their inexorable drama. Vincent emerges as one of those cases in which—whatever the dynamic psychological forces and issues that raged in stormy and conflictual turmoil within him—the issues of the reality, the vitality, the meaning and integration of his self held a central and a dominant position. Vincent spent his life in a frustrated and repeatedly defeated effort to discover and create a sense of self that would provide him with what he needed to continue to exist. This process is revealed most decisively and dramatically in the self- portraits. Vincent continually experimented in these unique works to find that meaning, that purpose, that sense of belonging and the legitimation of his human existence that would allow him to feel at peace with his world, his fellow men, his God, and himself. We can question whether this quest was ever completed, ever resolved. My own opinion is that it was not—that the closest approximation he ever found was in his final act—his own suicide—his final and ultimate effort to achieve resolution of his tragic flaw by seeking life in death.

The classic pathology involving the mirror image and ending in suicide was Narcissus. The water in which he sees his reflection and in which he meets death is a symbol of birth and the mother. The surface serves as a mirror, but its depth becomes the medium of symbiotic entrapment and death. The myth reflects the earliest mirroring experiences between mother and child that give rise to the rudiments of identity. When such mirroring is optimal, it implies acceptance of the child's separate identity; but where such acceptance and love do not obtain, as is thought to be the case in the replacement child syndrome, the child's individuation is severely compromised and the resort to pathological and narcissistically determined forms of introjection becomes inevitable. We can suggest that this may well have been Vincent's lot.

In a psychological sense, Vincent's self-portraits represent the pinnacle of his artist expression. His brush may have wrought greater works of art, but none that expressed the inner core of his being with such power and telling impact. As he entered the transitional space in which he confronted the empty canvas, unique forces were set in motion that brought into focus all the dynamic elements that played out their turbulent and conflicted roles in his inner world. The power of his art is that he was able to provide us a unique and privileged window to the inner core of himself with all its primitive torment and anguish. These portraits become a kind of desperate appeal for recognition, a last effort to be known and acknowledged and accepted—something that all his life he longed for and never seemed able to find. They are the portraits of a stranger on the earth, one who was rejected by men, who had no place to lay his head, no place that he could call home (Meissner 1993).

Art and Religion

The burden of what Vincent has conveyed to us about himself and the mean-ing of his art makes it clear that in his mind there was no division between the struggle for artistic realization and the search for the divine. If his conflicted and tortured effort to find healing for his fragmented self came to serve a dy-namic motivating role in his artistic endeavors, it is no less the case that the inner sense of meaning and purpose that were tied up in his sense of self were linked inexorably to the place and meaning of God in his life. The canvas be-came the locus were his efforts at self-definition and his search for God came into overlapping and inseparable conjunction. For Vincent, in a profound sense, finding himself and achieving a degree of healing of his tormented and suffering soul was the same as finding God and determining his relationship to God.

That quest was contaminated by his rebellion against and rejection of the traditional Calvinistic faith of his father. Vincent had rejected everything that his father stood for—most particularly his religious convictions. It was a wholesale abandonment of the kind of religion Freud would have had in mind—rooted in oedipal dynamics, bound in subjection to the father-god, and expressed in obsessional devices of prayer and ritual. For Vincent, God could not be found in the usual places—in churches, in religious rites and practices, in liturgical functions, in a community of prayer and sacrifice, or even altogether in the stale and lifeless word of God, the words of the Bible that he had so loved and cherished. Vincent had turned his back on all of these, but he could not turn his back on God. Quite the opposite—his need for God became even more pressing, more urgent, more poignant.

He had to define his own vehicle for finding God. His art became the chosen channel for expressing his yearning for the divine and his struggle to find God. As he stood before his easel with its empty canvas, he stood on the threshold of a kind of prayerful space, a sort of chapel of the mind, in which he was invited to enter the realm of the divine. As he applied brush and pig-ment to the canvas, he was performing a kind of religious rite, a meditation, or better a contemplation, in which he probed the mysteries of nature in order to discover the hand of God. Each of these paintings became in its own fashion a prayer, a hymn to the majesty, the mystery and the grandeur of God. But this God was Vincent's God, far removed from the God of his father, the God of Nature—whether that Nature was the realm of trees, skies, flowers, and fields of waving wheat, or the dimpled face of a child, the eyes of a peas-ant woman, the sensuous buttocks of a woman, the haggard breasts of a preg-nant woman of the streets, or even his own face as it peered out of the mirror at him. God was hidden in all of these, and Vincent's artistic mission was to

seek Him out, to discover His ways as they were expressed in the works of His hands.

The search for God through the window of his canvas was simultaneously and synonymously Vincent's search for himself, an effort to find himself and his meaning, the meaning and purpose of his life and his place in the world. Vincent could not divorce his own sense of himself, who and what he was, from his relation to God. The religious dimension was thus the ultimate defining dimension of Vincent's inner sense of self continuity and identity. He had struggled to capture that sense of himself in his identification with Christ—his identification with Christ sacrificing and suffering reached his climactic apogee in his orgy of self-denial and ascetical severity in the Borinage. But that effort collapsed. But the driving forces—largely narcissistic—that undergirded that identification could not be abandoned as readily as he might turn away from his father and his father's church. The identification extended as an unconscious force into his artistic life—he saw himself in the image of Christ as an artist (Christ's portraits were living men, not merely pictures), and his identification with the crucified Christ may well have played a powerful role in his self-mutilation (Lubin 1972; Edelheit 1974). But even this identification with Christ was burdened with the associations with his father's faith, in which, after all, Christ held the central place. The place of Christ in Vincent's transformation was taken by the sun—the *sol invictus*, the light of the world, that brought life and salvation into the darkness, the *rayon blanc* that stood in stark opposition to the *rayon noir*. Even the tradition figure of Christ had to be transmuted into a powerful symbol of Nature.

We can also be impressed with the extent to which much of Vincent's religious quest was overshadowed by his relation to the first Vincent. The first Vincent had died and been raised to glory to rest in the loving bosom of the eternal God. The influence of this theme on Vincent's spiritual journey was complex and manyfold, but at certain points it rose to a level of telling significance. One aspect was the siren call that Vincent felt to the grave—the place where the first Vincent had attained his triumph. The call of death had a powerful appeal to Vincent, since only in death could one find the love and acceptance from the mother that he had so desperately sought and that had so consistently eluded him. Better to be dead and loved than to alive and rejected. The theme found its way onto Vincent's canvases as well. In "The Raising of Lazarus" (F677, JH1972), Vincent painted himself into the place of Lazarus who emerges from the tomb into the embrace of a mother-figure. In the "Pietà" (F630, JH1775), the only representation of Christ he ever painted, the Christ-figure wears the face of Vincent and is clutched in death in the arms of a grieving and loving mother. Several themes come into conjunc-

tion in this painting—the identification with Christ suffering and dying, the identification with the dead Vincent who has found love and acceptance in the arms of the grieving mother because he is dead. We must conclude that, however powerful Vincent's unconscious identification with Christ may have been, it was overburdened with the associations with the dead Vincent and with the call to death itself, specifically in the engulfing and life-depriving embrace of the mother of sorrows.

Chapter XIV
THE SEARCH FOR GOD

Vincent's Mysticism

It may seem strange to find in Vincent's immersion in his art and nature the strains of mysticism. Even if we are compelled to expand the category somewhat, I will not shrink from the task because the idea seems to capture something of the inner dimension of Vincent's religious quest. Certainly, we would not have much reason to think of him as an authentic Christian mystic in the spirit of the mystical giants of the stature of Loyola, Teresa of Avila, John of the Cross, or even the Boehmes or Ruysboecks closer to Vincent's own culture. But there is a quality of mystical absorption that stamps Vincent's life and work—the question remains to what extent the driving force behind it was religious or spiritual in any sense. If we were forced to settle for a kind of quasi-mystical element in his personality and art, that might do well enough. Vincent's quest fits, in its own style, Hocking's (1912) description: "Mysticism is a way of dealing with God, having cognitive and other fruit, affecting first the mystic's being and then his thinking, affording him thereby answers to prayer which he can distinguish from the results of his own reflection. . . . rather an 'experimental wisdom,' having its own methods and its own audacious intention of meeting deity face to face" (p. 355).

I would make the case that Vincent's deeper religious instincts brought him to a form of nature mysticism (Otto 1932) that found its most sublime expression in some of his paintings. The mystical phenomena have been described in various ways. In its broadest sense, mysticism implies a seeking for union or communication with the divine—for the great Christian mystics the goal was the *unio mystica*, the highest level of religious and spiritual experience possible to man in this life. This may overstate the case for Vincent, but there is little doubt that his religious inspiration was distilled into a restless searching for meaning and for a sense of communication with something beyond experience, beyond the world of nature that he loved so well, that would fulfill the deepest yearnings and hopes of his tormented soul.

Vincent's alienation from his world and the companionship of his fellow men contributed to the mystical bent of his work. But in this he was not far removed from the great religious mystics. There has always been a certain tension, if not antipathy, between organized institutional religion and the spiritual deviance of the mystic. Mystical souls do not fit easily in any society; they are misfits, peculiar; they defy the security and conformity of normal religious beliefs and conventional religious practices and rites. Communal religion is social and interpersonal; the religious experience of the mystic is

personal, idiosyncratic, isolated. And this is, of course, the paradox—the
mystical inspiration is the highest peak and the very life blood of religious
vitality. Real religious devotion and spirituality thrives on mystical input,
while the unique experience of the mystic gains meaning only in terms of its
religious moorings.

We might argue that Vincent's conflicted rebellion against and rejection
of the conventional religion of his father did not allow him to experience his
searching for God in the more usual paths of Christian spirituality. But if he
had cut the ties to the religious world of his father, the dissociation was never
complete. The links to the figure of Christ were not totally lost. There was
his conflicted reluctance to paint the figure of Christ—recall the transforma-
tion of his thwarted effort in painting the Agony in the Garden, its transfor-
mation into "The Starry Night," the replacement of the Christ figure with the
sun in his "Raising of Lazarus." In each instance the conventional religious
iconography was transformed into a powerful symbol of the majesty and
beauty of natural images—the sun and stars.

I have tried to make the argument that the powerful religious motivation
that drove Vincent in his early immersion in religious ideas and devotional
practices was not lost, but became subverted and channeled into his devotion
to his artistic endeavors. The early religious immersion was intense, power-
ful, obsessive, fanatical, self-sacrificial, ascetical to the point of near self-
destruction, covered with extraordinary measures of zeal, charity, self-
mortification to rival the ascetical feats of the great saints. His inspiration
was to follow Christ, to imitate Christ in poverty, pain, suffering, and self-
sacrifice, to give his all in an ecstasy of spiritual self-immolation. The failure
of his efforts to become a minister of the gospel and to scale the heights of
ascetical perfection in the Borinage laid the axe to the roots of this spiritual
crusade. He recoiled like a wounded animal, and when he finally crawled out
of his cave of isolation and depressive pain, he had turned against the religion
of his fathers and had set himself on the path of artistic achievement and ex-
pression. But the spirit was the same—the same intensity, determination, fa-
naticism, self-sacrifice and immolation, the same unremitting asceticism and
self-denial. Nourishment, happiness, comfort, health—all meant nothing to
him. The only thing that mattered was his art.

The place where Vincent's mysticism comes into clearest relief is in his
paintings of nature—we can include in nature not just the trees and fields, the
flowers and gardens, the mountains and sky, but people—the poor peasants
whose misery and pain he strove so ardently to capture on his canvases, but
also the men and women whose features appeared on his canvases, the por-
traits in which he strove to capture the soul, the inner life, the unique charac-
ter and personality of his subject. He told us how he immersed himself in

these studies, striving to gain access to the vitality, meaning, and significance of what lie before him, searching to penetrate its inner reality and vitality, struggling to capture something that was hidden within and gave significance, moment, and a deeper grasp of existence—something that lay beyond the appearances, the configuration of light and shadow and shading, something that spoke to the inner being, a shadow of something beyond reality, beyond beauty, beyond mere existence.

In this respect, he finds common ground with some of the great mystics. We think of Assisi and his canticle to Brother Sun:

> Be praised, my Lord, with all Your creatures,
> Especially Sir Brother Sun,
> By whom you give us the light of day!
> And he is beautiful and radiant with great splendor.
> Of You, Most High, he is a symbol![1]

The litany of praise for nature continues to include the moon and the stars, the wind and the air, water and fire, Mother Earth with all her flowers and trees, and even Sister Death who is also part of God's creation. A similar theme is enunciated in the teaching of Francis' disciple, Bonaventure, who wrote of the journey to God through His creatures:

> In relation to our position in creation, the universe itself is a ladder by which we can ascend into God. Some created things are vestiges, others images; some are material, others spiritual; some are temporal, others everlasting; some are outside us, others within us. In order to contemplate the first principle, who is most spiritual, eternal and above us, we must pass through his vestiges, which are material, temporal and outside us. This means *to be led in the path to God.*[2]

As Eliade (1985) comments, ". . . as a good Franciscan, Bonaventure encourages a precise and rigorous knowledge of Nature. God's wisdom is revealed in the cosmic realities; the more one studies something, the more one penetrates into its individuality, and better comprehends it as the exemplary being situated in the spirit of God" (p. 193).

On another front we are reminded of the great Ignatius of Loyola, one of the greatest mystics of the Christian heritage, who made it a basic tenet of his spiritual to find God in all things. The power and spiritual aura of Vincent's painting of "The Starry Night" echo something of the spiritual immersion of Ignatius as he contemplated the starry vault of heaven as he prayed on the roof of the Jesuit house in Rome. His devoted follower Laynez, who was to succeed him as General of the Society of Jesus, provided a description of the scene:

At night he would go up on the roof of the house, with the sky there up above him. He would sit there quietly, absolutely quietly. He would take his hat off and look up for a long time at the sky. Then he would fall on his knees, bowing profoundly to God. Then he would sit on a little bench because the weakness of his body did not allow him to take any other position. He would stay there bare-headed and without moving. And the tears would begin to flow down his cheeks like a stream, but so quietly and so gently that you heard not a sob nor a sigh nor the least possible movement of his body.[3]

I do not mean to suggest that Vincent was a mystic in any but an analogous sense to Ignatius, but there are similarities that should not escape our appreciation. There was first the fervent seeking for God—Ignatius in prayer, Vincent in painting. Second, the devotion to and absorption in the power and beauty of nature—the vision of the starry heavens fascinated and inspired them both. Third, there is the quality of intense concentration that drew them both into a transitional phase, a state of altered consciousness, that focused all their mental power on the object of their devotion and pushed all other considerations to the side. Ignatius became lost in his prayerful union with God; Vincent was totally immersed in his effort to penetrate the nature and meaning of his subject. The most striking difference is that for Ignatius the object of his concentration was directly and immediately God—the hallmark of the true and authentic mystic. For Vincent, the seeking for and the presence of God was displaced onto his canvas, so that the search was indirect and filtered through the medium of his artistic imagination and the brush he held in his hand.

For Bonaventure, Loyola, Teresa, John of the Cross, and others, the mystical experience was intensely and orthodoxly religious—in fact the pinnacle of religious ecstasy. Vincent's mysticism was different and carried the unique stamp of his own personal vision. Whether we regard the mystical aspect as religious or nonreligious, Vincent's search for God may represent some form of monistic mysticism, at least in the sense of seeking for connection with some universal principle (Egan 1984). For Vincent, the immersion in and communion with nature was primary. Whatever the category—theistic mysticism, nature mysticism, monistic mysticism—Vincent's mystical experience was sporadic and untrained rather than cultivated, more in the order of a sense of contact with something beyond rather than the ecstasies and visions of the cultivated variety (Kakar 1991).

Eastern Mystical Strains
There is another strain in this aspect of Vincent's religious odyssey. We can recall his fascination and admiration for Japanese painting—he collected hundreds of prints. And when he sent his own self-portrait to Gauguin, it was in

the image of "a worshipper of the eternal Buddha" (F476, JH1581). He marveled that the Japanese artist could be so absorbed in a single blade of grass and find so much meaning in it—not unlike Blake's "to see a world in a grain of sand, and a heaven in a wild flower." As Vincent wrote to Theo, ". . . isn't it almost a true religion which these simple Japanese teach us, who live in nature as though they themselves were flowers" (Letter 542). In this immersion and penetration of nature, Vincent drew close to the mystical traditions of the East, particularly the brand of nature mysticism found in the esthetic visions of Ramakrishna (Kakar 1991), the appeal to Nature in the Bhagavad-Gita (Radhakrishnan and Moore 1957), and the immersion in the world of Nature of Taoism, Shinto, and Zen Buddhism. As Suzuki (Barrett 1956) observed, "The Chinese masters always prefer to be concrete. Instead of talking about 'Being' or 'Reason' or 'Reality,' they talk about stones, flowers, clouds, or birds" (p. 239). Vincent's spirit would have resonated with the words of Wang Wei (AD 415-443), the great Taoist painter, in his "Introduction to Painting":

> Gazing upon the clouds of autumn, my spirit takes wings and soars. Facing the breeze of spring, my thoughts flow like great, powerful currents. Even the music of metal and stone instruments and the treasure of priceless jades cannot match [the pleasure of] this. I unroll pictures and examine documents, I compare and distinguish the mountains and seas. The wind rises from the green forest, and foaming water rushes in the stream. Alas! Such paintings cannot be achieved by the physical movements of the fingers and the hand, but only by the spirit entering into them. This is the nature of painting.[4]

By Vincent's own confession, his mind struggled to reach beyond the canvas, beyond the reality and appearance of the subject before him, to something beyond and above. It might seem banal to suggest that that something was God, but I will not shrink from suggesting that it was. Vincent's artistic immersion was a fervent and unremitting probing of the world of nature that surrounded him in a quest for the divine. Every canvas was in some cryptic and hidden manner a prayer, a meditation, an effort to capture something that was resonant with the spirit of God. The borders of his canvas marked the confines of the transitional space within which he sought for the divine. In a sense the transitional character of his artistic experience became transfused and permeated with the transitional quality of his spiritual dynamism. Searching to penetrate and capture the inner meaning of the objects of his painting was in the same moment a searching after God, after that which would give his own life and artistic effort its inherent meaning and ultimate purpose. Vincent could not find any degree of inner satisfaction, peace, and fulfillment without God. This was the stamp of his existence and religious

devotion in his early days, and it was no less the stamp of his life's effort at the end. The question that haunts us, as it haunted him, is—what caused this intense and dedicated crusade to find God to go astray, to fall short of its mark, to end in despair and suicide?

Development of the God-Representation

One of the sources of enigmatic uncertainty that characterizes Vincent's religious odyssey lies in his concept of God. When psychoanalysts speak of God, they focus their attention on the God-representation in the human mind. They are therefore addressing an aspect of intrapsychic experience that is subject to all the dynamic and conflictual vicissitudes of man's psychic life. When theologians speak of God, the intentionality of the concept is not limited or focused on something mental or intrapsychic; the object of their reflections is a living God, a God out there, existing in time and eternity, the infinite causal source of the universe and all that exists. The God of the analysts exists only in the mind—he is a subjective God. The God of the theologians exists outside the mind, he is the existential cause and source of the mind, he is an objective God.

Consequently, when we ask about Vincent's God within the analytic framework, we seek an answer in terms of inner psychic life and seek to define as far as we can the nature of his God-representation and what function it served in his psychic economy. The God-representation, like other aspects of human intrapsychic experience, has a developmental history beginning at the earliest phases of infancy, and undergoes a progressive refinement and differentiation in the subsequent stages of psychological development. I am following here the work of Winnicott (1971)[5] on transitional phenomena and the extension of this approach to the concept of the God-representation by Rizzuto (1979). Our task is to try to discern the elements of the God-representation as it was shaped in Vincent's mind and heart.

The God-representation has certain definable characteristics: God is a special type of object representation created by the child in that psychic space where transitional phenomena exercise their illusory effects. It is a special form of transitional object created from representational materials derived from the representations of primary objects [the parents]. It also does not follow the usual course of other transitional objects that generally are gradually decathected and become not so much forgotten as relegated to limbo. They lose meaning because as transitional phenomena they become diffused over the whole cultural field.

The God-representation, on the other hand, is increasingly cathected during the pregenital years and reaches a peak of intensity at the high point of oedipal excitement. God, according to Freud, only becomes the object of

sublimated libido after resolution of the oedipal crisis. But God's representational characteristics depend on the type of resolution and compromises the child arranges with his oedipal objects. Throughout life the God-representation remains a transitional phenomenon caught up in the continuing transactions between oneself, others, and life itself. "This is so, not because God is God, but because, like the teddy bear, he has obtained a good half of his stuffing from the primary objects the child has 'found' in his life. The other half of God's stuffing comes from the child's capacity to 'create' a God according to his needs" (Rizzuto 1979, p. 179).

The process of creating and finding this personalized transitional God-representation never ceases in the course of life. The God-representation evolves in the course of the life cycle according to the epigenetic and developmental laws that govern human psychological development. Reelaborating the God-representation also follows the dynamic laws of psychic defense, adaptation, and synthesis, and is intertwined with the need for meaningful relations with oneself, others, and the world. For both child and adult, the sense of self is influenced by the traits of the individual's private God-representation. As Rizzuto (1979) puts it, "Consciously, preconsciously, or unconsciously, God, our own creation, like a piece of art dormant or active, remains a potentially available representation for the continuous process of psychic integration. As a transitional object representation God can be used for religion because he is beyond magic, as described by Winnicott: 'The transitional object is never under magical control like the internal object, nor is it outside control as the real mother is' " (p. 180).

If we turn to Vincent's God, we might ask what influences in the course of his life might have had an influence on his representation of God. At the most rudimentary level, the early infantile experiences of narcissistic mirroring in relation to the mother provide basic and important elements in structuring the God image. If the mother is experienced as a loving and caring presence, if the mother's participation in the mirroring process gives the child a sense of being narcissistically embraced, admired, accepted, and cherished, he gains a symbiotic attachment to the mother that serves as the basis for an emerging sense of trust and security. These rudimentary elements derived from the mirroring experience can be distilled later in the course of life into the individual's experience of God. For Vincent, the experience of narcissistic mirroring was contaminated by his mother's depression following the loss of the first Vincent, her narcissistic involution, and her consequent emotional unavailability. The conditions for effective narcissistic mirroring were lacking. The result of such defective mirroring for any child can be a sense of isolation, being cut off from the communion of men or lost and abandoned; or the process may take a turn toward a defensive sense of omnipotence and

grandiosity, a feeling of being like God rather than loved by God, a sense of self-sufficiency, of needing love from no one. We might surmise that both these variants found their place in Vincent's experience. Vincent's God had turned his face away from him, abandoned him, leaving him alone and without meaningful relationship.

The child normally passes beyond the mirroring phase to a stage of infantile dependence on the idealized mother. The image of God can be gradually shaped around this idealizing experience and its associated fantasy. As Rizzuto (1979) observes: "At the moment of their encounter it becomes clear that the child is small and needs the adult and that the adult is powerful and 'knows' the child internally. Now the fate of the child and the God representation alike depend on how the two characters—mother and child, God and child—are seen and the real and fantasied nature of their interaction" (p. 188). This aspect of Vincent's developmental experience would have been troubled by his mother's continuing depression and by the dynamics set up by the replacement child syndrome. Interfering effects would have arisen not only from her depression, but from the anxiety generated by the death of her firstborn and the anticipated threats to his replacement.

There is little doubt that both parents play a role in the development of the child's religious thinking. In general the family plays an important part in the development of religious experience (Vergote 1969). The parents' religious attitudes and behavior are inevitably transmitted to the child. Patterns of protection, well-being, and authority inherent in family structure find their natural extension and elaboration in religion. The earliest images of God are cast almost exclusively in the image of the parents, but may also be affected by other significant objects in the immediate family (grandparents, siblings) or outside it (priests, nuns, ministers, rabbis). Even though parental and divine images are at first almost totally confused, from about the age of three or four years the child has no difficulty in imagining a God. But the images of the divine are full of fantasy and fascination, not unlike the world of fairly tales. The child's image of God from the beginning is colored with ambivalence: feelings of trust and dependence on a kind, loving, and protecting God are matched by elements of awe and fear.

This ambivalence can reflect the child's relationship with the mother. She is experienced as loving, protecting, and nurturing, the good mother with whom the child feels security and trust. But there is also the bad mother, who withholds, is unavailable, not empathically attuned, who punishes, and is not available to satisfy the child's infantile wishes and needs; she becomes an object of fear. We can easily conjecture that the negative elements in Vincent's ambivalence toward his mother would have been relatively high, not only the early stages of his infancy but throughout his life. When the child's

early experience with the mother has been positive and gratifying, it lays a foundation for a sense of trust that contributes to later development of faith in the relationship with God. But when early infantile experience is discolored by insecurity, uncertainty, or anxiety, a sense of mistrust develops that can contaminate and distort later experience of God (Meissner 1987).

The succeeding phase of development (described by Freud in libidinal terms as the anal phase, particularly its latter, anal-sadistic portion) ushers in endless questions about how things are made or where they came from. The concept of God as having made the world or the sky soon leads to the notion of God as the most powerful of all causes, the power that is greater than any other. The child is left little recourse but to imagine this God in terms of the most formidable human beings he knows, his parents. At first he uses both father and mother for this purpose, but gradually father more than mother; this tendency is reinforced by the extent to which father is regarded as the more powerful, aggressive, or punitive parental figure.

As the child moves beyond the oedipal age, he gradually becomes aware of the distinction between God and his parents. His view of his parents becomes more realistic, more aware of their limitations and incapacities as human beings, and with this realization he begins to experience the erosion of his narcissistic ideals. He compensates for his disappointment in his parents by resort to the narcissistic investment in an omnipotent ideal of a heavenly Father, who promises to be all-powerful and perfect. The object relations that underlie the child's representation of God can shift their positions in a variety of ways. The parental image and the God image may be more or less continuous, allowing them to be used as equivalents or substitutes in the face of defensive pressures, or opposed and antagonistic, usually reflecting underlying processes of defensive splitting. God in this scenario may be utterly good and protecting, while the parents are regarded as mean, ungiving, or unloving. The opposite pattern can also happen—idealized parents and devalued God. Or the good and bad qualities of both God and parents may be seen in various combinations (Rizzuto 1979).

In latency, God is the creator of the world, of all the plants and animals, of nature and the beautiful things in it. The child becomes absorbed with Bible stories, listening to them over and over. God has become more real, so that prayers become more important, particularly insofar as he feels a growing sense of confidence that God will listen to and answer them. The child's notion of God at this stage is essentially anthropomorphic: a magnified human agent whose actions in and on the world are envisioned as like human actions. Even so, God is regarded as different from human beings in that he lives with the angels in heaven and cannot be seen or touched. However, as the child approaches puberty, notions of God become more spiritualized and seem to

lose the fairy-tale, magical, and fantastical qualities common in oedipal-age children. It was in this stage of development that Vincent's love of and immersion in nature took its origins.

The anthropomorphic characteristics of the child's view of God are also expressed in his fantasy of how God acts in the world. When the latency-age child begins to question the perfection and omnipotence of his parents, he may transpose some of the qualities formerly attributed to adults to the divine being. He first will imagine that God is like human beings, but not entirely— from time to time the division between God and all others leads to a view of God in increasingly symbolic terms. I would conclude that Vincent's unconscious imagery of God was largely cast in terms of his parental representations—more at this stage in relation to his father than to his mother. In general, the ambivalence toward the God-representation, expressed in terms of reverence, awe, and fear, increases with age. God is viewed not simply as one who is benevolent and good; his almighty power is to be both revered and feared. The child progresses from naive trust in God, rooted in his infantile dependence on the mother, to a fuller understanding of divine majesty, transcendence, and power.

Adolescence is one of the most crucial periods in the development not only of personality but also of religious attitudes. In this regard, Rizzuto (1979) has observed that ". . . adolescence confronts the growing individual with a need to integrate a more cohesive and unified self-representation which will permit him to make major decisions about life, marriage, and profession. That developmental crisis, with its intense self- searching and reshuffling of self-images in the context of trying to find a niche in the world for oneself, brings about new encounters with both old and new God-representations. They may or may not lend themselves to belief" (p. 201). At about the age of twelve or thirteen, thinking about God shifts from more or less attributional terms to increasing personalization—God is specifically God the Savior, God the Father. God is increasingly regarded in primarily subjective attitudes of love, obedience, trust, doubt, fear. The themes and corresponding God-representations that express the adolescent's religious experience are heavily influenced by his affective needs. This highly personalized and subjective God-representation may be frequently difficult for the adolescent to integrate with the more objective attributes proposed by organized religion.

We can guess what a difficult and prepossessing turn these developments took for Vincent. As he took his first steps into adolescence, his lot was exile from home—given his basic sense of alienation and his strained position within the family, the exclusion of his boarding school experience must have driven the stake of parental alienation deeper into his heart. Was his unexplained desertion of his secondary schooling propelled by this inner despair

and the unavailing attempt to reconnect with his family and home? The ambivalent and alienated representations of his parents would have found their way into his evolving God-representation. The personalized adolescent image of God in its benign rendition most often takes the form of a providential father who watches over and guides the adolescent along life's uncertain path. The image of Vincent's father was far from providential or guiding with a loving hand. Was it the austere, critical, judging and disapproving Theodorus whose imagery determined the shape of Vincent's God-representation? Or was there a defensive countercurrent that created an opposite image of a benign and loving heavenly father—the father Vincent would have wished for but never had? Often adolescents attribute to God the qualities they would seek in special and intimate friends, emphasizing understanding and affective communication.

Moreover, the increased measure of narcissism in adolescent development influences the ego-ideal which plays a part in the religious sphere as well. The adolescent idealizes the adult figures whom he seeks to imitate and with whom he ultimately wishes to identify. The components of his inner, idealizing narcissism are thus transferred to the object in whom the adolescent seeks the perfection that he himself wishes to possess by identification. This scenario came to full fruition in Vincent's idealization of his father who became the embodiment of all Christian and ministerial virtues. The dominating motif at this stage of Vincent's adolescent idealization was his ardent wish to follow his father's example and follow in his father's footsteps in the service of God in the ministry. This idealization had its effect on the God-representation insofar as God was cast in the role of a pure and perfect being, the elevation of the father-figure to its ultimate and sublime expression.

The frequent waning of these religious ideals toward the end of adolescence reflects the diminishing intensity of the narcissistic idealizing process with the adolescent's gradual assimilation of more mature and adult life patterns and commitments. But this transition was not untroubled for Vincent. His efforts to translate his wishes and idealizing fervor into real terms met with disaster and dismal failure. Rather than gaining the cherished access to his father's approval and favor, he met nothing but further negativity and doubt. The path to religious fulfillment was blocked, so that any transposition to any more mature and adaptive religious realization was thwarted.

Among Christians, the figure of Christ in particular becomes an important object for narcissistic idealization and attachment. Where adolescent idealization is not tempered by greater maturity of judgment and discretion, the figure of Christ can become a superhuman model and a repository for fanatical tendencies. Adolescence is also a period of increased sexual conflict and guilt. The degree of superego repression and guilt can be reinforced by re-

ligious prescriptions and ideals—a form of moral masochism that carries a
sense of sinfulness that can become such a burden and a narcissistic impedi-
ment that it results in a rebellion against all religious standards and values.
Adolescents find themselves caught between standards of moral laxity on one
side and hyperrigid moralism on the other.

Along with these tendencies to moralism and internalization of religious
experience, adolescence is also a time for intensifying religious doubt. Doubt
expresses the adolescent's need for autonomy in the face of the regressively
reactivated pull to dependency on parental objects. For some adolescents the
quest for independence can be pursued only through overthrowing and re-
jecting parental norms and standards. Religion in such cases may become the
symbolic repository for parental authority and the corresponding conflicts of
continuing dependence. The adolescent who needs to reject authority may
find this need perverting his religious experience and his relation to God as
well. This doubt may be reinforced by adolescent affective turmoil, particu-
larly by conflicts over sexuality. Plagued by sexual conflicts and feelings of
guilt, the adolescent may be overwhelmed by shame and insecurity over his
inability to live up to lofty religious standards of conduct. Consistent with the
continuing influence of parental figures and family milieu, the adolescent's
religious crisis often reflects conflicts and tensions between his parents or
between them and their children. The result may be a form of rebellion and
alienation that not only impedes the adolescent's growth to maturity but cor-
rupts and subverts his further religious development as well.

These formulations, focusing on more or less normal adolescent devel-
opment, find a degree of valid application to Vincent's early religious experi-
ence. While the formulas ring true, they found their idiosyncratic expression
in Vincent. His transition from latency to adolescence was not the usual
brand of adolescent turmoil, but ran into added turbulence from the painful
impediments stemming from the contaminated representations derived from
his relations with his parents and the internalized conflicts and compromises
that emerged in his struggles to find himself and to secure his place in the
world. The intense religious obsessions and the idealizing idolatry that drew
him toward the ministry and the service of Christ ran into disastrous difficul-
ties and disappointments. The effect on his God-representation had to be
profound and far-reaching.

Vincent's God

The resolution of adolescent issues normally leads the young believer to the
threshold of a religious struggle that he must carry on for the rest of life. This
allows the young believer to think more freely about the meaning of life and
his involvement in the world. He becomes less centered on himself and more

committed to human society. But, for Vincent, the path led in the opposite direction. The uncertainties, doubts, and disappointments he had to face left him immersed in insecurity and the agony of self-doubt. Rather than less centered on himself, his narcissistic needs were intensified and left him in the pit of depleted self-esteem and depressive hopelessness. He was drawn step-by-step toward a crisis of belief that found its resolution in religious doubt, in an almost complete loss of faith in the religious tradition and cult he had been raised, in a vehement and uncompromising rejection of everything that his father stood for in religious terms, and in a tortured transformation of his sense of religious self-identity—a retreat from the profound sense of identification with Christ and an obliteration of the God he had sought so desperately to find.

The course of Vincent's religious odyssey took a decidedly different direction. The normal course of adult religious experience may reflect the more or less satisfactory integration of derivatives from all developmental phases. Primitive experiences from archaic developmental levels may be successfully transformed and integrated with later developmental achievements and thus take on a different significance and a more differentiated symbolic reference (Meissner 1984). This transformation allows us to identify both the original relevance of the archaic symbol and its more evolved, symbolically differentiated and enriched context without reducing their connection to an identity or resorting to the developmentally obtuse formula of repetition. The essence of development lies in the "overcoming" and differential superseding of origins, not in their simple repetition. The individual's emerging religious experience may achieve developmental resolution in varying degrees, so that the result is a heterogeneity of relatively mature and relatively archaic elements, stemming from any of the developmental levels. Rizzuto (1979) comments on these adult vicissitudes:

> For the rest of the life cycle the individual will again find himself in need of critical changes in self-representation to adapt to the inexorable advance of the life cycle as well as to new encounters with peers and parental representatives. God—as a representation—may or may not be called in to undergo his share in the changes. Finally, when death arrives, the question of the existence of God returns. At that point, the God-representation, which may vary from a long-neglected preoedipal figure to a well-known life companion—or to anything in between—will return to the dying person's memory, either to obtain grace of belief or to be thrown out for the last time. (p. 201)

The crisis and the decisive religious revolution that marked the end of Vincent's formally religious career did not coincide with the transition from adolescence to adulthood. That crisis was more connected with his departure from the school at Tilburg. It was, in a sense, his first crisis of adolescent

identity. He was only 15 at that point. He spent the next eight years in his desultory dalliance with the career in art dealing, only to experience another failure and another crisis. His subsequent religious adventure was a desperate attempt to salvage some sense of self-esteem and to establish some more meaningful sense of identity. The calamity of his failure in his religious vocation and his turning from traditional religion to art came in 1878, when he was almost 25. If it could not be called an adolescent crisis in the usual sense, it was certainly a profound disruption of his inner sense of identity and of the meaning of his life. It could be regarded in that sense as a delayed, or perhaps a second or third, identity crisis in the Eriksonian sense (Erikson 1956, 1959).[6]

The dynamics of his personal and religious development played themselves out in tragic terms, and the vicissitudes of his representation of God underwent a parallel course of mutation and transformation. The violent overturning of his idolization of his father and with it the abandonment of all traditional beliefs and worship cut him adrift on a sea of religious and existential uncertainty. The turning away from religion was a kind of conversion—conflictual and traumatic—a conversion from the religion of his father to a religious path that had to be idiosyncratic and highly personal. In the shaping of the God-representation, the originating parental images are not abandoned, but they can be repressed or diminished to accord with the dynamic forces and needs at play in the psyche. The revolt against the father and the religion of the father could be expected to leave room for a renewed influence coming from the mother—the essential preoedipal object. If we can entertain the hypothesis that something like this occurred in Vincent's inner world, what would the consequences have been?

If Vincent's relation with his father had been overburdened by ambivalence and the dynamic dialectic of idealization and devaluation, Vincent's relation with his mother was no less troubled and painful. Affectively his involvement with her was overshadowed by the replacement child syndrome, by her depression and its consequences of emotional unavailability, by her incapacity for empathic attunement with her oldest living son, by the difficulties she had in understanding his inner torments and difficult, isolated, and alienated behavior—not only as a child but on into his adult life. She never understood him, never accepted his bizarre and idiosyncratic ways, always regarded him as a strange and perplexing child who was the constant object of her worry and guilt-ridden anxiety.

If Vincent's God-representation came to reflect the imago of his mother in his later years, what would this God look like? We can guess that Vincent's God was a hidden God, the *Deus ignotus* of early Christian theology, the God whose face was veiled and glimpsed only through a glass darkly,

who was withdrawn and concealed behind his creatures and the world He created. For Vincent, this God particularly concealed behind the veil of nature and it was in nature that he sought Him.

We speak of God as "Him," but we can also ask from where Vincent's image of this hidden and unavailable God was drawn. Certainly we cannot discount the continued influence of his father, but in the wake of his rejection and rebellion against his father's religious stance, we would have to think that whatever of it remained would have been relatively repressed. The influence of his mother weighs in more heavily in this connection. The hidden, withdrawn, unavailable and unempathic God of Vincent's inner life reflects many of the characteristics that marked Vincent's experience of his mother, especially in his early years when the deeper layer of preoedipal experiences and their associated psychic formations were laid down. The implications are clear. God's love and care and approval were withheld, and were only to be gained by the ultimate sacrifice and surrender—death. Only then could he be received into the loving embrace of an accepting and approving mother-God after the template of the first Vincent. Through much of his life, but with increasing intensity and urgency in the years of his artistic vocation, Vincent struggled, sacrificed, went to the limits of human endurance and strength, to search out and find the elusive God who seemed constantly beyond his grasp. He sought for this hidden God primarily in nature—no small coincidence that it was in Mother Nature that he immersed himself in the course of his quest. The frustration of his endless and unfulfilling search, combined with the mounting losses that crowded in on him from all sides, drove him to the ultimate sacrifice that would finally gain for him what he had sought so desperately—to follow the footsteps of the first Vincent to the grave, where he might find, once and for all, the love and acceptance that had eluded him in life.

NOTES

Prelude—In Search of Vincent

1. These issues are explored by Spector (1988) and are well displayed in the acerbic dialogue (debate?) between the psychoanalyst J. Gedo (1987ab) and the art historian T. Reff (1987ab) over the role of homosexuality in the personality of Cezanne.
2. See chapter I.
3. Vincent's paintings and drawings are referred to according to the two major catalogues of his works—the de la Faille (1970) catalogue designated by F-numbers, and the more current Hulsker (1980) catalogue designated by JH-numbers.

Chapter I Background and Beginnings

1. These considerations are qualified by the apparent role of toxic (alcohol, absinthe) and infectious (syphilis) agents in both Vincent and Theo. Both brothers apparently suffered from advanced tertiary syphilis and possibly general paresis.
2. The psychoanalytic literature on perinatal mortality has been recently reviewed, emphasizing the phenomenon of loss, grief, mourning, depressive sequelae, and the impact on family relationships. Important aspects of perinatal loss are the narcissistic trauma to the mother and the effects on her self-esteem, the sense of shame and inferiority, and the intensification of regressive narcissistic vulnerability, which severely affect her mothering capacity. See Leon (1990, 1992) and Peppers and Knapp (1980).
3. There is a considerable literature on the replacement-child syndrome. Cain and Cain (1964) emphasized the psychological damage to the surviving child; Poznanski (1972) described the role of the idealization of the dead child; Pollock (1972) stressed the role of unresolved mourning and idealization of the dead child; Volkan (1981) discussed the role of the surviving child as a linking object. Additional studies have focused on the effects of the replacement syndrome in the lives of famous persons: Schliemann (Niederland 1965), Ataturk (Volkan and Itzkowitz 1984), Stendhal (Wilson 1988), and so on.

 The phenomenon of sibling loss has played a part in the lives and work of other artists: Mary Cassatt, for example, suffered the loss of several siblings at critical phases of her own development that left her with an intense degree of survival guilt and may have influenced an effort to recreate these lost siblings on canvas. See Zerbe (1987).
4. References to Vincent's letters are taken from van Gogh-Bogner, and van Gogh (1959).
5. Vincent's case provides another striking example of what Shengold (1975, 1979, 1988, 1989) calls "soul murder," a vicissitude that plays a particular role in the life histories of a number of creative individuals. Shengold has written specifically about Kipling (1975), Dickens (1988, 1989), and Orwell (1989). We shall see in later chapters the ways in which this circumstance of Vincent's birth and early life played a crucial role in his development, in his life course, and in his religious attitudes.

Chapter II Religious Vocation

1. See Vincent's account of the story in Letter 55.
2. Made famous in Dickens' *Nicholas Nickleby*.

3. Reproduced in Letters I, 87–91.
4. His tutor, Mendes da Costa, recorded his recollections of Vincent from that time:

"I soon discovered what was absolutely necessary in this case: to gain his confidence and his friendship. Since he had begun his studies with the best intentions, we made rapid progress from the start, and soon I was able to let him translate an easy Latin author. Needless to say, fanatic as he was at that time, he immediately started applying that little knowledge of Latin to reading Thomas à Kempis in the original. . . . but the Greek verbs soon became too much for him. No matter how I approached it, whatever means I invented to make the task less tedious, it was to no avail. 'Mendes,' he said, . . . 'do you really think such horrors are necessary for someone who wants what I want: to give poor creatures a peacefulness in their existence on earth?' And I, who as his teacher could not possibly agree, but in the depth of my soul found that he—mind you I say: he, Vincent van Gogh—was entirely right, I defended myself as staunchly as possible; but it was futile.

" 'John Bunyan's Pilgrim's Progress is of much more use to me, as is Thomas à Kempis and a translation of the Bible; more than that I don't need.' I no longer know how many times he said that to me, nor the number of times I went to the Reverend Mr. Stricker [Vincent's uncle by marriage to his mother's sister was a respected minister in Amsterdam and had engaged Mendes to undertake Vincent's instruction.] to discuss the matter. In any event, each time it was decided once again that Vincent should give it another try. . . .

"Our association lasted a little less than a year. By then I had become convinced that he would never be able to pass the required examination. . . . I advised his uncle, completely in accordance with Vincent's wishes, to let him stop. And so it happened" (Cited in Stein (1986), pp. 44–45. Also Letter 122a.).

5. Mendes da Costa provides some information about these penances: "Whenever Vincent felt that his thoughts had deviated too much from what he considered proper, he took a cudgel to bed with him and scourged his back; if he felt that he had forfeited the privilege of spending that night in bed, he would slip out of the house unnoticed and, upon returning late to find the door locked for the night, he forced himself to lie on the ground in a small wooden shed, without bed or blanket. And he preferred to do this in the winter, so that the punishment, which I suspect was a form of mental or spiritual masochism, would be more severe" (Cited in Stein [1986], p. 44).

6. The owner of the bookstore in Dordrecht described an incident in which Vincent came across a lost mutt in the street. He took one of his last two pennies and bought a couple rolls that he fed to the dog. The rolls disappeared in an instant. Vincent turned to his companion and said, "What do you think this animal told me just now? That he would like another couple rolls like that." Whereupon Vincent spent his last penny on two more rolls for the dog. The story comes from Görlitz; see Letter A7.

7. A slightly different rendering is found in Schapiro (1994), p. 144. Schapiro (1968, p. 140–141) also cites a slightly different but similar account from Gauguin of the same story.

Chapter III The Path to Despair
1. See Letters R3 and R41 to Rappard, also Letter 153.
2. See Letters 193, 193a, 194, 197, 202, 212, among others.

3. See Letter 290.

4. Vincent's frequent commerce with prostitutes was by no means unique to him as a participant in the world of late nineteenth-century art and literature. I am indebted to Prof. Jeffery Howe for the following observations: "Van Gogh's association with prostitutes may have been influenced by a broader literary and artistic tendency in the late 19th century to use prostitutes as a subject intended to expand the boundaries of realism, and as a pretext for social criticism. Realist authors such as the Goncourt brothers (Galantiere 1937; Becker and Philips 1971; Goncourt 1877) and J. K. Huysmans (1876) wrote sympathetically of prostitutes. Earlier, Baudelaire had explicitly compared the fate of artists and prostitutes, both of whom were exiled from 'respectable' society and both of whom were trapped by commercial transactions. Baudelaire was particularly concerned to highlight the sterile, unnatural aspect of prostitution, which also reflected back ironically on his view of his art. Baudelaire and the Goncourts were read by Vincent; at least one van Gogh painting features a novel by the Goncourts clearly visible. Toulouse-Lautrec, of course, later went even further in his identification with prostitutes, to the point of moving into a brothel for a short time in the 1890's. Van Gogh's recurrent affiliation with prostitutes is, perhaps on one level at least, a case of 'life imitating art,' as Oscar Wilde would have it. Probably also, it relates to his identification with Christ and the theme of the redemption of the Magdalene." One can add, as a sort of footnote, that the temper of the times does not necessarily replace or rule out personal motivations and dynamics. They can and often are mutually reinforcing and sustaining.

Chapter IV Theo

1. The evidence seems to suggest that Theo was suffering from syphilis if not more.

2. The relation between twinning and creativity has been discussed by Arlow (1960) and Glenn (1966); the creativity of the Schaffer brothers has been of particular interest (Glenn, 1974abc; Hamilton, 1979b; Stamm, 1976).

3. Hulsker's viewpoint would have to be characterized as, if not analytically uninformed, for all purposes antianalytic.

4. See my discussion of these issues and their relation to Vincent's suicide that was to follow shortly (Meissner 1992b).

5. It is worth noting that Freud's creativity did not seem to dim after the rupture of his relationship with Fliess. Something similar may have taken place for Vincent in the face of the threatened loss of his connection with Theo. In both cases, the role of the symbiotic connection in creativity is not exclusive, but requires integration with other influences on the creative individual.

Chapter V In the Midi

1. There is some question as to the reliability of this account. There is no question that Vincent suffered a psychotic break, but the validity of the details rests only on Gauguin's reminiscence written in 1903. Gauguin could hardly be regarded as the most reliable witness in all this, but his account is of interest nonetheless.

2. Wauter's painting of the mad painter van der Goes provided an image in which Vincent could increasingly see his own reflection. He had referred to it as early as July 1873 (Letter 10).

3. His religious preoccupations affected his view of the nuns who acted as nurses in the hospital. He wrote: "What annoys me is constantly seeing these good women who believe in the Virgin of Lourdes, and make up things like that; and to think that I am a prisoner under an administration of that sort, which willingly fosters these sickly religious aberrations, whereas the right thing would be to cure them" (Letter 605).

4. The self-portrait referred to was the last done at St. Remy, and possibly the very last—the one with the light green background [F627, JH1772].

5. Written August 1, 1890; cited in Stein (1986), pp. 219–220.

Chapter VI Art and the Artist
1. See chapter II.
2. See the discussion of shame in chapter XII.

Chapter VII Creativity
1. Also Letter 533: ". . . the picture is one of the ugliest I have done. . . . I have tried to express the terrible passions of humanity by means of red and green." And Letter 535: ". . . [pictures] like this 'Night Café' usually seem to me atrociously ugly and bad, but when I am moved by something . . . then these are the only ones which appear to have any deep meaning."

2. Or meant to be so. Vincent told Theo that the painting "is to be suggestive here of *rest* or of sleep in general. In a word, looking at the picture ought to rest the brain, or rather the imagination" (Letter 554). However, as Rose (1991) notes, the painting is not always experienced that way.

Chapter VIII Religious Themes
1. See the discussion of the family romance in chapter VI.
2. The "Black Ray" was a reference to his father; see chapter III.
3. He pictured himself as a big, rough, and untamed dog—see Letter 346 in chapter III.
4. This odd spelling of "Christians" is Vincent's way of expressing his rejection of religious conventions.
5. On the the page of the open Bible, one can read "Isaie 53"—the classic locus of the song of the Suffering Servant.
6. See the discussion of "La Berceuse" in chapter XI.
7. Even the figure in "La Berceuse" seems to have had religious overtones. He wrote Theo: "And I must tell you—and you will see it in 'La Berceuse,' however much of a failure and however feeble that attempt may be—if I had had the strength to continue, I should have made portraits of saints and holy women from life who would have seemed to belong to another age, and they would be middle-class women of the present day, and yet they would have had something in common with the very primitive Christians. However, the emotions which that rouses are too strong, I shall stop at that, but later on, later on I do not say that I shall not return to the charge" (Letter 605).
8. i.e. the process of translating religious concepts into natural symbols.
9. ". . . it is not a return to the romantic or to religious ideas, no" (Letter 595).

Chapter IX Theological Perspectives

1. The full text of the sermon is found in Letters I, 87–91.

2. In light of Vincent's quasi-religious view of art and the artist's vocation, the question of his relationship to the Nabis—the group of "prophets" who had gathered around Paul Sérusier, Emile Bernard and Maurice Denis. This group was profoundly influenced by the ideas of Gauguin, particularly his emphasis on the use of flat, pure colors, and were known as Synthetists or Symbolists, or the school of Pont-Aven.. The group also had a quasi-mystical bent, reflected in their view of themselves as the prophets of the new art. They shared a longing for a utopian era, an idealized golden age, that may have influenced Vincent's ideas about Japan and Japanese art. They effectively broke away from the naturalism of impressionism and opened the way to an emerging symbolism and ultimately expressionism. The later group, known as Nabis from 1890 on, had no direct influence on Vincent.

The group was actually founded by Sérusier, who came to Paris from Pont-Aven to spread the gospel of Gauguin; the "good news" of this aesthetic doctrine was received as a sort of mystical revelation. The members included, besides Bernard and Denis, Bonnard, Ranson, Vuillard and Maillol among others. There is no evidence that Vincent ever belonged to this group, but he certainly was in close contact at different times with many of its members—especially Gauguin and Bernard. Vincent was not particularly receptive to Gauguin's aesthetic theories, as became clear in their debates at Arles, but the more subtle mystical implications may not have escaped him—particularly during his Paris sojourn. An especially sympathetic note was the view that a work of art is the product and visual expression of the artist's personal aesthetic metaphors and symbols.

Chapter X Imitation of Christ

1. The *Imitation* was first published anonymously in 1418. Its authorship remains uncertain, but it is usually attributed to Thomas à Kempis. It represents the spiritual teachings of the *devotio moderna* that arose in the context of the early Reformation and the rise of humanism. Kempis was schooled at Deventer and became a member of the Brothers of the Common Life at Windesheim. The congregation had been founded by Gerard Groote expressly for the purpose of promoting the *devotio moderna*. The *Imitation* distilled the teaching of this movement which emphasized an affective spirituality rather than scholastic learning. It was better to feel compunction than to know its definition. The roots of its spirituality go back to earlier Cistercian and Franciscan mysticism, and the little book of spiritual maxims has probably had as much impact on Western Christian spirituality as any. It was quite influential among the humanists of Northern Europe, and played a considerable role in the life of Erasmus and Ignatius of Loyola.

2. See also Letters 109, 116, 120, 267.

3. He referred to both Millet's "The Sower" and Delacroix's "Christ in the Boat" in the same context. See Letters 503 and B8. Further comments on Delacroix and Rembrandt appear in B12. See also the discussion in Holstijn (1951).

4. Runyan (1987) has surveyed the various interpretations and has composed a list of 13. Not all have the same degree of cogency; I have taken the liberty of dividing them between those that in my judgment have some relevance and those that do not. The relevant hypotheses in the order of their viability are: (1) the act of mutilating his ear reflected his

sense of loss and rage at the prospect of Theo's marriage and the loss of his illusion of the artists' colony to be gathered around Gauguin and himself; (2) Related to the first, he realized that he was losing the attention and close affection of Theo around the Christmas holidays, so that the mutilation was an attempt to draw Theo closer to himself and away from his fiancee; (3) As a symbolic form of self-killing, the mutilation was an effort to achieve the place of the dead Vincent through a symbolic death and thus gain the love and affection he yearned for from his mother; (4) In his identification with the crucified Christ, he offered his dead body to the substitute Virgin-Mother—the mother of the Pietà; (5) Gauguin's rejection stirred the residues of oedipal hatred of his father that were turned against himself out of guilt in the form of symbolic castration; (6) The act was a result of homosexual conflicts aroused by the close involvement with Gauguin and thus a form of autocastration; (7) Exposure to the local bullfights provided a symbolic pattern for the expression of his self-destructive impulse; and (8) The scene in the Garden of Gethsemane was much on his mind, and he had made an abortive attempt to paint it in the summer of 1888—this provided another template for acting out the themes of aggression and victimization.

Other explanations that seem less relevant are: (1) The story of Jack the Ripper, who cut off the ears of prostitutes as part of his grisly ritual, was in the news and Vincent may have had his sadistic impulses stimulated, but true to his masochistic disposition turned the urge against himself and presented the ear to the prostitute in reparation; (2) His painting of "La Berceuse" may have stimulated latent wishes for love and affection and caring from Madame Roulin and the postman as substitute parents; (3) The mutilation may have been an expression of his identification with prostitutes; (4) The mutilation was an attempt to change the "rough boy" image he felt he had in his mother's eyes by a symbolic form of castration, making himself more feminine and therefore more acceptable; (5) Cutting off his ear may have been an attempt to rid himself of terrifying auditory hallucinations accompanying his psychotic decompensation.

All these conjectures are within the realm of possibility, given Vincent's psychotic state, but some are merely conjectural, and others have some evidence to support them. Other interpreters might weigh these alternatives differently—and, of course, none can be totally and unequivocally eliminated.

5. References to the bullring and the ritual of the bullfight are found in Letters 498a and B3.

Chapter XI Death and the *Mater Dolorosa*

1. The theme of the graveyard seems to resurface again and again. He wrote: "I was really very glad to see Father and to talk to him. I again heard a great deal about Nuenen; that churchyard with the old crosses. I cannot get it out of my head. I hope I shall be able to paint it someday" (Letter 234). And again: "I can't get that churchyard with the wooden crosses out of my mind. Perhaps I shall make some studies of it beforehand" (Letter 236).

2. The green of her face matches the green background in his concurrent self-portrait of himself as a Buddhist monk (F476. JH1581). This led Gedo (1983) to ask: "Was van Gogh expressing in these related images the idea that his monkish character was an outgrowth of his mother's granitelike inaccessibility?" See Vincent's comments on these

paintings in Letter 540; the portrait of his mother was based on the photograph. See also Letters 546 and 548. Our knowledge of Anna is sketchy at best, so we are left with little more than questions.

3. Conjectures on life after death are also found in Letter 518, B8.

4. See Letter 91 and the connection of this memory to the painting of "The Starry Night" in chapter VIII.

5. Schnier (1950) also suggested that one relatively unconscious link between the sowers and reapers was the unconscious guilt arising from repressed oedipal dynamics and the symbolic castration reflected in the images of the reaper that also found symptomatic expression in his mutilation of his ear when the psychosis broke through the repressive barriers.

6. See Letters 541 and 625.

7. Frederik van Eeden (December 1, 1890), cited in Stein (1986), p. 245. Van Eeden was a writer, and also a practicing psychiatrist who was involved in Theo's treatment in Paris in the fall of 1890.

8. See also the connection between reaping and human death in letter 604, cited above. Vincent compares himself to wheat caught between the millstones in Letter 518.

Chapter XII Vincent's Personality

1. The diagnostic possibilities are multiple—primary affective disorder, schizophrenia, schizophreniform psychosis, borderline personality, chronic brain syndrome due to substance abuse, alcoholism, paranoid personality, episodic dyscontrol and temporal lobe epilepsy (complex partial seizures). The slender indications we have would seem to point to the epileptic diagnosis as strongly probable: the attacks can very likely be ascribed to periodic seizures in the limbic system that have been described as "episodic behavioral disorders" (Monroe 1978). Such episodic psychotic reactions are characterized by painful emotions (often depressive), hallucinations, delusions, loss of identity, and self-destructive impulses.

2. This apparent progression might suggest that the underlying epileptic condition was gradually worsening and only began to reach a level of psychotic disruption in Arles. Neurophysiologists have described the phenomenon of "kindling" which involves a gradual and progressive lowering of the seizure threshold by subthreshold stimulation in vulnerable neural tissue until finally the seizure threshold is lowered to the point that frank dysrhythmic activity can be identified (Goddard et al. 1976). Such kindling in the limbic system of certain patients with temporal lobe syndrome can lead to behavioral changes and even psychosis (Stevens and Livermore 1978; Trimble 1981). The consensus view is that it takes from 10 to 14 years for the process to progress from the onset of temporal lobe problems to the first outbreak of psychosis (Slater et al. 1961; Toone 1981). This may well have been a major contributing factor in the progression of Vincent's final illness.

3. The constituents of absinthe were quite toxic, consisting of a mixture of herbs including wormwood which contains thujone, a substance with epileptogenic properties. Thujone is one of a class of aromatic compounds known as terpenes that are often associated with stomach symptoms and have been documented to produce a variety of central nervous system symptoms, including mood swings, epileptic seizures and hallucinations. The pharmacology of thujone, documentation of Vincent's addictive consumption of absinthe,

and the possible role of this intoxicant in his mental and physical pathology are discussed by Arnold (1988). Additional information on the pharmacology and history of absinthe abuse is found in Arnold (1989).

Absinthe was widely held to be a stimulant which increased the flow of ideas and creativity. As such it was praised and utilized by many artists often resulting in epileptic manifestations (Lubin 1972)—and particularly forms of destructive dyscontrol (Monroe 1978). After a series of famous crimes, the Swiss and soon after the French banned it. It is regarded as a potent stimulant for psychotic and violent behavior.

Vincent's contemporary and fellow absinthe-bibber, Oscar Wilde, described the effects of absinthe: "After the first glass, you see things as you wish they were. After the second, you see things as they are not. Finally you see things as they really are, and that is the most horrible thing in the world. . . . That is the effect absinthe has, and that is why it drives men mad" (Cited in Ellmann 1988), p. 469).

4. The phenomenon of the double has its place in medical lore, mainly as a neurological expression of central nervous system pathology, usually temporoparietal seizures. Even though Vincent probably suffered from temporal lobe seizures, there is nothing to suggest autoscopic hallucinations. Autoscopic hallucinations have been variously described (Lhermitte 1951; Pearson and Dewhurst 1954; Lukianowicz 1958; Ostow 1960), but generally involve some form of projected self-image. The syndrome may be related to the so-called "illusion of doubles," the Capgras syndrome, in which the subject feels that some important other has been replaced by an exact double. The syndrome is usually connected to a paranoid psychosis (Enoch 1963; Arieti and Meth 1959; Meissner 1978b). The theme of the double has also found its way into literature. In de Maupassant's famous tale, "Le Horla," the malignant and persecuting double reflects the destructive sense of the author's own self and may have reflected an actual autoscopic experience of de Maupassant (Rank 1914; Meissner 1977). In Dostoevsky (1846), as in Oscar Wilde (1891), the double is a harbinger of death and madness.

5. See chapter I. The complex aspects of the symbiotic dependence between the two brothers is discussed in chapter IV above.

6. The unconscious theme of procreation must be kept in perspective. In the nineteenth century, sexual and procreative metaphors were by no means uncommon in the language of painters regarding their art. Renoir's brush was a phallic instrument, and Edvard Munch often regarded his paintings as his children. In a later generation, Picasso would regard painting as a form of love-making.

Chapter XIII Vincent's Religion
1. See the discussion of religion as transitional in chapter IX.

Chapter XIV The Search for God
1. Cited in Egan (1991), p. 219.
2. Cited in Egan (1991), p. 239.
3. From the *Fontes Narrativi*, IV, 746-749, cited in Meissner (1992a).
4. Cited in de Bary, Chan, and Watson (1960), p. 255).
5. See my previous discussion of Winnicott's contributions regarding transitional phenomena as applied to art (Chapter VII) and religion (Chapter IX).

6. This delayed crisis in religious orientation is not at all unusual. The story of Ignatius of Loyola again comes to mind—the events surrounding his identity crisis and the beginnings of his religious mission came in his 30th year. See Meissner (1992a) for details.

References

Agger, E.M. (1988) Psychoanalytic perspectives on sibling relationships. *Psychoanalytic Inquiry*, 8: 3-30.

Arieti, S., and Meth, J. (1959) Rare, unclassifiable, collective, and exotic psychotic syndromes. In Arieti, S. (ed.) *American Handbook of Psychiatry*, Vol. 1. New York: Basic Books, pp. 546-563.

Arlow, J. (1960) Fantasy systems in twins. *Psychoanalytic Quarterly*, 29: 175-199.

Arnold, W.N. (1988) Vincent van Gogh and the thujone connection. *JAMA*, 260: 3042-3044.

_____ (1989) Absinthe. *Scientific American*, 260: 112-117.

Bak, R.C. (1958) Discussion. *Psychoanalytic Study of the Child*, 13: 42-43.

Balsam, R.H. (1988) On being good: the internalized sibling with examples from late adolescent analyses. *Psychoanalytic Inquiry*, 8: 66-87.

Barrett, W. (ed.) (1956) *Zen Buddhism: Selected Writings of D.T. Suzuki*. Garden City, NY: Doubleday.

Becker, G.J., and Philips, E. (eds.) (1971) *Paris and the Arts, 1851-1896: From the Goncourt Journal*. Ithaca, NY: Cornell University Press.

Boyer, L.B. (1956) Christmas neurosis. *Journal of the American Psychoanalytic Association*, 3: 467-488.

Brice, C.W. (1991) Paradoxes of maternal mourning. *Psychiatry*, 54: 1-12.

Cain, A.C., and Cain, B.S. (1964) On replacing a child. *Journal of the American Academy of Child Psychiatry*, 3: 443-456.

Coles, R. (1975) On psychohistory. In *The Mind's Fate: Ways of Seeing Psychiatry and Psychoanalysis*. Boston: Little, Brown.

de Bary, W.T., Chan, W., and Watson, B. (eds.) (1960) *Sources of Chinese Tradition*. Vol. I. New York: Columbia University Press.

Dostoevsky, F. (1846) The double. In *Great Short Works of Fyodor Dostoevsky*. New York: Harper and Row, 1968.

Edelheit, H. (1974) Crucifixion fantasies and their relation to the primal scene. *International Journal of Psychoanalysis*, 55: 193-199.

Edwards, C. (1989) *Van Gogh and God: A Creative Spiritual Quest*. Chicago: Loyola University Press.

Egan, S.J., H.D. (1984) *Christian Mysticism: The Future of a Tradition*. New York: Pueblo.

_____ (1991) *An Anthology of Christian Mysticism*. Collegeville, MN: Liturgical Press.

Elgar, F. (1966) *Van Gogh*. New York: Praeger.

Eliade, M. (1985) *A History of Religious Ideas. Vol. 3: From Muhammad to the Age of Reforms*. Chicago: University of Chicago Press.

Elkisch, P. (1957) The psychological significance of the mirror. *Journal of the American Psychoanalytic Association*, 5: 235-244.

Ellmann, R. (1988) *Oscar Wilde*. New York: Alfred A. Knopf.

Enoch, M.D. (1963) The Capgras syndrome. *Acta Psychiatrica Scandinavica*, 39: 437-462.

Erikson, E.H. (1956) The problem of ego identity. *Journal of the American Psychoanalytic Association*, 4: 56-121.

_____ (1959) *Identity and the Life Cycle*. New York: International Universities Press. [Psychological Issues, Monograph 1]

_____ (1975) On the nature of psychohistorical evidence: in search of Gandhi. In *Life History and History*. New York: Norton.

Faille, J.-B. de la (1970) *The Works of Vincent van Gogh: His Paintings and Drawings*. New York: Reynal.

Fisher, D.J. (1991) *Cultural Theory and Psychoanalytic Tradition*. New Brunswick, NJ: Transaction Publishers.

Freud, E. (ed.) (1960) *The Letters of Sigmund Freud*. New York: McGraw-Hill.

Freud, S. (1910) Leonardo da Vinci and a memory of his childhood. *Standard Edition* 11: 59-137.

_____ (1923) Remarks on the theory and practice of dream-interpretation. *Standard Edition*, 19: 107-121.

_____ (1930) Civilization and its discontents. *Standard Edition*, 21: 57-145.

_____ (1933a) New introductory lectures on psychoanalysis. *Standard Edition* 22: 1-182.

_____ (1933b) Why war? *Standard Edition* 22: 195-215.

_____ (1936) A disturbance of memory on the Acropolis. *Standard Edition* 22: 239-248.

Galantiere, L. (ed.) (1937) *The Goncourt Journals: 1851-1870*. Garden City: Doubleday, Doran and Co.

Gay, P. (1988) *Freud: A Life for Our Time*. New York: Norton.

Gedo, J.E. (1983) *Portraits of the Artist: Psychoanalysis of Creativity and Its Vicissitudes*. New York: Guilford Press.

_____ (1987a) Interdisciplinary dialogue as a *lutte d'amour*. In Gedo, M.M. (ed.) Psychoanalytic Perspectives on Art. Vol. 2. Hillsdale, NJ: The Analytic Press, pp. 223-235.

_____ (1987b) Paul Cezanne: symbiosis, masochism, and the struggle for perception. In Gedo, M.M. (ed.) *Psychoanalytic Perspectives on Art*. Vol. 2. Hillsdale, NJ: The Analytic Press, pp. 187-201.

Glenn, J. (1966) Opposite-sex twins. *Journal of the American Psychoanalytic Association*, 14: 736-759.

_____ (1974a) Anthony and Peter Schaffer's plays: the influence of twinship on creativity. *American Imago*, 31: 270-291.

_____ (1974b) Twins in disguise: a psychoanalytic essay on *Sleuth* and *The Royal Hunt of the Sun. Psychoanalytic Quarterly*, 43: 295-301.

_____ (1974c) Twins in disguise: plays by Anthony and Peter Schaffer. *International Review of Psychoanalysis*, 1: 373-381.

_____ (1979) Narcissistic aspects of Freud and his doubles. In Kanzer, M., and Glenn, J. (eds.) *Freud and His Self-Analysis*. New York: Jason Aronson, 297-301.

Goddard, G.V., McNaughton, B.L., Douglas, R.M., et al. (1976) Synaptic change in the limbic system: evidence from studies using electrical stimulation with and without seizure activity. In Livingstone, K.E., and Hornykiewicz, O. (eds.) *Limbic Mechanisms*. New York: Plenum Press, pp. 355-368.

Godin, S.J., A. (1955) The symbolic function. *Lumen Vitae*, 10: 277-90.

Goldberg, C. (1984) The role of the mirror in human suffering and in intimacy. *Journal of the American Academy of Psychoanalysis*, 12: 511-528.

Gombrich, E.H. (1963) *Meditations on a Hobby Horse and Other Essays on the Theory of Art*. London: Phaidon Press.

Goncourt, E. de. (1877) *La Fille Elisa*. Paris: Charpentier. Translation: *Elisa: The Story of a Prostitute*. New York: Hillman Books, 1959.

Graetz, H.R. (1963) *The Symbolic Language of Vincent van Gogh*. New York: McGraw-Hill.

Greenacre, P. (1947) Vision, headache, and the halo. In *Trauma, Growth, and Personality*. New York: International Universities Press, 1969, pp. 132-148.

———— (1956) Experiences of awe in childhood. *Psychoanalytic Study of the Child*, 11:

———— (1957) The childhood of the artist: libidinal phase development and giftedness. *Psychoanalytic Study of the Child*, 12: 47-72.

———— (1958) The family romance of the artist. *Psychoanalytic Study of the Child*, 13: 9-36.

Hamilton, G.H. (1967) *Painting and Sculpture in Europe 1880-1940*. Baltimore, MD: Penguin Books.

Hamilton, J.W. (1979) The doppelgänger effect in the relationship between Joseph Conrad and Bertrand Russell. *International Review of Psychoanalysis*, 6: 175-182.

Heelan, P.A. (1972) Toward a new analysis of the pictorial space of Vincent van Gogh. *Art Bulletin*, 54: 478-492.

Heiman, M. (1976) Psychoanalytic observations on the last painting and suicide of Vincent van Gogh. *International Journal of Psychoanalysis*, 57: 71-79.

Hocking, W.E. (1912) *The Meaning of God in Human Experience: A Philosophic Study of Religion*. New Haven, CT: Yale University Press, 1963.

Holstijn, A.J.W. (1951) The psychological development of Vincent van Gogh. *American Imago*, 8: 239-273.

Hulsker, J. (1980) *The Complete Van Gogh*. New York: H.N. Abrams.

———— (1990) *Vincent and Theo Van Gogh: A Dual Biography*. Ann Arbor, MI: Fuller Publications.

Huysmans, J.-K. (1876) *Marthe, Histoire d'une Fille*. Brussels: Gay. Translation: *Martha, the Story of a Woman*. New York: Lear, 1948.

Kakar, S. (1991) *The Analyst and the Mystic: Psychoanalytic Reflections on Religion and Mysticism*. Chicago: University of Chicago Press.

Kanzer, M. (1979a) Freud and his literary doubles. In Kanzer, M., and Glenn, J. (eds.) *Freud and His Self-Analysis*. New York: Jason Aronson, 285-296.

_____ (1979b) Sigmund and Alexander Freud on the acropolis. In Kanzer, M., and Glenn, J. (eds.) *Freud and His Self-Analysis*. New York: Jason Aronson, 259-284.

Kernberg, P. F., and Richards, A.K. (1988) Siblings of preadolescents: their role in development. *Psychoanalytic Inquiry*, 8: 51-65.

Kodera, T. (1990) *Vincent van Gogh: Christianity versus Nature*. Amsterdam: John Benjamins.

Kohut, H. (1971) *The Analysis of the Self*. New York: International Universities Press.

_____ (1977) *The Restoration of the Self*. New York: International Universities Press.

Kris, E. (1952) *Psychoanalytic Explorations in Art*. New York: Schoken Books, 1964.

Lacan, J. (1953) Some reflections on the ego. *International Journal of Psychoanalysis*, 34: 11-17.

Leavy, S.A. (1986) A paschalian meditation on psychoanalysis and religious experience. *Cross Currents*, Summer, 147-55.

Leon, I.G. (1990) *When a Baby Dies: Psychotherapy for Pregnancy and Newborn Death*. New Haven, CT: Yale University Press.

_____ (1992) The psychoanalytic conceptualization of perinatal loss: a multidimensional model. *American Journal of Psychiatry*, 149: 1464-1472.

Levin, S. (1971) The psychoanalysis of shame. *International Journal of Psychoanalysis*, 52: 355-362.

Lhermitte, J. (1951) Visual hallucination of the self. *British Medical Journal*, 1: 431-434.

Lifton, R.J. (1974) On psychohistory. In Lifton, R.J., and Olson, E. (eds.) *Explorations in Psychohistory: The Wellfleet Papers*. New York: Simon and Schuster, pp. 21-41.

Lubin, A.J. (1972) *Stranger on the Earth: A Psychological Biography of Vincent Van Gogh*. New York: Holt, Rinehart and Winston.

Lukianowicz, N. (1958) Autoscopic phenomena. *Archives of Neurology and Psychiatry*, 80: 199-220.

Lynch, S.J., W.F. (1960) *Christ and Apollo: The Dimensions of the Literary Imagination*. New York: Sheed and Ward.

Mack, J.E. (1971) Psychoanalysis and historical biography. *Journal of the American Psychoanalytic Association*, 19: 143-179.

Mahler, M.S. (1952) On childhood psychosis and schizophrenia: autistic and symbiotic infantile psychoses. *Psychoanalytic Study of the Child*, 7: 286-305.

_____ (1958) Autism and symbiosis: two extreme disturbances of identity. *International Journal of Psychoanalysis*, 39: 77-83.

_____ (1968) *On Human Symbiosis and the Vicissitudes of Individuation. Vol. I: Infantile Psychosis*. New York: International Universities Press.

_____ and Furer, M. (1963) Certain aspects of the separation-individuation phase. *Psychoanalytic Quarterly*, 32: 1-14.

_____ and Gosliner, B.J. (1955) On symbiotic child psychosis: genetic, dynamic and restitutive aspects. *Psychoanalytic Study of the Child*, 10: 195-212.

_____, Pine, F., and Bergman, A. (1975) *The Psychological Birth of the Human Infant*. New York: Basic Books.

Meissner, S.J., W.W. (1977) A case in point. *Annual of Psychoanalysis*, 5: 405-436.

_____ (1978a) The conceptualization of marriage and family dynamics from a psychoanalytic perspective. In Paolino, T.J., and McCready, B.S. (eds.) *Marriage and Marital Therapy: Psychoanalytic, Behavioral and Systems Theory Perspectives*. New York: Brunner/Mazel, pp. 25-88.

_____ (1978b) *The Paranoid Process*. New York: Jason Aronson.

_____ (1981) *Internalization in Psychoanalysis*. New York: International Universities Press. [Psychological Issues, Monograph 50]

_____ (1984) *Psychoanalysis and Religious Experience*. New Haven: Yale University Press.

_____ (1986) *Psychotherapy and the Paranoid Process*. New York: Jason Aronson.

_____ (1987) *Life and Faith: Psychological Perspectives on Religious Experience*. Washington, DC: Georgetown University Press.

_____ (1992a) *Ignatius of Loyola: The Psychology of a Saint*. New Haven: Yale University Press.

_____ (1992b) Vincent's suicide: a psychic autopsy. *Contemporary Psychoanalysis*, 28: 673-694.

_____ (1993) Vincent: the self portraits. *Psychoanalytic Quarterly*, 62: 74-105.

_____ (1994) The theme of the double and creativity in Vincent van Gogh. *Contemporary Psychoanalysis*, 30: 323-347.

Menninger, K.A. (1938) *Man Against Himself*. New York: Harcourt Brace.

Miller, A. (1981) *Prisoners of Childhood*. New York: Basic Books.

Modell, A.H. (1961) Denial and the sense of separateness. *Journal of the American Psychoanalytic Association*, 9: 533-547.

_____ (1968) *Object Love and Reality*. New York: International Universities Press.

_____ (1970) The transitional object and the creative act. *Psychoanalytic Quarterly*, 39: 240-250.

Monroe, R.R., (1978) The episodic psychoses of Vincent van Gogh. *Journal of Nervous and Mental Disease*, 166: 480-488.

Morrison, A.P. (1989) *Shame: The Underside of Narcissism*. Hillsdale, NJ: Analytic Press.

Muller, J. (1985) Lacan's mirror stage. *Psychoanalytic Inquiry*, 5: 233-252.

Nagera, H. (1967) *Vincent Van Gogh: A Psychological Study*. Madison, CT: International Universities Press, 1990.

Niederland, W.G. (1965) An analytic inquiry into the life and work of Heinrich Schliemann. In Schur, M. (ed.) *Drives, Affects, Behavior*. New York: International Universities Press, pp. 369-396.

Olivier, J. (1951) Letter dated 4 August 1951. In *The Complete Letters of Vincent van Gogh*, vol. 3. Greenwich: New York Graphic Society, 1959.

Oremland, J.D. (1989) *Michelangelo's Sistine Ceiling: A Psychoanalytic Study of Creativity*. Madison, CT: International Universities Press.

Ostow, M. (1960) The metapsychology of autoscopic phenomena. *International Journal of Psychoanalysis*, 41: 619-625.

Otto, R. (1932) *Mysticism East and West: A Comparative Analysis of the Nature of Mysticism*. New York: Macmillan, 1972.

Pearson, J., and Dewhurst, K. (1954) Sur deux cas de phenomenes autoscopiques consecutifs a des lesions organiques. *L'Encephale*, 43: 166-172.

Peppers, L.G., and Knapp, R.J. (1980) Maternal reactions to involuntary fetal/infant death. *Psychiatry*, 43: 155-159.

Pickvance, R. (1986) *Van Gogh in Saint-Remy and Auvers*. New York: Metropolitan Museum of Art.

Pollock, G.H. (1961) Mourning and adaptation. *International Journal of Psychoanalysis*, 42: 341-361.

_____ (1962) Childhood parent and sibling loss in adult patients. *Archives of General Psychiatry*, 7: 295-305.

_____ (1964) On symbiosis and symbiotic neurosis. *International Journal of Psychoanalysis*, 45: 1-30.

_____ (1972) Bertha Pappenheim's pathological mourning: possible effects of childhood sibling loss. *Journal of the American Psychoanalytic Association*, 20: 476-493.

Poznanski, E.O. (1972) The "replacement child": a saga of unresolved parental grief. *Journal of Pediatrics*, 81: 1190-1193.

Radhakrishnan, S., and Moore, C.A. (eds.) (1957) *A Sourcebook in Indian Philosophy*. Princeton, NJ: Princeton University Press.

Rank, O. (1914) *The Double: A Psychoanalytic Study*. Chapel Hill, NC: University of North Carolina Press, 1971.

Reff, T. (1987a) The author, the authority, the authoritarian. In Gedo, M.M. (ed.) *Psychoanalytic Perspectives on Art*. Vol. 2. Hillsdale, NJ: The Analytic Press, pp. 237-243.

_____ (1987b) John Gedo and the struggle for perception. In Gedo, M.M. (ed.) *Psychoanalytic Perspectives on Art*. Vol. 2. Hillsdale, NJ: The Analytic Press, pp. 203-221.

Rizzuto, A.M. (1979) *The Birth of the Living God: A Psychoanalytic Study*. Chicago, IL: Chicago University Press.

Rochlin, G. (1965) *Griefs and Discontents: The Forces of Change*. Boston: Little, Brown.

_____ (1980) *The Masculine Dilemma: A Psychology of Masculinity*. Boston, MA: Little, Brown.

Rose, G.J. (1978) The creativity of everyday life. In Grolnick, S.A., and Barkin, L. (eds.) *Between Fantasy and Reality: Transitional Objects and Phenomena*. New York: Aronson, pp. 345-362.

_____ (1987) *Trauma and Mastery in Life and Art*. New Haven: Yale University Press.

_____ (1991) Abstract art and emotion: expressive form and the sense of wholeness. *Journal of the American Psychoanalytic Association*, 39: 131-156.

Runyan, W.M. (1987) Why did Van Gogh cut off his ear? In Cocks, G., and Crosby, T.L. (eds.) *Psycho/History. Readings in the Method of Psychology, Psychoanalysis and History*. New Haven: Yale University Press, pp. 121-147.

Schapiro, M. (1952) On a painting of Van Gogh. In *Modern Art: 19th and 20th Centuries, Selected Papers*. New York: Braziller, 1978, pp. 87-99.

_____ (1968) The still life as a personal object—a note on Heidegger and van Gogh. In *Theory and Philosophy of Art: Style, Artist, and Society*. New York: George Braziller, 1994, 135-142.

_____ (1980) *Van Gogh*. Garden City, NY: Doubleday.

_____ (1983) *Vincent van Gogh*. New York: Abrams.

_____ (1994) Further notes on Heidegger and van Gogh. In *Theory and Philosophy of Art: Style, Artist, and Society*. New York: George Braziller, 143-151.

Schneider, D.E. (1950) *The Psychoanalyst and the Artist*. New York: International Universities Press.

Schnier, J. (1950) The blazing sun: a psychoanalytic approach to van Gogh. *American Imago*, 7: 143-162.

Schur, M. (1972) *Freud: Living and Dying*. New York: International Universities Press.

Shengold, L. (1974) The metaphor of the mirror. *Journal of the American Psychoanalytic Association*, 22: 97-115.

_____ (1975) An attempt at soul murder: Rudyard Kipling's early life and work. *Psychoanalytic Study of the Child*, 30: 683-724.

_____ (1979) Child abuse and deprivation: soul murder. *Journal of the American Psychoanalytic Association*, 27: 533-559.

_____ (1988) Dickens, Little Dorrit, and soul murder. *Psychoanalytic Quarterly*, 57: 390-421.

_____ (1989) *Soul Murder: The Effects of Childhood Abuse and Deprivation*. New Haven, CT: Yale University Press.

Slater, E., Beard, A.W., and Glithero, E. (1961) The schizophrenia-like psychoses of epilepsy. *British Journal of Psychiatry*, 109: 95-150.

Soth, L. (1986) Van Gogh's agony. *Art Bulletin*, 68: 301-313.

Spector, J. (1988) The state of psychoanalytic research in art history. *Art Bulletin*, 70: 49-76.

Stamm, J.L. (1971) Vincent van Gogh: identity crisis and creativity. *American Imago*, 28: 363-372.

_____ (1976) Peter Schaffer's *Equus*—a psychoanalytic exploration. *International Journal of Psychoanalytic Psychotherapy*, 5: 449-461.

Stein, S.A. (ed.) (1986) *Van Gogh: A Retrospective*. New York: Park Lane.

Stevens, J.R., and Livermore, A. (1978) Kindling of the mesolimbic dopamine system: animal model of psychosis. *Neurology*, 28: 36-46.

Sweetman, D. (1990) *Van Gogh: His Life and His Art*. New York: Crown Publishers.

Toone, B. (1981) Psychoses of epilepsy. In Reynolds, E.H., and Trimble, M.R. (eds.) *Epilepsy and Psychiatry*. Edinburgh: Churchill Livingstone, pp. 113-137.

Tralbaut, M.E. (1969) *Vincent van Gogh*. New York: Viking Press.

Trimble, M.R. (1981) The limbic system. In Reynolds, E.H., and Trimble, M.R. (eds.) *Epilepsy and Psychiatry*. Edinburgh: Churchill Livingstone, pp. 216-226.

van Gogh-Bonger, J. (1959) Memoir of Vincent van Gogh. In van Gogh-Bonger, J., and van Gogh, W. (eds.) *The Complete Letters of Vincent van Gogh*. 3 vols. Greenwich, CT: New York Graphic Society.

_____ and van Gogh, W. (eds.) (1959) *The Complete Letters of Vincent van Gogh*. 3 vols. Greenwich, CT: New York Graphic Society.

Vergote, A. (1969) *The Religious Man: A Psychological Study of Religious Attitudes*. Dayton, OH: Pflaum Press.

Villarreal, I. (1988) Fear and desire in the transformation fantasy. *International Review of Psychoanalysis*, 15: 135-147.

Volkan, V. (1981) *Linking Objects and Linking Phenomena. A Study of the Forms, Symptoms, and Therapy of Complicated Mourning*. New York: International Universities Press.

_____ and Itzkowitz, N. (1984) *The Immortal Ataturk. A Psychobiography*. Chicago: University of Chicago Press.

Wallace, R. (1969) *The World of Van Gogh: 1853-1890*. New York: Time-Life Books.

Walther, I.F., and Metzger, R. (1990) *Vincent van Gogh: The Complete Paintings*. 2 vols. Köln: Benedikt Taschen Verlag.

Wilde, O. (1891) *The Picture of Dorian Gray*. New York: Magnum Books, 1968.

Wilson, E. (1988) Stendhal as a replacement child: the theme of the dead child in Stendhal's writings. *Psychoanalytic Inquiry*, 8: 108-133.

Winnicott, D.W. (1965) *The Maturational Processes and the Facilitating Environment*. New York: International Universities Press.

_____ (1971) *Playing and Reality*. New York: Basic Books.

Wurmser, L. (1981) *The Mask of Shame*. Baltimore: Johns Hopkins University Press.

_____ (1987) Shame: the veiled companion of narcissism. In Nathanson, D.L. (ed.) *The Many Faces of Shame*. New York: Guilford Press, pp. 64-92.

Zerbe, K.J. (1987) Mother and child: a psychobiographical portrait of Mary Cassatt. *Psychoanalytic Review*, 74: 45-61.

THE RESHAPING OF PSYCHOANALYSIS
From Sigmund Freud to Ernest Becker

This series is designed to offer works which are concerned with the reshaping and revitalization of psychoanalysis. Also critical to this series is the interweaving of such disciplines as psychology, psychiatry, religion, and philosophy so as to promote dialogue and offer avenues toward rapprochement.

This series will publish and proffer studies of Freud and Neo-Freudians such as Becker which are most aware of the long term contributions of psychoanalysis toward the healing of self and society. Studies should be scholarly and clinically discerning. This is a series which is keenly concerned with the bridging of disciplines, the networking of ideas and peoples, and with the perpetuation of the psychoanalytic questions, and, at times, its answers. This is a series which is also very open to its authors' creativity and most appreciative of those efforts which reshape, revamp, revitalize, and transform Freudian psychoanalysis.

The general series editor is Barry R. Arnold, an Emory Ph.D., who is Associate Professor of Religious Studies and Philosophy at the University of West Florida. His speciality area is psychoanalysis and medical ethics.